MANY FAIR BLOSSOMS MAKE A FINE TREE

Commissions of Scholar's Objects and Furniture by Kössen Ho

BY

KÖSSEN HO

Translated by
Cameron Henderson-Begg

商務印書館
THE COMMERCIAL PRESS

In memory of Wang Shixiang and Zhu Jiajin
and to my parents

In 1994, to celebrate Wang Shixiang and Zhu Jiajin's 80th birthdays, I commissioned a series of photographs of each of them. Tian Jiaqing organised the project for me, and afterwards he sent me two of the portraits, one of Wang and one of Zhu, so I could have them signed on my next visit to Beijing.

As it turned out, Wang Shixiang did not like the portrait Tian had chosen for me, and when I produced the photograph, he asked me where I had got it. He got the whole story out of me, and I went away empty handed. Later I visited Zhu Jiajin's home, Baoxiang Studio, where I had more luck.

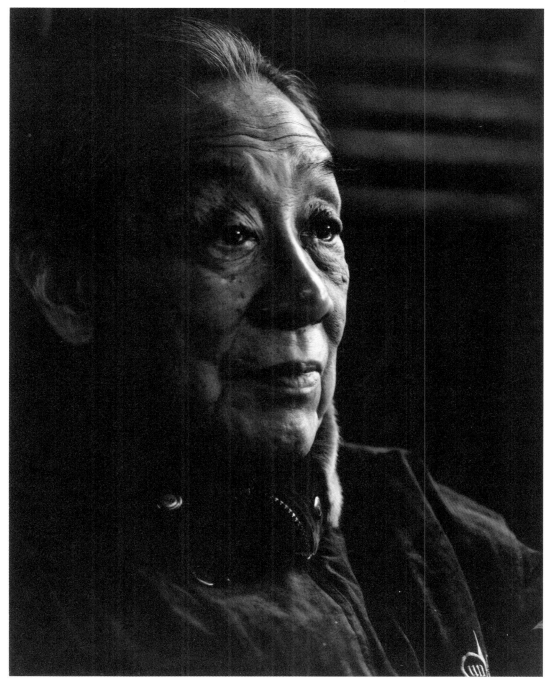

Zhu Jiajin (1914–2003)

I would have to wait until October 1996 to get the right photo of Wang Shixiang. He was visiting London, and Craig Clunas took him on a guided tour of the British Museum. I was living in the UK at the time, and I went with them. After a while we reached the Elgin Marbles, where I noticed a carving of a horse's head that looked like it could have been done in the Han dynasty. I can still remember Wang nodding in agreement when I pointed out the resemblance. I took this picture of him next to it, and when I brought a copy to Beijing, he signed it with pleasure.

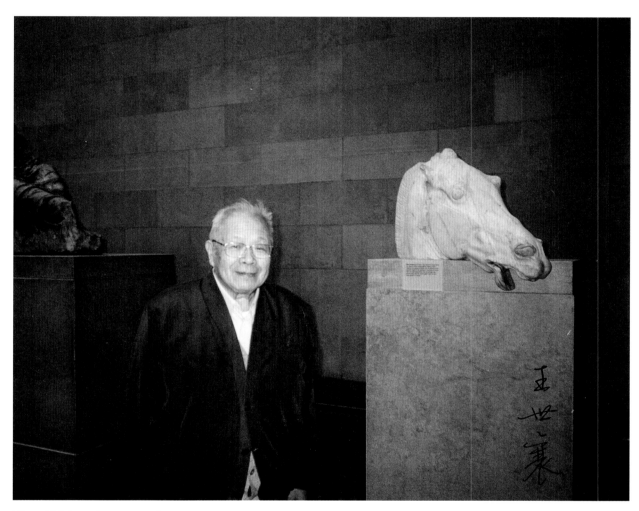

Wang Shixiang (1914–2009)

宛似春華競綻枝何家千載
令名垂從花萼思前範玉
樹交輝又一時為
孟澈先生出驕頴沒文題一絶
世襄

孟澈先生屬書
癸酉夏王世襄

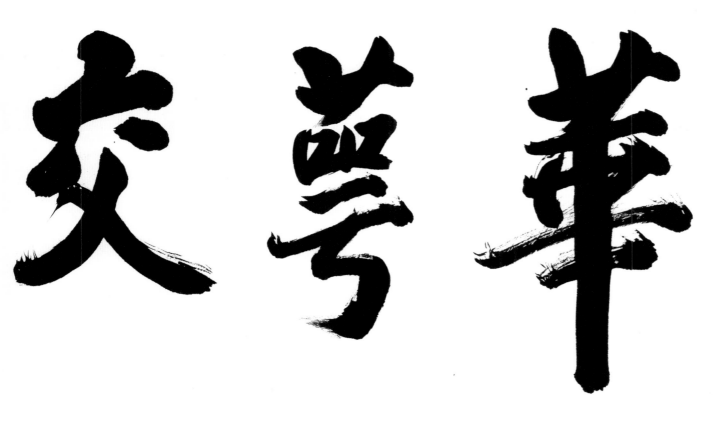

Poem and Postscript on the Title

Translator's note:

The book's title, Many Fair Blossoms Make a Fine Tree, has a long association with the Ho family. This poem was originally composed to accompany a calligraphic version of the phrase, written for the author by Wang Shixiang in 1993 for use on a decorative name plaque. As is customary, the calligraphy is accompanied by a postscript, in this case supplied by Wang's friend Zhu Jiajin. In both texts, "He" is the Mandarin pronunciation of the Cantonese name Ho, written 何 in Chinese.

As blossoms on a branch in spring
 will vie to cast their gleam:

Just so, a thousand years of Hes
 have carried on that name,
And now, fair blossoms calling him
 to think upon those folk,
A fine young sapling gives these boughs
 a season more to shine.

For Kössen
A quatrain to accompany your studio's name plaque
Shixiang

In his moments of leisure away from medicine, Mr Kössen Ho can be found happily engrossed in the great books or indulging his refined taste for antiquities. In summer 1993, while he was living in England, he came to Beijing for a visit. There he asked Wang Shixiang to write him a piece of calligraphy to use as a name plaque for his home, and he asked me to write a postscript to go with it. The phrase Kössen chose was 花萼交輝, "many fair blossoms make a fine tree".

This saying has a long history. Its connection to Kössen's family goes back to 1117, when the brothers He Li, He Tang, and He Ju all passed the metropolitan examinations in the same year, allowing them to enter the civil service. In honour of this feat, people said of them that "many fair blossoms make a fine tree". He Li later became a government minister, but his life ended tragically. During the Jingkang Disaster of 1126–1127, the state of Jin took Emperor Qinzong captive, and He Li went with him. The imperial entourage marched all the way to Mount Yan, where He Li died. Not wanting to sacrifice his principles to the enemy, he had refused to eat.

To this day, the He family maintains an ancestral temple in Dongguan, just over the border from Hong Kong in Guangdong Province.

Zhu Jiajin of Xiaoshan
at the Hall of Fair Fortune
Midsummer 1993

Author's note

Zhu's account of He Li is drawn from a family genealogy, *The Manual of the Hall of Gathering the Dispersed* (*Cuihuan tang pu* 萃渙堂譜), printed in the early years of the Qianlong reign (1735–96). Since it was written so long after the fact, it is hardly a perfect source. However, I wanted to include Wang's poem and Zhu's postscript in full in recognition of all the encouragement and guidance I received from them both.

Wang Shixiang—王世襄 (1914–2009). A towering figure in the study of traditional Chinese culture, Wang produced a substantial and varied output of books and essays over the course of his long life. In his later years, he acquired an almost legendary status as a connoisseur, mentor, and teacher.

Zhu Jiajin—朱家溍 (1914–2003). Like Wang, Zhu was an accomplished – and exceptionally long-lived – scholar and artist. Together with Qi Gong and Huang Miaozi (see notes to items 8 and 10), they formed one of the most revered quartets in 20th-century Chinese arts and letters.

Many fair blossoms make a fine tree—translating 花萼交輝 (*huā'è jiāo huī*, lit. 'blossom and calyx beautify each other'). The phrase, drawn from the canonical Book of Songs (see notes to item 33), describes the relationship between brothers, envisioned as integral parts of the same flower.

the brothers He Li, He Tang and He Ju—respectively 何桌 (= 何㮚, 1089–1127), 何棠 and 何㮚 (both late 11th to mid-12th cen-

tury). He Li, the eldest, was also known by his soubriquet, He of the Northern Studio (He Beizhai 何北齋). For a single member of a family to pass the metropolitan examinations, the prerequisite for government service, was an achievement in itself. For three to do so was a remarkable feat. Accounts differ as to whether the three brothers did in fact pass in the same year, but He Li, who placed first in the examinations while still in his twenties, is known to have passed in 1115. (The source text for the preface, the family genealogy referred to in the Author's Note above, errs slightly in dating his success to later in the decade.)

the Jingkang Disaster—Jingkang zhi bian (靖康之變), in which invading armies from the northern state of Jin sacked the capital of the Northern Song dynasty at Kaifeng and carried its last emperor into captivity. Named for the title of the reign period during which it occurred. Mount Yan (*Yanshan* 燕山) was a waypoint on the route north.

何孟澈先生擅岐黃之術濟世

餘暇怡情書史博雅嗜古於癸酉

仲夏自美倫來京觀光求主瑩安

兄書花萼交輝四字以顏其居室

又屬余為之跋按此四字由來久矣蓋

君之先世有何北齋先生諱橐者

與兄弟諱棠及藥者聯登宗政和

七年進士遂有花萼交輝之稱

北齋先生官至尚書靖康之變從

Translator's Note

Chinese titles, names, and terms are rendered in Pinyin, except where a different romanisation is more widely recognised in English. In the headings in the main text, historical figures are dated by dynasty, with their birth and death dates (where known) provided in the notes. For those active after the fall of the final imperial dynasty in 1912, dates of birth and death are given throughout.

The Chinese text of this catalogue follows traditional East Asian naming conventions. Individuals' style or courtesy names (*zi* 字, usually bestowed to mark the person's coming of age) are often preferred to their personal names (*ming* 名), so that the 20th century artist Pu Ru (溥儒, 1896–1963) is always called Pu Xinyu (溥心畬). In some cases, both names are replaced by a literary soubriquet (*hao* 號), as with the Yuan painter and calligrapher Zhao Mengfu (趙孟頫, 1254–1322), who is regularly referred to in the Chinese text as "the Man of the Way Amid Snow in the Pines" (*songxue daoren* 松雪道人). These alternative names are important – soubriquets in particular often tell us much about how people were seen or wished to be seen by their contemporaries – but for ease of reference I have preferred to use personal names throughout. Where an alternative name is especially significant or well-known, it is indicated in the notes.

Figure references are to the Chinese volume of the catalogue.

This book is a story of mentorship, told through objects. My own mentors have been many, and I have called on the guidance and wisdom of all of them in preparing this translation. I wish to acknowledge in particular the teaching of Shio-yun Kan (干曉允), Margaret Hillenbrand, Justin Winslett, Craig Clunas, Song Yang (宋陽), Hu Bo (胡泊) and others at Oxford's Institute for Chinese Studies. My gratitude is also due to Kössen Ho for entrusting me with this translation and for his generous counsel during the writing process.

This translation is for Helena, to whom be joy.

Cameron Henderson-Begg (韓凱邁)
Another Mountain Studio (他山齋)
January 2023

Contents

Foreword by Tung Chiao

Translated by Chloe Tung

Doctor Kössen Ho has cured my obsession with antiques. The first course of 'medication' he prescribed was to allow me to witness how the innovative artistry of Wang Shixiang and Zhu Jiajin instigated his journey into the world of bamboo carving. He befriended renowned experts in the field, who custom-made exquisite pieces of bamboo-ware. These sculpted articles combine ancient with modern, exerting an aura of elegance little different from antique pieces.

My second 'prescription' allowed me to view my beloved Song dynasty calligraphy by Su Shi, "Poems on the Cold Food Festival", intricately etched into an ancient *huanghuali* brush pot. Carved by Fu Jiasheng, the characters are striking yet charming, and were sure to have pleased his concubine, Zhao Yun. Moreover, after failing to acquire "Studio of Bitter Rains" at auction – a horizontal tablet written by Shen Yinmo for Zhou Zuoren – Kössen went to the extent of commissioning Fu to inscribe the words "kuyu" or "bitter rains", as well as the word "zhai" or "studio", as they appear in Su's work, on a wooden tablet given to me for my seventieth birthday the following year.

The third dose of medicine came when he requested that I copy a section from the story "Fine and Fair Women" found in *A New Account of the Tales of the World*, to be meticulously inscribed into a wrist rest made by Fu from red sandalwood. The tale postulates, "If clothes do not start out new, how are they supposed to grow old?" In a similar vein, one might ask, "If objects do not start off as new, how do they become antiques?"

This type of profound insight from Kössen is finally presented one by one in "Many Fair Blossoms Make a Fine Tree". Exuding a sense of modernity without understating elements of the past, the volume is profound yet practical. Looking past the classical crescent doors of the floral garden, Kössen is less concerned with the legend of Chang'e but is instead pondering when his personally hand-planted Magnolia coco were set to blossom. Practically all of his treasures are engraved with the words "an elegant creation of Kössen Ho", and rightfully so. The type of composition, innovation, experience and depth that is ingrained into an artist's essence can, likewise, not be taken away from Kössen's creative endeavours. His collection acts precisely as his interpretation of traditional culture and art, while serving as a new realm gifted to the world of antique collecting. Dur-

ing a conversation between Wang Shixiang, Zhu Jiajin, and I about Kössen's resolute adoration of Chinese culture and art, Zhu's smile suddenly disappeared, giving way to a sombre expression. He then remarked, "Without dogged determination and enthusiasm, there is no courage and insight, and thus no way for successes to come about", As matters stand, Kössen's accomplishments in collecting indeed satisfy Zhu's judgment.

Kössen relishes Pu Ru calligraphy and paintings as much as my generation of elders and feels that the self-contained traces of variation within the words and pictures constitute an aesthetic that is impossible to ignore. In 2010, the six small ink paintings *Plants from an Autumn Garden*, which I had spent years collating, finally ended up in Kössen's hands. The entire album includes the script "Poems on Fallen Flowers", written to me by Qi Gong, as well as a text and postscript by my old friend Chiang Chaoshen. Kössen invited bamboo carver Bo Yuntian to adapt the paintings into twelve wrist rests, and summoned Fu (the seal cutter) to carve twelve ebony paperweights. While flicking through *Many Fair Blossoms Make a Fine Tree* to admire these twenty-four exquisite carvings, I was reminded of the time Chiang was in my study, examining a red sandalwood wrist rest of Bada Shanren's poems and paintings. While gently stroking the wrist rest, he sighed softly, saying, "Antique ornaments? Now this is what I call an antique ornament." I bought this Qianlong wrist rest at an auction at the old City Hall in the early 1970s. Huang Miaozi was also present, and I waited for him to examine and commend the piece before I set about purchasing it. After so many years, I carefully surveyed the many treasures included in *Many Fair Blossoms Make a Fine Tree* and recognised the brush pot decorated with Yang Buzhi's painting of a plum blossom that had been gifted to me by Kössen – a new engraving of an ancient painting. It is not an antique, but it is better than an antique. Dr Ho has truly cured my obsession with antiques.

Foreword by Hui Lai Ping

Translated by Ashley Wu

Kössen Ho is a respected doctor, whose vocation is to better the world by saving lives, and whose avocation is to immerse himself in art.

Many Fair Blossoms Make a Fine Tree: Commissions of Scholar's Objects and Furniture by Kössen Ho shows us the perfect "one part" (item 014) he played in the commissions. Although he humbly downplays the role of his own "handiwork", (item 015) the heart of his commissions lies in the ingenuity he mobilises to "transform antiquity" (item 016). The title of the book is a tribute to Kössen's ancestry, just as his commissions are extensions of a thousand years of cultural lineage.

As the age-old saying goes, "If you cannot be a good chancellor, then be a good doctor." Kössen carries inside him grand aspirations. We have all heard it said, "Chess is an easy game, but one would never master it without dedication." The commissions are reflections of Kössen's utmost commitment towards his artistic pursuit. I hereby dedicate this humble foreword to Kössen Ho in celebration of his fruitful endeavours.

Foreword by Wu Guangrong

Translated by Cameron Henderson-Begg

In preparing a foreword for this volume, I fell to thinking about its author, my dear friend Kössen Ho, who has devoted so much of his leisure time to the world of scholar's objects. As I did so, another man's name came to mind: Chen Jieqi, the late Qing seal maker and collector.

A sometime government official, Chen ended his public service in 1854, when he was in his early forties. From that time until his death 30 years later, he devoted himself to antiquities: to collecting them, appraising them, interpreting them, and passing them on. In all these pursuits, he was highly successful. Later experts and scholars describe him as a particular authority on ink rubbings – life-size, white-on-black copies taken from the surface of an inscription or carving – and as a master of epigraphy, the most important area of antiquarian study of his day. Like the monk artist Liuzhou before him, he changed the rules of the game in this field.

As a collector, Chen amassed a rich array of objects; as an appraiser, he created an entirely new approach to spotting fakes. His work in interpretation established basic classification systems for the epigraphic study of ancient pottery and seals, significantly enlarging the field's scope from its early focus on stone tablets and bronze vessels. He also worked with rubbing makers to develop new methods for their craft, helping to preserve the past for future generations.

Although their specialisms differ, and there is always a measure of hyperbole to comparisons like this, I am struck by the many similarities between Chen and Kössen.

When Kössen started out, he sought the guidance of an earlier generation of scholars, including Wang Shixiang and Zhu Jiajin. They set him on the right path, steering him first to the arts of bamboo and then broadening his horizons to other forms: the furniture of the scholar's studio and so on. Kössen found a way to make this world his own. He studied the works of the past, learning by imitating them. From their examples – from the copying of calligraphy and from carving, engraving, and rubbings – he grasped the whole method of creating works of art, the combination of choosing materials, borrowing from the past, and innovating. In his own works across different media, he integrates paintings and their inscriptions with epigraphy and calligraphy to form complete, unified designs. He then collaborates with different artists to bring his ideas into being. Once the resulting works have taken the best possible form, they are turned into rubbings, and he records the whole process of making them, along with all the people and events that have been part of their creation. These are the rules of Kössen's own, utterly distinctive game. His work has not only ensured that traditional skills are passed on and broadened: it has helped our traditional aesthetics to take a step forward. These days, such an achievement is both difficult and commendable.

Kössen studied in the UK – his specialism is urological surgery – but he works close to home in Hong Kong, and a few years ago I was able to see a draft of his book at the studio of our friend, the designer Zhang Midi of Hangzhou. I was excited and determined that the objects Kössen had written about should be exhibited. Sadly, with the pandemic dragging on, it was too difficult to make that a reality. But as I write this, the finished book is soon to appear, and that has helped to settle my regrets.

China Academy of Art
Winter Solstice, 2022

Readers of Chinese may enjoy a recent article in Guangming Daily, noted in the Chinese version of this preface, which introduces Chen's achievements in each of these fields.

Author's Preface

Translated by Cameron Henderson-Begg

So much of what we do fades. Consider Wang Wei, the great poet of China's Tang dynasty. To his contemporaries, he was not just Wang Wei the writer: he was Wang Wei, high minister at the Tang court, Wang Wei, owner of a fabulous estate on the Wheelrim River. But political achievements are things of one time and place, and even the grandest estates do not last forever. Today all that survives of Wang is his poems.

In time, the Tang dynasty gave way to the Song. This era produced two pieces of prose that students in China recite to this day: Fan Zhongyan's *On Yueyang Tower* and Ouyang Xiu's *The Old Drunkard's Pavilion*. Like Wang Wei, Fan and Ouyang enjoyed distinguished careers in government, but no-one's life is touched by their policies now. Only their writing lives on.

When the Song dynasty fell, the Yuan sprang up in its place. Its Mongol rulers were lords of the world – for a moment. After less than a century, their empire collapsed, never to return. But some things did survive. Visitors to the Tuancheng Fortress, the great castle in western Beijing, still stop to marvel at a huge, ornate basin, the "Sea of Jade from Mount Du", commissioned by Genghis Khan's son Khubilai when he governed as Emperor of China. The carved dragons and beasts that decorate its surface stand as monuments to a vanished age.

Things that fade, fade fast. The *Draft History of the Qing*, the official history of China's last dynasty, includes stories of all the leading lights of the age. Pick up a copy and you will encounter hundreds of names: faithful officials, dutiful children, loyal partners, steadfast friends. Men and women of the highest character will leap up from the page – but no matter how much history you know, you will recognise almost none of them. A few centuries are all it has taken for their memory to disappear.

As a surgeon, I have always known that my work will be short-lived. Even with the best care, my patients will be gone someday, and so will I. So, since the 1990s, I have been building a second body of work, commissioning dozens of pieces of traditional Chinese art and craftsmanship. I have concentrated on the objects that make up a scholar's study: chairs, tables, and bookcases, as well as pots for writing brushes, wrist rests to support the calligrapher's hand, seals for affixing to documents, and all the other accoutrements that in Chinese are called "scholar's objects".

In my early days as a collector, I was fortunate to be mentored by Wang Shixiang, whose writing, research, and teaching contributed as much as anyone in the 20th century to the appreciation of China's cultural heritage. Under his tutelage, I selected paintings, calligraphy, and literature to decorate the objects I commissioned. He wrote for me the four Chinese characters that I use as a maker's mark: 孟澈雅製, "an elegant creation of Kössen Ho".

Wang Xizhi's "Orchid Pavilion Preface", the great masterpiece of Chinese calligraphy, includes a line that reads, "just as we in the present turn our gaze to the past, so those yet to come will turn their gaze to the present". I like to think that, someday, a collector or visitor to a museum may look at a piece of mine and notice the mark that Wang Shixiang wrote for me all those years ago. Perhaps they will read it and think to themselves, "Kössen Ho. Who was he, I wonder?" What an honour that would be.

K.H.
Hong Kong
July 2018

Wang Wei—王維 (c. 701–761). One of the greatest poets of the greatest age of Chinese poetry. Wang's long career in government service culminated in his tenure as First Deputy of the Bureau of State Affairs (*shangshu youcheng* 尚書右丞), a prestigious ministerial post.

Wheelrim River—Wangchuan (輞川), where Wang retired and after which one of his most notable works, the *Wheelrim River Collection* (*Wangchuan ji* 輞川集), was named.

Fan Zhongyan…Ouyang Xiu—respectively, 范仲淹 (989–1052) and 歐陽修 (1007–72). Two noted scholar-officials. The works named are Fan's "Yueyanglou ji" (岳陽樓記) and Ouyang's "Zuiwengting ji" (醉翁亭記), both of which are commonly taught to beginner students of Classical Chinese.

the "Sea of Jade from Mount Du"—the *Dushan da yuhai* (瀆山大玉海), a massive jade wine vessel, weighing several tonnes. Commissioned in the early years of the Mongol Yuan dynasty (1271–1368), of which Khubilai Khan (1215–94) was the first emperor.

Draft History of the Qing—Qingshi gao (清史稿). A massive, official history project covering the final imperial dynasty, the Qing (1644–1912). Begun in 1914, the *Draft* was completed in 1928 but proscribed by the Nationalist government in 1930, primarily be-

cause of its compilers' conservative attitude to the political reformers of the dynasty's last years.

Wang Shixiang—see notes to the Postscript to the Title.

Wang Xizhi—王羲之 (303–361). "Orchid Pavilion Preface" (*Lanting xu* 蘭亭序), which introduces a set of poems written at a scholarly gathering in the early 350s, is generally considered to be the supreme masterpiece of the Chinese calligraphic tradition, and Wang that tradition's supreme exponent. The original does not survive, and today the work is best known through a copy made by the calligrapher Feng Chengsu (馮承素, 617–72). This latter version is now in the collections of the Palace Museum (the museum of the Forbidden City in Beijing). See also item 67.

Introduction

By Kössen Ho Translated by Ashley Wu

I vacillate on every single word,
For I am touched, and more than I can say.

These are the final two lines in a 1705 poem from the then 64-year-old Shitao to a friend who gifted him a brush that belonged to Emperor Shenzong (Wanli Emperor) of the Ming Dynasty.

This publication is a compilation of scholar's objects and furniture commissioned over the past 30 years as I honed my skills in urology. While minimally invasive instruments and surgeries might be my calling, I have always felt inadequate when it comes to calligraphy and paintings, and neither do I possess any talent in chiselling and carving. Mentors and artists were instrumental in fleshing out and materialising my ideas. I titled this introductory essay "I vacillate on every single word, for I am touched, and more than I can say" to express my heartfelt gratitude towards them.

A. Carved Bamboo Scholar's Objects

Wang Shixiang (1914–2009) was an eminent scholar in the study of Ming Dynasty furniture. He was also dedicated to the revival of lacquerware, bamboo carvings, gourd vessels, as well as pigeon whistles. In addition, he published on handicraft regulations, paintings, music, pigeon connoisseurship, cricket fighting, and the practices of raising eagles, chirping insects, and dogs for badger hunting.

At first Wang and I bonded over our shared interest in Ming furniture. He later introduced me to the world of carved bamboo scholar's objects, and I have been enamoured with the craft ever since.

Wang was dedicated to the revival of bamboo carvings throughout his life. In 1973, he began editing the book *Zhuke xiaoyan* (*On bamboo carvings*) authored by his uncle, Jin Xiya, upon returning to Beijing from the cadre school of Xianning in Hubei province. Wang compiled six publications between 1980 and 2003:

1. *Bamboo Carving of China* (co-authored with Wan-go Weng)

2. *Zhuke* (*Bamboo Carvings*)

3. *Zhuke jianshang* (*Connoisseurship of Bamboo Carvings*)

4. *Zhongguo meishu quanji: Gongyi meishu bian. Zhumu yajiao qi* (*Complete works of Chinese fine arts: Arts and Crafts. Art crafts made of bamboo, wood, ivory, and rhinoceros horn*, co-edited with Zhu Jiajin)

5. *Zhuke yishu* (*Carved Bamboo Art*, including Jin's *Zhuke xiaoyan*)

6. *Zhuke xiaoyan* (*Manuscripts on bamboo carvings*)

The Wangs passed me a copy of *Zhuke* in 1993 when I visited them in Beijing. I brought it back with me to Britain and enjoyed reading it outside of hospital work.

On July 8, 1994, Wang wrote to Fan Yaoqing in Changzhou to commission a wrist rest, a gift intended for me, and subsequently followed up with three more letters. See *Zhumo liuqing: Wang Shixiang zhi Fan Yaoqing shuhan tanyilu* (*Ink on Bamboo: Letters on art from Wang Shixiang to Fan Yaoqing*).

At Mid-autumn Festival in 1994, Wang gave me a bamboo wrist rest carved with Qi Gong's calligraphy of a couplet from Li Bai's *qi jue* (heptasyllabic quatrain), *Song He binke gui Yue* (*Seeing off He Zhizhang on his return to Yue*), accompanied with a note in ink on red paper (Figs A. 1.1, 1.2).

The object marked my first physical encounter with bamboo carving. It is a demonstration of Fan's refined craftsmanship. As I marvelled at Qi's calligraphy, I was also drawn to his written work, deeply resonating with his prologue of *Lun Shu jue ju bai shou* (*One Hundred Quatrains on Calligraphy*): "The old masters were not gods; they were just people like me." (See Item 13). Wang's wrist rest is living proof that our contemporaries, just like the old masters, can possess an aptitude for elegant literati designs. Still undergoing my doctoral training in urology at Oxford at the time, I began exchanging letters with Wang. They are compiled under Items 1 to 9 and 18 to 21 in this publication, and each one is detailed by an essay.

It is worth noting that the design and production process of Item 8 *Pingfu tie* (*Letter on recovery*) and Item 9 *Lou Shi Ming* (*Inscription for a lowly abode*) resemble the structure of a palindrome, which reads the same backwards as forwards. It tells of the cyclical nature of our lives – travelling a long way only to return to the starting point.

In Zhou Wufang's *Zhuke jingyan tan* (*My experience with bamboo carving*), published in *Zhuke*, an excerpt under "*Yang du*" ("Nurturing magnanimity") impacted me

profoundly: "The effortless mastery of a subject requires knowledge beyond it. If attention is solely devoted to a single subject, one lacks elegance and sophistication, and can only become good at the subject at best."

Wang, Zhu, and Fu Xinian have published widely on paintings and calligraphies. Their works, together with *Qi Gong Cong Gao* (*Anthology of Writing by Qi Gong*), Huang Miaozi's *Yi lin yi zhi: Gu Meishu wen bian* (*The world of fine arts: Writings on ancient art*), and *Gugong bowuyuan cang wenwu zhenpin quanji* (*The complete collection of the treasures of the Palace Museum*), published by the Commercial Press, are crucial to my understanding of paintings and calligraphies, thanks to the depth and breadth of the research. I am blessed to have the access to calligraphies and paintings from over the centuries in museums, a privilege the old masters did not enjoy. Some of the carved bamboo scholar's objects took their design blueprint from the imperial collection of the Qianlong Emperor, referencing motifs of flower, bird, animals, human figures, landscape, and calligraphy.

Wang frequently shared his advice with me on the design of carved bamboo scholar's objects. He proposed to carve Jin's painting on my wrist rests in item 1. Jin's original wrist rest was executed in intaglio, but in Fan's recreation the narcissus was carved in relief using the *liuqing* technique. Wang included the phrase "changing *yin* (in intaglio) to *yang* (in relief, or *liuqing*)" in the inscription.

The *yang* and *yin* dichotomy encapsulates the relationship between light and shadow, which is descriptive of the carving techniques involved: *liuqing* relief is a form of *yang* carving representing light, while *yin* carving (in intaglio), representing shadow, makes use of a sunken negative space. The practice can be traced back to the Renaissance in fifteenth-century Europe, a time when masters such as Leonardo Da Vinci used *chiaroscuro* to add depth and to create visual drama. In the exhibition "The Virgin of the Rocks" at the National Gallery in London, light from different angles and intensity was cast on a rock (Figs A. 2.1–2.5) and demonstrated how light and shadow could be manipulated to shape the viewer's experience, showing the interchangeability between *yang* and *yin*.

Yin can turn into *yang*, and vice versa. By the same token, *yin* carving can also embody *yang* in its execution. This publication includes objects carved in this manner. The techniques involved owe their sources to a selection of scholar's objects in Wang's *Zi zhen ji* (*Compendium of a Few Old Things*). For clarity, I set them out in a table in the Chinese text.

In Wang's collection, the *zitan* brush pot decorated with high relief of dragons, fish and sea creatures is an outstanding work of its kind (Fig. A. 6.1). I wrote a quatrain in tribute to the brush pot in awe of its beauty. The ornaments on the brush pot remind me of those on "Sea of Jade from Mount Du", a jade basin commissioned by Khubilai Khan, son of Genghis Khan.

Jade and stone carvings are similar in nature; thus, both can be used as a reference point for a high relief brush pot. High relief and round relief are regarded as the pinnacle of

bamboo carving. I chose Zhou Hansheng when designing a bamboo brush pot using high relief as he is one of the few masters of these techniques.

I have always been fascinated by the art in Dunhuang, Yungang, and Longmen, with a predilection for *apsarās*. As the motif is frequently seen in stone carvings, I therefore commissioned Zhou to carve a bamboo brush pot in high relief of *apsarā*.

The brush pot (Item 79, Fig. A. 6.2) is on one hand an attempt to revive the art of high relief. Three *apsarās* are seen on the brush pot, one playing the *pipa*, one the *konghou* harp, and one the panpipes. On the other hand, it is paying homage to Wang's harsh life in the 1950s, when Li Yuanqing and Yang Yinliu, directors of the folk music department at the Central Conservatory of Music, extended a helping hand to Wang by admitting him to the study programme of ancient music and musical instruments. Wang's collection also includes some impressive Buddhist sculptures – the said brush pot decorated with *apsarās* was also meant to be a tribute to his Buddhist art collection.

Wang was also a crucial figure in restoring the production of gourd vessels. Gourds grown in containers that mould them into various shapes are turned into homeware, pigeon whistles, and feeders for eagles and chirping insects. The use of the gourd in scholar's objects and musical instruments is a Chinese invention championed by the Qing Dynasty emperors. Wang started designing and producing gourd vessels at a young age. Later in his life, he transferred his knowledge by authoring *Shuo Hulu* (*Notes on gourd*), which revitalised the endangered craft. The scholar's objects produced under the supervision of Wan Wenqiang in Tianjin, including the gourd brush pot in Item 20, are recent examples of gourd vessels produced within the paradigm.

When Wang was working on the annotation of *Xiu shi lu* (*The Crafts of Lacquerware*) in the 1950s, he asked lacquerer Duo Baosheng to decorate a lacquer box with a Northern Song brocade pattern to facilitate his understanding of two specific technical terms (Figs A. 8.1, 8.2). Items 56 and 57 are brush pots decorated with a brocade pattern of a running hare and that of a pair of beasts.

To further his understanding of lacquer techniques, Wang once commissioned a round lacquer box based on a carved *Huanghuali* (fragrant rosewood) openwork disc with *chilong* dragon motif from Fu Zhongmo's collection (Fig. A. 9). In 2016, I adopted a similar motif in designing Item 97, a large, rounded-corner cabinet.

Not long after my return to Hong Kong post-2000, a time when I was not familiar with the auction market, I asked Tung Chiao's help in acquiring Shen Yimo's fan painting in ink on bamboo (Fig. A. 10). On its reverse is Shen's calligraphy of Su Shi's description of his writing, which Su compared to a "thousand tons of spring water that can burst forth from anywhere on the ground".

Su's words speak to my creative urge to design scholar's objects and furniture. Such inspiration is with me all the time.

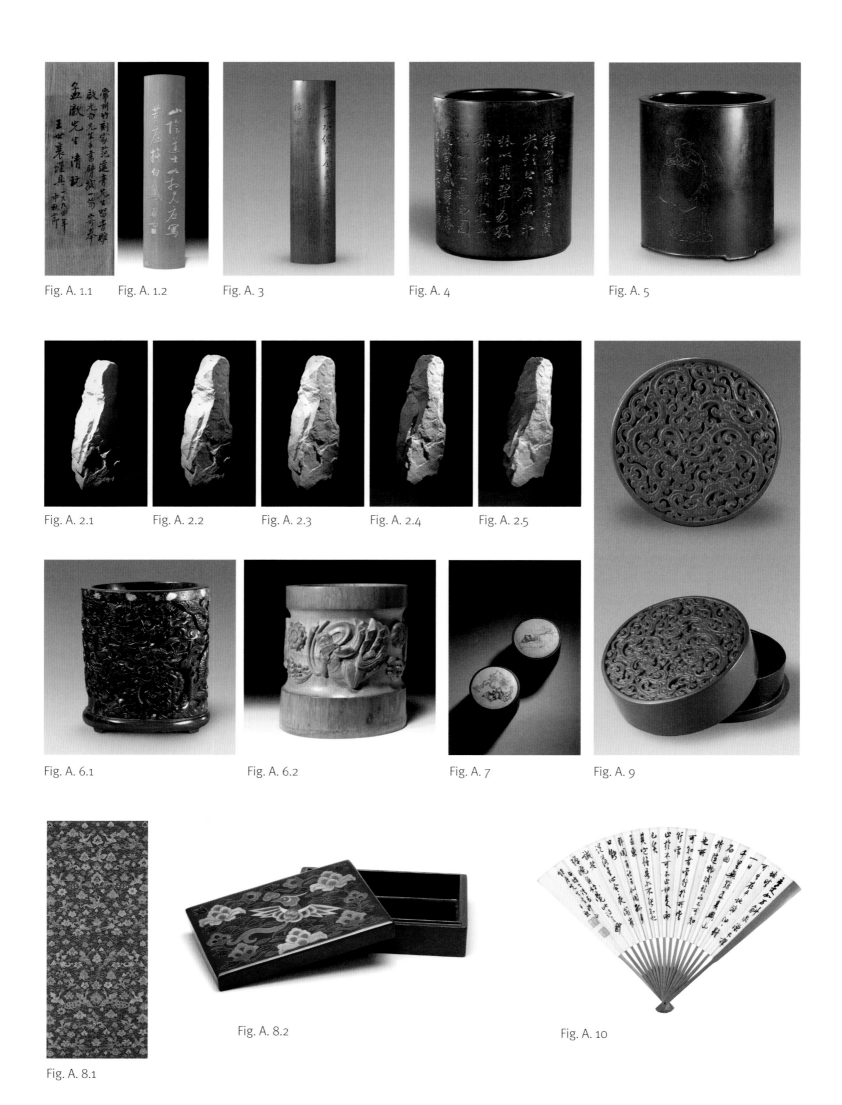

Fig. A. 1.1 Fig. A. 1.2 Fig. A. 3 Fig. A. 4 Fig. A. 5

Fig. A. 2.1 Fig. A. 2.2 Fig. A. 2.3 Fig. A. 2.4 Fig. A. 2.5

Fig. A. 6.1 Fig. A. 6.2 Fig. A. 7 Fig. A. 9

Fig. A. 8.2 Fig. A. 10

Fig. A. 8.1

B. Poetry and Rhyme

Thus said the Master: "Young ones, why do you not study the Poems? One may use them for stimulation, for contemplation, for bringing people together and for raising complaints. Thanks to them, you may serve your father near at hand and your lord further afield, and you will better know the names of bird and beast, plant and tree."

Analects, Yang Huo XVII.9

Wang Shixiang and I first bonded over our mutual interest in Ming furniture. Soon after, under the guidance of Wang, I ventured into the world of poetry and rhyme.

Poetry as an outlet for discontent

Wang gifted me *Bamboo Carving* in 1993. Despite its rich and informative content, Wang was upset with the publication due to the subpar printing quality. He expressed his frustration by including in the book the manuscript of a rhyme he wrote (Figs B 1.1, 1.2):

Seven long years this book has taken me:
Seven long years of saying how great it is.
My poor little feet have come out in calluses,
But I always kept my eyes on the far-off prize.
It started in portrait; now it's landscape-wise;
The forewords have fallen into disarray;
The text is like columns of ants; the paper's grey,
The calligraphy blurred, like misty mountaintops.
Thus, with a burning shame that never stops,
I send you this gift of mediocrity.

In the hopes of assuaging Wang's concern, I wrote to him offering my opinion. I told him that the affordability of *Zhuke* was key to popularizing bamboo carvings, and at ¥18 per copy it was perfect. The book did end up nurturing the bamboo sculptor Zhu Xiaohua.

Wang showed me how to grumble subtly with poetry.

Poetry's role in fostering relationships

In the essay *"Ji Nongmin Zhukejia Fan Yaoqing"* ("Fan Yaoqing: The Country Bamboo Carver") published in *Zhuke*, Wang wrote a seven-character quatrain as a gift to Fan.

In the postscript, Wang wrote: "Mr Fan Yaoqing was a peasant with extraordinary skills in bamboo carving. His craft has long surpassed that of Zhan Sheng from the Northern Song. Although Fan is world renowned, Wuzhong has never heard of this homegrown talent. I hope this little poem will bring a smile onto his face".

Qi Gong and Huang Miaozi then followed Wang's rhyme scheme, and each composed a poem that complemented the other.

As a doctor, I was astounded by the exchange of odes between literati I witnessed – a literal, real life example of poetry's role in fostering relationships.

According to my family genealogy, revised on the third year of the Qianglong era, three brothers from the He family who attained *jinshi* (the highest and final degree in the imperial examinations in Imperial China) during the Song Dynasty, were described collectively as *hua'e jiaohui* (華萼交輝): "flower and calyx sharing their splendour", a Chinese analogy for fraternity between brothers. This gave rise to this book's title in Chinese, along with a loose English version: "Many fair blossoms make a fine tree." In summer 1993, Wang inscribed the said expression on a plaque (Chinese text p. VIII, IX & item 103), which was accompanied by Zhu's postscript (Chinese text p. 10–11) and Wang's quatrain:

As blossoms on a branch in spring
will vie to cast their gleam:
Just so, a thousand years of Hes
have carried on that name,
And now, fair blossoms calling him
to think upon those folk,
A fine young sapling gives these boughs
a season more to shine.

For Kössen
A quatrain to accompany your studio's name plaque
Shixiang

I later attempted to adopt the poem's rhyme scheme and composed a quatrain myself. The end result, expectedly, deviated from the template. Wang rewrote my draft and sent me his edits in ink and paper.

They said of Confucius that he "was good at leading people forward, step by step". Here was Wang doing the same thing for me.

Contemplating the life mirrored by poetry

I wrote to Wang and Fan in 1996 about my plan to design a bamboo brush pot with narcissus flower motifs. In our correspondence on March 6, 1997, Wang advised: "I suggested that Fan Yaoqing carve a pair of wrist rests instead of a brush pot, as bamboo pots are prone to cracking. I also proposed to Fan that he use Jin Xiya's liuqing narcissus bamboo as a reference and carve my version of *Gazing on Jiangnan*. I composed the lyrics some years ago in admiration of narcissus flowers, and plan to write in brush for the wrist rests. As such, your original design can be encapsulated in a more material friendly manner. What is your thought? If you agree with the suggestions, I could ask Mr Fan to prepare the raw materials and send me a sample. I can return it to him after I complete the calligraphy, then he can proceed with the carving."

I have been familiar with Bai Juyi's *Gazing on Jiangnan* since primary school. Seeing the tune title was like visiting an old friend. This was Wang's lyric to the tune *Gazing on Jiangnan*:

How fine is Xiangcheng!
For what is she famed throughout the world?
For immortals without number,
who have taken on a new form,
In emerald robes, their faces jade,
their hair in golden buns,
Whose spring looks fill the human realm.

Wang's ancestral home is located in Fuzhou, Fujian. In

his lyrics to the tune, written during a visit to Xiangcheng district in Zhangzhou, Fujian, late in his life, sentiment towards the people and scenery of his ancestral province echoes throughout. Wang's lyrics managed to follow the structure of traditional Chinese literature in its entirety, which includes introduction, elucidation, transition, and conclusion, in just twenty-seven characters. "Whose spring looks fill the human realm" brings the lyrics to a halt, leaving us enchanted with the final sounds.

> "For immortals without number,
> who have taken on new form,
> In emerald robes, their faces jade,
> their hair in golden buns."

Poetry visualises images through words like a mirror.

Enlightenment through poetry

I came across Su Shi's *Cheng tian si ye you ji* (*A Night Walk at Cheng Tian Temple*) in secondary school. Su wrote it in Huangzhou, around the same time as he wrote the poem *Han Shi tie* (*Poems on the Cold-food Festival*; the title refers to a three-day traditional Chinese holiday in spring that begins on the day before the Qingming Festival) (Item 70).

The closing line in *Cheng tian si ye you ji*, "Yet, there are rarely idlers like us two", made an impression on me. On a summer night, when Tian Jiaqing and I were navigating our way in Wang's courtyard at Fangjiayuan in complete darkness, the line flashed into my mind – aren't we exactly those "idlers", despite our full-time jobs, who are characterised in Su's poem? Tian is a chemical engineer in the fossil fuel industry, I am a medical doctor. Our shared interest outside of our own professions brought us together on a trip to visit a towering figure in the study of traditional Chinese culture, who was yet to be widely known at that time (Chinese text Fig. 5.5).

During this trip, Wang gave me his new book, *Xishuai pu ji cheng* (*Guide to Crickets*; Chinese text Fig. 5.2). The book opened with six quatrains about crickets, which Wang wrote in lieu of an author's preface. The first one is as follows:

> *The winds of autumn rise. A change*
> *is coming now, at last,*
> *Their cries, their chirps, their whirrs and chirrups*
> *lodging in my heart.*
> *And don't you know how many*
> *fellow fools have done the same –*
> *Have loved these, finest members*
> *of the insect world by far?*

I wrote to Wang on the first lunar month in 1998 about my intention to commission a wrist rest featuring the above quatrain on its upper half, and to decorate it with crickets whose wings were to be carved in *liuqing* style (Chinese text Fig. 5.4) on the lower half. He wrote to Fan in approval of my design: "I have sent your drawing and inscription over with registered mail...I am very fond of the cricket drawing. I hope you can carve it onto another wrist rest. Not urgent at all. You could finish Mr Ho's commission first before starting mine (Item 5). I would like to write another poem to be inscribed on my wrist rest. It is not ready yet anyway. Raising crickets has been my hobby for years, but I am too old for that now. A wrist rest in memory of those times would offer me some comfort (Item 5, Chinese text Fig. 5.1; Item 6, Chinese text Figs 6.1, 6.2)".

In the 1990s, cricket fighting was all the rage in China. As a result, cricket doping was very common, with trainers and breeders feeding their charges hormones to improve their chances in the ring. The situation reminded Wang of an anecdote from his elder and friend Zhao Liqing, who was also devoted to raising crickets. Wang expressed his affection through the following poem:

> *Old White-Claw with your crab-like shell,*
> *and yellow Black-of-Fang:*
> *Should you lock horns someday, you both*
> *are sure to come to grief.*
> *Better to be painted crickets,*
> *facing off for aye,*
> *Unharmed from head to toe, a pair*
> *of little insect kings.*

During the early years of the Republic of China, Zhao, who was from Wang's father's generation, procured a yellow cricket with ink-black fangs. At the time, Tao Zhongliang, from Wang's family-in-law, also owned a white-clawed cricket with a shell that resembled that of a crab. The two crickets were similar in weight, both trained and nurtured extremely well. They were kings, superior to all crickets, and were invincible until late autumn.

At the start of winter, two separate gamblers asked to borrow the crickets from Zhao and Tao for a match in Shanghai between the two kings. Zhao and Tao knew a battle between the crickets would injure them, and thus adamantly declined the offer. Wang, influenced by the two elders, would rather see the crickets carved on bamboo, face to face, than to see them suffer in a fight. Wang turned his feelings towards the two creatures into a transcendental poem.

In other words, poetry can stimulate thinking, even enlightenment.

Reference work

At the end of 1999, on my visit to the Wangs, Wang gave me a copy of *Shi yun ji cheng* (*Collected Rhyming Dictionaries*) (Fig. B. 2) that belonged to his mother, Jin Zhang (Chinese text Figs 7.1, 7.2). He left me a note on the front cover:

> *This edition of Shiyun jicheng was from late Qing. It once resided on my mother's desk. I am glad to learn that you have fostered an interest in poetry, and I wish to present this to you as a gift.*
>
> *– Winter 1999 Wang Shixiang*

Wang's gift to me also included a copy of *Zhongguo jingdai shuhua quanji: Jin Zhang* (*Paintings of Famous Modern Chinese Artists: Jin Zhang*, Chinese text Fig. 7.5) printed by Han Mo Xuan. From reading this book, I developed a deeper understanding of Jin's life.

Shiyun marked my first encounter with a reference work about poetry writing. As a doctor, the sciences had been my natural home during my studies. Here was a whole new world.

In winter of the same year, Zhu Jiajin composed and wrote two pairs of calligraphy couplets for me. In addition, Mrs Wang (neé Yuan Quanyou) made me a large paper cutting with mandarin ducks motifs. The design carries its own merits even when juxtaposed against those in *You ren ji: Quanyou ke zhi (Paper cutting by Quanyou)*. The gift was completed by Wang's five-character quatrain composed for the occasion. I was deeply grateful for such impressive and thoughtful gifts.

In the title of one of his books, Zhu Jiajin uses a delightful expression to describe writing done outside of one's day job: *tuishi* (退食), 'withdrawing and dining'. The term originally referred to courtiers going out from the emperor's presence to eat, and it is exactly how I experienced beginning to write poetry 'on my own time'. First, I had to be in the right frame of mind, at leisure away from work: I had to withdraw. Then, I had to experience something new, a culture shock that would put me in the emotional place to write. In other words, I needed something to feast on. In summer 2003, I was learning bladder cancer surgery in Mansoura Hospital located in the Nile Delta in Lower Egypt. I spent my free time visiting museums and historic sites in the area. The ancient civilisation's extreme glamour urged me to practice writing with rhyme schemes. My stint in Egypt was followed by advanced courses in urology in Belgium and Germany. "The Hall of Looking at the Hills" in Appendix 2 of the Chinese text gives details of my study experience.

In winter 2003, I wrote to Wang from Brussels, sending him *In honour of the gilt-bronze Buddhist statues in the Lisongju collection*, one of five poems I wrote in honour of Wang's collection in his studio, *Lisongju (Paired Pines House)*.

The following week I called Wang from Brussels. He said, with pleasure, "You got that completely right", acknowledging my correct adoption of the rhyme schemes. It was a tremendous encouragement that still brings me strength today.

In winter 2003, Wang passed me an entire set of *Peiwen Yunfu* (Chinese rhyme dictionary of literary allusions and poetic dictions) (Fig. B. 3), which was photocopied and published by the Shanghai Bookstore from the Commercial Press version. *Peiwen Yunfu* is a rhyme dictionary edited upon imperial order and prefaced by Emperor Kangxi himself and was Wang's most frequently consulted reference work. I am in my element when I compose rhymes with *Peiwen Yunfu* and *Shiyun jicheng*.

A place to call home

In 1994, on Wang's eightieth birthday, Mrs Wang prepared a paper cutting with motif of a great tree, designed with reference to the gingko tree in the background of a stone buddha statue from the Northern and Southern Dynasties. Wang composed a lengthy five-character quatrain to complement Mrs Wang's work.

The Wangs were a doting couple. Mrs Wang once told me that Mr Wang had not once raised his voice to her. In winter 2003, while I was at the University Hospital in Brussels, Mrs Wang passed away. I wrote an eight-line poem with seven characters to a line, *In memory of Mrs Wang*, and sent it to Wang for his edits.

In the beginning of summer in 2004, while I was studying minimally invasive prostate cancer surgery at the Leipzig University hospital in Germany, Wang celebrated his ninetieth birthday. At that time, I spent all my free time on writing a long ballad that summarises Wang's life achievements, which I subsequently transferred onto a red paper and sent to Wang by registered airmail in celebration of the momentous occasion. (Fig. B. 4)

In 2004, Wang's fourteen-year-old grandson, Wang

Fig. B 1.1

Fig. B 1.2

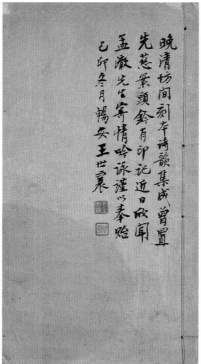

Fig. B 2

Fig. B 3

Fig. B 4

Zheng, published a *wuxia* (martial heroes) novel *Shuang fei lu*, the title of which was inscribed by Huang Miaozi. In the preface, Wang wrote, "I am ninety years old now. My body is declining, and my eyesight becomes increasingly blurry. I could no longer write. I was unable to spend much time teaching and playing with my grandchild in the past but writing a short preface for my fourteen-year-old grandson's first publication brings me so much more joy than that", Writer Tung Chiao mentioned the novel *Shuang fei lu* in his writing, and I received a copy of it from Wang.

During my trip to Beijing in September 2005, Wang gifted me *The Third Lovely Ash-Heap*. The chapter "Wang's poetry recitation", includes fourteen poems collected under the title, *"Gao Quanyou"* ("Notes to *Quanyou*"). One was dedicated to his son, Wang Dunhuang; one was to his grandson, Wang Zheng. I wrote my thoughts in prose and sent them to Wang after reading the works.

Wang, in his old age, enjoyed bliss and tranquillity under Dunhuang's care. In August 2007, Wang gave me his latest work *Not Quite a Lovely Ash-Heap* in person and added, "This will be the last one". I savoured the gift, but with a heavy heart.

C. Furniture

> Huan, General of the Chariot and Horse, disliked wearing new clothes, so his wife decided to send some to him after his bath. The general flew into a rage and told the servant to take them away. His wife then brought them back again and passed him a message: "If clothes do not start out new, how are they supposed to grow old?" Lord Huan laughed heartily, and he put them on.
>
> *A New Account of the Tales of the World*
> (see item 11)

In *A Second Lovely Ash-Heap*, under the chapter "Wang's Poetry Recitation", Wang Shixiang succinctly outlined the furniture making process in a twenty-characterquatrain, describing the raw materials, construction methods, structure, and the thought processes involved.

The quatrain was Wang's translation of a poem written in English by Dr Yip Shing Yiu:

> Good matter comes from the wild,
> Fashioned by the wise into round and square;
> For furniture is more than wood,
> It's the interaction of Nature and Man.

My furniture commissioning journey began with Tian Jiaqing's handmade furniture models. In summer 1997, the Wangs moved into their new residence in Fangjiayuan outside Chaoyangmen. In his letter in June, Wang mentioned a new table that I could view when I visited them in Beijing. The sizable *huali* (rosewood) table stood solemnly at the centre of Wang's living room (Fig. C 3, Chinese text Fig. 86.1.2), accompanied by the following inscription:

> This mighty bough became a desk
> Adapted from a Ming design.

> The chisel's strikes, the hatchet's work:
> All are here on proud display.
> Each piece, each part forms one vast whole,
> Whale-backed, with elephantine feet.
> These days, folk like things gaudy
> But plain will do for me.

Seeing the table inspired me to commission one of my own. I solicited help from Tian, who first constructed a full scale, Yellow Jade Table (Item 87) before completing the final Purple Jade Table (Item 86). Wang then wrote an inscription for the piece, his longest ever for a table, detailing its form and function:

> A table made from fine zitan,
> After Song Luo's:
> Dark as lacquer, deep and black,
> Smooth and soft its gloss.
> Just the thing for reading at
> Or taking up your brush;
> A stand for ancient vessels, or
> For viewing curios,
> But better still for leaning on,
> Lost in reveries.
> Protect it and preserve it, pray,
> To treasure and to use.

Tian and I maintained an active conversation throughout the design and construction process of the tables (Item 86). They were built entirely by hand, rendering them even more rare and precious than their machine-made counterparts. The inscriptions Wang wrote for his *huali* (rosewood) table, and the Purple Jade Table were exemplary, and served as a guide when I composed mine for the Yellow Jade and the Purple Jade Tables in 2000. My inscription was later carved onto the Yellow Jade Table by Li Zhi in 2015 (Chinese text Figs 87.6–9).

This is Tian's inscription on the *huanghuali* shelf units with cruciform latticework railings in 2002 (item 90):

> This pair of shelves, made by hand from the finest *huanghuali* timbers, took a team of six carpenters two years to complete. No adhesives were used for the frame. It is joined by mortices and tenons. The twenty-four railing panels consist of almost a thousand components. Concave on the outside and convex on the inside, all locked together with *chuaichuai* tenons. The railings and the frame are held together with removable wooden pins. The piece demonstrates traditional Chinese carpentry at its finest.

By varying the convexity and concavity of the columns and railings, and by using wood of different colours, one can produce a range of combinations to cater for different tastes and needs.

In executing the trestle table (Item 94) I envisaged, Tian was met with the challenge of finding the right ratio for the components. He endeavoured to find a solution, and eventually devised a scheme that worked for tables of the kind (See his fax in Item 94). Utilising the scheme, Tian realised several large tables with his expertise and experience, each with its merits and features. They say great things have small

beginnings, and I am honoured to have helped Tian to make a start.

The commissioning of the set of four *huanghuali* high yoke-back armchairs was a journey to remember (Item 92). Their full scale model alone took several years and many design iterations to finalise. The finished works were adorned with inscriptions composed by Qi Gong, Wang Shixiang, Zhu Jiajin, and Huang Miaozi, all carved by Fu Jiasheng on their slats. The carvings were later made into rubbings by Fu Wanli. It was unprecedented to have a whole set of armchairs inscribed, each composed and written in calligraphy by a towering scholar. The set can be read as a gesture of respect to the above four scholars and mentors who taught with words and by example.

In 2004 I came across the book *Contemporary Furniture* in London. The co-author Sebastian Conrad, a furniture designer, started his preface with an analogy between furniture and poetry:

> *Compare furniture to a poem; poems are constructed from words, just as furniture is constructed from details.*
>
> *A wrong word will jar, producing a clumsy metre, while a poor detail will produce visual imbalance.*
>
> *In the same way, in our homes, a wrong piece or one in the wrong place can upset the equilibrium of an otherwise harmonious environment.*

I wrote a quatrain to try out his analogy on Chinese verse. The tonal pattern and rhyme scheme in poetry are just as crucial as the components of furniture and their proportion, both playing a role in aesthetics.

Similar parallels can be drawn between furniture and calligraphy, as well as between furniture and traditional Chinese architecture. With a few simple tweaks my single verse blossomed into a family of three. Calligraphy gives endless possibilities upon varying the choice of writing instrument, the length and thickness of a stroke, and the space between each radical. People from different times, or even just two different people, might create multiple expressions of the same character. This is the case in furniture too.

Genealogically, Ming furniture borrowed its structure from the beam frames used in traditional Chinese architecture. Poetry, calligraphy, traditional architecture, and furniture are so intertwined that they can be discussed collectively or individually.

Poetry and Furniture

Polymerase chain reaction (PCR) testing has become part of our lives in recent years due to the COVID-19 pandemic. Intriguingly, lessons on poetry writing can be learnt from PCR, a technique used to amplify DNA or RNA. Qi Gong once compared the base pairs (A:T, G:C) linking the two strands in a DNA structure to poems that follow an ABAB rhyme scheme and tonal prosody.

Changing the building blocks of a poem would compromise its fluency. By the same token, adjustments in measurement and the proportions of a component would alter the look and feel of a piece of furniture. I tried to illustrate the awkwardness a minor change in tone would make with a

stanza about the historical attire worn by male students during examinations at Oxford University: in the 1990s, it was still mandatory for the male students to sit their exams in a mortarboard hat, with an academic gown with a carnation pinned to it over an outfit known as sub fusc, which includes a dark suit, and a white shirt with a white bowtie. Just like the exam attire, the elegance of a poem depends on having all elements in place.

The small zitan inkstone screen in Item 100 can serve as another metaphor: while the vertices of the square prism are harsh on the eyes, fluidity can be achieved by simply rounding the corners.

Calligraphy and Furniture

The Beauty of Reduction in Calligraphy and Furniture

Yuan Dynasty artist Ni Zan (倪瓚) would ease the bulkiness of his first name "瓚" by removing a stroke from the two "先" components to slim it down to "夫" when he signed his paintings.

Furniture design adopts a similar simplification strategy. One example is the Purple Jade Table in Item 86, which used the Song Luo Table in the Shanghai Museum collection as a protype. In designing a second version for T.T. Tsui, Tian Jiaqing parsed down the angular spiral pattern at the ends of the apron seen on the former, adding a touch of grace to the table (Chinese text Figs 86.13.1–2).

Small regular script and large regular script in calligraphy and furniture

In this book, a few brush pots and a paperweight are inscribed with small regular script and medium regular script calligraphy by Zhao Mengfu (Items 58, 62, 64) and Ni Zan. On the other hand, large running script calligraphy by Zhao and Ni is spotted on a brush pot (Item 74) and a pair of scroll weights (Items 77, 78), respectively.

In item 091, the pair of kang tables juxtaposed with their model exemplify the relationship between large regular script and small regular script calligraphy. The same relationship applies to a pair of foot stools (Item 88, Fig. C 18) and a couch (Fig. C 19, Chinese text Fig. 88.4), designed with reference to the paintings *Vimalakîrti Spreads the Teachings* and *The Non-Duality of Vimalakîrti* (Chinese text Figs 88.1, 88.2): I commissioned Tian to create the foot stools based on that of Vimalakîrti in the paintings, which he subsequently enlarged to construct a double-waisted, pedestal-style couch (Fig. C 19, Chinese text Fig. 88.4). The relationship between the works is similar to that between small regular script and large regular script or the larger characters commonly seen on plaques.

The "body shapes" of calligraphy and furniture

Huang Tingjian and Su Shi famously enjoyed teasing each other about their work, and their polar opposite calligraphic styles were a source of much merriment. Huang compared Su's thick, full-bodied brushwork to "a toad squished by a rock" (Item 70), while Su likened his friend's

thinner, more elongated strokes to "snakes hanging from tree branches" (Item 72).

Wang told Sa Benjie that he adapted the design features of Ming-style small stools in commissioning his large *huali* table (Fig. C 3, Chinese text Fig. 86.1.2). We can understand his thought process by visualising the compression, lengthening, and simplification of the vernacular furniture that was formerly in his collection (Figs C 4.1, 4.2).

According to *Ming Resonances II* (2019), Tian's original design of Wang's painting table follows the harmony between balance and proportion aspired to in Ming furniture (Fig. C 5.1, 5.2). He gave the table a fuller body by rounding its legs and corners and adding convexity to the aprons and spandrels.

Tian actually designed his version of the table with a large Ming zitan recessed-leg painting table in the Palace Museum in mind (Fig. C 6.1, 6.2). The table was previously in the collection of Zhu Youping of Xiaoshan, Zhu Jiajin's father. In section B115 of Wang's *Connoisseurship of Chinese Furniture* and in Item 190 in *Complete works of Chinese fine arts: Arts and Crafts. Art crafts made of bamboo, wood, ivory and rhinoceros horn*, the table is described as having "rectangular legs that extend downwards and aprons that are convex". When we compare the tables closely, it becomes clear that Tian rounded the edges and legs of the Ming table in his design, echoing the convex moulding of the spandrels and aprons.

The design of a beech, single-plank top painting table (Fig. C 7) published in Shen Ping's catalogue (2012) was another adaption of Zhu Youping's *zitan* large painting table, again achieved by adjusting the proportions of its components.

The five-legged zitan incense stand designed by Shen Ping is rather low. I elongated it in designing Item 098.

I designed and commissioned Tian to produce the trestle table in Item 094 with reference to a small, square *huanghuali* table in the Nelson-Atkins Museum of Art collection (Fig. C 8, Chinese text Fig. 94.1). Tian shortened the trestles in the original design (See notes in Item 94), resulting in the final *tieli* (ironwood) and *zitan* trestle table (Fig. C 9, Chinese text Fig. 94.4). Taking it further, the design can be flattened and stretched into the shape of a barrel, as seen in the "Reclining Dragon Table" (Fig. C 10, Chinese text Fig. 94.6).

Traditional characters and simplified characters in calligraphy and furniture

The longest table in the Palace Museum is a trestle table veneered with *zitan* (Fig. C 11, Chinese text Fig. 96.4). The panels of its legs are covered with a carved *chilong* pattern, resembling the character "匯" in traditional Chinese.

Tian made a trestle table and a large marble top trestle table by refraining from decorating the leg panels (Fig. C 12, 13). He instead cleared the area in favour of a negative space. The legs now look like the simplified character of "匯", which is written as "汇" (See *Ming Resonances II*).

The reverse can also be the case, and furniture can be transformed from "simplified character" to "traditional character".

In Item B84 of *Connoisseurship of Chinese Furniture*, Wang elaborated on a recessed-leg table with an unmitred bridle joint and long front stretcher: "The joinery of this table is similar to that in architecture. The long front stretcher strengthens the structure. Tables in this form were often depicted in Song dynasty paintings. It was the most popular form during the Ming dynasty". Shen made a piece following the principles Wang described (Fig. C 14).

In designing the large *tieli* table with the nanmu single-plank top seen in Item 060 of *In Company of Spring* (2013), Shen employed the basic framework of the above Ming-style table but removed the side stretchers (Fig. C 15) to give a restrained yet voluminous table form.

In the exhibition "We Refined It Together" (*Wuwo tongxiu*) in early 2022, Tian adjusted the said design by adding beadings to the apron and spandrels, in addition to altering the braces and spandrels to form right angles, giving straight and sharp lines to the table (Fig. C 16). The example illustrates the case of changing a piece of furniture from its "simplified" form to its "traditional" form.

Traditional architecture and furniture

Module

In designing architecture, a façade and its corresponding unit may follow a set ratio and proportion allowing it to be replicated in the building process. Fu Xinian's hand-drawn elevation of the Foguang temple from the Tang dynasty is one example (Fig. C 17 and in Fu Xinian's *City planning in ancient building complex layout and building design methods*). We can understand the above foot stools (Item 088, Fig. C 18) commissioned with reference to the paintings *Vimalakîrti Spreads the Teachings* and *The Non-Duality of Vimalakîrti* (Chinese text Figs 88.1, 88.2) using the same logic.

There are two *kunmen* openings in the pairs of footstools designed by Tian (Item 088, Fig. C 18). He modified the design into a pedestal by enlarging the footstool and adding one extra *kunmen* (Fig. C 19, Chinese text Fig. 88.4). Tian went on to divide the pedestal and kept only one of the *kunmens*, resulting in a supporting base for the Reclining Dragon Table (Fig. C 20, Chinese text Fig. 94.6).

Similarly, the framework of a Chinese hall is built from lateral load-bearing columns and horizontal beams (See *Treatise on Architectural Methods*, Fig. C 21). Tian borrowed the method and placed a large panel over the column and beam structure, turning the timber into the support for an exquisite, large table (Fig. C 22)

Around 2010, Shen Ping rounded and thickened the recessed-leg table with an unmitred bridle joint and long front stretcher (Fig. C 14) when designing the *tieli* trestle table (Fig. C 23; *In Company of Spring* pg. 48). Wang expressed his fondness for the table and said that it captured the essence of Ming furniture. In Sa Benjie's interpretation, Wang was referring to how the external form and presentation of the table are expressions of its inner fineness.

Fig. C 1

Fig. C 2

Fig. C 3

Fig. C 4.1

Fig. C 4.2

Fig. C 5.1

Fig. C 5.2

Fig. C 7

Fig. C 6.1

Fig. C 8

Fig. C 9

Fig. C 10

Fig. C 6.2

Fig. C 11

Fig. C 12

Fig. C 13

Fig. C 14

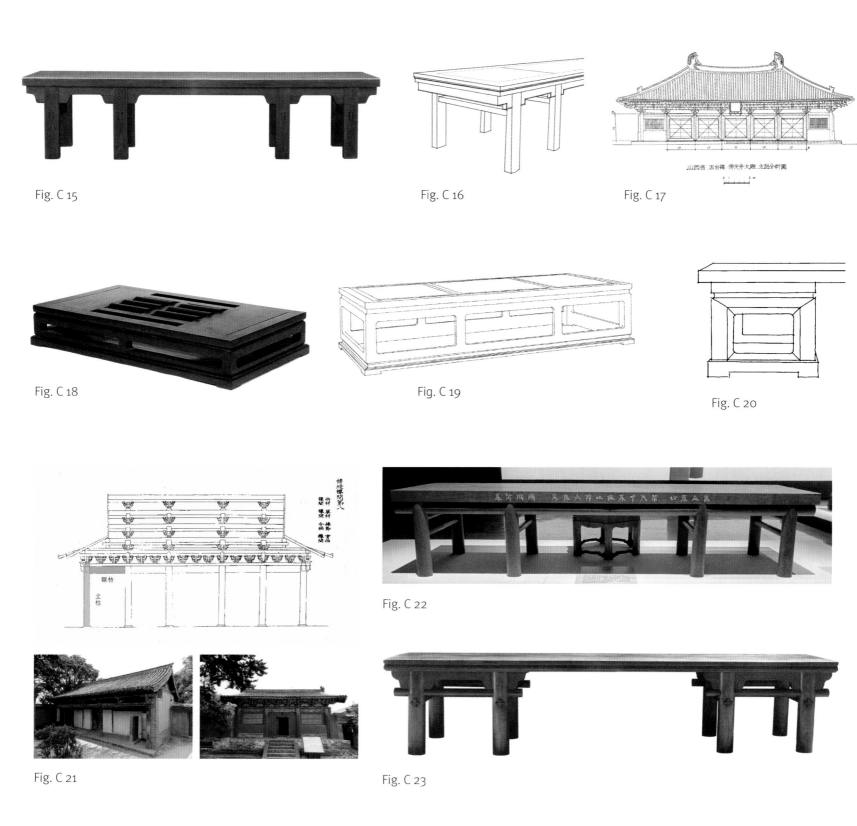

Fig. C 15

Fig. C 16

Fig. C 17

Fig. C 18

Fig. C 19

Fig. C 20

Fig. C 22

Fig. C 21

Fig. C 23

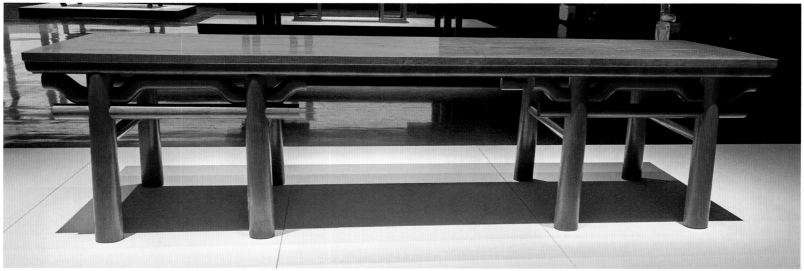

Fig. C 24

Using Shen's design as a foundation, Tian simplified the aprons and spandrels into a single, curved stretcher (Fig. C 24), just as a calligraphic character relaxes its structure to allow for more space, heightening the table's ethereal beauty.

This section barely scratches the surface of the parallels between poetry, calligraphy, traditional architecture, and furniture. Such a subject warrants a dedicated essay.

Finally, the Heavenly Numbers Tables (Items 95, 96) are attempts to apply the philosophy in the Book of Changes (the *Yijing*) into furniture design, in the hopes of sparking new conversations in the study of Ming and Qing furniture.

D. Mentors and Peers

> *Bo Yi and Shu Qi may have been worthy people, but they have only become household names because Confucius commended them. Likewise, [Confucius's disciple] Yan Yuan may have been a diligent student, but no-one would remember his good conduct were it not for his connection to the master. Is it not tragic that, if a man lives a good life in seclusion, away from watching eyes, his name will disappear without a trace, unpraised? And what is someone of mean circumstances to do if they wish to make a name for themselves by their conduct? Unless they win over some lofty scholar to their cause, their fame will never be passed down to later generations.*
> *Records of the Grand Scribe*
> *Sima Qian*

The bamboo brush pot in Item 46 has carved on it, Li Tang's *Picking Fiddlehead Ferns* (Chinese text Fig. 46.1) from the Song Dynasty. It portrays the story of the brothers Bo Yi and Shu Qi, recluses living on Mount Shouyang after the fall of the Shang Dynasty.

Confucius commended the brothers a number of times in his *Analects*. Sima Qian also placed them at the beginning of the "Ranked Biography" section in his *Records of the Grand Scribe*. He emphasised the significance of Confucius's recognition of Bo Yi and Shu Qi, who would have been forgotten despite their sagacious qualities. Likewise, contemporary bamboo carvers owe their recognition to Wang's guidance, support, and writings.

It was Wang who led me into the realm of bamboo carving. He enlightened me with his books and guided my thought processes throughout when he commissioned Fan Yaoqing for me. The result was a bamboo carving that I, for the very first time, could at once hold and behold (Fig. A. 1.2).

Subsequently, Wang introduced me to two major bamboo artisans, Fan and Zhou Hansheng. The communication between us relied on the exchange of letters, and later, faxes. We thus accumulated a handsome quantity of physical written records. Wang embraced my ignorance and was very generous with his encouragement. I am still humbled by Wang's words in his letter introducing me to Fan and Zhou (Figs D1, D2).

Wang's response to my request for his script for Item 1 warrants a special mention. Wang, in his letter dated on May 15, 1997, wrote, "Your narcissus is meant to be paired with a piece of calligraphy. Your request is answered, and you will always be welcome. When it comes to bamboo carving, working with the calligraphy in hand is preferable." Inscribing regular script in small characters is a proven challenge and often requires multiple attempts. Sharp focus on the brush tip demands good eyesight. However, Wang was suffering from intractable eye disease in the beginning of 1996. He had discussed his vision problem in his letter to Fan on July 19, 1990: "I feel powerless in writing small characters. None of the finished works look adequate. I am frustrated" (See *Ink on Bamboo: Letters on art from Wang Shixiang to Fan Yaoqing*). In recent years, I caught myself stepping into Wang's shoes time and again when I was inscribing for my furniture collection. The experience taught me that a character or two are bound to look out of place in each attempt and reminded me of the time and effort Wang spent on inscribing for my sake. These items have grown on me and are dear to my heart.

Mailing involves trips to a post office and time spent in queues. Similarly, a bamboo carving needs to be picked up from the post office every time it arrives in Beijing. On a letter dated on August 1, 1997, Wang wrote to me acknowledging the receipt of the narcissus bamboo wrist rests by the post office on Shenlu Street near Fangjiayuan, saying that Mrs Wang would pick them up that day. The Wangs, at the time, did not have any family helpers. Spending most of their days on writing, they often "…do not have time to cook" and had to "subsist on instant noodles or frozen food" (See the postscript in *You yin ji: Quanyou ke zhi*). Reflecting on these memories, I am embarrassed by the inconvenience I caused them throughout the years.

The age gap between Wang and I spans almost half a century. In addition to his seniority, Wang was a highly respected scholar in bamboo carving while I was just a novice. Yet, Wang addressed me courteously as "Mister" in all our correspondence, including on scripts and bamboo carvings. I shy away from it every time: I have never measured up to the title.

Our bond over bamboo carvings occupied a place in Wang's mind well into his nineties. He not only kept works by Zhu Xiaohua and Bo Yuntian, both bamboo artisans, for my viewing, but he went to great lengths and arranged for us to meet at his residence. His good intentions and efforts, considering his high age, filled me with gratitude. Zhu and Bo contributed to some significant bamboo carvings compiled in this book.

Wang reserved for me Zhu's wrist rests decorated with a portrait of Confucius in an inscribed box (Fig. D 3.2). They must have reminded Wang of an excerpt from "A Eulogy of Confucius" in Sima Qian's *Records of the Grand Scribe*: "The world has witnessed countless emperors and sages; most led glorious lives but left no trace on earth. Confucius, a commoner, has remained significant through the ages. He is respected by people in all walks of life, from the Son of

Heaven and princes to students of the six arts. He is the most venerable sage of all time".

I met Zhu for the first time at the Wang residence in August 2007. Zhu showed me his wrist rest carved with a portrait of Dongfang Shuo, the rubbing of which can be found in *Compendium of a Few Old Things* (Appendix 3) and *A Second Lovely Ash-Heap*. Fu Xinian, who was present, said half-jokingly that Zhu was brought to fame by this wrist rest. I earnestly asked Zhu if he would part with it. He declined initially but did so after Wang's persuasion.

I commissioned Zhu to make the bamboo wrist rest with the *liuqing* relief portrait of Yuan Mei shown in Item 40 (Chinese text Fig. 40.1). When Zhu and I presented it to Wang, he endorsed Zhu's very fine work by inscribing his calligraphy on the cloth-covered box (Chinese text Fig. 40.3).

The inkstone screen based on Chen Hongshou's *Double Purity* (Item 25) and the brush pot decorated with a portrait of Ge Yilong by Zeng Jing (Item 41) underwent a similar commissioning process: I first presented Wang with the design drawing at his residence, then confirmed with Yuntian immediately following Wang's approval. When Yuntian finished his part, usually within several months, we would return to Wang for his final seal of approval. Wang turned to me after looking at the carvings, and said, "You are helping push the art forward." That was as much an encouragement to me as it was to Yuntian.

Wang was a strong advocate for the restoration of high relief and round relief in bamboo carving. In his later years, he gifted me a bamboo brush pot decorated with waterfall and lotus petal relief carvings by Hong Jianhua from Anhui province, and he included with it his own inscription (Fig. D 5.1, 5.2). In return, I wrote a six-character regular verse to express my gratitude.

In a photograph of the Wangs, printed on the back of Wang's *Connoisseurship of Chinese Furniture*, we are offered a glimpse of the hardwood paper weight inlaid with bamboo inscribed by Huang Miaozi and carved by Fan Yaoqing in 1985 (Figs D. 6.1, 6.2). It is shown resting on a zitan painting table that once belonged to Song Luo, an official in the early Qing Dynasty (see Fig. 86.2). When I met up with Wang in Beijing in winter 2007, he said, "I am not getting any younger. Keep the paperweight as a memento". From the dried splatters of ink on the item, I could tell it was well-loved by Wang. On the bamboo is a *liuqing* carving of a quote from Li Shangyin's poem,

> Heaven pities plants in far, dark spots
> And gives them extra sun at eventide.

Just as it describes, Wang met with hardship in midlife but lived in serenity with his loving son in his later days.

On another winter morning in 2007, Bo Yuntian and I paid a visit to Wang. The sun was bright, and the room was warm. Wang, in good health and spirits, said to Bo, "I have sent the wrist rest carved with a cicada along with a letter to T. T. Tsui, who will give them to Tung Chiao in Hong Kong. I did not mention the arrangement earlier, or you might have turned down any form of payment."

Tung Chiao is a fellow bamboo carving enthusiast.

In his obituary for Wang, he retold this story of Wang when he was ninety-three: "At the dinner table we were exchanging views on Zhou Hansheng's round relief and Fan Yaoqing's *liuqing* carving. Someone spoke about the support and encouragement Wang had shown to these younger artisans. Wang explained plainly, 'Their talent deserves to be recognised.' Years later, Wang repeatedly mentioned in our letter and phone exchanges the peasant Zhu Xiaohua from Nanxiong county and Bo Yuntian from the County Archives in Sanhe county, two young bamboo carving practitioners he recently discovered. He said that both Zhu and Bo 'excelled at their craft and are industrious'. On the Double Ninth festival in 2007, Tsui brought me Bo Yuntian's wrist rests carved with a cicada (Fig. D 7) as instructed by Wang. The gift note read, 'This is a form of encouragement to Bo'. Wang, after dedicating so much to the field, still spared thoughts for the younger generation who were striving for success. Such is the Wang Shixiang we know. He is respected like no others."

In Winter 2008, on his sick bed in Peking Union Medical College Hospital, Wang asked Zhu, "Are you still carving bamboo?" Wang smiled when he was met with a positive reply.

Wang passed away on November 27, 2009. I composed an elegiac couplet that was written out in calligraphy by Sa Benjie in Beijing (Fig. D 8):

> *To do great deeds, to speak great words, to stand by works of merit: three things that last, that pass on down the generations.*
> *Or genuine, or excellent, or filled with empathy: such the souls they summon up to Ninefold Heavens.*

After the surrender of Japan, between September in 1945 and October in 1946, Wang served as the Assistant Representative in Beijing and Tianjin, assisting Shen Jianshi, Tang Lan, and Fu Chenlun, in a Chinese government body organized to investigate cultural relics that had been lost or damaged during the war. He handled a total of six items during his service. (See: *Not Quite a Lovely Ash-Heap* [Chinese text Fig. 92.10])

My ballad composed for Wang's ninetieth birthday, detailing Wang's achievements for the nation, is summarised as follows:

> *1. Wang oversaw the transfer of Puyi's estate in Zhangyuan, Tianjin, to the Palace Museum in Beijing.*
> *2. Wang, on Zhu Qijian's behalf, wrote to Song Ziwen to claim Zhu's collection of textile and embroidery stranded in Northeast China.*
> *3. Wang travelled to Japan in December 1946 and recovered 107 crates of rare books and manuscripts in February 1947. They were shipped to Taiwan right before the conclusion of the War of Liberation.*
> *4. Wang was behind the acquisition of the porcelain objects in Guo Baochang's Zhizhai Collection by the Palace Museum.*
> *5. Wang acquired two hundred and forty bronzewares from the German W. Jannings for the Palace Museum.*

Such were five out of Wang's six meritorious achievements. Wang was a prolific scholar and built substantial schol-

arship on various topics in the study of traditional Chinese culture.

Such were Wang's written contributions.

Wang mentored many younger talents throughout his life. In the field of bamboo carving, Wang endorsed several individuals in his Bamboo Carving, *A Lovely Ash-Heap, A Second Lovely Ash-Heap*, and *Compendium of a Few Old Things*. They include Bai Shifeng (note 1), Xu Subai and Xu Bingfang (note 2), Fan Yaoqing (note 3), Liu Wanqi (note 4), Zhou Hansheng (note 5) and Zhu Xiaohua (note 6). In *A Third Lovely Ash-Heap*, authored by Wang in his nineties, a special mention was given to Wang Xinming from Fujian (note 7). These gestures, like the attention Confucius gave to Bo Yi and Shu Qi in his *Analects*, granted visibility to emerging bamboo carving practitioners who would otherwise be obliterated or overshadowed.

Such are Wang's virtuous deeds.

Bai Shifeng had a long track record in the field, while Xu Subai, Xu Bingfang, and Wang Xinming came from a long line of artisans. Liu Wanqi held a position at the People's Art Centre in Guizhou, and Zhou Hansheng was the Dean of Jianghan University's Department of Fine Arts. Fang Yaoqing and Zhu Xiaohua were both farmers before practising the craft. Bo Yuntian was a civil servant, and Hong Jianhua has built a career out of bamboo carving.

As for me, I am simply delighted to engage in bamboo carving outside my profession. It brings me immense pleasure to learn from and be inspired by my mentors and peers. In 2010, with the help of Zhou Hansheng, I compiled the correspondence between Wang and Zhou, as well as Zhou's complete works, in *Bamboo Carvings of Zhou Hansheng*, published by Zhonghua Company (Fig. D 9). I hope to express my gratitude towards Wang by championing artists like he did.

In lieu of presenting my couplet at Wang's memorial service, I wish to commemorate him with my elegy along with this publication. He made every effort to contribute to the study of Chinese traditional furniture, bamboo carvings, and beyond. Just as Qi Gong described, "Every book, every page, every line, every word [Wang wrote], were rooted in his profound respect for traditional Chinese culture". We strive to trace Wang's footprints with a curious and diligent mind to keep his legacy alive.

Included in: *A Lovely Ash-Heap*, volume one: III Bamboo Carving

Note 1. "New buds on an ancient tree: Bamboo carving by Bai Shifeng"

Note 2. Xu Subai and Xu Bingfang: father and son bamboo artisans

Note 3. "Fan Yaoqing: The country bamboo carver"

Note 4. "Breakthrough: Bamboo sculptor Liu Wanqi"

Note 5. "Keeping traditions alive with innovations: An introduction to Zhou Hansheng's bamboo carving"

Included in: *A Second Lovely Ash-Heap*

Fig. D 1

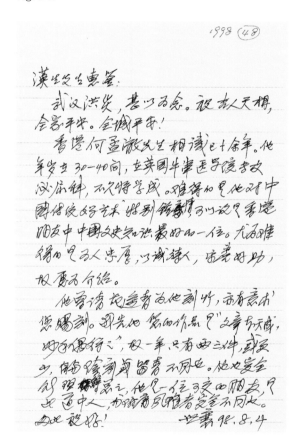

Fig. D 2

Note 6. "Bamboo carving from a farmer: Zhu Xiaohua's shallow sunken relief and liuqing."

Included in: *A Third Lovely Ash-Heap*

Note 7. "Wang Xinming – a round bamboo relief artisan"

Fig. D 3.1

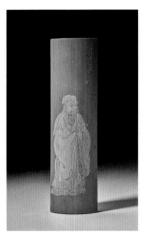
Fig. D 3.2

Fig. D 4

Fig. D 5.1

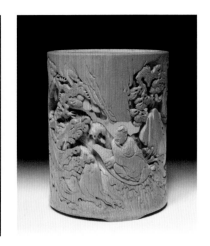
Fig. D 5.2

Fig. D 6.1

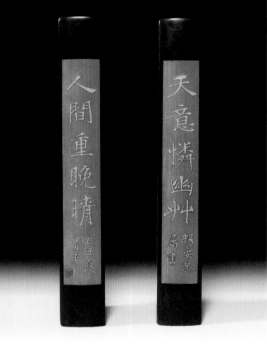
Fig. D 6.2

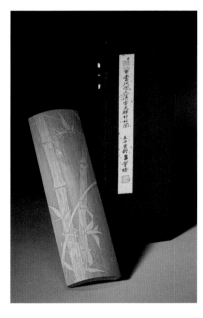
Fig. D 7

Fig. D 9

立功立言立德遺世三不朽
唯真唯善唯仁招魂九重天

王暢安先生靈右

受業 何孟澍 拜輓

Fig. D 8

CATALOGUE

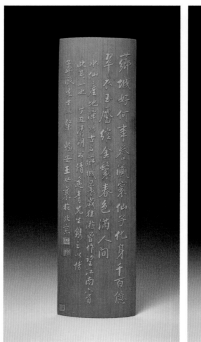
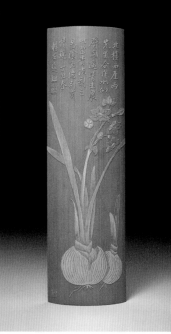

OOI

Pair of bamboo wrist rests

1997
Decorated with *liuqing* relief of narcissus
(Jin Beilou, 1878–1926)
Text: "How fine is Xiangcheng"
(Wang Shixiang, 1914–2009)
Carving: Fan Yaoqing
Rubbing: Fu Wanli

I have always loved the narcissus. In Lingnan, the region of southern China in which Hong Kong lies, it is the main decoration at Chinese New Year celebrations. (Plum blossom, which is customary elsewhere, does not grow well in the hot climate.) Growing up there, the old description of the narcissus – "a golden cup on a deck of jade, an emperor's vessel indeed" – never felt like an exaggeration.

The original inspiration for these wrist rests came from two pieces I saw as a young man: a long handscroll of narcissus by the Song painter Zhao Mengjian and a carved, round, red lacquer box, decorated with narcissus. I initially wanted to commission Fan Yaoqing to make a brush pot for my desk based on the two works. However, when I wrote to Wang Shixiang to ask his advice, he pointed out that new brush pots have a tendency to crack when carved. It is never possible to avoid this risk entirely, and it has since happened to several pieces in my collection. For this project, however, Wang thought it would be better not to take the chance. He suggested making a pair of wrist rests instead, as their flatter shape makes them more durable. He proposed basing them on a rubbing of a wrist rest decorated with a narcissus by Jin Beilou, which he had included in his book *The Art of Bamboo Carving*. One of the wrist rests would be decorated with

the Jin Beilou picture and the other with a stanza of poetry about the narcissus by Wang himself, written in his own calligraphy (Figs 1.1, 1.2).

I was thrilled with this idea. Wang and I both wrote to Fan Yaoqing to ask him to carve the wrist rests, which took three months to complete. The finished rests, which Fan described as one of his finest works, went first to Beijing for Wang to examine. The original wrist rest had been executed in intaglio, but in Fan's recreation the narcissus is carved in relief using the *liuqing* technique. The painting and calligraphy on the two rests complement each other perfectly, and I love the elegance of the work as a whole. Below the narcissus is a seal reading, "May spring return", a play on the season for narcissus and my work as a doctor. The text of the poem is as follows:

From *A lyric to the tune*
"Gazing on Jiangnan"
How fine is Xiangcheng!
For what is she famed throughout the world?
For immortals without number,
 who have taken on new form,
In emerald robes, their faces jade,
 their hair in a golden buns,
Whose spring looks fill the human realm.

a golden cup on a deck of jade, an emperor's vessel indeed—金盞玉台, 紫宸重器. The phrase also occurs in a number of other variants.

wrist rests—part of the standard apparatus of the scholar's studio. Used to support the wrists while writing with a brush.

Zhao Mengjian—趙孟堅 (1199–c. 1267). Zhao, the cousin of the more celebrated Zhao Mengfu (see notes to item 60), was especially noted for his plant paintings. His career straddled the Song dynasty and the rise of its successor, the Yuan.

Jin Beilou…The Art of Bamboo Carving—the soubriquet of Jin Shao-cheng (金紹城, 1878–1926). Jin, a lawyer, financier, and respected artist, was Wang Shixiang's maternal uncle. Wang's 1980 *The Art of Bamboo Carving* (Zhuke yishu 竹刻藝術), parts of which were adapted into an English version (*Bamboo Carving of China*, 1983), draws extensively on work by his younger brother, the architect and bamboo carver Jin Xiya (金西厓, 1890–1979), who carved the rest from the older Jin's painting.

liuqing—a highly demanding method of relief carving, *liuqing* (留青, "leaving the green") requires stripping away the thin top layer of the bamboo's surface to leave behind a decorative pattern.

"Let spring return"—a doctor who returns a patient to health is said to have "made spring return" (*huichun* 回春).

A lyric to the tune "Gazing on Jiangnan"—poems in the lyric or ci form (詞) are written to the metre and rhyme scheme of a set of canonical songs from the Tang court. Since the tunes themselves do not survive, *ci* are generally not intended to be sung aloud, and the content of a given *ci* may be far removed from the subject of the tune on which it is patterned.

Xiangcheng—薌城. The historical name for Zhangzhou (= Changchow 漳州), a city in Fujian province known for its narcissus.

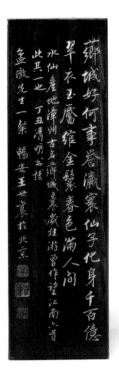
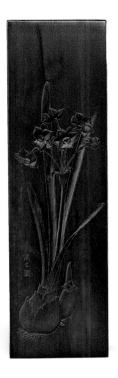

002

Ebony scroll weight with intaglio narcissus

2010
Carving: Zhou Hansheng
Rubbing: Fu Wanli

Ebony scroll weight

2010
Decorated with "How fine is Xiangcheng"
(Wang Shixiang, 1914–2009)
Carving: Fu Jiasheng
Rubbing: Fu Wanli

For my first pair of scroll weights, Fan Yaoqing created a *liuqing* relief based on an intaglio original (Fig. 2.1). In his inscription for the work, Wang Shixiang described this as "changing *yin* into *yang*".

In summer 2009, I asked Zhou Hansheng to adapt the Jin Beilou original again, this time changing Fan Yaoqing's *yang* carving back into *yin*. Before executing the carving, Zhou first completed a painted draft for me (Fig. 2.2). At the same time, I asked Fu Jiasheng to produce a companion piece with an intaglio carving of Wang Shixiang's lyric on the narcissus (Figs 2.4). Fu also carved my maker's mark ("An elegant creation of Kössen Ho") and a pair of my seals on the reverse of the two items.

003

Zitan brush pot

2012
Decorated with *Narcissus* (Zhao Mengjian, Song dynasty)
Carving: Fu Jiasheng
Rubbing: Fu Wanli

A few years ago, I acquired a brush pot made from *zitan*, that is, red sandalwood. As it was an older piece (and so unlikely to crack), I was finally able to create the brush pot I had first proposed to Wang Shixiang in the 1990s, complete with a narcissus from the work of Zhao Mengjian. This wonderfully graceful rendition of the flower was carved by Fu Jiasheng of Beijing's Rongbao Studio, and whenever I look at it, I am reminded of a famous line of Song poetry:

> The immortals' grace, the ascetics' air:
> they live in you today,
> A hatpin set in place above
> a lightly pencilled brow.

Rongbao Studio—榮寶齋, one of Beijing's oldest stationery shops.

a famous line of Song poetry—from "Four verses on Liu Bangzhi's gifts of early plum blossom and narcissus flowers" ("Liu Bangzhi song zaomei shuixian hua si shou" 劉邦直送早梅水仙花四首), a quartet of poems by the Northern Song writer and calligrapher Huang Tingjian (黃庭堅, 1045–1105). Liu (劉邦直, dates unknown), a contemporary of Huang, had himself written a number of narcissus poems, including an ode to the flower ("Yong shuixian" 詠水仙).

004

Handscroll of poems
on the narcissus

1997–2018
Various authors and calligraphers
Mounting: Wang Xinjing

In summer 2018, I asked Wang Xinjing of the Rongbao Studio to create a commemorative handscroll consisting of Wang Shixiang's narcissus poem, rubbings from my narcissus carvings and various poems and lyrics on the narcissus given to me over the years by friends and mentors.

The contents of the scroll are as follows:

Opening text: Sa Benjie

Wang Shixiang: "How fine is Xiangcheng"

Wang Shixiang: inscription for item 1 (pair of wrist rests with liuqing narcissus)

Rubbing of item 1 (pair of wrist rests with liuqing narcissus)

Rubbing of item 2, part I (ebony scroll weight decorated with "How fine is Xiangcheng")

Rubbing of item 2, part II (ebony scroll weight with intaglio narcissus)

Zhou Hansheng: draft for the decoration for item 2 (narcissus scroll weight)

Fu Xinian: calligraphy of a poem by Huang Tingjian (Song dynasty)

Tung Chiao: calligraphy of a poem by Chen Yuyi (Song dynasty)

Ambrose Y.C. King: calligraphy of a lyric to the tune "The Mountains in Wu Are Green" by Zhao Jin (Song dynasty)

Peter Y.K. Lam: calligraphy of a poem by Yang Wanli (Song dynasty)

Steven N.S. Cheung: calligraphy of "For Zhao Mengjian, Rhapsody on a Ballad of the Narcissus" by Zhou Mi (Song dynasty)

Ambrose So: calligraphy of a lyric to the pattern "Busuanzi" by Lu Zugao (Song dynasty)

Chan Man Kam: calligraphy of a lyric to the pattern "Moon on the Western Yangzi" by Zhang Yan (Song dynasty)

Yang Zhishui: calligraphy of poems by Yang Wanli (Song dynasty) and Ni Zan (Yuan dynasty)

Hui Lai Ping: calligraphy of a lyric to the pattern "The Sands of Huan Creek" by Yang Zemin (Song dynasty)

Huang Heiman: calligraphy of a poem by Huang Tingjian (Song dynasty)

Shi Yuan: calligraphy of a poem by Sun Qizhi (Ming dynasty)

Lu Hao: calligraphy of two poems by the Kangxi Emperor (Qing dynasty)

Fan Yaoqing: calligraphy of a poem by Xu Sidao (Song dynasty)

Zhou Hansheng: calligraphy of a poem by Qian Xuan (Yuan dynasty)

Xu Bingfang: calligraphy of a poem by Jiang Teli (Song dynasty)

Liu Wanqi: calligraphy of a poem by Wang Guxiang (Ming dynasty)

Fu Wanli: calligraphy of a poem by Yang Wanli (Song dynasty)

Fu Jiasheng: calligraphy of a poem by Chen Chun (Ming dynasty)

Rubbing of item 3 (zitan brush pot decorated with narcissus), with calligraphy by Kössen Ho of Song and Yuan inscription poems from Zhao Mengjian's original painting (Huang Tingjian, Zhang Bochun, Qiu Yuan, Deng Wenyuan)

Zhu Xiaohua: calligraphy of a poem by Yu Ruoying (Ming dynasty)

Bo Yuntian: calligraphy of a poem by Seng Chuanchuang (Song dynasty)

Li Zhi: calligraphy of a poem by Du Dazhong (Ming dynasty)

Zhang Midi: calligraphy of a poem by Li Dongyang (Ming dynasty)

Jiao Lei (Xiaochongguang Studio): calligraphy of a poem by Wen Zhengming (Ming dynasty)

Meng Zhong: calligraphy of a poem by Chen Tuan (Song dynasty)

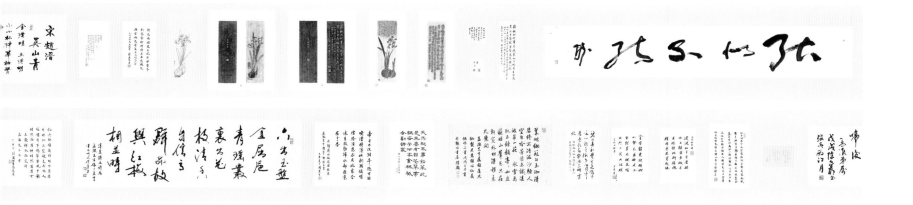

The contents of the scroll—the individuals mentioned are listed alphabetically by family name below, except for those where a reference is given to other items in the main text.

Chan Man Kam: 陳文岩. Hong Kong nephrologist, poet, and calligrapher.

Chen Chun: 陳淳 (1483–1544). Scholar-artist and student of Wen Zhengming (see below).

Chen Tuan: 陳摶 (d. 989). An important Daoist teacher of the early Song period.

Chen Yuyi: 陳與義 (fl. 12th century). Scholar and calligrapher, also known by the soubriquet Chen Jianzhai (陳簡齋, "Chen of the Simple Studio").

Steven N.S. Cheung: 張五常 (b. 1935). Hong Kong-American economist.

Deng Wenyuan: 鄧文原 (1259–1328).

Tung Chiao: 董橋 (=Dong Qiao, b. 1942). A well-known writer and former editor of Hong Kong's *Ming Pao* newspaper.

Du Dazhong: 杜大中 (16th–17th century).

Fu Xinian: 傅熹年 (b. 1933). Architectural historian and connoisseur.

Huang Heiman: 黃黑蠻 (b. 1952). Painter and calligrapher.

Huang Tingjian: see notes to item 71.

Jiang Teli: 姜特立 (1125–1204). Song dynasty poet.

Jiao Lei: 焦磊. Contemporary calligrapher and doctoral graduate of the Hong Kong University of Science and Technology. The studio name is *Xiaochongguang guan* (小重光館), "The Studio of Seeing the Light Again, a Little".

The Kangxi Emperor: 康熙, the fourth emperor of the Qing dynasty (1654–1722, r. 1661–1722).

Ambrose Y.C. King: 金耀基 (b. 1935). Sociologist and Vice-Chancellor Emeritus of the Chinese University of Hong Kong.

Peter Y.K. Lam: 林業強. Former Director of the Art Museum, The Chinese University of Hong Kong. Honorary Fellow, Institute of Chinese Studies, The Chinese University of Hong Kong.

Li Dongyang: 李東陽 (1447–1516). Mid-Ming scholar and official.

Liu Wanqi: 劉萬琪 (b. 1935–2021). Bamboo carver and Professor of Art at Guizhou University.

Lu Hao: 陸灝 (b. 1963). Journalist and newspaper editor.

Lu Zugao: 盧祖皋 (c. 1174–1224). Poet and *jinshi* degree holder. The work mentioned is his 卜算子.

Meng Zhong: 蒙中 (b. 1976). Painter and calligrapher.

Ni Zan: 倪瓚 (1301–74). Widely regarded as one of the finest painters in the entire Chinese canon.

Qian Xuan: 錢選 (13th century).

Qiu Yuan: 仇遠 (1247–1327). Writer and calligrapher.

Seng Chuanchuang: 僧船窗 (Song dynasty). Monk.

Shi Yuan: 施遠. Researcher on bamboo carving at the Shanghai Museum.

Ambrose So: 蘇樹輝 (b. 1951). Hong Kong and Macanese businessman, politician, and calligrapher.

Sun Qizhi: 孫齊之 (c. 1528–1600). Writer and bibliophile. Also known by his original name, Sun Qizheng (孫七政).

Wang Guxiang: 王穀祥 (1501–68). Suzhounese scholar and painter.

Wen Zhengming: 文徵明 (1470–1559). One of the most prominent scholar-artists of the mid-Ming, active in the prosperous Jiangnan region.

Xu Bingfang: 徐秉方 (b. 1945). Contemporary bamboo carver.

Hui Lai Ping: 許禮平 (b. 1952). Proprietor of the art dealership and publishing house Han Mo Xuan (翰墨軒, "The Studio of Brush and Ink"). See also item 80 and *passim*.

Xu Sidao: 徐似道 (fl. late 12th century). Scholar-official and poet.

Yang Wanli: 楊萬里 (1127–1206). Scholar-official and poet.

Yang Zemin: 楊澤民 (dates unknown). Southern Song writer and scholar. The work mentioned is his "Huanxi sha" (浣溪沙).

Yang Zhishui: 揚之水 (b. 1954). Literary scholar at the Chinese Academy of Social Sciences. Sometimes known by her birth name, Zhao Liya (趙麗雅).

Yu Ruoying: 于若瀛 (1552–1610). Official, poet, and calligrapher.

Zhang Bochun: 張伯淳 (1243–1303). Official, artist and in-law of Zhao Mengfu (see notes to items 060–062 and 074).

Zhang Midi: 張彌迪 (=張米笛, b. 1986). Graphic designer and calligrapher.

Zhang Yan: 張炎 (1248–1320). Lyricist and literary theorist. The work mentioned is his "Xijiang yue" (西江月).

Zhao Jin: 趙溍 (fl. late 13th century). Writer and scholar. The work mentioned is his "Wushan qing" (吳山青).

Zhao Mengjian: see notes to item 1.

Zhou Mi: 周密 (1232–98). The poem mentioned is his "Shuixian yao wei Zhao Zigu fu" (水仙謠爲趙子固賦).

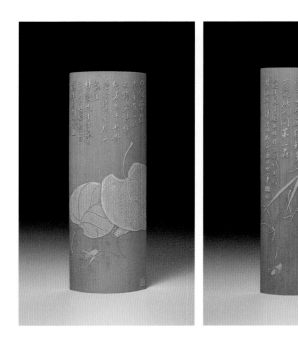

005–006
Two bamboo wrist rests

1998, 1999
Decorated with *liuqing* relief of crickets
Inscription: Wang Shixiang
Carving: Fan Yaoqing
Rubbing: Fu Wanli

In addition to his writing, teaching and research, Wang Shixiang also had a distinguished career as a collector. In 2003, towards the end of his life, he published a book about his personal collection, the *Compendium of a Few Old Things*. One of the items he mentions is a wrist rest decorated with crickets, carved by Fan Yaoqing with an inscription by Wang himself (Fig. 5.1), which was sold at auction by China Guardian in the autumn of 2003. He does not give much detail about the origins of the item, so I thought I would tell the tale myself.

One hot summer's evening in 1996, I visited Wang with Tian Jiaqing (of whom more, later). At that time Wang and his wife, Yuan Quanyou, were living in an old court-yard residence in Beijing's Fangjiayuan district, which had been their home for many years. It was a very dark night, so dark that when we got there, we had to practically feel our way across the unlit courtyard to reach the north side, where their rooms were. At the door there was a notice in Wang's handwriting, written on white paper in vertical columns of large characters: "By order of the authorities, I am unable to appraise artefacts". A few antique *qin* zithers hung from the walls in brocade pouches. We sat down, and Yuan Quanyou produced a plate of watermelon to help with the heat.

Wang showed us his latest work, *Guides to the Cricket*, and gave me a copy with my mark already added to the title page (Fig. 5.2). The book opened with several poems about crickets, which Wang had written in lieu of an author's preface.

The thing that caught my eye at first was not the poems but the seal at the end of them, written in a Han dynasty seal script and reading, "the seal of Thousand Year Wang". It was not one I had seen in his books before. Wang told me that a friend had given it to him to wish him long life.

On my return to Oxford, I read the book from cover to cover. This time, it was the poems that held my attention. I found myself coming back to them again and again, and it was as I recited them that I first had the idea for a wrist rest decorated with crickets. I wrote to Wang and to Fan Yaoqing to propose the project, and they agreed to it. Fan devised the picture and Wang provided the first poem in the set as the inscription:

> The winds of autumn rise.
>> A change is coming now, at last,
> Their cries, their chirps,
>> their whirrs and chirrups
>> lodging in my heart.
> And don't you know how many
>> fellow fools have done the same –
> Have loved these, finest members
>> of the insect world by far?

That might have been the end of the story. A while later, however, Fan Yaoqing wrote to tell me that my wrist rest, which had been inspired by Wang's writing, had spurred him to write another poem – and that, in turn, had led to another wrist rest.

In the 1990s, cricket fighting was all the rage in China. There was even cricket doping, with trainers and breeders feeding their charges hormones to improve their chances in the ring. Fan's picture for my wrist rest had left a considerable impression on Wang Shixiang, and his new poem was an homage to fighting crickets. When it was finished, he asked Fan to incorporate it into a second wrist rest. It is this piece, with the same image as mine but a different inscription, which appears in Wang's *Compendium*. On one of my visits to Beijing, he presented me with a rubbing of it (Fig. 5.1) along with a copy of the new poem:

> Old White-Claw with your crab-like shell,
>> and yellow Black-of-Fang:
> Should you lock horns someday, you both
>> are sure to come to grief.
> Better to be painted crickets,
>> facing off for aye,
> Unharmed from head to toe, a pair
>> of little insect kings.

Once I had heard the story, I asked Fan Yaoqing to create a third wrist rest, this time using Wang's second poem but pairing it with a different picture. Wang generously provided a new version of the calligraphy, and the result was a rest with the same text as the one in Wang's *Compendium*, but written differently (Fig. 6.2).

Compendium of a Few Old Things—Zizhen ji 自珍集. The self-deprecating title, frustratingly unreproducible in English, derives from a line in "Autumn Yearning" ("Qiu si" 秋思) by the Song

writer Lu You (陸游, 1125–1210): "Even a broken broom, though slight, will nonetheless treasure itself [zizhen]".

Tian Jiaqing—田家靑 (b. 1953). Scholar, furniture designer and sometime student of Wang Shixiang.

courtyard house—a *siheyuan* (四合院), composed of four buildings ranged in a square around a central yard.

Yuan Quanyou—袁荃猷 (1920–2003). Musicologist, musician, and collector. Yuan was particularly known for her mastery of the *qin* zither (琴).

Guides to the Cricket—the cricket has a long history as a pet in China, and cricket fighting can be traced back to at least the 1200s. Wang's book is a compilation of over a dozen works on crickets, dating back to the Southern Song dynasty (1127–1276).

Thousand Year Wang—Wang Qianqiu (王千秋), or more literally "Wang of a Thousand Autumns".

fellow fools—translating *chijue* (癡絕, "those of surpassing madness"), a self-deprecating term for scholarly men. The phrase derives from a quip in the official history of the Jin dynasty (晉代, 265–420) that a scholar is surpassing in three things: talent, painting, and madness.

007

Bamboo cross-piece

1998
Decorated with *liuqing* relief of fish among water weeds
(Jin Zhang, 1884–1939)
Inscription: Wang Shixiang
Carving: Fan Yaoqing

I spent part of the 1990s in Oxford studying for a doctorate in urology. One of my favourite books during that period was *Zhuangzi*, an extraordinary collection of essays and tales from the end of the Warring States period. Eventually I came to the famous story of Master Zhuang and the fish, simple in language but full of meaning:

Master Zhuang and Master Hui were wandering on a fishing weir over the River Hao. Master Zhuang said, "The minnows are out and wandering here and there. What a fishy joy!"

Master Hui said, "You are not a fish – how do you know what a fishy joy is?"

Master Zhuang said, "You are not me – how do you know I don't know what a fishy joy is?"

Master Hui said, "I am not you, so I don't know you – that's obvious. But then you are obviously not a fish, so you don't know what a fishy joy is. We've come full circle."

Master Zhuang said, "Why don't we go back to where we started? When you said, 'How do you know what a fishy joy is?' you already knew I knew what it was, but you asked me anyway. I knew it by being here on the Hao."

This story has been much cited down the centuries. One of my favourite examples comes from Wang Shixiang's mother, the painter Jin Zhang (Figs 7.1, 7.2). Sometimes known by her courtesy name, "the Lady Scholar Taotao", one of her books was devoted to the painting of a single theme, fish among aquatic plants. It is titled, delightfully, *Knowing Joy on the Weir Over the Hao*.

After reading the *Zhuangzi* story, I saw Pan Tianshou's painting *Master Zhuang Observing the Fish*, and I thought it would make the perfect picture for a wrist rest. Remembering the Jin Zhang book, I thought of asking Wang Shixiang to provide an inscription, using the book title. However, when I wrote to Fan Yaoqing to commission the object, he wisely pointed out that if Wang were to provide the inscription, it would make more sense to use a painting by Jin Zhang herself. He adapted part of her handscroll *The Hundred Games of Fish Among Water Weeds* onto a cross-piece (Fig. 7.3), and Wang happily provided the inscription (Fig. 7.4). Later, during one of my visits, Wang gave me a book on his mother's work, and I was finally able to learn about her life and to read *Knowing Joy on the Weir Over the Hao* properly.

The scroll of *The Hundred Games of Fish Among Water Weeds* is now in the Palace Museum, Beijing.

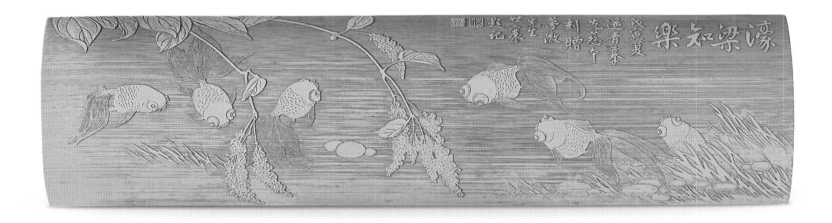

cross-piece—hengjian (橫件). A type of desk ornament, usually featuring carved decoration.

Zhuangzi—莊子. Compiled from a range of material dating from the fourth to second centuries BCE, *Zhuangzi* or *Master Zhuang* is a collection of tales, parables, and essays either about or purportedly by the shadowy title character. Its playful irreverence and dazzling linguistic inventiveness have made it one of the most enduringly popular texts in the early Chinese philosophical canon.

The famous story of Master Zhuang and the fish—from the "Autumn Waters" (*Qiushui* 秋水) chapter. This vignette has delighted countless readers for its wordplay (Is it the fish who are happy or Master Zhuang who is happy looking at the fish?) and for Master Zhuang's combination of sincerity and insouciance in confronting a serious question about the limits of knowledge.

Knowing Joy on the Weir Over the Hao—Haoliang zhile ji (濠梁知樂集), published posthumously in 1985. Below, the painting *The Hundred Games of Fish Among Water Weeds* is Jin's *Yuzao baixi* (魚藻百戲).

Pan Tianshou—潘天壽 (1897–1971). Chinese artist and art educator. As well as his paintings, Pan was known for his calligraphy, seal carving, and poetry. The work referred to here is his *Zhuangzi guanyu tu* (莊子觀魚圖).

a book on his mother—*Mingjia hanmo: Jin Zhang* (名家翰墨: 金章), part of a series on notable artists and calligraphers issued by the Hong Kong publisher Han Mo Xuan (翰墨軒).

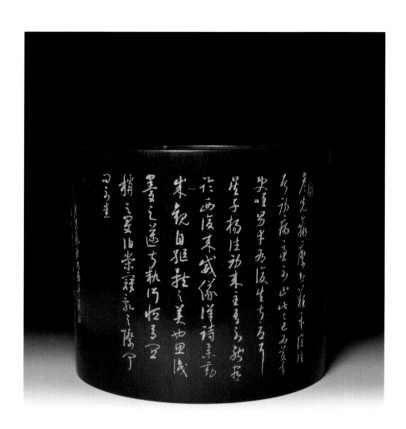

008

Zitan brush pot

2008–9
Text and calligraphy: "Letter on recovery"
(Lu Ji, Jin dynasty)
Copy and annotations: Qi Gong
Carving: Fu Jiasheng
Rubbing: Fu Wanli

In summer 1996, while visiting Hong Kong to see my family, I spotted a large *zitan* brush pot in the Ever Arts Gallery. One side had been burned, and no collector would give it a glance – the Zhong Wuyan of brush pots. Charles Wong, the owner of the gallery, let me have it for a small sum, and he was kind enough to repair it for me. The wood had a wonderful, deep patina, which polished up beautifully.

The base of the pot was slightly recessed, and in the middle there was a small cavity, just like the hole at the centre of *bi*, the jade discs found at early Chinese archaeological sites. Around the hole was a raised line, reminiscent of the double circle around the year inscription on the base of Ming and Qing imperial porcelain. It was clear that the maker of the pot had taken great care even over these hidden areas, and it reminded me of the way furniture used to be made for the emperor's household in the imperial treasuries, with every

surface, even the braces on the underside, chamfered and smoothly finished. I even found myself wondering if my pot could have come from the treasuries too. One of my friends jokingly suggesting it might be a relic from the burning of the Old Summer Palace.

Whatever the real story, it was clear that the pot had had a complex life before it came into my hands. Fittingly, the decoration I eventually chose for it was the culmination of another long journey.

Liu Yuxi's "Inscription for a Lowly Abode" has been one of my favourite pieces of Chinese literature, ever since I first read it after class during my boarding school days in England in the 1980s. Then, in the 1990s, I fell in love with the calligraphy of Qi Gong. Qi, who at the time was China's most famous contemporary calligrapher, was a close friend of Wang Shixiang, and it was Wang who introduced me to his work, when he gave me a wrist rest decorated with a running script inscription in Qi's hand in 1994 (Fig. A1.2). At around the same time, I began to notice Zhu Jiajin's wonderful landscape paintings in the publications of the Central Research Institute of Culture and History, and, after I acquired the brush pot, I decided to ask Qi to write me a copy of the "Inscription for a Lowly Abode", then ask Zhu to paint an accompanying illustration. My original idea was that both would be carved onto the brush pot, along with a postscript, which I hoped would come from Wang himself.

I wrote to Wang to suggest the project, and he talked it over with Zhu. In January 1997 he wrote back to me suggesting a change of plan (Fig. 8.1): "A picture engraved on the brush pot will be difficult to see clearly, and unlike painting on paper it will be not be at all easy to add detailing. I therefore think it would be better to only engrave Qi Gong's cal-

ligraphy and to ask Zhu for a separate painting on paper or silk. That painting could then carry inscriptions from several people, and the two items [the brush pot and the painting] would complement each other, one on the desk and one on the wall". It was good advice, and I accepted it.

My next step was to take the brush pot to Beijing to ask Wang to examine it. In his next letter to me, he was full of praise. He was especially struck by the pot's unusually large size, which he told me made it "something to cherish". After the visit, he wrote again, this time to Qi Gong, to ask him if he would copy the Liu Yuxi inscription for me. This letter was a more formal affair, written not with a pen but with a calligraphy brush and ink. Hoping to persuade Qi to participate in the project, Wang sang my praises: I still smile to remember reading the copy he sent to me, in which he extolled my "keen love for our country's culture" to the greatest living calligrapher in China. He erred slightly in describing the brush pot as being made of *huanghuali*, an equally precious but much lighter-coloured wood than *zitan*. As Horace famously said, "*Quandoque bonus dormitat Homerus*" (or "Even Homer nods").

Along with the letter, Wang sent Qi a full-scale model of the brush pot, made of Xuan calligraphy paper, to help him plan the work. As he told me at the time, it is important that there should be some space, around 10cm, at either end of a calligraphy scroll, to stop it looking too crowded; and allowing Qi to work on a life-size version of the pot would help him to arrange and size the text to make that possible. Sadly, however, the project never came to fruition. At that time, Qi Gong was a delegate to the annual Chinese People's Political Consultative Conference, one of China's main deliberative bodies, and his very demanding schedule, coupled with his advanced age and poor eyesight, meant he was unable to complete the scroll. It would be another ten years before I found the right text with which to decorate the pot.

Shortly after Qi Gong's death in 2005, I was afforded the opportunity to see one of his finest works in person. This was his copy and annotations of "Letter on Recovery", an important piece of calligraphy by the Jin-dynasty writer Lu Ji, which Qi had given to his close friend Professor Ma Guoquan (Fig. 8.3). As soon as I saw it, I knew it would be perfect.

The "Letter on Recovery" (Fig. 8.2) is the oldest known piece of Chinese calligraphy to have survived intact to the present day: all the earlier works that have come down to us are either excavated archaeological finds or are known only from copies. Its value was summarised most succinctly by Dong Qichang, the Ming scholar and artist, who noted that, of the century of calligraphic art between Zhong You in the early third century and Wang Xizhi in the mid-fourth century, only these few lines survive. "It is", as he put it, "the rarest of treasures".

By the early 1900s, the Letter was in the collection of Pu Ru, an artist and member of the Qing imperial clan. Zhang Boju, an important collector, fell in love with it, and in 1936 Pu offered to sell it to him. But there was a catch: an asking price of 200,000 silver dollars, a truly astronomical sum and too high a price for Zhang.

The following year, Pu's mother died, and he decided to sell the piece to help cover the funeral expenses. Fu Zengxiang (whose grandson Fu Xinian we will meet below) brokered the sale, and Zhang finally acquired the letter for a significantly reduced price of 40,000 silver dollars. For a sense of just how much this was, we might compare it to the 10,500 silver dollars Zhu Jiajin's father, Zhu Yian, paid in 1934 for Prince Seng House, his home in Beijing's Chaodou Hutong. Formerly home to Sengge Rinchen, an imperial prince and general, this was a large and important residence in the very heart of the capital. Assuming that there had been no major shift in prices over the three years between the house purchase and the purchase of the calligraphy piece, the value of the "Letter on Recovery" was around four times that of the former prince's home.

Among the articles, books and treatises on the Letter, Wang Shixiang's 1957 "Study on the Transmission of the 'Letter on Recovery' by Lu Ji of the Western Jin" is particularly notable; it appears in volume one of his essay collection *A Lovely Ash-Heap*. The original text of the Letter is difficult to decipher, and it would be another four years between Wang's article and the first full explanation of the text by Qi Gong in 1961. In 1975, Qi went one step further and created a complete, annotated copy of the text. The conditions under which he undertook the work were nothing short of extraordinary. It was the tail end of the Cultural Revolution, and he was confined to a tiny home in Xiaocheng Alley near what is now Xizhimen Station. In the preface to one of his poems, Qi describes it as "a two-room dwelling, each around 10 feet wide, with a coal shop on the south side".

Ma Guoquan, the friend to whom Qi gifted the copy, died in 2002. I am grateful to Ruan Shuzhen, his widow, for giving me permission to use the copy on my brush pot. My thanks are also due to Li Pengzhu, the chairman of the *Macao Daily News*, who generously approached Ms. Ruan on my behalf in 2008, and to Hui Lai Ping, the proprietor of Han Mo Xuan, who provided images of the text for carver Fu Jiasheng to work from. Fu decided early on that the carving was to be done, as he put it, "to the highest standard that can possibly be achieved", and his painstaking work on the arrangement of Qi's annotations shows that he meant every word. It took him two years to complete the project, and his skill is showcased in a meticulous rubbing by Fu Wanli. In the finished piece, the three virtues of a good scholar's object come together in one: a fair vessel, storied calligraphy, and fine workmanship. What more could I ask for?

Perhaps there is one thing. By the time the brush pot was finished in summer 2009, Wang Shixiang was 95, and his long life was nearing its close. When I visited him for the last time, in the Intensive Care Unit at Peking Union Medical College Hospital, I brought the pot with me, just in case. By then, however, he was too ill to look at it. I wish he could have seen how the story ended.

Zhong Wuyan—鍾無艷 (lit. "No-looks Zhong"), Warring States period (c. 475–221 BCE). Famed for her outstanding character,

Zhong became a byword for the idea that outward appearances are not everything.

Charles Wong—王就穩. Carpenter and founder of Ever Arts Gallery.

the Old Summer Palace—also known as the Gardens of Perfect Brightness (*Yuanming yuan* 圓明園). A major palace complex in Beijing, set in extensive grounds. Anglo-French troops burned and looted the majority of the site in 1860, in the last days of the Second Opium War.

Qi Gong—啓功 (1912–2005). Painter, calligrapher, and scholar. Qi, who also went by the courtesy name Qi Yuanbai (啓元白), was a descendent of the Manchu imperial house. His name is sometimes written in the Manchu style as Qigong.

Zhu Jiajin—see notes to the Poem and Postscript on the Title.

Central Research Institute of Culture and History—the *Zhongyang wenshi yanjiu guan* (中央文史研究館), founded by the Communist Party in 1951. Its membership is by convention composed of the leading literary figures and researchers of the day. See also item 92.

the annual Chinese People's Political Consultative Conference—the Political Consultative Conference's yearly sessions bring together delegates from the Communist Party and other nominally independent political groups. Qi was an advisor to the September Third Society, one of eight minor parties permitted to participate in the conference.

Ma Guoquan—馬國權 (1931–2002). Calligrapher and, from the late 1970s, a newspaper arts editor in Hong Kong.

Dong Qichang—董其昌 (1555–1636). A doyen of the elite art world of the late Ming, Dong was the first to propose the long-accepted division of late imperial painting into professional "Northern" and literati "Southern" schools. See also item 43.

Zhong You—鍾繇 (151–230). An important calligrapher of the late Han dynasty. For Wang Xizhi, the most famous calligrapher in the Chinese tradition, see notes to the Author's Preface.

Pu Ru…Zhang Boju—respectively, 溥儒 (1896–1963), painter and calligrapher (see items 30, 83, 84, and 85), and 張伯駒 (1898–1982), collector and connoisseur.

Fu Zengxiang—傅增湘 (= Fu Yuanshu 傅沅叔, 1872–1949). Like Zhang, Fu, also known by his soubriquet, the Old Man of the Garden of Collecting (*Cangyuan laoren* 藏園老人), was an important collector and connoisseur. For his grandson Fu Xinian, see items 4, 9, 95, and 96.

Zhu Jiajin's father, Zhu Yian—朱翼盦 (1882–1937). Often referred to as Zhu Yian of Xiaoshan (蕭山朱翼盦) after a city in Zhejiang province, now part of the suburbs of Hangzhou, to which the family traced their lineage.

Sengge Rinchen—僧格林沁 (1811–65). Mongol nobleman and commander who saw service in numerous conflicts, including the Second Opium War (see above).

A Lovely Ash-Heap—*Jinhui dui* (錦灰堆), a three-volume collection of Wang's essays and poems. Wang also published three subsequent collections, *A Second Lovely Ash-Heap, A Third Lovely Ash-Heap,* and *Not Quite a Lovely Ash-Heap* (*Jinhui erdui* 錦灰二堆, *Jinhui sandui* 錦灰三堆 and *Jinhui bucheng dui* 錦灰不成堆), mostly composed of essays written in the last years of his life. The title of the series derives from a painting by Qian Xuan depicting a pile of leftovers – the "ash-heap" here standing for

any kind of litter. Wang's self-deprecating suggestion is that his writings are not a full meal, but the scattered remains of something beautiful – in this case, a life devoted to the arts.

the Cultural Revolution—*Wenhua geming* (文化革命, 1966–76), sometimes known by its full name as the Great Proletarian Cultural Revolution (*Wuchan jieji wenhua da geming* 無產階級文化大革命). Launched with the aim of eliminating conservative forces in Chinese society, the movement quickly devolved into one of the most turbulent periods of modern Chinese history. Intellectuals were among its earliest targets. For Wang Shixiang's fate during this period, see item 92.

Li Pengzhu—李鵬翥 (1934–2014). The *Macao Daily News* (澳門日報) is the city's paper of record.

Hui Lai Ping…Han Mo Xuan—see notes to items 4, 7, and 81.

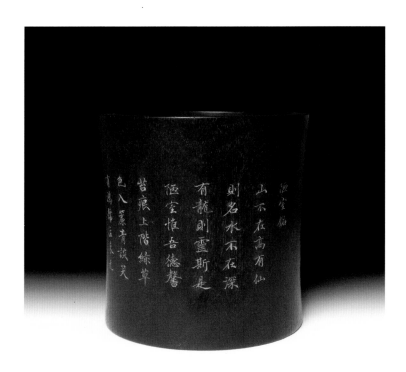

009

Zitan brush pot

2007
Text: "Inscription for a Lowly Abode"
(Liu Yuxi, Tang dynasty)
Calligraphy: Fu Xinian
Carving: Fu Jiasheng
Rubbing: Fu Wanli

At the Spring Festival in 2005, Tian Jiaqing and I visited Fu Xinian, the architectural historian, to wish him a happy new year. Fu knew that I had wanted, but never been able to obtain, a copy of Liu Yuxi's "Inscription for a Lowly Abode" from Qi Gong (see item 8), and during our visit he gave me a set of red-ink copies of the "Inscription" on two sheets, one an exquisite Qianlong paper, written in his own hand in small characters in standard script. It was a true cal-

ligraphic gem. Fu's grandfather Fu Zengxiang was famous for his beautiful standard script, which he modelled on Tang dynasty writers from the late first millennium. Xinian's calligraphy was exactly what one would have expected from his grandson: he and it were clearly cut from the same cloth.

The following year I acquired a second *zitan* brush pot, and I asked Fu Jiasheng to engrave it with a copy of the calligraphy Fu Xinian had given me. To fit the text on the pot, Jiasheng rearranged the layout of Xinian's calligraphy from portrait to landscape, with six characters per line. As well as my seals and maker's mark, he also added three other seals: two for Fu Xinian and one of his own, a plain affair tucked modestly away at the bottom and reading, "Text carved by Fu Jiasheng". After the pot was finished, Fu Wanli took a rubbing of the decoration. This was a very labour-intensive job, since the shape of the pot, which curves in slightly at its waist, required a specially cut piece of rubbing paper rather than a standard sheet.

In early 2008, I was able to personally show the brush pot to Fu Xinian and his wife Madame Li. It was a far happier ending than I would experience the following year with the original pot.

Liu Yuxi's inscription has been such a favourite of mine that I include it in full:

> A mountain need not tower to the skies:
> Immortals' mere presence brings renown.
> A river need not run to boundless depths
> When dragons can invest it with their power.
> Though this abode is lowly as can be,
> If I show virtue, then its fame resounds,
> Though marks of moss may mount its steps in vibrant
> green
> And paler hues of grass slip in the curtain door:
> For here are mighty scholars, come to take their ease,
> And no unlearned simpletons may pass these walls.
> Here you may:
> Pluck out a tune on a plain old qin
> Or pore your way through golden scriptures.
> And you will face:
> No harsh cacophony of instruments, no pipes and
> strings;
> No wearing reams of documents to check, no office
> scrawl.
> A cottage such as Zhuge Liang's, his Nanyang seat,
> Or Yang Xiong's at Xishu, little viewing halt,
> Recalls Confucius' words:
> "It may be much, but lowly it is not."

Spring Festival—Chinese New Year.

Fu Xinian—see notes to items 4, 95 and 96.

Qianlong paper—antique paper produced during the Qianlong reign (1735–96). At auction, single sheets of such paper can fetch several thousand *yuan*, and a vibrant market in fakes has flourished in recent years.

Liu Yuxi—劉禹錫 (772–842). Tang scholar-official noted for his poetry and essays.

When dragons can invest it with their power—in the East Asian tradition, the dragon (*long* 龍) is a water-dweller.

golden scriptures—the Confucian canon (though the same term is sometimes also used for the Buddhist sutras).

Zhuge Liang...Ziyun—the statesman Zhuge Liang (諸葛亮, 181–234 CE) and the poet-lexicographer Yang Xiong (揚雄, courtesy name Ziyun 子雲, 53 BCE–18 CE) were both notable figures living in humble dwellings.

Confucius' words—in Book IX of the *Analects*: "A place where a gentleman resides may be many things, but lowly it is not" (君子居之，何陋之有). The remark became a byword for the ability of the cultured man to transform – or at least neuter – an unfavourable environment by force of moral rectitude.

010
Pair of scroll weights

2010
Decorated with a couplet on the *qin* zither
(calligraphy by Huang Miaozi, 1913–2012)
Carving: Fu Jiasheng
Rubbing: Fu Wanli

The calligrapher Huang Miaozi was one of Wang Shixiang's closest friends, and we will meet him several times in these pages. The decoration on this item comes from his work, and I think it is best summed up by the following postscript, which I wrote for it shortly after Huang's death, in 2012:

In early 2006, I visited Huang Miaozi at the Cottage of Peaceful Retirement [his home in Beijing]. While I was there, he gave me a photo reproduction by the Palace Museum of a piece of his calligraphy [Fig. 10.1]. The text was a couplet on the qin zither:

The voice of a qin
quietens the river:
A dream like a poem
in the blossoms of the plum.

It was such a lovely piece that I went straight to Wang Shixiang's home, Paired Pines House, to show it to him.

In 2010, I asked Fu Jiasheng to carve Huang's couplet onto a scroll weight. That autumn, he and I went to Chaoyang Hospital, where Huang was being treated, to show him the weight and the accompanying rubbing by Fu Wanli. Normally Huang would have offered to write an inscription, but by that time he was too ill to do so. Now he, like Wang Shixiang, has returned to Mount Dao, and I mark a few words of theirs carefully, to pass them on to generations to come.

Kössen Ho
written on a winter's night in 2012

Huang Miaozi—黃苗子. Huang (1913–2012), a calligrapher, and his wife, the painter Yu Feng (郁風, 1916–2007), were among the most remarkable couples in 20th century Chinese arts and letters. Imprisoned for almost a decade during the Cultural Revolution, both would be largely rehabilitated in later years, and later, in 2011, honoured with a joint exhibition in the Forbidden City.

the Cottage of Peaceful Retirement…Paired Pines House— two literary residence names, Huang's *Anwan jilu* (安晚寄廬) and Wang's *Lisong ju* (僧松居). Like studio names, residence names may move from place to place with their creator, so that Paired Pines House refers both to Wang and Yuan Quanyou's courtyard house in Fangjiayuan (see items 5 and 6), and, in this case, to a new home in the Fangcaodi area (芳草地), slightly to the east, where the couple moved shortly after the author's visit in 1996. Wang would continue to live there after Yuan's death in 2003. For the significance of the name, see item 33.

returned to Mount Dao—that is, passed away. Mount Dao, the Mountain of the Way (*Daoshan* 道山), was a mythical peak on which the immortals made their home.

011
Zitan scroll weight

2016
Text from *A New Account of the Tales of the World*
(Liu Yiqing, Southern dynasties)
Calligraphy: Tung Chiao
Carving: Fu Jiasheng
Rubbing: Fu Wanli

This scroll weight is decorated with a favourite story of mine about the fourth-century general Huan Chong, from *A New Account of the Tales of the World*:

Huan, General of the Chariot and Horse, disliked wearing new clothes, so his wife decided to send some to him after his bath. The general flew into a rage and told the servant to take them away. His wife then brought them back again and passed him a message: "If clothes do not start out new, how are they supposed to grow old?" Lord Huan laughed heartily, and he put them on.

I drew up the design for this item myself, in imitation of bamboo wrist rests. I had a full-scale model made in nanmu wood before the real thing was carved out of small-leaf *zitan* (red sandalwood, *Pterocarpus santalinus*). The calligraphy, executed by Fu Jiasheng, is by my friend Tung Chiao, and the excellent rubbing was taken by Fu Wanli. I still remember Tung's grin when he saw his writing flawlessly reproduced on the surface of the weight. As he put it, "There's not a stroke out of place."

A New Account of the Tales of the World—a collection of stories and vignettes compiled by the fifth-century writer Liu Yiqing (劉義慶, 403–444). This tale appears in the chapter on "fine and fair women" (*xianyuan* 賢媛).

Huan Chong—桓沖 (328–384). An important commander under the Eastern Jin dynasty, Huan is often referred to by his military title, General of the Chariot and Horse (*cheqi jiangjun* 車騎將軍) as simply "Chariot and Horse Huan" (*Huan cheqi* 桓車騎). The Huan family were at the centre of late Jin political life, and Huan Chong's nephew Huan Xuan (桓玄, 369–404) would briefly proclaim himself emperor in the early 400s.

012

Seal

2006
Text: *"I'll look at hills, but only once
I've scaled the Five Great Peaks"*
Carving: Chen Ziwei (decoration), Fu Jiasheng (text)

The story of this seal goes back to 2002. That year, I visited Po Toi Island, just off the tip of Hong Kong. There I came across a poem written on a wall:

> *Each day, I open up these doors
> and see the wide, green hills,
> They're all I see, these wide, green hills,
> of ageless countenance.
> "So tell me, wide, green hills", I ask,
> "I've grown old – when will you?"
> They answer me, "And you're surprised
> you've aged? You never rest!"*

The speaker in this poem is warned to carve out time for themselves amid the stresses of life. I borrowed that idea, along with the rhyming words of the original Chinese, for a poem of my own about putting down my surgeon's tools. It was that poem that gave me the text for the seal:

> *The joy of poetry and books
> keeps vigour in my face.
> This life is brief, and so I've learned
> to snatch a moment's peace.
> My fine old blade, my Dragonspring,
> is safely stored away.
> I'll look at hills, but only once
> I've scaled the Five Great Peaks.*

The last line describes how, in literature and art, the only way to learn good judgment is through painstaking effort. The greatest poems and the most powerful paintings are not always easy to get to grips with. But it is only by studying them – by climbing the highest peaks – that everything else begins to make sense.

The seal is made from tricolour Furong stone from Shoushan and was cut by Chen Ziwei, a carver from Fuqing in Fujian province. (The signature, "Drunk-on-Stone", carved in relief on its surface, is Chen's soubriquet). The decoration, which he titled *Carefree and Contented*, depicts a small skiff anchored at a river's edge beneath a cliff. From the prow, under the shade of the trees, a fisherman casts a leisurely eye over the world. Chen's composition echoes one of the great masterpieces of modern Chinese painting, Zhang Daqian's giant splash-ink *Peach Blossom Spring* (Fig. 12.1). The subject, meanwhile, recalls a famous Tang dynasty poem, Liu Zongyuan's "The Old Fisherman":

> *Tonight, he moors his boat and sleeps
> abreast of Western Cliff.
> At dawn he draws the Xiang's clear waters;
> spot-bamboo his fire.
> The smoke drifts off; the sun comes out,
> and nobody is there –
> Only the creak of sculls sounds now
> amid the green river and hills.
> He turns his gaze downriver, lets
> the boat gather speed on the stream.
> Above the cliff, insensible,
> the clouds bring up the rear.*

The text of the seal was carved by Fu Jiasheng.

written on a wall—poems written into the landscape, either on walls or, just as commonly, on cliff faces, are an important feature of Chinese literary culture. The untitled poem quoted here has circulated in numerous variants down the years. The present version (beginning 開門日日見青山) is sometimes attributed to Sir Quo-wei Lee (利國偉, 1918–2013), although it seems more likely that Lee, a key figure in the Hong Kong business community who headed the Hang Seng banking house during the 1980s and 90s, was simply fond of quoting it.

Dragonspring—longquan 龍泉, sometimes known as Dragondeeps (*longyuan* 龍淵), was a legendary blade supposed to have been fashioned by Ou the Smelter (Ou Yezi 歐冶子), the master swordsmith of the late Spring and Autumn Period (trad. 770–476 BCE). Here it stands metaphorically for the surgeon's knife.

the Five Great Peaks—the *wu yue* (五嶽), five sacred mountains to which Chinese emperors traditionally made pilgrimages and sacrifices. The peaks are centred on Mount Song (*song shan* 嵩山) in Henan province, with the other four lying to the north, south, east, and west.

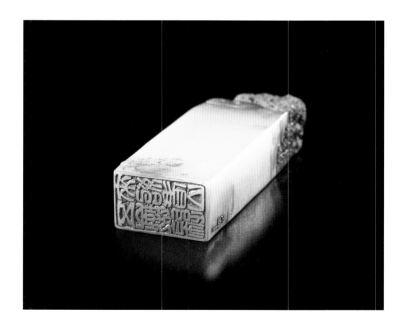

Furong stone…Shoushan…Fuqing—furong or hibiscus stone (*furong shi* 芙蓉石), sometimes known as rose quartz, is a fine, readily carvable soapstone often used for seals. Shoushan or Mount Shou (壽山), near the city of Fuzhou (福州) on the coast of Fujian, produces some of China's most highly prized seal stone. Carver Chen Ziwei's home of Fuqing (福清) is located around 50 miles further south. Below, Chen's soubriquet is *shizui* (石醉) and the title of the seal carving is *Youran zide* (悠然自得).

Zhang Daqian—張大千 (= Chang Dai-chien, 1899–1983). See also item 39. Zhang was among the most versatile and celebrated Chinese painters of the 20th century. In addition to producing work under his own name, he was also an accomplished forger, and his imitations of the great masters have made their way into the collections of major museums. The painting referred to here is the monumental *Taoyuan tu* (桃源圖, 1983).

Liu Zongyuan—柳宗元 (773–819). Poet and contemporary of Liu Yuxi (see item 7 above). The poem referred to is "Yu weng" (漁翁).

013
Seal

2007
Text: "The Hall of Looking at the Hills"
Carving: Fu Wanli

Hills seem to have been everywhere in my life – something of an occupational hazard for a Hong Konger. My home faces one hill and backs onto another, and I expect it was partly this that made me so enjoy the poem I found on Po Toi (see above), with its line about opening one's door each morning "to see the wide, green hills". Eventually, I picked my studio name, "The Hall of Looking at the Hills", from the quatrain I wrote in response to the Po Toi poem. This seal was the result.

I chose the phrase "looking at the hills" to remind me of the idea I tried to express in my poem: that genuine artistic discernment requires careful, hard study of the works of the past. But what is it like to actually go through that process, to learn to look at the hills?

Many centuries ago, the Zen Buddhist master Xuanlang wrote to another master, Xuanjiao of Yongjia, inviting him to come and live in contemplative solitude in the mountains. Xuanjiao replied:

Some people go off and dwell in the hills before they have recognised the Way; when they do, they see the hills and forget about the Way. But others recognise the Way having never lived in the hills at all, and they forget about hills and see only the Way. If I am one of them – if I have seen the Way and forgotten about hills – I will be at peace even in the midst of the mortal world. But if I am not – if I am a seer of hills and a forgetter of the Way – then when I reach your hills, all I will do is make a racket.

For Xuanjiao, it is not what you look at that determines whether you see things clearly. It is how you have learned to look. This is one aspect of what I would call "looking at the hills".

How does it feel to learn how to look? For that we could do worse than consult the writings of Qingyuan Weixin, the ninth-century Zen master. He described three stages in the process of refining oneself as a Buddhist: beginnings, partial enlightenment, and complete enlightenment:

When I began to practise meditation thirty years ago, I saw hills as hills and rivers as rivers. When I reached a more intimate knowledge, I came to a point where I saw hills as not hills and rivers as not rivers. Now I have reached a point where I know things in my very self and am at peace, and I see hills as hills again and rivers as rivers again, just as they were before.

This is another aspect of "looking at the hills": sometimes you need to not see hills at all.

In his celebrated *Remarks on Lyrics Poems in the World of Men*, Wang Guowei illustrates each of Qingyuan Weixin's three stages using quotations from the great poets:

In any age, those who have been successful in some great enterprise or great field of study have always passed through the "three stages".

The first stage is like this:

> *Last night, the westerly wind*
> > *stripped the green trees bare.*
> *I climbed the high tower alone*
> > *And looked on all the roads*
> *that run to the edge of the sky.*

The second stage is like this:

> *My robes and belt grow loose,*
> > *but why should I regret?*
> *For this I'll grow so thin*
> > *I pale and shrivel up.*

And the third stage is like this:

> *I search for you in the crowd*
> > *a hundred, a thousand times,*
> *Till suddenly I turn back,*
> > *And there you are at last,*
> *Just where the lamplight ends.*

Wang highlights a third aspect of learning to "look at the hills": it takes not just time but toil.

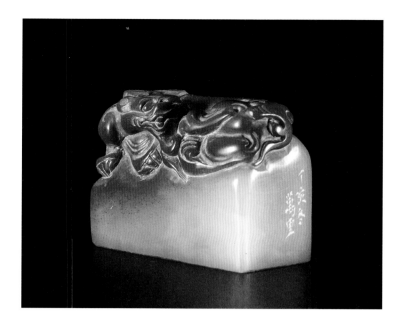

chives, aubergines, bitter melon, autumn cabbage, pea shoots, sweetcorn, sugar cane, shallots, you name it. They come in one by one with the changing of the seasons, and each season there is something new. It's more fun looking at them than any priceless work of art." Tung answered, "That's the way of things in life. Bravo, Kössen: you've worked it out!"

Xuanlang…Xuanjiao—respectively 玄朗 (673–754) and 玄覺 (665–712).
 Qingyuan Weixin—青源惟信, a later Zen monk sometimes known by the Japanese name Seigen Ishin.
 Wang Guowei—王國維 (1877–1927). One of the most prominent scholars of the late Qing and early Republican eras, Wang is now remembered chiefly for his contributions to early epigraphy. His work on oracle bone inscriptions, the first written texts known in China, remains a cornerstone of the field. The work cited here is his 1908 *Renjian cihua* (人間詞話).
 One Hundred Quatrains on Calligraphy—Qi's *Lunshu jueju bai shou* (論書絕句百首).

Discernment requires engaging with the works of the masters, but that engagement should not be uncritical. In his author's preface to *One Hundred Quatrains on Calligraphy*, Qi Gong writes about how he learned his art:

> *I was only a child when I first gave myself up to calligraphy. In the early days I followed the methods described by the old masters, but I found it was like putting a square peg in a round hole. One day I thought indignantly to myself: what made these people I am copying so special? They had to eat and excrete too. They were not gods; they were just people like me. Their styles – the ancient styles – did not come out of nowhere: they had to be invented. So why should later generations not adopt a different style altogether? Many Qing calligraphers based all their theories of the art on stone carvings of examples from the masters. But do rubbings of those carvings, mere copies of copies, really show all the subtleties of a great piece of calligraphy? My doubts had been building up, and now they had found an outlet.*

> *Worse still, I found that the reputations of famous calligraphers from the past were not always based solely on their artistic abilities. In the old days, if you were a high official, every normal person seemed like a potential lackey. Likewise, once you had acquired a reputation, all of your contemporaries seemed like disciples to be tutored. The greater a man's power and lands, the more easily his name and artistic works would gain currency. And everyone who looked at those works in later years would sigh to each other with serious faces and think how unfathomably deep they were, how unattainably subtle. Now all my doubts came flooding out again.*

This is a fourth aspect of "looking at the hills": you cannot be too wedded to established views. They may not tell you who was a great artist, only who was a powerful one.

Sometimes "looking at the hills" means putting art aside completely. In early summer 2018, I was talking to Tung Chiao, and I told him about one of my favourite places: "There's an organic vegetable market at Star Ferry Pier where you can find all kinds of produce grown right here in Hong Kong: spring

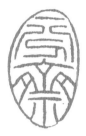 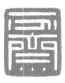

014
Two seals

2009, 2010
Text: "One-Part Studio"
Carving: Fu Wanli

In "On Garden Construction", the first section of his *The Craft of Gardens*, the Ming horticulturist Ji Cheng writes about the balance between the craftsman who makes something and the person who commissions it: "These days, when people build their gardens, they think all they need to worry about is choosing the right craftsmen. Have they never heard the saying, 'three parts for the one who crafts, seven parts for the one in charge'? Don't just own your garden: *take ownership.*" Ji also writes, "In the building of a mansion or garden, nine tenths must rest with the person in charge, one tenth with the craftsmen they use." Four hundred years later, in the 1960s and 1970s, Ji Cheng was attacked in China for displaying "contempt for the proletariat". According to Chen Congzhou, the garden historian, it was passages like these that landed him in hot water.

When I commission a scholar's object, I provide a concept and a general plan, but the carving is left entirely to the artist. I put in one part in ten, and everything else comes

from them. I wanted to put that rule in writing, so I asked Fu Wanli to create a seal for a studio name, "One-Part Studio". Fu was not happy with the original intaglio version (right), so he created another in relief, which he presented to me as a gift (left).

The Craft of Gardens—Yuanye (園冶). Largely forgotten until the publication of a new edition in the 1930s, this text, the masterpiece of Ji Cheng (計成, b. 1582), is now regarded as one of the foremost works of garden literature in any language.
Professor Chen Congzhou—陳從周 (1918–2000).

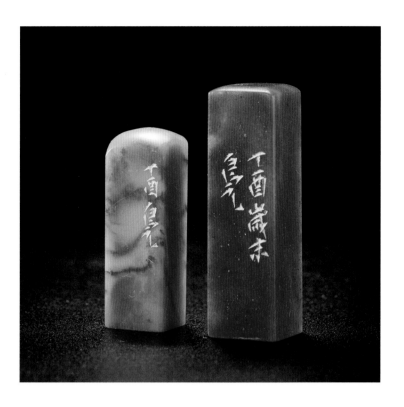

015
Seal

2017
Text: "A career of the hand"
Carving: Li Zhi

This seal is full of meaning for me. In my professional life, I am a urologist, specialising in minimally invasive surgery. Like painting, calligraphy or seal making, it is a career of the hand. The modern surgeon relies on their equipment – laparoscopes, endoscopes, even robotic arms – but that equipment still needs to be operated manually. So, like an artist, a surgeon often does their best work between the ages of 30 and 60, before their dexterity is diminished by age. This vulnerability is beautifully expressed in a famous line by the Qing poet Zhao Yanxue. In her "Lament for Lady Jin", she writes of a woman who passed away before her time:

> *Generals and lauded beauties*
> > *share this much:*
> *They never get to show the world*
> > *a wrinkled face.*

There is one place where surgeons and artists diverge: a surgeon's work will eventually disappear, whereas a carver or a painter's creations can still attract praise hundreds of years after they are made. Artistry can survive forever, but surgery is not so lucky.

I asked Li Zhi to carve this seal.

Zhao Yanxue—趙艷雪 (fl. early 18th century). The poem quoted is "Dao Jin furen" (悼金夫人), her most famous work.

016
Seal

2017
Text: "Feed on antiquity and transform it"
Carving: Li Zhi

The text of this seal, which is discussed further in my introductory essay, is best explained by a line from Wang Shixiang's preface to his *Compendium of a Few Old Things*: "I suddenly realised that the value of a life does not lie in possessions, but in examination and appreciation, in discovery, in understanding hidden things, in turning that into knowledge and in aiding research into, and the development of, culture."

The seal was carved by Li Zhi.

Compendium of a Few Old Things—see notes to items 5 and 6.

017
Large, naturally shaped *zitan* scroll weight

2017
Inscription: "Rejoicing in poems and books" (Kössen Ho)
Calligraphy and carving: Fu Jiasheng

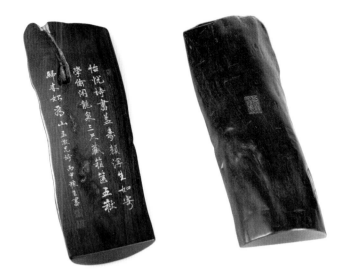

The section of wood that Chan cut was very striking. The inside was flat where he had split it from the rest of the log, while the outside was an irregular, rounded shape. It looked for all the world like a giant's foot. Fu and I decided we would leave it like that. Once the wood was polished, Fu engraved the text on the flat side, leaving the finished piece half carved and half plain. It is an unusual piece: looking at it, you know you are seeing something truly original.

018
Bamboo cross-piece

1998
Decorated with *liuqing* relief of bamboo (Fan Yaoqing)
Inscription: "How could I go a day without these gentlemen?"
Calligraphy: Wang Shixiang
Carving: Fan Yaoqing

Each year I produce a calendar showcasing some of my commissions. In the winter of 2016, I decided to use my poem on "Looking at Hills" as the cover of the 2017 version (Fig. 17.1), and I asked Fu Jiasheng to write the calligraphy. He wrote the poem so beautifully that we decided to carve it onto a scroll weight.

I asked two friends in China to create a design for this weight and make a full-scale model in *nanmu* wood. Once the work was completed, I asked them to make the full version in small leaf *zitan (Pterocarpus santalinus)*, then send it to me to be polished and decorated.

When the finished item reached me, the wood did not seem 'right'. Eventually, I began to wonder if it was actually *zitan* at all. To test my theory, I decided on an experiment. I took a log of *zitan*, which I had kept in storage for over a decade, and asked Master Chan Tak Yan, a local carver, to split it for me and make a new scroll weight. I watched the process from start to finish, and this gave me a much better understanding of *zitan*, from the wood shavings and the grain to the colour and smell of the newly split timber before it is polished and decorated.

The text on this item is borrowed from another story from *A New Account of the Tales of the World*:

When Wang Ziyou was briefly staying in a vacant house, he had some bamboo planted. Someone asked him why he had taken the trouble, since he was only there temporarily. Wang whistled an air and, pointing at the bamboo, he said, "How could I go a day without these gentlemen?"

I asked Wang Shixiang to provide the calligraphy (Fig. 18.1). Originally, I commissioned Fan Yaoqing to create either a wrist rest or a cross-piece. We eventually settled on a cross-piece, but we were unable to get the composition of the picture right. Wang was never satisfied with the result, and it was for this reason that I had the following three items made several years later. All feature bamboo in a starring role.

A New Account of the Tales of the World—see notes to item 11. The tale is taken from the chapter on "wild and wilful characters" (*rendan* 任誕).

Wang Ziyou—王子猷, also known as Wang Huizhi (王徽之, 338–86). Wang, the fifth son of legendary calligrapher Wang Xizhi, was talented with a brush in his own right.

019

Huanghuali brush pot

2007
Decorated with *Bamboo Stalk* (Ni Zan, Yuan dynasty)
Carving: Fu Jiasheng

Bamboo, like hills, seems to be everywhere in Hong Kong, so it is appropriate that it should feature in my commissions not just as a material but also as a motif. As Wang Ziyou put it, you cannot "go a day without these gentlemen".

When I was young, my family owned an old, run-down garden in hills opposite the south side of Victoria Peak. From it you could see the fishing harbours below the peak, full of bobbing masts, and the garden itself was full of Cantonese plants and fruit trees. I had endless fun playing there as a child. Halfway up the hillside, towards the top of the garden, two bamboo brakes had been planted, their leaves like arrowheads pointing to the clouds. Behind them, the cogongrass grew way over head height. Wild dogs and huge snakes would appear out of it, then vanish again. I never dared to go in: the bamboo was the edge of my world.

When I was a little older, I went with the adults to see a spirit opera. It was staged in an old-fashioned temporary theatre, built from a frame of Chinese fir and huge bamboo rods covered with iron sheeting (Fig. 19.1). Inside, facing the stage, was a spirit tablet emblazoned with the words "reverence them as though they are present", to remind every-

one there that this was no ordinary auditorium, but a sacred space.

The theatre was constructed like a palace hall, with a double-eaved hip and gable roof, the same design as the Great Hall of Preserving Harmony, one of the three main buildings in the Forbidden City in Beijing. Clearly the spirits were meant to be venerated like emperors. I have always been struck by the fact that, whether they knew it or not, the carpenters who built that theatre were working in the finest imperial style. Thousands of miles from the capital, in an unimportant little strip of land in the far south, a few ordinary people were keeping the tradition alive, using the cheapest materials possible, bamboo and iron. It was a perfect of demonstration of the old adage, "When the rites are lost, look for them in the countryside."

The most remarkable thing about bamboo as a building material is its extraordinary versatility. Probably the most famous bamboo structure ever built was the Song writer Wang Yucheng's house in Huangzhou, immortalised in his much-loved *Record of a Bamboo House at Yellow Ridge*. This was a small building with only one or two rooms. At the other end of the scale, a bamboo theatre of the kind I visited as a child can have space inside for a stage and an audience of hundreds, and it can be put up in a matter of days and taken down in a few days more.

Bamboo is not just a practical material: it also has a special place in Chinese culture, cropping up in story after story and painting after painting. A favourite tale of mine comes from a Cantonese opera, *The Search at the Academy*, in which bamboo delivers a shock to the system. In the early 1980s, as China opened up, opera troupes began visiting Hong Kong from across the border, and *The Search*, which had started life as a Hainanese opera but was adapted to the Cantonese style in the 1950s, proved especially popular with the city's residents. Set in the 18th century, it relates events at the Qiongtai Academy on the southern Chinese island of Hainan. In the Cantonese version, the part of Xie Bao, the academy's head, was played by legendary actor Man Gok Fei. In one act, Xie Bao is pacing in the moonlight, lamenting his troubles, when he hears something:

> Xie Bao: *What was that noise?*
> His Page: *Perhaps it is the plaintive cry of a lonely goose?*
> Xie Bao: *It is not.*
> His Page: *Perhaps the plangent lament of the cuckoo?*
> Xie Bao: *It is not that either.*

Then he delivers a recitative:

> *It is not for the wind in the bamboo's branch,*
> *Nor the pitterpat tinkle of rain,*
> *But the pain and the hardships the people have borne*
> *That the air on all sides is a-wail.*

I studied and worked for 20 years in England, but I often pined for Hong Kong, and in 2001 I bought my ticket home. Outside my apartment in the city there was a cluster of bamboos, from which a stalk or two would stretch out sideways across my window. I noticed how their appearance seemed to change completely whenever the weather turned (Figs 19.2,

19.3). I also saw how resilient they were. Even in a typhoon, they would simply bend with the wind and emerge completely unscathed. The work that decorates this brush pot, Ni Zan's famous ink handscroll of a single bamboo stalk (Fig. 19.4), reminds me intensely of the slanting bamboo outside my window, with its spare branch and profusion of leaves. In 2007, I saw the painting in Hong Kong at the Exhibition of National Treasures held to mark a decade since the handover of the city to China. The scroll has a particular connection to Hong Kong, having previously been in the collection of Wang Nanping, one of my elders in the city's Min Chiu Society.

The brush pot itself, a large *huanghuali* example, long predates my encounter with the Ni Zan painting. In fact, it had been gathering dust on my shelves since I bought it in the 1990s from Kai Sum Lau of Hon Ming Antique Furniture. I thought that its coarse grain would be a perfect fit for Ni's bamboo, and Fu Jiasheng agreed. However, before he carved the painting, there was one change to make.

One of the most important landmarks in Chinese art theory is Xie He's articulation of the "Six Principles of Brushwork" in the sixth century. Xie's Principles were later popularized by the Tang writer Zhang Yanyuan in his *Record of Famous Paintings Through the Ages*. The fifth of these principles is that objects in a composition must be correctly placed. There is one area in which, by Xie He's standards, the Ni Zan scroll falls short, namely the poem that sits just above the bamboo at the top of the painting. This was added by the Qianlong Emperor in the 1700s, and in its current position it does little other than distract the viewer. So, on the brush pot, Fu and I chose to move the poem so that it followed Ni Zan's own inscription to the left of the bamboo. If you had tried doing that in Qianlong's day, you would have been hauled up on charges of *lèse-majesté*, and it would have been curtains for everyone involved. All I can say in defence of our boldness is that, as far as I can tell, the painting is better for it.

Wang Shixiang loved bamboo. Way back in 1942, when he was 28, he made a handwritten copy of *Gao Song's Guide to Bamboo*, a Ming dynasty manual devoted to teaching the reader how to paint the plant. In his preface to the copy, which he later gave to the Beijing Library, he describes the process of transcribing Gao Song's words and model paintings by hand:

I stayed glued to my desk, sweating through the sweltering summer heat, working day and night. It took me a month to finish, and soon my mind was filled with visions of bamboos in the breeze, and whenever I lay down to sleep their slender shadows would appear behind my eyelids. Yet still I loved what I was doing, and it never felt like a hardship...

Each day, as I became more and more engrossed, the dust and clamour of the world outside fell further away. It was like a cooling balm – the perfect thing to drive away the heat. "These gentlemen" and I must have had a special connection.

In 2006, the year before this item was made, Fu Jiasheng had decorated two other brush pots for me, one with Wu Guan's *Plum and Bamboo* (see item 26) and the other with calligraphy in running script by Zhao Mengfu (see item 74). I had taken them to show to Wang Shixiang, who liked them so much that he wrote an inscription for them that became my maker's mark: "An elegant creation of Kössen Ho". I later had it carved on the base of both pots.

I decided to keep up the tradition with this item and to take it to Wang for his approval too. So, in 2007, I brought it with me on one of my visits to him. The malachite pigment had not yet been added, but Fu had finished carving the decoration, so the pot was essentially complete. Wang was 93 by that time, and I was worried that the pot might be too heavy for him, but he picked it up and inspected every inch. In fact, as far as he was concerned, its size and weight seemed to be points in its favour, and finally I got what I had been hoping for: a nod of approval.

Just like my cricket wrist rest a decade earlier, this brush pot went on to inspire a poem, though this time I was the writer rather than Wang. In June 2009, on the anniversary of the Hong Kong handover, I was sitting at home by the window. The sun was streaming in, and I was toying with the brush pot when a quatrain came to me:

> *Outside the window,*
> > *Ni's bamboo – an outline draft –*
> *While, on my desk,*
> > *his branch and leaves as clear as day.*
> *Oh, how I love these gentlemen's fair knots*
> > *and joints,*
> *Who walk with me each day, in sunshine and in rain.*

spirit opera—*shengong xi* (神功戲). Performed for the benefit of the spirits (and a large worldly audience) at Hong Kong's major religious festivals.

Reverence them as though they are present—jing ru zai (敬如在), a common expression describing the proper approach to rituals and sacrifices. Both this contraction and the longer form of the phrase, *jing shen ru shen zai* (敬神如神在), derive ultimately from two similar expressions in *Analects* 3.12.

Great Hall of Preserving Harmony—the Great Baohe Hall (*Baohe dian* 保和殿), the venue for the palace examinations for entry into the civil service during the Ming and Qing dynasties. Passing these tests, held every three years in the spring and traditionally administered by the emperor himself, was a mark of extraordinary prestige which only a tiny minority of the educated elite could hope to achieve. As one of the few places where a scholar might personally interact with his ruler, the Great Hall of Preserving Harmony is an apt model for a space in which the human and the divine meet.

"When the rites are lost, look for them in the countryside"— 禮失求諸野, an aphorism originally attributed to Confucius.

Wang Yucheng—王禹偁 (954–1001). The *Record of a Bamboo House at Yellow Ridge* is his *Huanggang zhulou ji* (黃岡竹樓記).

The Search at the Academy—Sou shuyuan (搜書院). The opera's plot revolves around a young woman who escapes her life as a serving girl by enrolling at the titular academy. The popular Cantonese stage version was released on film in the mid-1950s and is sometimes known by its English title, *The Lost Kite*.

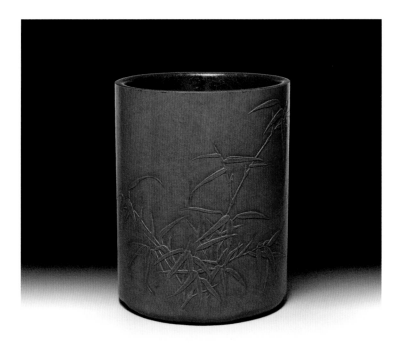

Man Gok Fei—文覺非 (1913–97).

Ni Zan—see notes to items 76–78.

Wang Nanping—王南屏 (1924–85). Major 20th-century collector and connoisseur. The Min Chiu Society (*Minqiu jingshe* 敏求精舍) is an association of private collectors of Chinese art, founded in 1960.

Kai Sum Lau—劉繼森. Hon Ming Antique Furniture (*Hanming jiaju* 翰明家具), which grew out of a furniture making business set up by Lau's father Ban Lau (劉賓, born c. 1930), has been behind the development of some of the most significant collections of Chinese furniture in Hong Kong.

The Qianlong Emperor—the Qing emperor Gaozong (r. 1735–96), better known as the Qianlong Emperor after the name of his reign period, was a skilled painter and the owner of an extensive art collection.

Xie He—謝赫 (fl. early sixth century). Xie's Six Principles (*liu fa* 六法) are notoriously difficult to interpret, but various readings of them have been central to later Chinese painting theory.

Zhang Yanyuan—張彥遠 (9th century). Tang dynasty calligrapher, painter and writer on art history and theory. The *Record of Famous Paintings Through the Ages* (*Lidai minghua ji* 歷代名畫記) is his most notable work.

Gao Song's Guide to Bamboo—Gao (高松, fl. 1522–66) produced three manuals on the painting of bamboo, known collectively as *Gao Song's Guide to Bamboo* (*Gao Song zhupu* 高松竹譜). Wang's copy was widely reprinted and became one of the standard editions of the text. See also item 20 below.

Wu Guan—吳瓘, 14th century painter. *Plum and Bamboo* is among his best-known works.

020

Bottle gourd brush pot

2012

Impressed with extracts from *Gao Song's Guide to Bamboo*
(Ming dynasty)
Calligraphy: Wang Shixiang
Workshop of Wan Yongqiang

Wang Shixiang achieved much in his long life, but one of the things of which he was most proud was his work to revive an old and neglected tradition: the use of the bottle gourd as an objet d'art. The book he published on the subject, *The Charms of the Gourd* (Fig. 20.1), clearly had a deep significance for him. In a letter to Fan Yaoqing in July 1994, he wrote:

> *I spent 13 painstaking months writing it. It is the first thing I have done without thinking about the reader – I wrote however I felt like writing. It is also the work I am most satisfied with: no-one else could have written it. And I wrote it in Classical Chinese, which drew on all my talent… The book will be published in Hong Kong. I want it to be printed exquisitely, with no expense spared.*

The decoration on this item comes from another work Wang poured his heart into, his copy of *Gao Song's Guide to Bamboo* (see item 19). It is a wonderful book, but it was the source of a moment I would rather forget. In summer 2005, on one of my visits to see Wang, I asked him to write a dedication in my copy. I still remember his face falling as I handed the book over: it turned out I had bought a pirated version by accident, something that was all too easy to do in those days. Wang took it off me, and I went away mortified. Happily, it was only a temporary loss, and I got my dedication – in a real copy – a few months later in October 2005 (Fig. 20.2).

The brush pot itself is made from a moulded gourd from the studio of Wan Yongqiang. When Wan offered it to me in 2012, I took the chance to combine two of Wang Shixiang's passions. I asked him to decorate the pot with two pictures from the section on "sparse bamboo" in Gao Song's *Guide*, along with a few phrases from Gao's notes on how to paint bamboo "in sunshine with 'double-man' leaves". Impressing the decoration took Wan's workshop several months.

The Charms of the Gourd—Wang's 1993 說葫蘆, more literally *On the Bottle Gourd*.

A letter to Fan Yaoqing—later published in a collection of Wang's correspondence with Fan, *Ink on Bamboo: Letters on Art from Wang Shixiang to Fan Yaoqing* (*Zhumo liuqing: Wang Shixiang zhi Fan Yaoqing shuhan tanyi lu* 竹墨留青: 王世襄致范遙青書翰談藝錄).

Wan Yongqiang—萬永強 (b. 1957), the leading expert on the uses of the gourd in Chinese art. Sometimes affectionately known as "Gourds Wan" (葫蘆萬), he is noted for refining the technique of "mould-growing", in which a cast is used to produce a gourd of the desired shape.

Bamboo "in sunshine with 'double-man' leaves"—that is, leaves painted like two versions of the character 人 (*ren*, "per-

son, man"), placed one above the other along the branch. Gao's *Guide* also outlines other characters that can be used to approximate the shape of bamboo leaves, such as "woman" (女, *nü*), "hand" (手, *shou*) and "separate" (介, *jie*).

021
Bamboo wrist rest

2010
Decorated with *liuqing* relief of *New Bamboo*
(Gu An, Yuan dynasty)
Carving: Chen Bin
Rubbing: Fu Wanli

The painting that decorates this wrist rest, by the Yuan artist Gu An, depicts a young bamboo shoot struggling to grow upwards through thorns (Fig. 21.1). For me, it symbolizes Wang Shixiang's extraordinary effort to revive the art of bamboo carving in the 1970s, as China emerged from one of the most difficult periods in its modern history.

New Bamboo was previously in the collections of Ye Gongchuo and Wang Nanping before making its way to the Palace Museum in Beijing. It is a wonderfully poetic painting, and Gu may have had a similarly titled poem, Wei Yingwu's "Looking on New Bamboo", in mind as he worked:

> *Fresh and green, the buds emerge,*
> *Then the shoots, still sweet in scent.*
> *Strewn with dew, a slow unfurl of leaves,*
> *Step by step, a thicket stretches out.*
> *Stop here alone when day breaks: then you may admire*
> *A shady grove, full grown, beside a viewing halt.*

Chen Bin, who carved this item, was still an apprentice when I first met him in 2009. I was in Shanghai for the World Conference of the Société Internationale d'Urologie, and I made time for a visit to the suburb of Jiading, where I met Chen at the small shop where he was working. I began commissioning work from him the following year, and this wrist rest was one of the first pieces he completed for me. It gives me great pleasure to have spotted Chen's talent. As the old saying goes, "Many a horse can run a thousand miles, but you must have wits to pick them."

Gu An—顧安 (fl. late 13th to mid-14th centuries).
 Wei Yingwu—韋應物 (737–after 790). The poem is his "Dui xin huang" (對新篁).
 Ye Gongchuo—葉恭綽 (1881–1968). Politician, artist, and collector known for his taste in and talent for calligraphy. For Wang Nanping, see notes to item 19.
 Many's the horse...—quoting the great Tang dynasty scholar-official Han Yu (韓愈, 768–825). The original phrase (千里馬常有, 而伯樂不常有) references the legendary horse tamer Bo Le (伯樂, late 7th century BCE).

022
Brush pot

2005
Decorated with a painting of plum blossom
(Yang Buzhi, Song dynasty)
Carving: Fu Jiasheng
Rubbing: Fu Wanli

The blossom of the Chinese plum, *Prunus mume*, is among the most popular motifs in Chinese painting, and there

are many ways to paint it. So-called "palace plums", like the tree in Ma Lin's famous *Layers of Ice-Silk* (Fig. 22.1), look like something out of a greenhouse, full of charm and grace. In contrast, the "rustic plums" in Yang Buzhi's Four Plums are tough old things, tall, steely, and staunch. This brush pot is decorated with one of them, a tree "on the brink of blossoming" (Fig. 22.2). The carving is by Fu Jiasheng.

When the pot was finished, I gave it to Tung Chiao, and to my surprise it soon appeared in print in one of his essays, "Notes from the Eighth Day of the Year". His praise for Fu's carving and Yang's original painting is spot on:

> Whether in the sparse branches or the blossoms themselves, every stroke of the knife is imbued with the sense of an elegant, frozen waste… In a painting of plants, the worst possible fault is overcrowding. It is a courtly extravagance, pandering to a boorish taste for riches and beauty. A sparser image, by contrast, captures something better: the feeling of a half-deserted village outside a study window. Yang Buzhi's plum blossoms are known as "rustic plums" for a reason: they are the product of an elevated, scholarly spirit, a deliberate challenge to "palace plums".

Ma Lin—馬麟 (c. 1185–after 1260). The painting is his *Cengdie bingxiao tu* (層疊冰綃圖). "Ice-silk" (*bingxiao* 冰綃), a white, diaphanous raw silk, stands metaphorically for the white blossoms that pile up on the branches of Ma's tree.

Yang Buzhi—揚補之 (1097–1171). Now best known for his poetry in the *ci* or lyric form. The painting used for the brush pot is "Yu kai" (欲開), a section of Yang's larger *Si mei tu* (四梅圖).

Tung Chiao—see notes to item 11 and section III of the Chinese text. The essay is Tung's "Chuba suoji" (初八瑣記), first published in February 2006.

painting lotuses in snatched moments. I read the story in primary school, and it stuck with me. Wang is best known for his depictions of plum blossom. As an adult I read some of the poems he wrote to accompany his work, and I quickly fell in love with his highly individual style.

I have seen many of Wang's plum blossom paintings over the years in museums in Taiwan and mainland China, but this work, now housed in the Palace Museum in Beijing, stands out for its restraint. Often Wang's compositions can seem crowded, with a profusion of flowers and branches packed close together. Here, by contrast, he depicts only a few branches, which trail across the picture from right to left. The blossoms themselves are wonderfully handled, each rendered with a simple dot of light ink (Fig. 23.1). It is a work of extraordinary refinement and elegance.

I commissioned the cross-piece from Zhu Xiaohua in summer 2008. After the picture, Zhu carved Wang's accompanying poem:

> I wet my inkstone's well, and by
> a pool, there sprouts a tree:
> One by one its blossoms open,
> marked with faint, light ink.
> They need no praise from anyone,
> no talk of colours bright:
> They simply pour their goodness out
> to fill the earth and sky.

Wang Mian—王冕 (1287–1359), a specialist in the painting of plum blossom.

goodness—translating as *qingqi* (清氣), literally "pure breath", "pure spirit", "fragrance". When used to describe humans, the term indicates an upstanding, pure character.

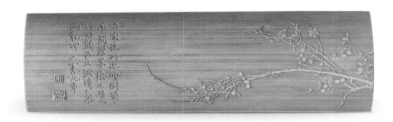

023
Bamboo cross-piece

2008
Decorated with *liuqing* relief of *Plum Blossom*
(Wang Mian, Yuan dynasty)
Carving: Zhu Xiaohua
Rubbing: Fu Wanli

Wang Mian, whose painting decorates this cross-piece, is famously supposed to have worked as a cattle herder,

024
Huanghuali brush pot

2010
Decorated with *Plum Blossom* (anon., Yuan dynasty)
Carving: Fu Jiasheng
Rubbing: Fu Wanli

The Chinese plum is a hardy tree. It blossoms in late January or early February, long before most other plants. This is why it is associated so strongly with Chinese New Year, which falls around this time.

The anonymous Yuan painting that decorates this brush pot, depicting plum branches buffeted by a high wind, perfectly captures this hardiness (Fig. 24.1). It reminds me of one of Mao Zedong's poems, in which he describes the plum tree standing alone in the depths of winter:

> The snow weighs down the winter clouds;
> its cotton wisps take wing.

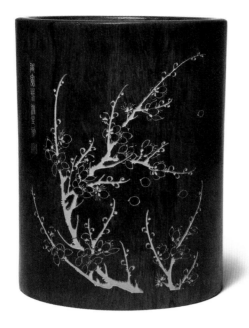

No flower blooms in such a time:
 they wither one by one.
/ … /
While plums in bloom delight to face
 A sky of swirling snows.

It is easy to imagine the plum in this painting turning its face to the wind with that same grim pleasure.

The brush pot itself, a tall, thin example with ramrod straight sides, is made from *huanghuali* or yellow rosewood. The decoration is by Fu Jiasheng and is executed in intaglio. Shortly after finishing this item, Fu began to experiment with sunken relief, where low relief is incorporated into intaglio carving. An example of this new technique is shown below in item 30.

one of Mao Zedong's poems—"Winter Clouds" ("Dong yun" 冬雲). The idea of the ruler-as-poet or ruler-as-artist has deep roots in the Chinese tradition.

025
Bamboo inkstone screen

2008
Decorated with *liuqing* relief of *Double Purity*
(Chen Hongshou, Ming dynasty)
Carving: Bo Yuntian
Rubbing: Fu Wanli

"Double purity" paintings combine common motifs in pairs. Chen Hongshou painted several examples; the one that decorates this item marries bamboo and Chinese plum. It is a wonderfully elegant work. The composition is simple and uncluttered, and the two plants are handled with great subtlety. Chen clearly defines the layering of the bamboo leaves, and he picks out the shadows in the centre of the plum blossoms so delicately that you can almost smell their fragrance.

In the winter of 2007, I decided to commission an object from the carver Bo Yuntian using Chen's painting as decoration. Bo and I met at Wang Shixiang's house, where I showed him the painting and suggested using it on a brush pot. At meetings like this, Wang would often give his view first. This time, however, Bo spoke straight away, telling us that, because of the way the branches moved across the painting, it was unlikely to transfer well to a round pot. He thought a flatter surface would be more suitable, so we settled on an inkstone screen. Bo's carving is exceptional, perfectly capturing the exquisite elegance of the original.

One thing that stands out to me now is the sheer realism of Chen's painting. A few years ago, I saw a wonderful photograph of plum blossom by Professor Richard Y.H. Yu (Fig. 25.1). Comparing this image to the painting made me appreciate just how accurately Chen had studied his subject.

Chen Hongshou—陳洪綬 (1599–1652), a celebrated painter of the late Ming dynasty, hailing from Shaoxing in Zhejiang province.

inkstone screen—designed to prevent spatter while the ink is mixed.

Professor Richard Y.H. Yu—余宇康 (= Yu Yue Hong). A distinguished Hong Kong physician, now an honorary professor at Hong Kong University's Department of Medicine.

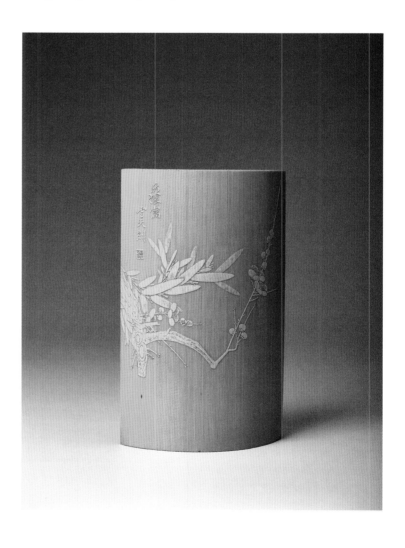

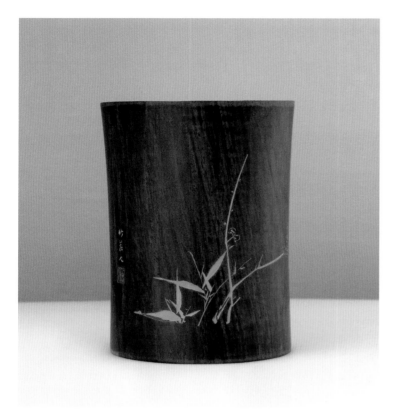

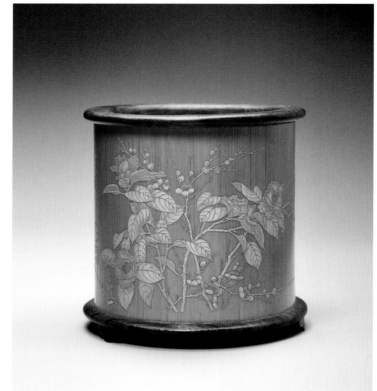

026

Brush pot

2006
Decorated with *Plum and Bamboo*
(Wu Guan, Yuan dynasty)
Carving: Fu Jiasheng
Rubbing: Fu Wanli
Private collection, Hong Kong

The pairing of plum blossom and bamboo, seen above in item 25, is a popular subject in Chinese painting. The example that decorates this item is typical of Yuan literati painting (Fig. 26.1). The free brushwork gives it a very different quality to the court painting of the Song period, where crafted brushwork and double outlining are used to precisely capture the plants.

crafted brushwork and double outlining—crafted or artisan's brushwork (*gongbi* 工筆) describes a style of painting characterised by close attention to detail and verisimilitude. It contrasts with the "sketched ideas" (*xieyi* 寫意) or "free brushwork" (*yibi* 逸筆) style traditionally associated with amateur scholar-painters. Double outlining (*shuanggou* 雙勾), commonly used in the copying of calligraphy, involves creating a close facsimile by reproducing the edges of a shape and filling in the resulting trace. For the artist, Wu Guan, see notes to item 19.

027

Bamboo brush pot

2009
Decorated with *liuqing* relief of
plum blossom and camellia from
The Hundred Flora (anon., Song dynasty)
Carving: Bo Yuntian
Rubbing: Fu Wanli

I first saw the anonymous Southern Song scroll that decorates this item at the Exhibition of National Treasures held to mark the 10th anniversary of the handover of Hong Kong to China. It is the first section of the scroll that appears on this brush pot (Fig. 27.1).

The camellia appears frequently in Song painting – one particular miniature, showing crimson camellias "after a snow", is exceptionally beautiful. The flower is native to China, and several wild species grow in Hong Kong. Chinese varieties have enjoyed enormous popularity abroad, but in China itself people prefer to seek out imported varieties, and traditional camellias are being squeezed out of the market. How small it all makes one feel…

camellias "after a snow"—*shancha jixue* (山茶霽雪). Referring to a work of that name by Lin Chun (林椿, fl. 12th century), now in the collections of the Palace Museum, Taipei.

The first two lines of this poem appear on the back of the pot in my own calligraphy.

Sadly, the finished pot is marred by a crack between the kingfisher and the lotus flower, which opened up after the decoration was completed.

Shen Yue—沈約 (441–513). The poem is his "Yong furong" (詠芙蓉).

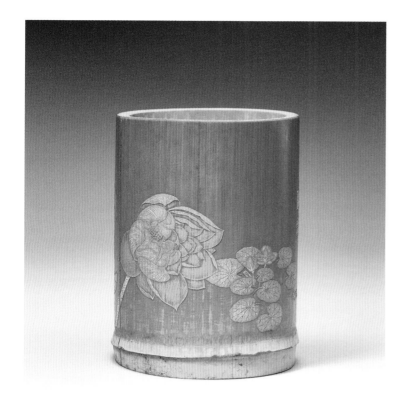

028
Bamboo brush pot

2010
Decorated with *liuqing* relief of lotus flowers and a kingfisher
from *The Hundred Flora* (anon., Song dynasty)
Carving: Chen Bin

For this item I chose another section of *The Hundred Flora*, showing lotuses beside a group of lily pads (Fig. 28.1). One lotus leaf juts up like a canopy, while the other is curled up ready to open. Set against the leaves are two flowers, one in full bloom and the other still in its bud. Between the flowers is a single lotus seed head. A kingfisher perches on its stalk, staring intently at the water, waiting for its moment to strike. In the lower third of the pot, some of the pale outer skin of the bamboo has been left on to suggest light reflecting off the water.

The way the lotuses lean to the right, stretching out over the water, reminds me of the scene in "Ode to the Lotus" by the Southern Dynasties scholar Shen Yue:

> *A gentle breeze*
> > *ruffles purple leaves,*
> *Little dewdrops*
> > *sprinkle scarlet pods.*
> *The reservoir*
> > *remains a verdant green*
> *Waiting for*
> > *my rosy light to spread.*

029
Brush pot

2005
Decorated with *Orchid* (Zheng Sixiao, Yuan dynasty)
Carving: Fu Jiasheng
Rubbing: Fu Wanli
Private collection, Hong Kong

After the fall of the Song dynasty, the loyalist painter and poet Zheng Sixiao refused to serve the Yuan regime. So strong was his aversion to his new Mongol rulers that he changed his name and became a recluse. He even adopted a soubriquet, "Sited-in-the-South", to show that he had turned his back on the northern invaders.

Orchid, the painting that decorates this brush pot, is Zheng's most famous work. Orchids are a symbol of political loyalty, and the story goes that Zheng often painted them with their roots exposed, as a metaphor for the loss of his beloved Song: everything above ground is there, but the land,

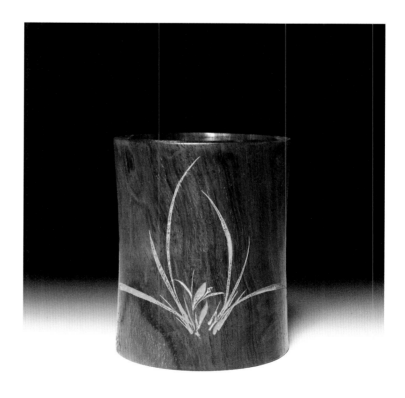

the soil, has been taken away. In this painting, no roots are visible (Fig. 29.1). Perhaps Zheng means to suggest that only those with deep roots can flourish. In his original inscription for the painting, he imagines the orchid as Fuxi, the mythical ruler of high antiquity, turning it into an emblem of his culture's survival. I think the poem is worth including in full:

> Once, I bowed my reverent head
> and asked you, "Great Fuxi,
> Why, I pray you tell me, lord,
> can you have joined me here?"
> Then, before I painted you,
> I drew a breath and caught
> Your drifting fragrance on the air:
> the scent of times gone by.

One of the seals affixed to the painting carries a meditative poem that echoes Zheng's tone in the inscription:

> What is sought will not be gained.
> Seek not: it may be granted.
> Old eyes take a broader view,
> A pure breeze down the ages.

Zheng's original painting is now held in the Osaka City Museum of Fine Arts. A 19th or 20th century copy also survives in the Freer Gallery of Art in Washington, D.C.

Zheng Sixiao—鄭思肖 (1241–1318). Zheng chose the name Sixiao as a pun on the graphically similar *si Zhao* (思趙, "thinking of the Zhao", referring to the name of the Song imperial house). Below, his soubriquet, *suonan* (所南), plays on the Chinese expression for serving a ruler, "facing north" (*beixiang* 北向, after the orientation of the traditional palace hall, with the throne at the northern end). His painting is sometimes called *Ink Orchid* after its usual Chinese title, *Molan tu* (墨蘭圖).

Fuxi—伏羲. The poem names him by his alternate title, Xi the August (*Xi huang* 義皇).

Then, before I painted you...times gone by—the final couplet can also plausibly be read as describing Zheng standing "before" his own painting and catching the orchid's scent from it. This reading intensifies the sense of spatial rupture created by the first couplet, which invites the reader to imagine Zheng bowing his head to a ruler seated above him before abruptly substituting a picture of him lowering his head to a flower on the ground. Alternatively, the final couplet can also be read as suggesting, not that Zheng smells the orchid from the painting, but that painting cannot adequately capture this quality of the flower: that the scent, like the Song, is lost. The difficulty of parsing the poem, which refuses to resolve itself into a single, definite shape, puts the reader in the position of Zheng himself: confounded, rootless in the face of something he cannot comprehend.

Your drifting fragrance—as well as political loyalty, the orchid's delicate scent made it a symbol of, among other things, refinement and moral rectitude.

A pure breeze—*qingfeng* (清風), a standard metaphor for integrity and honesty. The quatrain continues the complex layering of the inscription, reading differently depending on what the subject is taken to be. If "what is sought" is Zheng's obedience to the Yuan state, the poem takes on a thunderous tone, furiously asserting the painter's moral purity in the face of political upheaval. Alternatively, "what is sought" is a return to Song rule, in which case the text takes on a more meditative quality, as the speaker accepts that the old world cannot be restored by force of his will.

030
Zitan brush pot

2013
Decorated with *Orchid* (Pu Ru, 1896–1963)
Carving: Fu Jiasheng
Rubbing: Fu Wanli

From a 13th-century orchid, we now turn to a more recent example. Pu Ru, the Manchu noble who sold the "Letter on Recovery" to Zhang Boju (see item 8), was among the most accomplished poets, calligraphers, and painters of his age. Art by members of the Qing imperial lineage often has a particular character: a kind of ease, a freedom from care and inhibition that one sees nowhere else. Pu's work epitomises this trait.

The piece that decorates this small *zitan* brush pot, a scroll of an orchid with an accompanying poem, fits so perfectly that it could practically have been made to measure. I commissioned the pot after being given a facsimile of it by Sa Benjie (Fig. 30.1). Pu's poem at the start of the scroll is especially lovely:

> An orchid is transplanted here,
> its roots washed clean and fair,
> Growing towards the thin-aired sky
> to walk with jade-skinned nymphs.

Fu Jiasheng carved most of the decoration in intaglio, but for the orchid petals he switched to a mixture of intaglio and sunk relief – that is, raised areas within the intaglio sections. This new method required meticulous attention to the layering and orientation of the petals in Pu Ru's painting. With little room for adjustment as he worked, Fu needed to

have the placement of every petal clear in his mind before he began to carve.

the Manchu noble—Pu Ru was a cousin of the last Qing emperor Puyi (溥儀). In common with Qi Gong and a number of other members of the imperial house, Pu switched to a Chinese-style name following the collapse of the Manchu dynasty, dropping his royal clan name (Aisin-Gioro). He is sometimes also referred to by his Chinese courtesy name, Pu Xinyu (溥心畬), or simply as Puru, his original Manchu forename. See also notes to item 8.

Sa Benjie—薩本介 (1948–2019). Painter, calligrapher, and collector from a prominent family in Fujian province.

nymphs—the Chinese term is *yuren* (玉人), "a person fashioned from jade", indicating either a beautiful woman or an immortal.

sunk relief—relief decoration executed in a recessed area, so that the raised parts of the composition sit level with or below the surrounding surface. Here the usual Chinese term for this technique, *xiandi ke* 陷地刻 ("carving in recessions"), is replaced by the rarer term *yinzhong dai yang* 陰中帶陽, ("relief-in-intaglio"). Use of this method represented a new departure for Fu, who had previously worked in simple intaglio and relief.

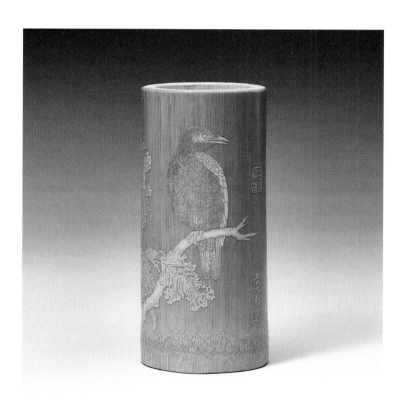

<div align="center">

031

Bamboo brush pot

2011
Decorated with *Autumn Tree with Crested Myna*
(anon., Song dynasty)
Carving: Bo Yuntian
Rubbing: Fu Wanli

</div>

The anonymous Song painting that decorates this brush pot depicts a crested myna on a bare branch, looking over its shoulder with a lively expression. Beside it, on another branch, seven leaves begin to wither as autumn sets in (Figs 31.1).

Like parrots, many myna species can learn to talk, and this ability features in a thought-provoking tale by the Ming writer Zhuang Yuanchen, from his collection *Master Gather-hemp*:

> *In the South, where the crested myna comes from, the locals catch them and train their voices. Given long enough, they can imitate human speech, but never more than a few sounds. So, all their lives, this is all they ever sing: a few sounds.*
>
> *A cicada was chirping in a courtyard, and a myna heard it and laughed at it. The cicada said to the bird, "You can talk like a human very nicely, but all your words never seem to be saying anything. Better to be like me, chirping out exactly what I mean." The bird hung its head in shame, and it never imitated humans again.*

Something to think about, perhaps, as you look at this brush pot.

Like parrots…learn to talk—the Mandarin term for the crested myna, *bage* (八哥), likely derives from *babbaḡā*, the Arabic word for parrot.

Zhuang Yuanchen—莊元臣 (1560–1609). The child of a gentry family in the prosperous Jiangnan region, Zhuang passed the metropolitan examinations towards the end of his life and enjoyed a brief official career. His soubriquet, Master Gather-hemp (*Shujuzi* 叔苴子), comes from a line from "The Seventh Month" (*qi yue* 七月), an account of the changing seasons from the canonical *Book of Songs* (see notes to item 33): "In the ninth month, we gather the hemp seeds" (九月叔苴). The poem's sense that everything should be done in its proper time and order tallies neatly with the tale quoted here, which warns the reader not to try to be something that they are not.

<div align="center">

032

Bamboo brush pot

2011
Decorated with *liuqing* relief of
Spider's Web with Grasping Gibbon (anon., Song dynasty)
Carving: Bo Yuntian
Rubbing: Fu Wanli

</div>

A spider in its web might seem an odd subject for a painting, but these little creatures can have an outsized importance. It is said that, in ancient times, Fuxi was the first person to learn to make nets to catch fish and animals. It was

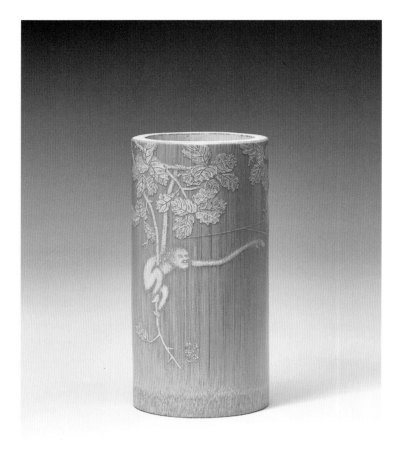

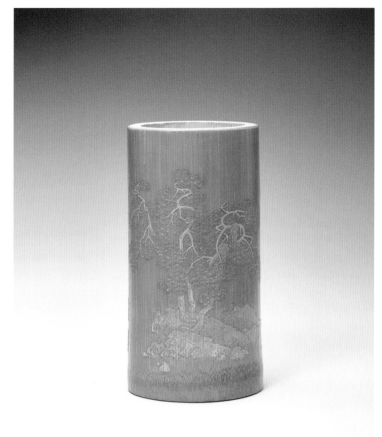

a moment that revolutionised daily life, and it was watching spiders at work that gave him the idea. Another famous tale involves Gong She, an advisor from the state of Chu, who served during the late Western Han dynasty. The story goes that Gong went with the king of Chu to an audience with the emperor. In the capital, they stayed at the Weiyang Palace, and during their visit Gong spotted a spider's web in one of its rooms. Suddenly, he was struck by a thought: that government service, like the spider's web, was a trap, and he was caught in it. He resigned at once and went home to Chu. Looking at the spider's web had opened up a new path for him.

The anonymous Song artist whose work decorates this brush pot looked at a spider's web and had a different thought: that he had seen something worth painting. It may not have been a thought that changed the world, but no-one who sees the picture – the delicate web, the gibbon reaching its long arms out towards it – could argue against him (Fig. 29.1). I asked Bo Yuntian to turn the image into a *liuqing* relief, and this pot was the result. Every detail is outstandingly executed, from the fine hairs of the gibbon's coat to the individual threads of web and the elegant, cross-legged spider at their centre. Even the original *liuqing* master, Zhang Xihuang, could not have done better.

Fuxi—see notes to item 29.

Gong She—龔舍 (c. 60–7 BCE). Gong was famous for his repeated retirements from official service, usually on health grounds. The Weiyang Palace (*Weiyang gong* 未央宮) was an imperial residence in the capital at Chang'an (present-day Xi'an).

Zhang Xihuang—張希黃. Late Ming or early Qing master carver.

033
Bamboo brush pot

2011
Decorated with *liuqing* relief of three pine trees from "Winter Scene" (Four Scenes, Liu Songnian, Song dynasty)
Carving: Bo Yuntian
Rubbing: Fu Wanli

This brush pot, carved by Bo Yuntian, is decorated with three spectacular pine trees from Liu Songnian's depiction of the four seasons (Fig. 33.1). Pines feature in thousands of Chinese poems and artworks, but when I look at this pot there are a few special trees that come to mind.

Pines held a special place in Wang Shixiang's heart. Before he and Yuan Quanyou married in 1945, Wang gave her a round box made from *hongmu* wood and bottle gourd and filled with red beans (a common love token in China). On the lid was a small pyrography picture of a pine tree in a landscape. Years later, Wang took a trip to the Huang Mountains, a range in eastern China famous for its sharp peaks and rugged, twisting pines. When he came back, he was carrying a fine bonsai pine that looked like it could have come straight out of a Wen Zhengming painting. He had to buy an extra seat on the bus to get it home. From then on there were two pines in Wang and Yuan's home, and that was how it got its name, "Paired Pines House": a nod not just to Wang and Yuan's marriage but to the two little trees they kept.

As well as being a calligrapher and poet, Wang also painted occasionally. By the 1990s he had largely given this

up, but I remember asking him if he would consider picking up his brush again to paint me something. I still think fondly of the subject I suggested to tempt him out of retirement. I was a junior doctor at the time, and I had picked out a poem by Jia Dao that combined my career path with his beloved pine trees:

> Beneath a pine, I asked for you. Your lad
> Replied, "The master's gone. He's picking herbals
> Somewhere in these hills, he is. It's just
> That, with the clouds this thick, I'm not sure where".

Sadly, it never happened: Wang was out of practice as a painter, and most of his time was taken up with writing in any case. I still think that the poem would have made a beautiful painting.

To understand why pines became such a frequent subject in Chinese art, it helps to visit some of the most impressive real-life examples. There is the famous Marquis of the Shade (Fig. 33.2), a Manchurian red pine planted in the Tuancheng Fortress in Beijing during the Jin dynasty, and its companion, General White-robes, a lacebark pine from the same period (Fig. 33.3). I remember seeing them on a visit to the fortress and being struck, not just by their immense age – both are almost a thousand years old – but by how large they are, with thick trunks and branches that tower over the nearby buildings.

It is the sound of pines that marks them out as much as their looks. There is a well-known story that Tao Hongjing, the Daoist polymath of the fifth and sixth centuries, was obsessed with the way pine trees seem to sing in the wind. His biography in the *History of the Southern Dynasties* tells of how "his courtyards were full of pine trees, and whenever he heard their sound, he was filled with joy". I never properly understood Tao's fixation until I visited the Jietai Temple at Ma'anshan, west of Beijing. The temple grounds are home to two even older trees than the ones at the Tuancheng Fortress. From under a ginkgo in the temple's peony garden, I could see them both: the younger of the pair, the Liao dynasty Lying Dragon pine (which has its own memorial stele, written by Prince Gong, who ruled China as regent in the 1860s); and at the side of the gate to the Lesser Court, the lacebark Nine Dragons pine, planted as far back as the Tang. The lightest breath of wind seemed to set their branches singing. Like Tao Hongjing, I was transfixed.

The trees on my brush pot are depicted in the depths of winter. (In Liu Songnian's original painting, you can clearly see the snow on the ground around them). The pine's refusal to shed its leaves in winter has made it a fertile vehicle for metaphor over the centuries. Two examples from early Chinese literature spring to mind for me. There is the pine as a symbol of strength in adversity, seen in the aphorism from the Analects that "it is only when winter comes that you realise the pine and cypress are the last to drop their leaves". And lastly, from "Heavenly Protection", a poem from the "Lesser Hymns" section of the *Book of Songs*, the pine as a token of good wishes and favourable prayers:

> Heaven protect and establish you
> To flourish in everything.

> *Like mountains, like hills,*
> *Like ridges, like knolls,*
> *Like rivers that run ever on,*
> *May you increase in everything.*
> …
> *Like the moon waxing full,*
> *Like the sun as it rises,*
> *Like the age of the southern hills,*
> *May you not fade or fall:*
> *Like the flourishing cypress and pine,*
> *May you pass ever on, ever on.*

red beans—hongdou (紅豆). In everyday speech, the term indicates the edible adzuki bean, but in the context of romance it is a catch-all, covering several kinds of red seed used to symbolise faithfulness. (In contemporary usage, the jequirity or rosary pea is a common referent.) The association derives from a story in which a wife waiting for her warrior husband to return home cried for him in blood, which fell to the earth and grew into a tree with blood-red beans.

the Huang Mountains—Huangshan (= Yellow Mountains, 黃山), an important mountain range in southern Anhui province, the subject of a vast catalogue of Chinese poetry and painting.

Wen Zhengming—文徵明 (1470–1599). Traditionally ranked as one of the Four Masters of the Ming Dynasty (*Ming si jia* 明四家), Wen was among the most esteemed painters of his age.

Paired Pines House—see notes to item 10.

Jia Dao—賈島 (779–843). Buddhist monk, official, and poet. The poem is his "On Searching for a Hermit and Not Finding Him" ("Xun yinzhe bu yu" 尋隱者不遇).

Tao Hongjing—陶弘景 (456–536). Founder of the Highest Clarity (*Shangqing* 上清) school of Daoism. The account of his life in the *History of the Southern Dynasties* (*Nan shi* 南史) comes from the section of "Biographies of Hermits" ("Yinyi zhuan" 隱逸傳).

Prince Gong—1833–98 (= Prince Kung). Referring to the Manchu prince Yixin (奕訢), one of the most influential members of the imperial household in the second half of the 19th century, who served as regent for four years from 1861 to 1865. The prince spent an extended period at the Jietai Temple (*Jietai si* 戒臺寺) towards the end of his career, during a period in disgrace following the Sino-French War of 1884–5. Above, Ma'anshan, the location of the temple, is 馬鞍山 ("Saddle Hill").

it is only when…drop their leaves—歲寒而後知松柏之後凋也. From the "Zihan" chapter, usually taken as a metaphor for the qualities of the ideal gentleman, who is at his best in difficult circumstances.

The Book of Songs—the *Shijing* (詩經), sometimes known as the *Book of Odes* or *Classic of Poetry*. A canonical compilation of 305 songs, drawing on a larger oral tradition dating back to the late second and early first millennia BCE. The text, which remains the earliest surviving collection of Chinese poetry, consists of three sections: the "Airs of the States" (*Guofeng* 國風), the "Greater and Lesser Hymns" (*Daya* 大雅 and *Xiaoya* 小雅) and the "Eulogies" (*Song* 頌). The song quoted here is "Tianbao" (天保).

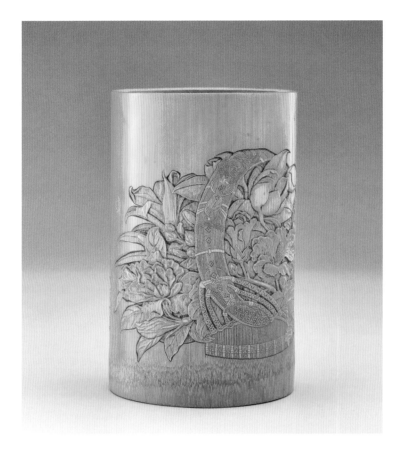

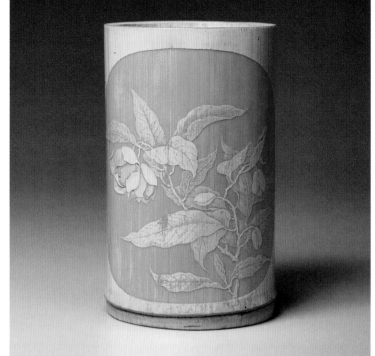

034
Bamboo brush pot

2012
Decorated with sunk relief of *Basket of Flowers*
(Li Song, Song dynasty)
Carving: Bo Yuntian
Rubbing: Fu Wanli

035
Bamboo brush pot

2012
Decorated with *liuqing* relief of *Coconut Magnolia*
(anon., Southern Song dynasty)
Carving: Zhu Xiaohua

Li Song's *Basket of Flowers* is filled with everything from coconut magnolia and daylily to pomegranate, okra, and cape jasmine (Fig. 34.1). In the carved version on this brush pot, Bo Yuntian renders the flowers in sunk relief and the basket itself in *liuqing*. The decoration is marred by a small crack in the pot's surface, but it is still an extraordinary feat of carving. The remarkable depth that Bo achieves makes the piece look almost like lacquerware (compare this with Fig. 34.2). It would not look out of place next to the work of the finest lacquer masters: a Zhang Cheng or Yang Mao; or even something from the Guoyuan Workshop, the early Ming imperial lacquer works.

Li Song—李嵩 (fl. 1190–1230). Li originally trained as a carpenter before turning to painting.
Zhang Cheng...Yang Mao...Guoyuan Workshop—Zhang (張成) and Yang (楊茂), both active in the 1300s under the Yuan, were among the most celebrated lacquer artists of their era. The Guoyuan Workshop (guoyuanchang 果園廠) in Beijing was headed by Zhang's son Zhang Degang (張德剛).

The coconut magnolia (*Magnolia coco*), a lovely plant with sweet smelling flowers and thin, leafy branches, is grown widely in the belt of provinces that runs from Yunnan to Zhejiang on China's south coast. It is a popular subject in Song painting, and the example that decorates this brush pot, an anonymous work held by the Palace Museum in Beijing, is particularly famous (Fig. 35.1).

In fact, there are more coconut magnolias in the Song canon than is generally realised, since they are often confused with other plants. I have seen a few cases of coconut magnolias in paintings being incorrectly labelled as Figs This confusion in naming persists in more recent works. The word for the coconut magnolia in Chinese is *yehehua*, 夜合花, "the night-closer", but in a 1914 painting, Jin Beilou refers to it by a homonym, 夜荷花, the "night-lotus". In his inscription, he describes having seen this alternative name used by traders at a local market.

My first encounter with a genuine coconut magnolia came many years ago, when the late George Ho Cho-chi, the founder of Commercial Radio Hong Kong, gave a potted coconut magnolia to me. In 2014, two years after this brush pot was made, his niece Ho Min-kwan kindly allowed me to transplant a few coconut magnolias from Ho Tung Gardens,

the old family plot on the Peak. They looked like they could have come straight out of a Song painting.

The picture on this pot was originally made as decoration for a silk fan. To preserve the fan shape, I asked Zhu Xiaohua to set his copy within a round panel on one side of the pot. The decoration is executed in *liuqing* relief, with deeper cuts in the flowers to give them added dimension.

Jin Beilou—see notes to item 1. Wang Shixiang discusses the painting in item 6.4 of *Compendium of a Few Old Things* (see notes to items 5 and 6).

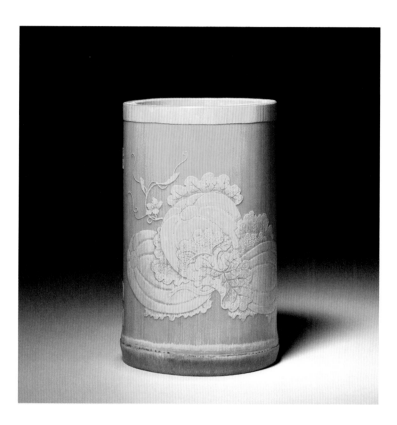

036
Bamboo brush pot

2012
Decorated with *liuqing* relief of *Autumn Melon*
(anon., Song dynasty)
Carving: Zhu Xiaohua

There were several other paintings of melons that I could have chosen to decorate this brush pot: a second work of the same title, Qian Xuan's *Autumn Melon*, springs to mind, as does the anonymous Song *Grasshopper and Melon*. However, both these works feature only one fruit, and I was worried that, if copied onto a brush pot, neither would have enough variety to hold the viewer's interest. The painting I eventually chose depicts three melons, along with their leaves and flowers. The main movement of the composition is from right to left, making it perfect for a brush pot (Fig. 36.1).

All three melons grow from the same runner, a nod to the expression used to wish someone many children and grandchildren, "many gourds from a single vine".

When I asked Zhu Xiaohua to carve the pot, I suggested that he use *liuqing* relief for the melons, the flowers, and the vines, but add elements of sunk relief to the leaves. I hoped that this approach, inspired by a Qing brush pot in the Shanghai Museum, would allow the arrangement of the leaves to come through more clearly. I also asked Zhu to add a sunken double outline along the edges of the vines and the melons to help bring these out.

The original painting was part of the imperial collections in the 18th century, and it carries six seals dating back to that time: "examined with discernment in the Hall of the Three Rarities", "fit for sons and grandsons", "the precious collection from the Stone Moat", "a treasure examined by the Qianlong Emperor", "examined and appreciated by the Qianlong Emperor", and "a treasure stored for examination in the Great Hall of Cultivating the Heart". The first three of these are retained in the carved version and can be seen to the immediate left of the melons.

Autumn Melon...Grasshopper and Melon—respectively *Qiugua tu* (秋瓜圖) and *Caochong guashi tu* (草蟲瓜實圖). For Qian Xuan, see notes to item 8.

many gourds from a single vine—*guadie mianmian* (瓜瓞緜緜). Originally a line from "Mian" (緜), a poem from the "Greater Hymns" section of the *Book of Songs*. For the *Songs*, see notes to item 33.

a Qing brush pot in the Shanghai Museum—the "*Autumn Cabbage* brush pot" (*Qiusong tu bitong* 秋菘圖筆筒), an important sunk relief work by Feng Ding (封鼎, dates unknown).

six seals—all associated with the Qianlong Emperor (r. 1736– 1795). The Great Hall of Cultivating the Heart (*Yangxin dian* 養心殿) in the northern section of the Forbidden City was home to part of the imperial collection; the Hall of the Three Rarities (*Sanxi tang* 三希堂), on the western side of the Great Hall, housed important works of calligraphy. The second seal, "Fit for sons and grandsons" (*yi zisun* 宜子孫), recalls the desire for numerous descendants, which the gourd symbolised. The third, "the precious collection from the Stone Moat" (*Shiqu baoji* 石渠寶笈), marks the painting as part of the imperial holdings.

037
Zitan brush pot

2015
Decorated with *Bamboo and Chrysanthemum*
(Chen Hongshou, Ming dynasty)
Carving: Fu Jiasheng
Rubbing: Fu Wanli

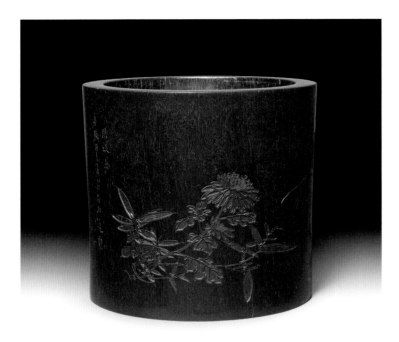

I have always loved Chen Hongshou's paintings. He was a wonderfully self-confident artist, always following his own path and never hewing to convention.

Bamboo and Chrysanthemum, the work that decorates this item, has always struck me as particularly suitable for carving. Nevertheless, this was a painstaking piece to create, and Fu Jiasheng spent many months planning his approach before he began work. The original painting was too tall to fit on a brush pot, so, in the carved version, the butterfly has been shifted slightly down and to the right.

Chen Hongshou—see notes to item 25.

038
Bamboo brush pot

2012
Decorated with *liuqing* relief of *Ginkgo and Chestnut*
(Yun Shouping, Qing dynasty)
Carving: Bo Yuntian
Rubbing: Fu Wanli

The picture that decorates this item, a wonderfully life-like sketch of two tree branches, would not look out of place in a book of botanical illustrations. Like Liu Songnian's pines, it stirs fond memories of trees I have seen.

The ginkgo, sometimes called the duck's-foot tree after the shape of its leaves, is a living fossil. The last survivors of a long-extinct family, ginkgoes can live to a remarkable age. The Tanzhe Temple in Beijing is home to a particularly notable example, the "Emperor Tree", which began life as a sapling under the Liao dynasty. Now, a millennium later,

it towers over the temple buildings, as it did when I visited a few years ago (Fig. 38.1). It used to be said that every time a new emperor ascended to the throne, another branch grew from the tree's base – hence its title, which was officially bestowed upon it by the Qianlong Emperor during the 18th century. Despite its imperial pedigree, however, there is one ginkgo to which it must give way: a tree in the courtyard of an unassuming primary school in Juge Manor, a small town in Miyun County, north-east of Beijing. Planted during the Tang dynasty, when the site was a temple, that ginkgo has witnessed over 1,300 years of change and upheaval.

When I think of chestnuts, there is no single tree that comes to mind. Instead, I remember a whole forest. One summer a few years ago, I visited the Yinshan Pagodas in the hills north of Beijing. When I arrived, early in the morning, the ground was still wet with dew. Behind the pagodas, chestnuts blanketed the slopes, their branches bristling with spiny fruit (Fig. 38.2). It was a beautiful scene. There is a line from the Book of Songs that goes:

> The plants on the mountain are fair:
> The plum and the chestnut they are.

It could have been written for those tree-clad hills.

The alert reader may notice that Yun Shouping's painting has been turned through 180° on my brush pot (compare Fig. 38.3). To me, the change makes it feel like an entirely new picture, and I like to think Yun would have approved. His words in the painting's inscription add to my confidence:

> For myself, I will water the flowers in the southern fields and revel in the moss and grass. I will take out my brush and grind my inks, and thus I will sing of my joy, believing it is in my gift to create and to transform.

This brush pot, beautifully carved by Bo Yuntian, is my own small act of creation-by-transformation.

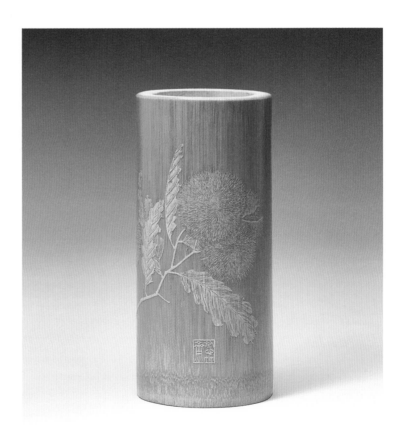

the *duck's-foot tree*—the name holds in both English and Chinese, in which the ginkgo (*yinxing* 銀杏, "the silver apricot") is sometimes called *yajiaozi* (鴨腳子).

Juge Manor...Miyun County—respectively Juge zhuang (巨各莊) and Miyun xian (密雲縣). Before being converted into the Tangzi Primary School (*Tangzi xiaoxue* 塘子小學) under the People's Republic, the site was home to the Xiangyan Temple (*Xiangyan si* 香岩寺). The tree has in fact also outlasted the primary school, which moved to new premises in 2009.

Yinshan Pagodas—referring to the Yinshan Pagoda Forest (*Yinshan talin* 銀山塔林) in Beijing's Changping district (*Changping qu* 昌平區).

a line from the Book of Songs—the quote is from "The Fourth Month" (*Si yue* 四月), a poem from the "Lesser Odes" section.

Yun Shouping—惲壽平 (1633–90), also known as Yun Nantian (惲南田). The inscription's reference to "the southern fields" (also *nantian* 南田) plays on this soubriquet.

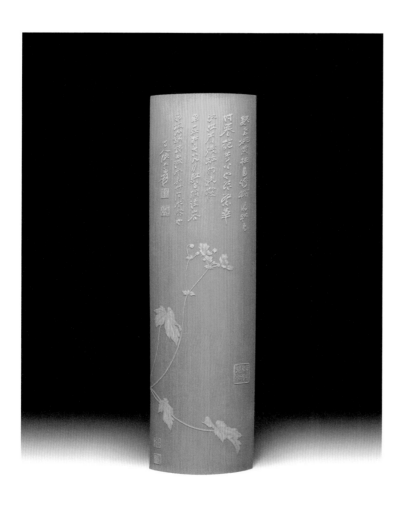

039
Bamboo wrist rest

2011

Decorated with *liuqing* relief of *Chinese Anemone*
(Zhang Daqian, 1899–1983)
Carving: Chen Bin
Rubbing: Fu Wanli

Zhang Daqian was perhaps the most important Chinese artist of the 20th century. The painting on this item (Fig. 39.1) is one of several he made of anemones at Mount Hua, the great mountain in Shaanxi province. This one found its way into Tung Chiao's collection, and I remember seeing it hanging in his apartment in the 2000s. I am grateful to Tung for allowing me to commission a carved version from Chen Bin, the former apprentice whom I met in Jiading in 2009.

To fit the shape of the wrist rest, I decided to move Zhang's original inscription from the right of the painting to the top and to replace it with one of Tung's seals: "Tung Chiao is obsessed with that good, old-fashioned moonlight". In Chinese, the anemones in Zhang's painting are referred to as "autumn peonies", and the inscription compares them to true peonies:

> *Wei the Mauve and Yao the Yellow*
> *need no empty praise:*
> *Fair autumns are their gift to us,*
> *their offering, winter blooms.*
> *Their fragrant hearts begrudge the way*
> *the other flowers wilt,*
> *And so they face the evening sun,*
> *bedecked in faded rouge.*
> *At Mount Hua, the anemones bloom in August or September, spreading over hill and valley like a fine, brocade cloak. They are the equal even of the great tree peony by the lake in the bamboo forest of Yongjia.*
> *– Zhang Daqian of Sichuan*

Anemones are another example of a plant that originated in China but has now spread far and wide. I have seen them in many parts of the world, from Oxford in England to Sydney on the other side of the globe. The best I have seen in the last few years have been in London: truly an international flower.

Zhang Daqian—see notes to item 12.

Mount Hua—Huashan (華山). The westernmost of the Five Great Peaks (for which see notes to item 12).

Tung Chiao is obsessed with that good, old-fashioned moonlight—translating 董橋癡戀舊時月色. "Old-fashioned moonlight" or "the moonlight of olden times" (*jiushi yuese* 舊時月色) refers, perhaps sardonically, to a poem of that name by Jiang Kui (姜夔 1155–1221), in which an aging speaker picks plum blossom and plays music in the company of a beautiful woman. An appropriate seal for a literary man in his later years.

autumn peonies—the Chinese term is *qiu mudan* (秋牡丹).

Wei the Mauve and Yao the Yellow—*Wei zi Yao huang* (魏紫姚黃). Two varieties of peony described in the writings of the Song scholar Ouyang Xiu (see notes to the Author's Preface) and others. Both were named for the families that originally cultivated them.

the lakeside bamboo forest of Yongjia—the Yongjia zhulin (永嘉竹林) in modern-day Zhejiang province. It is now a popular tourist destination.

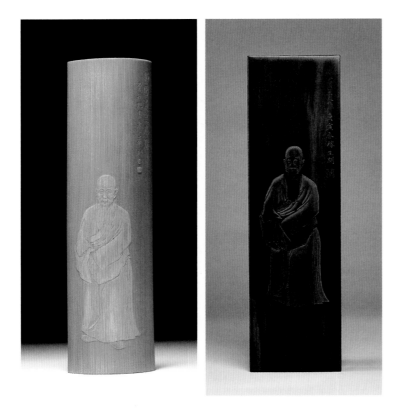

040

Bamboo wrist rest

2007
Decorated with *liuqing* relief portrait of Yuan Mei
(Fei Danxu after Zhou Dian, Qing dynasty)
Carving: Zhu Xiaohua
Rubbing: Fu Wanli

Ebony scroll weight

2010
Decorated with a portrait of Yuan Mei
(Fei Danxu after Zhou Dian, Qing dynasty)
Carving: Fu Jiasheng
Rubbing: Fu Wanli

The writer, official, and gastronome Yuan Mei, whose portrait decorates these two items, was a towering figure on the 18th century literary scene. He passed the civil service examinations in 1739 and went on to become one of the most famous poets of his day. Besides his writings, he was also notable as a designer. His soubriquet, "Mr Accommodation Garden", comes from his estate at Little Granary Hill in Nanjing, which he remodelled completely after acquiring the land in the 1740s.

Any reader of Chinese will have tales of their encounters with Yuan Mei, and I am no exception. In 2004, a few years before these items were made, my work took me from Hong Kong to Germany, where I was to study new surgical techniques at Leipzig University Hospital. Leipzig is famous for its history as a centre of printing and publishing and for the generations of talent produced by its university. Many of

the great musicians – Bach, Schumann, Mendelsohn, Mahler – lived and worked there or, like Wagner, were born in the city. Just after the First World War, the writer, translator, and inventor Lin Yutang studied for his doctorate in linguistics in Leipzig, the first step in a glittering career. It was during my time in the city that I bought one of the most beloved books in my library: a copy of Yuan's wonderfully stylish *Poetry Notes from Accommodation Garden*, which I acquired at a local antiquarian bookshop.

The portrait of Yuan that appears on these two items, originally painted by Zhou Dian with title calligraphy by Sun Xingyan, is now known through a 19th-century copy by Fei Danxu (Fig. 40.4). This was previously part of the Er Zhi Xuan Collection, owned by Harold Wong, a member of the Oriental Ceramic Society of Hong Kong. In the autumn of 2007, when I commissioned the wrist rest, the first item of the pair, I sent a reproduction to Zhu Xiaohua, who worked from it to create the carving (Fig. 40.1). The rest took Zhu a month to complete, and the first person to see it when it was finished was Wang Shixiang. He liked it so much that he commissioned a blue cloth box for it with a label written in his own hand, a gift for which I remain deeply grateful (Fig. 40.3).

Although the Zhou Dian–Fei Danxu portrait is full-length, it is the face that draws the viewer's attention, and here Zhu Xiaohua is at his best. The lines on Yuan's forehead and at the corners of his eyes, the mark of his age, are perfectly captured in the carving. The *coup de grace* is the eyes themselves, which Zhu renders in intaglio. They are so lifelike that, looking into them, one almost expects to see Yuan blink.

In spring 2008, I had a chance to see the original portrait in person (Fig. 40.4). Along with other paintings from the Er Zhi Xuan Collection, it was being auctioned by China Guardian in Beijing, and I invited Zhu Xiaohua to view it with me. Standing in front of it drove home to me just how well bamboo carving can capture the form and spirit of the subject. Two years later, I decided to commission another version of the portrait from Fu Jiasheng, this time on an ebony scroll weight. I asked him to switch the carving to intaglio throughout: another example of "changing *yang* into *yin*" (Fig. 40.5).

Yuan Mei—袁枚 (1716–98). Yuan produced a large and varied output, spanning poetry and criticism through to supernatural stories and gastronomical works. He was also noted for his interest in women's writing, and his literary circle included numerous women poets.

Little Granary Hill—Xiaocang shan (小倉山), a low ridge to the east of Qingliang Hill (*Qingliang shan* 清涼山) in the centre of the city.

Lin Yutang—林語堂 (1895–1976). Noted among other things for coining the modern Chinese word for "humour", Lin wrote widely in both Chinese and English.

Poetry Notes from Accommodation Garden—Yuan's *Suiyuan shihua* (隨園詩話).

Zhou Dian...Sun Xingyan...Fei Danxu—respectively 周典 (fl. mid-late 18th century); 孫星衍 (1753–1818); and 費丹旭 (1801–50). Sun was a much-admired collector and scholar of antiquity.

the Er Zhi Xuan Collection—an important Hong Kong collection. Its owner, Harold Wong, is known to be an accomplished painter as well as a collector, hence the studio name from which it derives: "The Two-Knowledge Gallery (*Er zhi xuan* 二知軒).

changing yang into yin—see item 2.

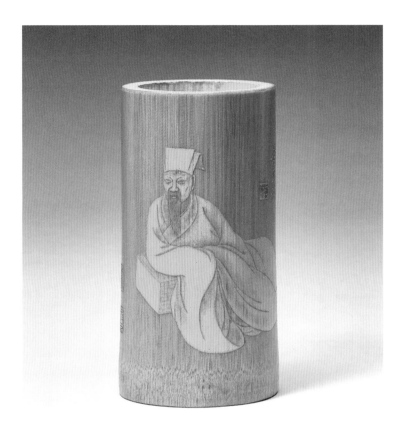

041
Bamboo brush pot

2008
Decorated with *liuqing* portrait of Ge Yilong
(Zeng Jing, Ming dynasty)
Carving: Bo Yuntian
Rubbing: Fu Wanli

I commissioned this pot from Bo Yuntian during our visit to Wang Shixiang in the winter of 2007. The portrait that decorates it (Fig. 41.1) depicts Zeng Jing's contemporary Ge Yilong, also known by the courtesy name Ge Zhenfu, who famously bankrupted his family by collecting books and antiquities. The painting shows Ge seated on the ground, reclining on a book box, and glowing with contentment.

In early summer 2008, Bo Yuntian and I visited Wang Shixiang to show him the brush pot and the *Double Purity* inkstone screen, the other piece of bamboo carving that I had commissioned from Bo the previous winter (see item 25). Wang gave both items his seal of approval. Then he turned

to me and said, "You are helping push the art forward." I think everyone who commissions art dreams of contributing something to the development of their field, and here was Wang Shixiang telling me that I was succeeding in that mission. It was one of my proudest moments.

Zeng Jing—曾鯨 (c. 1566–1650). A noted portrait painter who worked in several cities along the Yangzi River.

Ge Yilong...Ge Zhenfu—葛一龍 or 葛震甫 (1567–1640). Ge's self-destructive commitment to collecting was the stuff of legend during the late empire. By the 16th century, a flourishing print and manuscript culture had emerged in China, but even famous works of literature could nevertheless be difficult to come by. As a result, the pursuit of books (a frequent obsession for the scholarly elite) could easily lead to financial ruin.

042
Bamboo cross-piece

2008
Decorated with *liuqing* relief of
Zhuge Liang Rests with His Head Propped Up
(Emperor Xuanzong, Ming dynasty)
Carving: Zhu Xiaohua
Rubbing: Fu Wanli

Zhuge Liang, the legendary general of the late Han period, is best known for his appearances in the great Ming novel *Romance of the Three Kingdoms*. In one of the most famous passages, the ambitious warlord Liu Bei calls on him three times in an attempt to win him as an advisor. The details of their eventual meeting on the last of those "three visits to the thatched cottage" have been etched into the minds of generations of readers: the general in his scholar's garb with a silk kerchief and a feather fan; the warlord trying everything to secure his services. The picture on this item, painted in the early 1400s by the Ming emperor Xuanzong, shows us another Zhuge Liang altogether. Here he lies, his back propped up on a book box and with his stomach exposed, a world away from the exalted figure who will later hold audience with Liu.

Xuanzong, often known as the Xuande Emperor after the name of his reign, was an exceptionally talented artist.

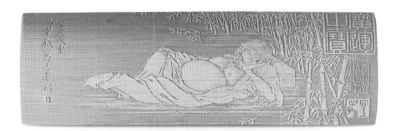

Many of his paintings survive in the Forbidden City as part of the Palace Museum's collection. Given his aesthetic sensibilities, it seems hardly surprising that some of the finest blue-and-white porcelain was produced by the imperial kilns during his reign. Xuanzong was no mere aesthete, however. At the British Museum's exhibition of Ming art in 2014, I saw several paintings of him hunting by Shang Xi, including *Pleasure Portrait of the Ming Emperor Xuanzong, Lakeside Hunting* and *On Horseback*. Successful hunts were a symbol of the emperor's military prowess, so it seems that, in addition to his feats as a man of culture, Xuanzong had a martial side as well.

Romance of the Three Kingdoms—Sanguo yanyi (三國演義), one of the so-called "Four Masterworks" of Ming literature. Traditionally attributed to the 14th-century playwright Luo Guanzhong (羅貫中, dates uncertain) but much modified in later times, the *Romance* deals with events during the collapse of the Han dynasty in the early second century. Liu Bei (劉備, 161–223) is a central figure, and his "three visits to the thatched cottage" (*san gu caolu* 三顧草廬 or more rarely *san gu maolu* 三顧茅廬) to recruit Zhuge Liang (諸葛亮, 181–234) as his strategist are a pivotal moment in the early section of the novel.

Xuanzong...the Xuande Emperor—referring to Zhu Zhanji (朱瞻基, 1399–1435), r. 1426–35. The reign name is 宣德, while Xuanzong (宣宗) is the "temple name" under which the emperor was honoured after his death.

Shang Xi—商喜, fl. mid-1400s, known for his paintings and murals. The paintings named are his *Ming Xuanzong xingle tu* (明宣宗行樂圖), *Hupan shelie tu* (湖畔射獵圖) and *Mashang tu* (馬上圖).

043
Bamboo wrist rest

2009
Decorated with *liuqing* relief portrait of Dong Qichang
(Zeng Jing, Ming dynasty)
Carving: Zhou Hansheng
Rubbing: Fu Wanli

Ebony scroll weight

2010
Decorated with a portrait of Dong Qichang in intaglio
(Zeng Jing, Ming dynasty)
Carving: Fu Jiasheng
Rubbing: Fu Wanli

The late Ming painter Zeng Jing makes a second appearance in these two items, which are decorated with a portrait he created jointly with the prominent painter and

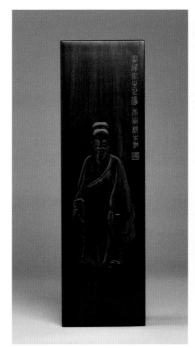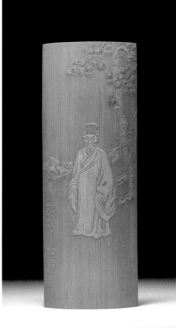

collector Xiang Shengmo (Fig. 43.1). It depicts their contemporary Dong Qichang, a giant of arts and letters in the late 16th and early 17th centuries, standing beneath a pine in his trademark outfit: a tall Jin hat and a lychee-coloured robe. A slight upward turn to Dong's mouth lends his face an ambiguous quality, reminiscent of the inscrutable expression of the *Mona Lisa* or perhaps the half smile of a Northern Wei Buddha statue.

The first item of this pair, a wrist rest by Zhou Hansheng, reproduces the portrait in *liuqing* relief. An inscription at the bottom left of the rest reads: "Carving as my forefathers did, I imitate their painting of Dong Qichang." After commissioning the rest, I asked Fu Jiasheng to carve the same portrait onto a scroll weight, this time in intaglio – another example of what Wang Shixiang called "turning *yang* into *yin*". To the right of the image, a title in seal script reads *Portrait of the Master of the Chamber of Painting and Meditation*, a reference to one of Dong's soubriquets.

It is hard to know what to make of Dong Qichang. On the one hand, few people in Chinese history can match his stature as an artist and writer on art. He was also an official of some importance, serving for a time as Minister of Rites, one of the most senior posts in the imperial government. He even earned the rare honour of a posthumous name, a title granted by the court to especially distinguished servants. So, in addition to his personal name, Qichang, his courtesy name, Xuanzai, and his main soubriquet, Sibai, he is also referred to as Dong Wenmin: Dong the Literary and Conscientious.

Yet, for all that official approbation, there are a few black marks against Dong's name which cannot be glossed over. For one thing, much of the calligraphy and painting attributed to him is not his own work, but the product of others working on his behalf. Hints of Dong's use of so-called "ghost brushes" appear in the writings of his contemporaries, and more recently Qi Gong explored the issue in depth in his essay, "On 'Ghost Brushes' in the Calligraphy and Painting of Dong Qichang".

Dong's personal conduct also seems to have left much to be desired. On one occasion, he allowed one of his sons and a servant to beat up a less powerful neighbour over a dispute. The ensuing outcry eventually led to his house being burned down by an angry mob. Two contemporary accounts of the incident – an anonymous pamphlet entitled *The Facts About Minister Dong's Seizure by the Commoners* and the second chapter of Cao Jiaju's *Of Dreams* – record a bloodthirsty chant that circulated in Susong, where Dong lived, around that time, lambasting him for ruining ordinary people's lives. Huang Miaozi quotes it in his essay "Elegance and Vulgarity Among Painters":

> *Want wood to burn? Want food to fry?*
> *Then Dong Qichang has got to die.*

Another critique of Dong shows his contemporaries were clear-eyed about the link between his art and his political career:

> *His high position now ensures*
> *his paintings garner praise,*
> *And, when he dies, that fame will keep*
> *his memory squeaky clean.*

A final note on Dong's private life comes from the Qing writer Mao Xianglin's *Records from Leftover Ink*, which includes a section, "A Story of Black and White", devoted exclusively to the subject. Mao's verdict is severe, and no-one in Dong's circle gets off lightly. I still remember the shock I felt when I first read it at university. Referring to the attack on Dong's neighbour, he writes:

> *Dong Qichang, who was from my prefecture, was the foremost writer, calligrapher, and painter of his time. All within the four seas looked to him as their lodestar. But he disdained the customs of the famous scholars and broke with every convention. He brought up his family according, not to the old ways, but to his own standards. As a result, Dong's sons rarely followed the proper rites. His second son, Dong Zuchang, had an especially violent nature, while his servant, the capable Chen Ming, was given a free hand. It is no surprise, then, that they would choose to lord it over others with a show of force.*

At the end of his essay, Mao adds:

> *When Dong Qichang was in residence in his hometown, he not only twisted friendly relations out of order; he discarded the precepts of moral conduct entirely, sowing disputes without rhyme or reason. People think he was an exemplar of fame and virtue, but I will say it directly: Dong Qichang was not a virtuous man.*

Dong Wenmin the lauded public servant and painter and Dong Qichang the man with no moral compass – it seems there really are two sides to every coin.

Xiang Shengmo—項聖謨 (1597–1658). For Zeng Jing, see notes to item 41. The painting is their undated *Portrait of Dong Qichang* (*Dong Qichang xiaoxiang* 董其昌小像).

Dong Qichang—see notes to item 8. In the second paragraph, Dong's alternative names are respectively 玄宰, 思白 and 文敏.

Jin hat…lychee-coloured robe—Jin mao li fu (晉巾荔服). The deep pink colour of the robe is more pronounced in another joint portrait of Dong by Xiang Shengmo and Zhang Qi (張琦, dates unknown), in the Shanghai Museum's 1652 *Venerable Friends* (尚友圖).

the Chamber of Painting and Meditation—huachan shi (畫禪室).

Qi Gong's essay—published in a collection of his draft works. See 啟功叢稿·論文卷.

Elegance and Vulgarity Among Painters—"Huajia de ya he su" (畫家的雅和俗), published in Huang's 2011 book, *A Branch in the Forest of the Arts* (*Yilin yi zhi* 藝林一支).

The Truth About Minister Dong…Of Dreams—respectively *Min chao Dong huan shishi* (民抄董宦實事) and *Shuomeng* (說夢). Cao Jiaju, the author of the latter, is 曹家駒 (dates unknown), a minor scholar and holder of a low-level examination degree.

Susong—蘇松. Near present-day Shanghai in the prosperous Jiangnan region.

Mao Xianglin—毛祥麟 (1812–83). *Records from Leftover Ink* is his *Moyu lu* (墨餘錄).

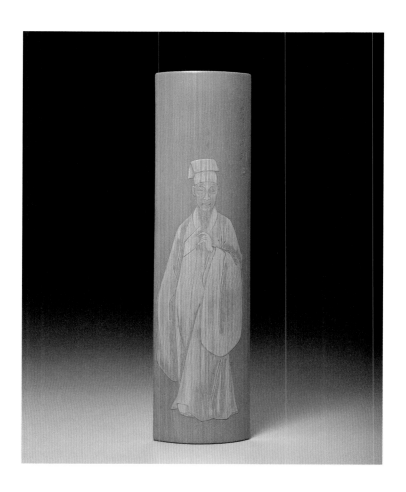

044
Bamboo wrist rest

2009
Decorated with *liuqing* relief of a portrait of Zhang Suichen
(Zeng Jing, Ming dynasty)
Carving: Zhu Xiaohua

Zhang Suichen, the man whose portrait decorates this item, is something of an inspiration for me. His life married artistic and literary achievements with medical work: he was known for his poems, but his output also included *Zhang Qingzi's Treatise on Febrile Diseases*, published under his soubriquet, which was reprinted widely during the Qing. Without Zhang's artistic and literary achievements, that book and the rest of his medical work might well have been forgotten.

This portrait of Zhang is our third and final encounter with the work of Zeng Jing. Zeng pays special attention to the details of Zhang's face (Figs. 44.1), and Zhu Xiaohua brings a similarly meticulous approach to the carved version.

Zhang Suichen—張邃辰 (1589–1668). Below, Zhang's soubriquet is 張卿子; the treatise is his *Zhang Qingzi shanghan lun* (張卿子傷寒論).

Zeng Jing—see notes to item 41.

045
Bamboo wrist rest

2010
Decorated with *liuqing* relief of *Self-Portrait*
(Ren Xiong, Qing dynasty)
Carving: Zhu Xiaohua

Ren Xiong, sometimes known by the courtesy name Ren Weichang, was a true original. He was to traditional painting what Li He, the eccentric Tang dynasty poet, was to

verse. This self-portrait, completed a year before the young Ren succumbed to illness (Fig. 45.1), was little short of revolutionary. Nothing like it had been seen before, and no-one has painted anything quite like it since. No account of Chinese painting would be complete without it.

Perhaps the most striking aspect of the *Self-Portrait* is how completely Ren departs from traditional depictions of the scholar-gentleman. The art historian Zhang Anzhi emphasises the point in his description of the painting:

> *Shaven-headed, his hat removed, Ren stares straight out, his chest and shoulders exposed beneath his cotton robe. He stands bolt upright, his hands clasped and his feet apart, looking wild but also deadly serious. There is not a trace of the refined scholar about him: this is no pensive master "picking chrysanthemums by the eastern hedge". No "raising a cup to the moon and inviting it to drink" here, no "hesitant pacing, caressing the pines". Instead, the subject of this painting looks determined and fearless: a man heading to his execution, perhaps ready to be martyred for a worthy cause. And there is something else about him too: a hint of the pugnacious outlaw, the bandit from the backwoods.*

Ren's original painting stands almost 1.8m high. Zhu Xiaohua's skill ensures that the portrait has lost none of its power, even when compressed down onto a wrist rest. When the lamplight hits the rest at just the right angle, Ren seems poised to leap off the bamboo's surface.

Ren Xiong—任熊 (1823–57, courtesy name 任渭長). Ren's short but productive artistic career is now remembered chiefly for this arresting self-portrait.

Li He—李賀 (c. 790–816). A Tang dynasty poet noted for his highly individual style.

Zhang Anzhi—張安治 (1911–91). Zhang was also a painter in his own right. The quotation is from his "Ren Xiong and his *Self-Portrait*" ("Ren Xiong yu ta de zihuaxiang" 任熊與他的自畫像, *Palace Museum Journal* 1979:2).

046
Bamboo brush pot

2012, 2022
Decorated with *Picking the Fiddlehead Ferns*
(Li Tang, Song dynasty)
Carving: Bo Yuntian
Calligraphy: Jiao Lei
Calligraphy carving: Li Zhi

When the Shang, China's first dynasty, fell to the Zhou in the 11th century BCE, it is said that the brothers Bo Yi and Shu Qi refused to submit to the usurpers. They would

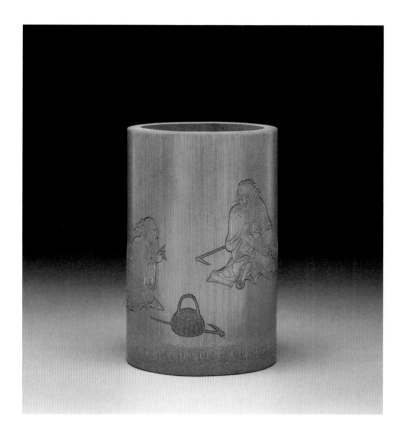

not even eat grain grown on Zhou lands, so they withdrew from the world and went to Mount Shouyang, where they survived on wild plants. The painting on this brush pot, Li Tang's *Picking the Fiddlehead Ferns*, shows them gathering food together (Fig. 46.1). In the carved version, Bo Yuntian omits the background and shows only the two solemn figures with their scythes and basket, all carved in shallow sunk relief.

The *Records of the Grand Scribe*, the great Han-dynasty history of early China, includes a biography of Bo Yi which also touches on his brother. In his conclusion, the author, Sima Qian, reflects movingly on all the upstanding characters whose names, unlike Bo's and Shu's, are lost to history. The passage can be seen at the end of Li Tang's painting, where it has been added as a postscript (Fig. 46.2):

> *Bo Yi and Shu Qi may have been worthy people, but they have only become household names because Confucius commended them. Likewise, [Confucius's disciple] Yan Yuan may have been a diligent student, but no-one would remember his good conduct were it not for his connection to the master. Is it not tragic that, if a man lives a good life in seclusion, away from watching eyes, his name will disappear without a trace, unpraised? And what is someone of mean circumstances to do if they wish to make a name for themselves by their conduct? Unless they win over some lofty scholar to their cause, their fame will never be passed down to later generations.*

Sima Qian's words are a rallying cry to preserve the memories of the good, whether they are great or not. In the art world, Hui Lai Ping, the editor-in-chief of art publisher Han Mo Xuan, has put that idea into practice by collecting the correspondence of contemporary calligraphers and painters. His archive goes back almost a century and includes stories of some of the finest people modern China has known: a clutch of modern-day Bo Yis and Shu Qis. Hui's mantra is to

"recruit hermits and promote the virtuous", and he has devoted himself to making sure that such people are not forgotten. It is laudable work, and it deserves to be widely known.

Bo Yi and his brother Shu Qi—伯夷 and 叔齊, nobles of the late Shang dynasty (c. 1600–1046 BCE). Praised repeatedly in the Confucian *Analects*, the two brothers were not only noted for their opposition to the Zhou, but they also both famously refused to take up the throne of their native kingdom, Guzhu (孤竹), after their father violated protocol by leaving the kingship to Shu Qi, the younger of the pair.

Li Tang—李唐 (c. 1050–1130). Known especially for his landscapes.

Records of the Grand Scribe—sometimes known as the *Records of the Grand Historian* or by the Chinese title *Shiji* (史記). The *Records* chronicle the history of China from the mythical rulers of antiquity down to the time of their composition in the early first century BCE. Their main author, court astrologer Sima Qian (司馬遷, 145–86 BCE), is generally regarded as the most important historian in the Chinese tradition, and the *Records* were a model for all subsequent writers in the genre.

Yan Yuan—顏淵, courtesy name Yan Hui (顏回), late 6th to early 5th century BCE. One of Confucius's most accomplished pupils.

recruit hermits and promote the virtuous—*zhao yinshi, ju yimin* (招隱士, 舉義民). A coinage of Hui's own devising, the first half quoted from the *Analects* and the second adapted from the early poetry anthology *Chuci* (楚辭, *Lyrics of Chu* or *Songs of the South*). There, the phrase is 舉逸民 ("promote recluses", also *ju yimin*). For Hui himself, see notes to item 8.

047
Bamboo wrist rest

2011
Decorated with *liuqing* relief of the Buddha Amitabha
(anon., Song or Yuan dynasty)
Carving: Zhu Xiaohua
Rubbing: Fu Wanli

We now come to two items with Buddhist subjects, both carved by Zhu Xiaohua. Portraits of buddhas occur frequently in Chinese art, running the gamut from crudeness to supreme elegance. The late Southern Song or early Yuan hanging scroll that decorates this wrist rest is one of the better examples (Fig. 47.1). The Buddha Amitabha stands atop two lotuses. With his left hand, he makes a ritual sign, the *mudra*, while his right hand hangs by his side. (An almost exact reverse of this pose appears in Fu Baoshi's depiction of Guanyin in item 48.)

This portrait is now in the Metropolitan Museum in

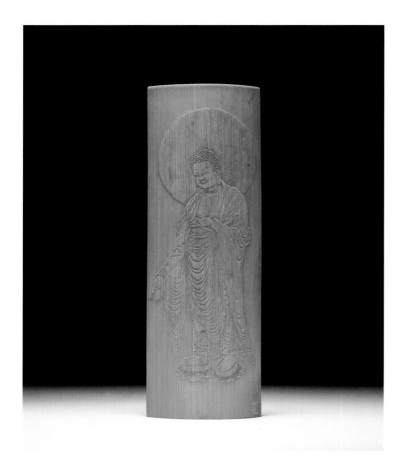

048

Bamboo wrist rest

2009
Decorated with *liuqing* relief of a portrait of the deity Guanyin
(Fu Baoshi, 1904–65)
Carving: Zhu Xiaohua
Rubbing: Fu Wanli

Fu Baoshi, the painter whose work decorates this brush pot, specialised in landscapes, but his oeuvre also includes portraits and figure paintings. His main model in these works was the painting of the early master Wu Daozi, but there are traces of other influences as well. One work I have been lucky enough to see in person, his portrait of the Buddha Amitabha, emulates the work of Zhao Mengfu, while the present painting, a portrait of the Bodhisattva Guanyin (Fig. 48.1), appears to be modelled on Tang sources. It bears a strong resemblance to the High Tang painted statues found at Dunhuang and to Zhou Fang's eighth century *Court La-*

New York, which also holds one of the most important Chinese buddha images of all, a massive, gilt bronze Northern Wei statue of the Maitreya Buddha dating to 486 CE (Fig. 47.2). Seen side by side, the line of descent from the statue to the painting is obvious. The drapery and patterns of our buddha's robes are rendered in the Cao Zhongda style, clinging to the figure's body as if they have been immersed in water. Chen Hongshou, the Ming painter whom we met in items 25 and 37, depicts clothing in a similar style in his distinctive "misshapen figures" paintings, whose subjects are shown with their features exaggerated almost beyond recognition. I suspect Chen may have based his work on portraits such as this one.

The alert reader may notice that the hair in the carved version of the portrait differs from the original. In the painting, the hair is rendered in thick, dark ink, which could not be replicated easily on bamboo. The Guanyin portrait in item 48 had posed a similar challenge when I commissioned it two years earlier, and, although Zhu Xiaohua had solved the problem with his usual skill, I was determined to make his work easier this time around. When I sent him a copy of this painting in mid-2011, I included pictures of three stone buddha heads from the Northern Dynasties – the same period as the Met's buddha statue – with my accompanying letter. The whorl pattern that Zhu adopted for the hair in this item was based on one of these.

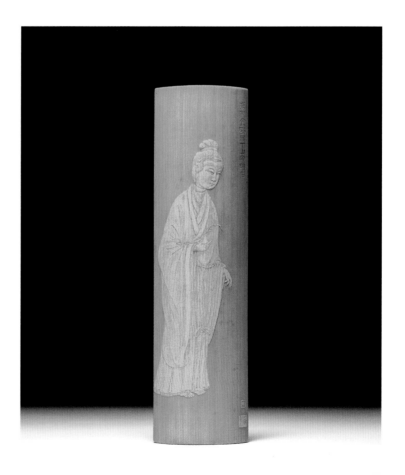

the Buddha Amitabha—the principal Buddha of the Pure Land tradition, whose chief attribute was his extraordinary longevity.
mudra—a symbolic pose, usually struck with the hands alone, common to Hinduism and Buddhism.

dies with Flowers in Their Hair.

Produced during Fu's time at Jingangpo in the suburbs of Chongqing, the Guanyin portrait is now housed in the Palace Museum in Beijing. The bodhisattva stands barefoot, wearing a necklace of pearl and jade. Her left hand hangs by her side, and in her right hand she holds the *kalasa*, the little bottle with which she is commonly depicted. As the embodiment of compassion, Guanyin is said to grieve for the state of the universe, to be moved by pity for the people and to work for the salvation of every living being. Something of that compassionate spirit is visible here in the expression of her eyes.

When I first gave Zhu Xiaohua, who decorated this wrist rest, a copy of Fu's painting in November 2008, he told me he was not sure how he would carve the hair. As in the Song dynasty portrait in item 47, Fu renders this by building up dots of thick, dark ink, presenting a challenge to the carver. On the finished object, Zhu has handled the problem with complete success. His carving is not merely a copy of the original painting, but a work of art in its own right.

Fu Baoshi may have had Tang paintings in mind when he completed his portrait, but early depictions of Guanyin differ from his own in one crucial respect: her sex. Guanyin began life as the male deity, Avalokitesvara, and it was only after Buddhism's arrival in China that he evolved into a female figure. This process can be seen in a number of early examples. A Tang silk painting of two Guanyins, brought from Dunhuang by the explorer Aurel Stein and now housed in the British Museum (Fig. 48.2), shows the bodhisattva with an androgynous face and a short, three-tufted beard. In a slightly later, Jin dynasty example, a painted clay statue in the central niche of the Guanyin Hall at Chongfu Temple in Shuozhou, Shanxi, Guanyin's facial features are identical to images of two male bodhisattvas, Manjusri and Samantabhadra, depicted on either side. Elsewhere at the same temple, a Jin dynasty mural in the Amitabha Hall depicts the Buddha accompanied by a group of supporting bodhisattvas. One of them is Guanyin, again sporting a three-tufted beard. Her face, though, is more ambiguous than either the Stein painting or even the Jin statue, since the distinctive beard is shared by all the other bodhisattvas in the mural.

Fu Baoshi—傅抱石. Republican and early PRC scholar-painter.

Wu Daozi—吳道子 (late 7th to mid-8th century). Most of Wu's oeuvre, much of it executed as murals, is lost, but by reputation alone he stands as one of the canonical greats.

Zhao Mengfu—see notes to items 60–62, 64, and 74.

the Bodhisattva Guanyin—bodhisattvas have attained Buddhahood but chosen to remain in the world rather than departing it, in order to work for the enlightenment of others.

Dunhuang—敦煌, an oasis city now part of China's western province of Gansu, at one time an important east-west trading station. A system of caves there has yielded Buddhist murals, sculptures, and a vast trove of documents from the second half of the first millennium, now held in libraries and museums across the world.

Zhou Fang—周昉 (c. 730–800). Painter and muralist. The work mentioned is his *Zanhua shinü tu* (簪花仕女圖).

Jingangpo—Fu spent the period from 1939 to 1945 at Jingangpo (金剛坡) in the suburbs of Chongqing, where he worked for a unit of the joint Communist–Nationalist Politics Division, producing anti-Japanese propaganda.

kalasa—the *kalasa* or "pure bottle" (*jingping* 淨瓶) is a ritual vessel closely associated with Guanyin.

Manjusri and Samantabhadra—two Buddhist figures linked to meditation and the attainment of wisdom.

supporting bodhisattvas—depictions of true buddhas often show them accompanied by two or more "supporting bodhisattvas" (*xieshi pusa* 脅侍菩薩), usually standing on each side.

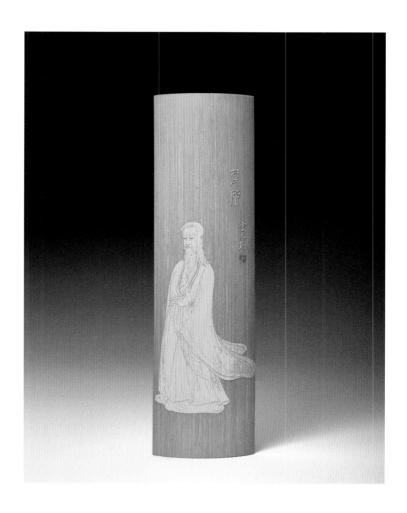

049

Bamboo wrist rest

2008
Decorated with *liuqing* relief of a portrait of Qu Yuan
(Fu Baoshi, 1904–65)
Carving: Bo Yuntian
Rubbing: Fu Wanli

As well as Wu Daozi, Fu Baoshi also borrowed from another early master in his figure paintings: the Eastern Jin painter Gu Kaizhi, whose "gossamer thread" technique,

with its fine, even lines, gives Fu's subjects an air of antiquity matched by no other artist. One subject to which he returned numerous times was the Warring States-era poet Qu Yuan. I have seen several portraits of him in Fu's hand, but the one on this wrist rest seems to me to best show the spirit of the man. The story goes that Qu's most important work, "Encountering Sorrow", was composed in response to his unjust banishment from the court of Chu. Fu's depiction captures him in the aftermath of that fall from grace: a former aristocrat sent off into the wilderness, reciting poetry at the edge of a marsh. His weariness, his frayed nerves and his anguish at the rumours and slander he has faced all come through clearly (Fig. 49.1).

I commissioned this wrist rest from Bo Yuntian in spring 2008. Of particular note is Bo's work on Qu's hair, which Fu depicts worn long and dishevelled. In carving it, Bo showed an admirable willingness to experiment, and the result is wonderfully fresh and unorthodox.

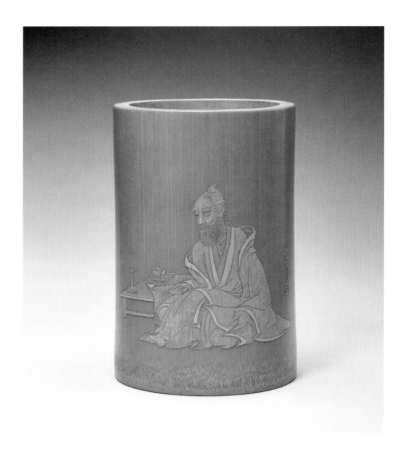

Gu Kaizhi—顧愷之 (340s–400s CE). Often mentioned in the same breath as Wu Daozi, Gu is famously the first painter to be specifically named in the Chinese written record. The technique mentioned is *yousi miao* (遊絲描 or sometimes 游絲描), which Gu was instrumental in popularizing.

Qu Yuan—屈原 (c. 340–278 BCE), purported author of the *Chuci* or *Songs of the South* (楚辭), an early anthology of poetry from the southern Chinese state of Chu. "Encountering Sorrow" (*Li sao* 離騷, sometimes glossed as "Sorrow at Parting" or "Parting Sorrow") is the first and most important work in the collection.

<div align="center">

050

Bamboo brush pot

2012

Decorated with *liuqing* relief of a portrait of Wen Tianxiang
(Fu Baoshi, 1905–64)
Carving: Bo Yuntian
Rubbing: Fu Wanli

</div>

My earliest encounter with Wen Tianxiang, who appears on this brush pot in another portrait by Fu Baoshi, was in primary school, when my Chinese teacher showed us two of his poems: "A Song of Rectitude" and "Crossing the Lingding Channel". Like Zheng Sixiao, whom we met in item 29, Wen refused to serve the Yuan dynasty following its conquest of the Song, a decision that would cost him his life. His patriotism and loyalty are the stuff of legend, so it was a thrill to discover while I was at university that one of my classmates from the New Territories was a member of his clan. Later, when I went to Beijing, I found an entire temple there devoted to him.

Fu Baoshi's portrait of Wen (Fig. 50.1) is one of his finest works. The inscription at the top of the painting, a copy of "A Song of Rectitude" in small standard script, was added by the calligrapher Shen Yinmo during the Second World War, when large parts of China were occupied by Japan. The historical significance is clear.

The version of the portrait that decorates this brush pot stands out for Bo Yuntian's work on the face. The carved Wen wears a pensive expression, and his brows and beard are strikingly lifelike. Zhang Yanyuan, the ninth century writer, once said of Wu Daozi's painting that "he kept his mind free and concentrated all his being, standing in union with the work of nature". Bo's carving here seems to me to hit those same heights.

The long Shen Yinmo inscription from the original painting is not retained in the carved version. Instead, the back of the brush pot is decorated with one of Wen's other poems, "The Robe Proclamation", which he wrote before his execution and carried with him in his robes when he was taken to die. The calligraphy is my own:

> *Confucius says,*
> *"Lay down your life when duty so demands",*
> *And Mencius,*
> *that we are to die when righteousness decrees.*
> *'Tis only if we follow righteousness where'er it leads*
> *That we have done the duty owed*
> *to all our fellow men.*
> *When we read the sages' books,*
> *or what the worthies wrote,*
> *What is it that we study?*
> *And what is it that we learn?*
> *We read so that, when we have done,*
> *we know how best to lead*

Such lives as keep the conscience clear
and give no cause for shame.

The brush pot is accompanied by a fine rubbing by Fu Wanli and by two copies of "The Song of Rectitude", which stand in place of the Shen Yinmo version. I am grateful to Fu Jiasheng and the calligrapher Su Yue for preparing these, including Wen's full, original preface (Figs 50.2, 50.3). Together, the brush pot, the rubbing and their calligraphy form a complete set, every element of which is a treasure in its own right.

Wen Tianxiang—文天祥 (1236–83). An official in the late Southern Song government, Wen was imprisoned and eventually executed for refusing to serve the new Mongol Yuan dynasty.

"A Song of Rectitude"—"Zhengqi ge" (正氣歌). One of a number of Wen's poems chronicling his refusal to collaborate. The two other poems mentioned are "Guo Lingding yang" (過零丁洋) and, below, "Yidai zhao" (衣帶詔).

the New Territories—Xinjie or, in Cantonese, San Gai (新界). Referring to a large area of Hong Kong leased to Britain in 1898. The New Territories, the last part of Hong Kong to come under British rule, comprise the majority of its landmass and include numerous outlying islands as well as all the land north of the Kowloon Peninsula.

a member of his clan—rather than Wen, the student would have been known by the Cantonese pronunciation of the clan name, Man.

an entire temple…to Wen Tianxiang—the Wen Tianxiang ci (文天祥祠), located off Fuxue Hutong (府學衚衕) north-east of the Forbidden City.

Shen Yinmo—沈尹默 (1883–1971). An important poet and calligrapher.

Zhang Yanyuan—see notes to item 19. For Wu Daozi, the revered early painter, see notes to item 48.

Su Yue—宿悅 (b. 1964). Based in Beijing, Su is noted for (among other works) his complete calligraphic version of the *Daodejing* (道德經, = *Tao Te Ching*).

051
Bamboo wrist rest

2008

Decorated with *liuqing* relief of *Chinese Juniper with Goshawk*
(Zhang Shunzi and "the Old Man of the Snowy Tracts",
Yuan dynasty)
Carving: Zhu Xiaohua
Rubbing: Fu Wanli

Discussing *Chinese Juniper with Goshawk* in *A Lovely Ash-Heap*, Wang Shixiang says that it captures the bird's grace better than any other work, ancient or modern.

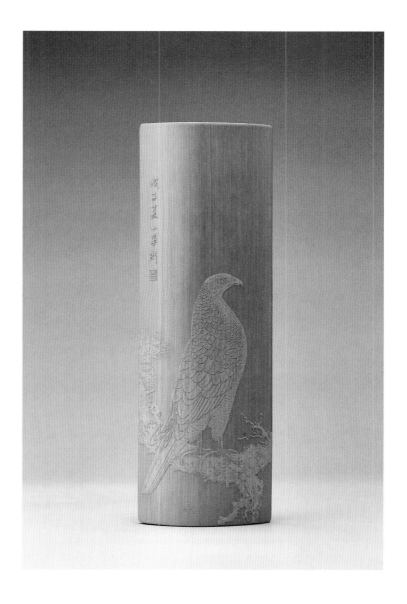

Wang was a master falconer, and there were times when he would spend whole days with his hawks. Looking at the painting, it is hard to argue with his judgment.

Assessments of the painting have not always been so rosy, however. When it was acquired in the 1960s by Huang Zhou, then a young painter and curator, it was in a seriously dilapidated state. In his 2007 book *Painting from the Past*, Chen Yan reports how, at the time, leading experts, including the legendary Xu Bangda, declared it to be a fake. Once Huang had had it remounted, however, its obvious quality shone through, and Xu et al. revised their opinion, admitting it as a masterpiece of Yuan painting. Of course, appraising antiques is difficult, as this story shows. At the same time, one has to admire the insight of the young pretender Huang Zhou, as well as his bravery in sticking to his guns.

I commissioned the carved version of the painting from Zhu Xiaohua in summer 2008. It is a *tour de force*: an intricate, "crafted brushwork" painting, in colour, transformed into a *liuqing* relief. I wish that Wang Shixiang could have seen it in person. Sadly, when I visited Beijing in autumn 2008, he had been taken to hospital. I never had the chance to show it to him.

Although Wang never owned *Chinese Juniper with Goshawk*, his collection did include the equally wonderful *Hawk on a Pine*, a Qing dynasty finger painting by Gan Shidiao.

One of my first poems in Classical Chinese was written in response to Gan's painting. I remember showing it to Wang after I finished it in 2004, and I think it captures something of this painting too:

> *"Reverently viewing Hawk on a Pine*
> *at Paired Pines House"*
> *Stood erect, he makes no cry,*
> *his perch the palace parvis.*
> *Sharp and grim the pine's high peak;*
> *its shadows sway and dance.*
> *His wings once spread, he'll soar aloft*
> *for many hundred miles.*
> *He'll take the heavens themselves for prey*
> *and dare to pluck down stars.*

Zhang Shunzi and "the Old Man of the Snowy Tracts"—the painting is the work of two hands. The first, Zhang Shunzi (張舜咨), was a 14th century figure also known by his courtesy name, Zhang Shikui (張師夔). The second, identified only by his soubriquet (*xuejie weng* 雪界翁), is not otherwise attested.

Huang Zhou—黃冑 (1925–97). A highly influential painter, collector and curator, Huang was staff artist to several military bodies before his appointment as Deputy Director of the Traditional Chinese Painting Research Institute.

Xu Bangda—徐邦達 (1911–2012). One of the 20th century's most prominent connoisseurs of Chinese painting.

Painting from the Past—*Wangshi danqing* (往事丹青), a memoir of the career of the painting and calligraphy expert Chen Yan (陳岩, b. 1942).

Gan Shidiao—甘士調 (early 18th century). A well-regarded early Qing painter. The painting in Wang's collection was *Songying tu* (松鷹圖).

he makes no cry / his perch the palace parvis—alluding to a tale recounted in the biography of the courtier Chunyu Kun (淳于髡, 4th century BCE) in the *Records of the Grand Scribe* (see notes to item 46). The biography tells how the king whom Chunyu served abandoned his duties for a life of leisure and inaction, leaving his state vulnerable to its neighbours. Seeking to rouse him, Chunyu recounted the tale of a bird that, like the king, had done nothing for many years:

> Chunyu Kun sought to persuade him with a riddle. He said, "In our state there was a huge bird that halted at the king's courtyard. For three years it never took flight, and it never made a cry. I cannot think why the bird did this." The king said, "Why did the bird not take flight? It is simple: one flap of its wings and it would have soared up to the heavens themselves. Why did it not make a cry? It is simple: one cry and it would have had everyone in shock." Thereupon he called the seventy-two district magistrates of the kingdom to court, and he rewarded one for his service and executed another. And he raised the army and went forth, and the feudal lords were shaken and astonished, and all returned the lands of Qi, on which they had encroached.

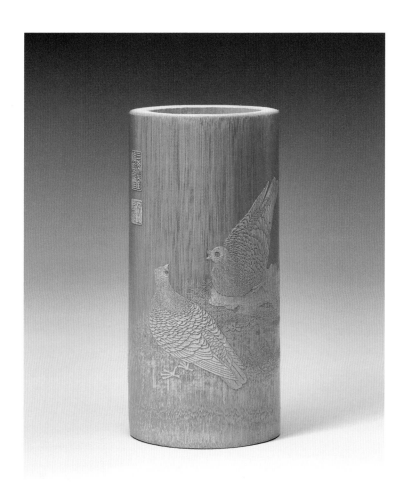

052
Bamboo brush pot

2012
Decorated with *liuqing* relief from
Handbooks of Pigeons from the Qing Court
Carving: Bo Yuntian
Rubbing: Fu Wanli

As well as hawks, Wang Shixiang loved pigeons. He began raising them as a boy, and he developed something of an obsession with pigeon whistles, small devices attached to the birds which make a sound as they fly. (His favourite was a kind made from bottle gourd and decorated with pyrography.) On one occasion while he was at university, he received full marks for a *Rhapsody on the Pigeon Whistle*, written for one of his composition assignments.

Several of Wang's books were about pigeons or their role in art, including *The Ming Dynasty Classic of Pigeons* and *Handbooks of Pigeons from the Qing Court*, which he published as a double set. Around 1996, while he was editing them, he wanted to get hold of additional material from outside China, and he asked me to help with his search in the UK. Sadly, I was preoccupied with my doctoral work at the time, and I was not able to find as much material as he had hoped.

In spite of my limited success, Wang kindly gave me a copy of the double set in 2000, along with *The Beijing Pigeon Whistle* (Fig. 52.1). The image on this brush pot is based on an untitled painting from the Qing handbooks, where it occurs as figure 46 in item D23 (Fig. 52.2).

Rhapsody on the Pigeon Whistle...The Ming Dynasty Classic of Pigeons...Paintings of Pigeons from the Qing Court...The Beijing Pigeon Whistle—respectively *Geling fu* (鴿鈴賦), *Mingdai gejing* (明代鴿經),*Qinggong gepu* (清宮鴿譜) and *Beijing geshao* (北京鴿哨).

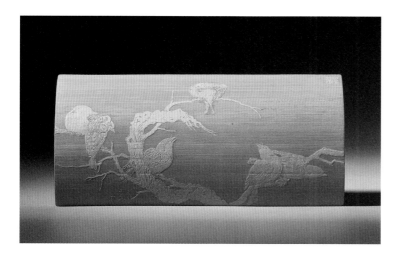

053
Bamboo cross-piece

2009
Decorated with *liuqing* relief of a detail from
Wintry Sparrow (Cui Bai, Song dynasty)
Engraving: Zhu Xiaohua

In spring 2009, I sent Zhu Xiaohua a section from Cui Bai's *Wintry Sparrow* (Fig. 53.1) and asked him to decorate a brush pot with it. In the event, Zhu made me a cross piece instead: he was worried that a pot would crack, and I believe he may also not have had the right materials on hand for one. The resulting piece is far from perfect, but it is still satisfactory.

Cui Bai—崔白, 11th-century painter.

054
Bamboo brush pot

2012
Decorated with *liuqing* relief of a detail from
Double Happiness (Cui Bai, Song dynasty)
Carving: Bo Yuntian
Rubbing: Fu Wanli

In item 22, we encountered Yang Buzhi's painting of a "rustic plum", so called to distinguish it from finer, less wild "palace plums". In the next two items, we will see that same distinction – rustic and palace, wild and tame – applied to another subject.

The hare from Cui Bai's *Double Happiness*, which appears on this brush pot, is our "rustic plum". In the original painting, it is shown looking back in surprise at a pair of azure-winged magpies squawking at it from a tree (Fig. 54.1). In an otherwise bleak and uninhabited vista, these little creatures provide a spark of vitality. For the pot, I picked out the hare and the slope on which the tree sits, with one of the clumps of grass turned slightly from its original position. Bo Yuntian took great care over the carving, and his accomplishments as a craftsman are visible in the softness of the hare's fur and the interlacing of the grass blades.

There is an old saying that "it takes a high wind to find the sturdy grass" – that the best show their true colours in adversity. Cui's grass is a perfect illustration of the metaphor: sturdy, resilient, standing up to everything that comes its way. Looking at it makes me think of one of my early poems from my days in Leipzig, which was inspired by a similar scene. As a Fellow in Urology, I spent much of my time in the operating theatre at the university hospital. Outside there was a terrace that had been turned into a garden as part of a greening drive, dotted with rocks and grass. Watching it one day, I improvised a few lines:

> *A terrace towers beyond the window;*
> *on it, clumps of grass.*
> *Upon their lush, abundant green*
> *the morning sunlight sparkles.*

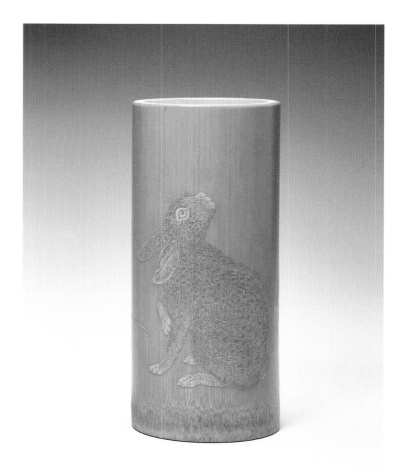

Suddenly the heavens open;
bolts of lightning flash,
But still, they laugh at claps of thunder,
dancing on the blast.

Cui Bai—see notes to item 53. *Double Happiness*, so called because of the magpie's status as a happy omen, is Cui's best-known work.

it takes a high wind to find the sturdy grass—*jifeng zhi jingcao* (疾風知勁草), often abbreviated to *jifeng jingcao* (疾風勁草, "sturdy grass in a high wind").

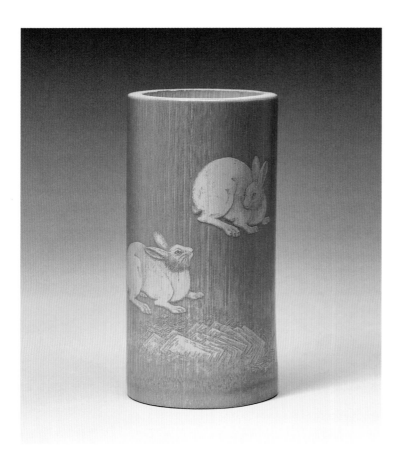

055
Bamboo brush pot and wrist rest

2011, 2019
Decorated with *liuqing* relief of *A Pair of Rabbits*
(Leng Mei, Qing dynasty)
Carving: Bo Yuntian
Rubbing: Fu Wanli

If Cui Bai's hare is a rustic plum, then here are our palace plums. Leng Mei depicts a pair of plump, white rabbits wandering through a palace park (Fig. 55.1). The shading of their bodies echoes the work of Giuseppe Castiglione, the missionary painter whose fusion of European and Chinese techniques was much admired at the 18th-century court. The rabbits' calm, placid expressions recall old tales of con-

cubines in the imperial palaces, living out their lives in ease and plenty.

In ancient times, white rabbits were regarded as a good omen. In fact, their white colouring comes from a genetic mutation. It has been suggested that rabbits with the white gene began to be brought into China from overseas under the Ming. At a stroke, this rare creature became commonplace, going from auspicious sign to palace pet.

In his carving of Cui Bai's hare, Bo Yuntian picked out every detail down to the individual strands of fur. For this pot, I had him take a different approach. The bodies of the rabbits are left as blank sections of bamboo skin, with fine hairs carved around their outlines. Over time, the background will darken where the bamboo skin has been removed, and the rabbits will stand out more and more clearly. It might be hundreds of years before this pot looks its best.

Leng Mei—冷枚 (c. 1669–1742). Qing court painter. *A Pair of Rabbits* was commissioned by the Qianlong Emperor, who was born in the year of the rabbit in 1711.

Giuseppe Castiglione—Italian Jesuit, also known by his Chinese name, Lang Shining (郎世寧). Understanding that connections with the Chinese elite were a prerequisite for successful missionary work, the Jesuits sent many of their most talented adherents to serve at the court in Beijing. Castiglione (1688–1766) worked there for several decades as a painter and occasional architect, producing a substantial body of imperial commissions.

056
Brush pot

2017
Decorated with a gold brocade pattern
of a running hare (Yuan dynasty)
and text from "Song of Antique Beauty" (anon., Han dynasty)
Calligraphy and carving: Fu Jiasheng
Rubbing: Fu Wanli

The pattern on this brush pot, a hare running through flowers, is taken from two pieces of Yuan dynasty gold brocade in my personal collection. They are identical to an item held in the Metropolitan Museum in New York – in fact, they may well have been cut from the same cloth (Fig. 56.1).

The hare pattern appears twice on opposite sides of the brush pot, once gilded and once plain against a gilt background. It is accompanied by the text of the Han dynasty "Song of Antique Beauty", written and carved for me by Fu Jiasheng:

A single, lonely hare
Runs east, but looks back west.

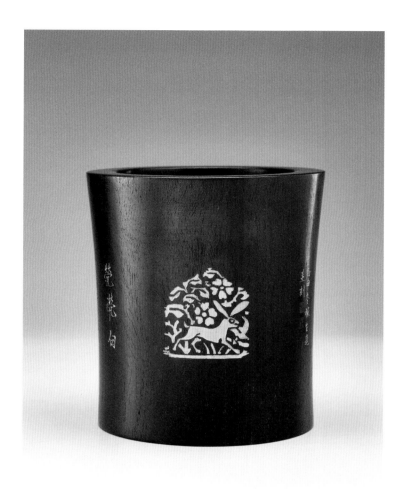

Our robes we prize when new;
With friends, though, old is best.

The text and decoration alternate, and as the pot is turned the view changes, like the silhouette lanterns used on Chinese festival days. Flipping between the two versions of the hare pattern makes me think of the ending of the old song about Mulan, who disguises herself as a boy to take her father's place in the army:

The boy-hare has puff on his paw,
The girl-hare has mist in her eye.
Two hares run, now hither, now yon,
But how
Can you tell if I'm girl-hare or guy?

Song of Antique Beauty—"Guyan ge" (古豔歌). An anonymous Han dynasty composition, usually understood as the lament of a discarded concubine pleading her merits against her replacement.

silhouette lanterns—similar to zoetropes, so-called "running horse lanterns" (*zouma deng* 走馬燈) feature paper cutouts fixed to a shaft inside the lantern shade. The lantern light projects silhouettes of the cutouts onto the shade, and a paper vane attached to the shaft makes the cutouts revolve as warm air from the light rises.

the old song about Mulan—the anonymous *Mulan shi* (木蘭詩), supposedly dating to the 6th century.

057
Brush pot

2014
Decorated with pattern of a pair of beasts from
a piece of gold brocade (Yuan dynasty)
Carving: Li Zhi
Rubbing: Zhang Pinfang

Gold brocades like the one whose pattern appears on this item came to China from Central Asia. Their precursors, Sogdian pieces decorated with string-of-pearls and paired birds patterns, began to emerge as early as the Tang dynasty. By the Yuan, patterns of paired beasts had become common, along with another style referred to in textual sources as "nasīj" or "nakh".

I acquired the example that inspired this brush pot, a length of brocade with three decorated sections (Fig. 57.1), some years ago in the UK. When I commissioned the pot from Li Zhi, I asked him to carve the pattern twice. To add variety, I had him swap the gilding from the beasts to the background in the second version, the same method that Fu Jiasheng would later adopt in item 56.

"nasīj" or "nakh"—in Chinese, *nashishi* (納石矢, though other transliterations are also seen).

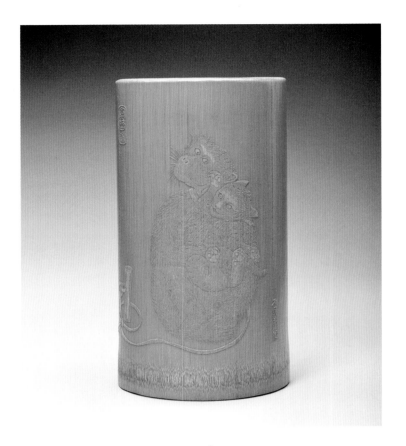

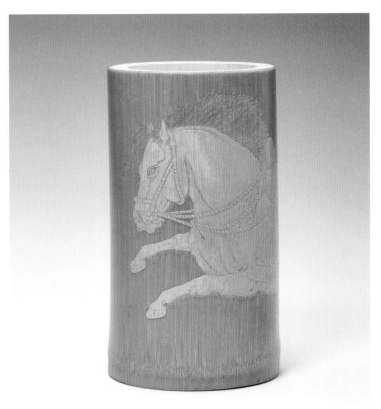

058

Bamboo brush pot

2013
Decorated with *liuqing* relief of *Monkey and Cats*
(Yi Yuanji, Song dynasty)
Carving: Bo Yuntian

B o Yuntian carved two versions of Yi Yuanji's *Monkey and Cats* for me (Fig. 58.1), both on brush pots. The first (Figs 58.2, 58.3) was exceptionally fine, but when it was sent to Fu Wanli to take a rubbing, it cracked. In the second, which I asked him to make as a replacement (Figs 58.4–58.6), something has been lost: the workmanship of the fur in particular feels less elegant. Seen side by side, as in the photographs presented in the Chinese volume, there is a clear difference in quality.

I could not bear to simply throw the cracked version away. Sometimes castoffs from workshops turn out to be valuable for other purposes: specialists in porcelain, for instance, prize fragments from the fabled kilns at Jingdezhen. Perhaps someday my pot may prove similarly useful.

Yi Yuanji—易元吉. 10th-century painter best known for his rendering of animal subjects.

Jingdezhen—景德鎮. A town in the southeastern province of Jiangxi. A longtime centre of porcelain production and, under the Ming and Qing, the home of the imperial kilns.

059

Bamboo brush pot

2008
Decorated with *liuqing* relief of the horse Black Whitehoof from
The Six Steeds of the Zhao Mausoleum (Zhao Lin, Song dynasty)
Carving: Bo Yuntian
Rubbing: Fu Wanli

B efore there were supercars, horses were the great obsession. The Six Steeds of the Zhao Mausoleum are among the most famous horses of all. They were ridden by Emperor Taizong, the son of the Tang founder Gaozu, during the wars that brought the dynasty to power. In recognition of their service to the state, they were honoured alongside the emperor at his tomb, the Zhao Mausoleum, near present-day Xi'an. The carvings of them that were erected there, said to have been based on drafts by the court painter Yan Liben, are widely recognised as among the finest in the Chinese tradition. They ensure that, even today, the Six Steeds are remembered.

Two of the group are now in the University of Pennsylvania Museum in Philadelphia. The others are still in Xi'an at the Stele Forest Museum, where I visited them some years ago (Fig. 59.1). In addition to the original carvings, there is also a painted copy of the Six Steeds, a Song handscroll by Zhao Lin. The decoration on my brush pot was taken from this version.

Like many other paintings in this book, the Zhao Lin scroll was at one time part of the imperial art collections. The Qianlong Emperor himself added one of his compositions, "The Song of the Stone Horses", to the start of the scroll, along with a postscript before the painting of Black

Whitehoof. The final line, which explains how he came to write the "Song", demonstrates the respect he felt for his Tang forebear: "In the autumn of 1783, in the ninth month, I reverently visited the Zhao Mausoleum. There, I composed the 'Song of the Stone Horses', which I then wrote on the scroll." As well as his calligraphy, the emperor also added several seals, including, "a treasure of the Emperor Emeritus", "a treasure of the Son of Heaven in his seventh decade, in the Hall of Five Blessings through Five Generations", and "a treasure for reflecting on the portents, which are the eighth element, in my eighth decade".

Taizong rode Black Whitehoof during his campaign against Xue Rengao, the ruler of the rival state of Qin. The horse, named for the white markings on its feet (Fig. 59.2), is depicted wearing a frontlet, an ornamental cover for the forehead. Given the length of its body, with the legs stretched out at full gallop, the painting would perhaps have been more effective on an oval-shaped pot.

The Six Steeds of the Zhao Mausoleum—Zhaoling liu jun (昭陵六駿). The mausoleum, located in the hills northwest of Xi'an, includes large numbers of secondary tombs spread over an area of around 20,000 hectares.

Taizong—太宗 (598–649, r. 626–649), also known by his original name, Li Shimin (李世民). The second Tang emperor, Taizong came to power after deposing his father, whom he had fought alongside in the rebellion that toppled the preceding Sui dynasty. He was revered under later dynasties for his success in expanding the empire's territory, which under his rule stretched into parts of modern Vietnam, Xinjiang, and Central Asia.

Yan Liben—閻立本 (d. 673).

Zhao Lin—趙霖 (fl. late 12th century). Southern Song painter and official.

Song of the Stone Horses—"Shima ge" (石馬歌), sometimes known by the longer title "Song of the Stone Horses from the Zhao Mausoleum" (*Zhaoling shima ge* 昭陵石馬歌).

a treasure of the Emperor Emeritus—the Qianlong Emperor (1711–99, r. 1735–96) abdicated in favour of his son in the mid-1790s, supposedly to avoid serving longer than his grandfather, the Kangxi Emperor (1654–1722, r. 1661–1722). In the last years of his life, he held the title of Retired Emperor or Emperor Emeritus (*taishang huangdi* 太上皇帝), although in reality his hold on power continued uninterrupted until his death.

the Hall of Five Blessings through Five Generations—*Wufu wudai tang* (五福五代堂). The name was given by the Qianlong Emperor to a hall in the Forbidden City following the birth of his first great-great-grandson in 1784. The Five Blessings – long life, wealth, health and peace, love of virtue and dying peacefully in old age – are named in the "Great Template" ("Hong fan" 洪範) chapter of the canonical *Classic of Documents* (*Shujing* 書經) as one of a set of nine aspects of good rulership. The final seal's reference to "the portents, which are the eighth element" (*ba zheng* 八徵) draws from the same text. A more straight-forward reading of the phrase would be simply "eight portents", but the emperor's explanation of the seal, the *Record of Treasures for Reflecting on the Portents, which Are the Eighth Element, During*

My Eighth Decade (*Bazheng maonian zhi bao ji* 八徵耄念之寶記), makes clear that he had in mind the text's description of signs or portents (*zheng* 徵) as the eighth of these aspects.

Xue Rengao—薛仁杲 (sometimes miswritten as Xue Renguo 薛仁果, d. 618). Ruler of the short-lived state of Qin (秦), established during the collapse of the Sui dynasty.

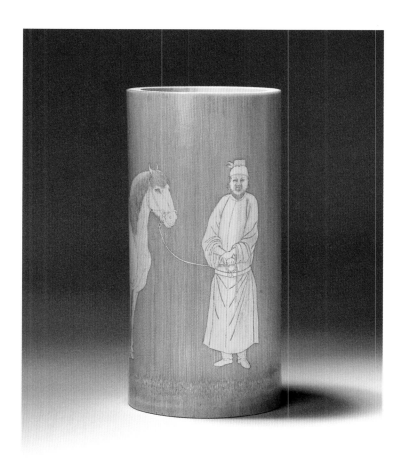

060

Bamboo brush pot

2008–9
Decorated with *liuqing* relief of *Groom and Horse*
(Zhao Mengfu, Yuan dynasty)
Carving: Bo Yuntian
Rubbing: Fu Wanli

The work that decorates this brush pot, a painting of a horse with its groom by the Yuan master Zhao Mengfu, started something of a family tradition. Zhao's son Zhao Yong and his grandson Zhao Lin both painted works under the same title, and all three were mounted as a single scroll, which I was once able to see at the Metropolitan Museum (Fig. 60.1).

Early examples of groom-and-horse paintings appear in the Tang dynasty. I suspect that Zhao's painting may be a re-imagining of just such an early work, either a Tang example he had seen or something by a Song artist. The calligraphy of the original inscription is quite weak, so, in the carved

version, some characters are borrowed from elsewhere in Zhao's oeuvre.

Zhao Mengfu—趙孟頫 (1254–1322). Zhao, sometimes known by his soubriquet, "Man of the Way Amid Snows in the Pines" (*songxue daoren* 松雪道人), was among the greatest literary and artistic figures of his age. Groom and Horse, one of his best-known works, was painted in 1296. Zhao Yong (趙雍, 1289–after 1360) and Zhao Lin (趙麟, fl. late 14th century), both respected painters in their own right, added their versions to the original in 1359 at the request of its then owner, a Jiangsu resident named Xie Boli (謝伯理).

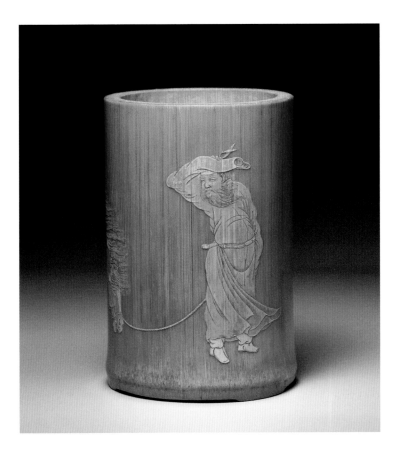

061
Bamboo brush pot

2009
Decorated with *liuqing* relief of *A Horse Well Trained*
(Zhao Mengfu, Yuan dynasty)
Carving: Zhu Xiaohua
Rubbing: Fu Wanli

In the painting in item 60, groom and horse stand still, and the scene is a static one. That feeling of calm is absent from *A Horse Well Trained*. The composition is full of movement, giving the viewer a sense of the ferocity of the weather that this groom and his horse are facing – the kind of weather that one old song calls "a great wind rising, the clouds climbing high" (Fig. 61.1).

Before he began to carve the brush pot, Zhu Xiaohua warned me that the material we had selected was slightly mottled. Usually this would be a fault, but I told him to go ahead regardless: he could use the spots as part of the horse's coat, and the piece would be even better because of them. In a way, it is a shame the spots were not larger. If they had been, we could have turned Zhao Mengfu's dark-haired steed into a Khotanese "flower horse". These were much prized in earlier times, and their distinctive spotted colouring was the subject of numerous poems and paintings. The Five Dynasties painter Zhao Yan depicts one in his *Training a Horse*, and another appears in Cen Shen's famous description of the harsh western frontier, where the cold freezes horses' hair:

> *Five-Flower's splotches, coins strung up,*
> *will soon have turned to ice.*

a great wind rising, the clouds climbing high—大風起兮雲飛揚. The opening line of "The Song of the Great Wind" (*Dafeng ge* 大風歌), a victory ballad attributed to Liu Bang (劉邦, 256–195 BCE), the founder of the Han dynasty.

flower horse—*huama* (花馬). The term can refer generically to any fine horse, but contemporary authors distinguish two varieties, "three-flower" and "five-flower" (respectively *sanhua ma* 三花馬 and *wuhua ma* 五花馬). The meaning of these more specific expressions is a matter of scholarly debate. In Cen Shen's line below, "five-flower" appears to refer to the extent of the patching in the coat; other writers, meanwhile, take "three-flower" to denote the number of decorative tufts into which the horse's mane would be trimmed.

Zhao Yan—趙岩 (fl. early 10th century). The painting is his *Tiaoma tu* (調馬圖).

Cen Shen—岑參 (715–770). One of the so-called "frontier poets" (*biansai shiren* 邊塞詩人), Cen was noted for his depictions of military service in the far west of the Tang empire. The line quoted here is from his "A Song of Running-Horse River" (走馬川行, sometimes known by the long title "A Song of Running-Horse River, presented to General Feng when seeing him off to lead his troops on the expedition to the west" 走馬川行奉送封大夫出師西征).

coins strung up—copper cash, the main form of Chinese coinage, was minted with a square hole at the centre, allowing sets of coins to be threaded onto strings for ease of transportation. The image intended is a pattern of interlaced circles.

062
Bamboo brush pot

2011
Decorated with *liuqing* relief of *Sheep and Goat*
(Zhao Mengfu, Yuan dynasty)
Carving: Bo Yuntian
Rubbing: Fu Wanli

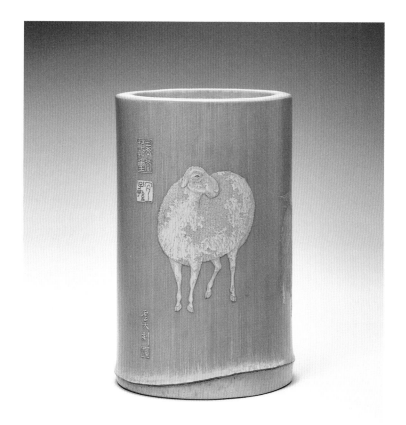

there was more to it than that. In his assessment of *Sheep and Goat*, the artist and art historian Kwan S. Wong discusses the significance of the animals' poses in light of the Mongol conquest of China, which occurred when Zhao was a young man: "The sheep is a Mongol, the goat a Han. The painting sketches an idea: that the people from the north can hold their heads high while those from the south keep theirs down."

Viewing Paintings Across America—"You Mei duhua ji" (遊美讀畫記). The essay is reproduced in volume one of Wang's *A Lovely Ash-Heap* (for which, see notes to item 8).

the Qianlong Emperor—see notes to item 19.

Zhongxin—仲信, apparently the commissioner of the painting, identified only by his personal name.

Kwan S. Wong—黃君實 (b. 1934). A highly regarded expert on Chinese painting, Wong is also a respected painter and calligrapher in his own right.

Sheep and Goat, another of Zhao Mengfu's masterpieces (Fig. 61.1), is now housed in the Freer Gallery of Art in Washington, DC. It was one of a number of paintings that Wang Shixiang saw during his visits to the US. In an essay on the subject, "Viewing Paintings Across America", he praises the scroll as "Pine Snow Zhao's finest work, whether from the perspective of painting or calligraphy". Another admirer was Zhu Jiajin. He made a copy of *Sheep and Goat* (Fig. 62.2), which I remember seeing in a journal many years ago.

I was lucky enough to see the painting myself in 2002. I was in the US for a urological conference, and on my way home I stopped off in Washington. When I got to the gallery, I was disappointed to find that *Sheep and Goat* was not on display. When I asked the museum staff, they told me that it would be possible to arrange a viewing, but that as it was near closing time, I would need to come back early the next day.

The next morning, I arrived at the museum and was taken down to the painting store in the basement, where *Sheep and Goat* was waiting on a table. I put on gloves as instructed and then sat down, determined to take in every detail. The scroll begins with a colophon by the Qianlong Emperor. Then there is the painting: a sheep and a goat – or more accurately, since the scroll runs from right to left, a goat and a sheep – portrayed side by side, one with its head down and one looking off into the distance. The piece closes with an inscription by Zhao:

> I have painted horses, but never sheep, so when Zhongxin asked for a painting, I sketched this playfully from life. Though I have not been able to come near the ancients, I have achieved something of the right spirit.

Zhao suggests that he chose the subject of the painting simply to try something new, but it is tempting to wonder if

063
Three brush pots

Decorated with *Wood and Rock* (Su Shi, Song dynasty)

Huanghuali brush pot

2018
Carving: Fu Jiasheng
Rubbing: Fu Wanli

Zitan brush pot

2018
Carving: Li Zhi
Rubbing: Zhang Pinfang

Bamboo brush pot

2019

Decoration in *liuqing* relief
Carving: Bo Yuntian

Wood and Rock, the painting which decorates these brush pots, has long been attributed to Su Shi. Although it is unsigned, the artist is identified in two colophons by his contemporaries Liu Liangzuo and Mi Fu.

Su was an enormously important painter. Along with his older contemporary Wen Tong and the Jin dynasty artist

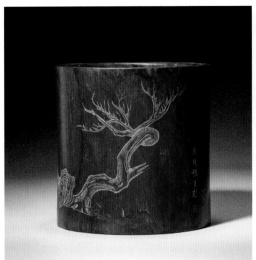 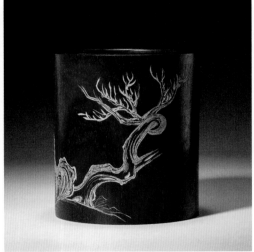

Wang Tingyun, he began a whole tradition of similar painting by literary figures. It is a tradition that Zhao Mengfu would take up under the Yuan, as we will see in item 64.

During the 20th century, *Wood and Rock* disappeared from view. It did not surface until 2018, when it was auctioned in Hong Kong. I was able to see it before the sale, and I was captivated. To keep the memory of that viewing alive, I asked Fu Jiasheng, Li Zhi, and Bo Yuntian to carve these three brush pots in *huanghuali*, *zitan*, and bamboo. The decoration on the first pot is executed in sunk relief, with the calligraphy infilled with malachite; the second is in gilded intaglio; and the third is a plain *liuqing* relief. The result is three contrasting images distinguished by different materials, different colours and different techniques.

The attribution to Su is given weight by the authoritative *Complete Compendium of Chinese Art*, which includes it in volume three in the "Drawing and Painting" section. In contrast, another work commonly attributed to Su, *Bamboo and Rocks by the Xiao and Xiang*, which was gifted to the Chinese National Museum of Art by the writer Deng Tuo, is missing. It appears that, while they were convinced by our painting, the committee behind the *Compendium*, the National Group for the Appraisal of Painting and Calligraphy, thought this second work was not genuine.

Wood and Rock—the *Kumu guaishi tu* (枯木怪石圖) or *Withered Tree and Strange Rock*. Usually known in English by its shorter title (*Mushi tu* 木石圖), the name under which it was auctioned in 2018.

Su Shi—蘇軾 (1037–1101). Song statesman and polymath, often referred to by his soubriquet Su Dongpo (蘇東坡, Su of the Eastern Slope).

Liu Liangzuo—劉良佐 (fl. 11th century). For Mi Fu, see notes to item 65. Below, Wen Tong and Wang Tingyun are 文同 (1018–1092) and 王庭筠 (fl. mid–12th century) respectively.

Complete Compendium of Chinese Art—*Zhongguo meishu quanji* (中國美術全集), a 60-volume reference work published in the 1980s. The third volume, edited by Fu Xinian (see notes to items 4, 9, and 96), covers the painting of the Song dynasty and appeared in 1988.

Bamboo and Rocks by the Xiao and Xiang—Xiao Xiang zhushi tu (瀟湘竹石圖). Deng Tuo (鄧拓, c. 1911–1966), also known by his pen name, Ma Nancun (馬南邨), was a writer, intellectual and one of the first victims of the Cultural Revolution. Prior to his suicide in 1966, he was an early editor-in-chief of *The People's Daily*, the Chinese Communist Party's paper of record.

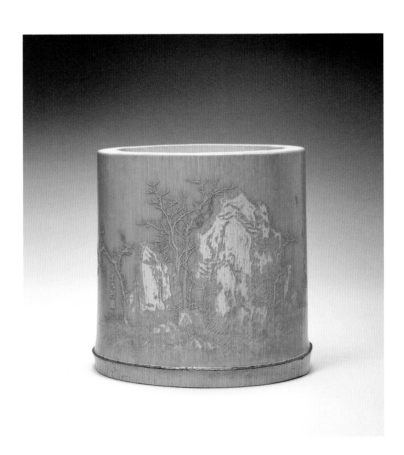

064

Bamboo brush pot

2012
Decorated with *liuqing* relief of *Fine Rocks*, *Sparse Trees*
(Zhao Mengfu, Yuan dynasty)
Carving: Bo Yuntian

Unlike most of the brush pots in this book, this pot is oval in shape. On the front is Zhao Mengfu's take on Su Shi's theme: a group of mountain rocks, a cluster of trees, a few branches of bamboo (Fig. 64.1). The back is decorated with two marvellous poems, both taken from the painting's colophons. The first, by Zhao himself, draws parallels between his painting and the techniques of Chinese calligraphy:

> The rocks I made like flying-white,
> the trees like seal script.
> To sketch the bamboo, knowledge of
> the Eight Strokes led me on.
> If only there were others who
> could grasp the same idea,
> Then all would know calligraphy
> and painting once were one.

The second poem, by Ke Jiusi, praises Zhao's skill:

> From Water Crystal Hall,
> a jade-fair man looks out to glimpse
> A gull at rest upon the waves –
> it might be catching fish.
> The rocks are fine, the trees are sparse,
> suffused with autumn hues –
> Soon he'll take his mighty brush
> and try his running script.

Readers may remember an excellent exhibition of Zhao's painting and calligraphy at the Palace Museum in 2017, which helped bring him back into the public eye. *Fine Rocks, Sparse Trees* was one of the exhibits. I had seen the painting a few years before in Wuying Hall, the museum's exhibition space for painting and calligraphy. It was a quiet afternoon, and I was shocked to see that, with almost no-one around, the gallery attendant had put a flask of water down on the case containing the painting. One false move and a great masterpiece could have been lost for good.

Ke Jiusi—柯九思 (1290–1343). Painter and contemporary of Zhao Mengfu.

flying-white—*feibai* (飛白), an effect produced by underloading the brush with ink or by moving it rapidly across the page. The result is a streaky brush stroke with gaps where the paper shows through the ink.

the Eight Strokes—*bafa* (八法, more literally the Eight Methods). The basic strokes in Chinese calligraphy.

calligraphy and painting once were one—a common refrain in literati writing, both arts being practiced with a brush in the Chinese tradition.

Water Crystal Hall...a gull at rest upon the waves—*Shuijing gong* (水精宮) and *oubo* (鷗波), respectively the name of one of Zhao's studios and one of his literary soubriquets. The gull alighting on the waves was a metaphor for a gentleman in retirement. Ke's poem toys playfully with the reader's perspective, as Zhao is first shown in his studio (line one), then apparently looking down at himself on the waves (line two), then in the actual scene he is painting (line three) and finally adding his inscription to the painted surface (line four).

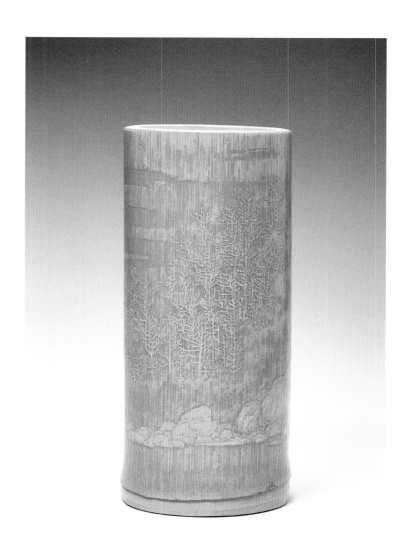

065
Bamboo brush pot

2012
Decorated with *liuqing* relief of
a landscape with clouded mountains (Wong Po-Yeh, 1901–68)
Carving: Bo Yuntian
Rubbing: Fu Wanli

The Wong Po-Yeh painting that decorates this item, with its scene of scattered mists and clouds (Fig. 65.1), is a match for any landscape by the greats of the past. Even Mi Fu or Mi Youren would be proud to have painted it. On the brush pot, it is paired with a couplet by Huang Miaozi, which fits it perfectly.

Wong Po-Yeh—黃般若 (1901–68). An important painter of the traditional school, active in the mid-20th century.

Mi Fu...Mi Youren—respectively 米芾 (1051–1107) and his son 米友仁 (1072–1151). The elder Mi was among the greatest painter-calligraphers of his time, and his son also earned a significant reputation. For the father, see also items 63 and 73.

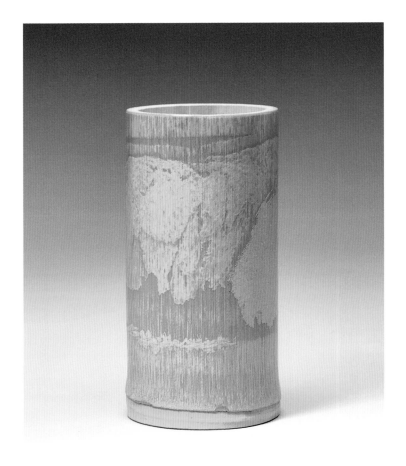

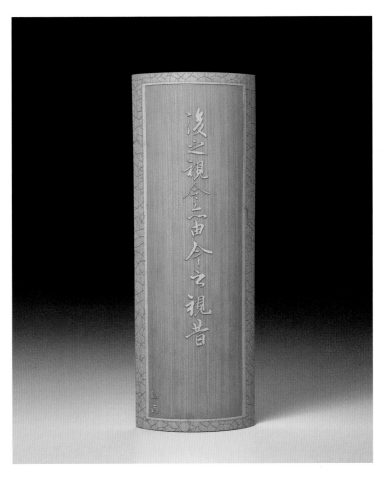

<div style="text-align:center">

066

Bamboo brush pot

2011
Decorated with *liuqing* relief of *Fishing Boats at Anchor at Dusk*
(Wong Po-Yeh, 1901–68)
Carving: Bo Yuntian
Rubbing: Fu Wanli

</div>

Wong Po-Yeh was close friends with Zhang Daqian, whose painting we met in item 39. In this work, he borrows one of Zhang's favourite techniques, splash- or splashed ink, where ink is spattered onto the page and the picture built up around it. The method affords the painting a spontaneous, almost improvised look.

The scene is Aberdeen Harbour on Hong Kong Island. At the east end of the harbour, the Catholic seminary in Sham Wan looms over a forest of masts in the water below (Fig. 66.1). It is a view I recognise from my childhood in the 1970s.

Splash-ink paintings are notoriously difficult to carve, but Bo Yuntian seemed to take the challenge in his stride.

Zhang Daqian—see notes to item 39.

<div style="text-align:center">

067

Bamboo wrist rest

2010
Decorated with *liuqing* relief of a quotation from
"Orchid Pavilion Preface" (Wang Xizhi, Eastern Jin dynasty)
Copy: Feng Chengsu (Tang dynasty)
Carving: Chen Bin

</div>

This was the first piece of bamboo carving I commissioned from Chen Bin after we met in 2009. For the decoration, I chose the same line that closes my preface to this book: "Just as we in the present turn our gaze to the past, so those yet to come will turn their gaze to the present" (Fig. 67.1). These words, borrowed from Wang Xizhi's legendary "Orchid Pavilion Preface", capture the same idea expressed in the story of General Huan in *A New Account of the Tales of the World*, which we met in item 11. There, the general's wife chides him for refusing to wear new robes, asking, "If clothes do not start out new, how are they supposed to grow old?" One might say the same thing about works of art.

The border around the decoration on this item imitates the silk mount of a painting or piece of calligraphy. In retrospect, I think the wrist rest would look better without it.

Chen Bin—see also items 21, 28, and 39.
Wang Xizhi—for Wang and the "Orchid Pavilion Preface", see notes to the Author's Preface.

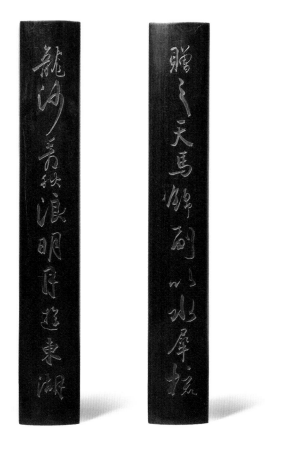

o68
Scroll weight

2014
Decorated with a quotation from "Poem for Chanteuse Zhang"
(Du Mu, Tang dynasty)
Carving: Li Zhi
Rubbing: Zhang Pinfang

The Tang poet Du Mu, whose work decorates this scroll weight, had what one might call a complicated love life. In one of his poems, he reflects on the reputation he acquired among the courtesans of Yangzhou, the city where he spent much of his life:

> I've woken up at last from ten
> long years of Yangzhou dreams,
> In which I earned a title in
> the pleasure quarter: "Trouble".

Du's "Poem for Chanteuse Zhang" tells the tale of a courtesan who won the favour of an acquaintance, Shen Shushi, only to later fall on hard times. Remarkably, Du's original calligraphy of the poem survives (Fig. 68.1): it was one of the works that the great collector Zhang Boju gifted to the nation during the early years of the People's Republic. For the scroll weight, I selected four lines in which Du describes the gifts Shen gave to Chanteuse Zhang when he took her as a concubine:

> He made her gifts of heaven-horse brocade

And followed them with combs of rhino horn.
They watched the autumn waves at Dragon-sands
And drifted on East Lake beneath the moon.

These lines paint an idyllic picture of Zhang's time with Shen. Items like decorative brocade and rhinoceros horn would have been imported via the Silk Road, making them the height of luxury during the Tang. And Shen's travels with his new concubine – viewing scenery, floating on a lake – recall one of Chinese history's great romances, the tale of Fan Li and his lover Xishi, who took to a boat on Lake Tai and were never seen again.

Du Mu—杜牧 (803–853). Poet of the late Tang dynasty. Sometimes known as "the lesser Du" (*xiao Du* 小杜) to distinguish him from the slightly earlier Du Fu (杜甫, 712–770). The first poem quoted is his "My Testament" (*Qian huai* 遣懷).

"*Trouble*"—translating *boxing* (薄倖, literally "thin-favour"). The phrase describes a man of fickle or changeable affections. It also appears as a term of endearment from women to their male lovers. Both meanings are likely intended here, as Du reflects on his exploits with regret tinged with a flicker of pride.

Shen Shushi—沈述師 (dates unknown). Younger brother of Shen Chuanshi (沈傳師, 777–835), an official in whose entourage Du served.

Zhang Boju—see notes to item 8.

Fan Li and his lover Xishi—respectively the statesman 范蠡 (late Warring States period) and the fabled beauty 西施.

o69
Brush pot

2017
Decorated with fragments of sutras from Dunhuang
Carving: Li Zhi
Rubbing: Zhang Pinfang

In ancient times, the desert city of Dunhuang was an important stop on the route from China to Central Asia, an oasis on the Silk Road. Its cliffside caves yielded one of the great discoveries of the 20th century: a cache of thousands of primarily Buddhist documents dating from the fifth to the 11th centuries, preserved for hundreds of years by the desert climate.

Today, the Dunhuang manuscripts are dispersed around the world, mostly in museums and libraries. A few remain in private hands, however, and the fragments that decorate this brush pot fall into that rare category. All four are taken from *Treasures from the Desert Sands*, an album that the painter, calligrapher, and connoisseur Kwan S. Wong acquired as a young man from Sotheby's New York (Figs 69.1–69.5).

The documents that make up the album are fragmentary,

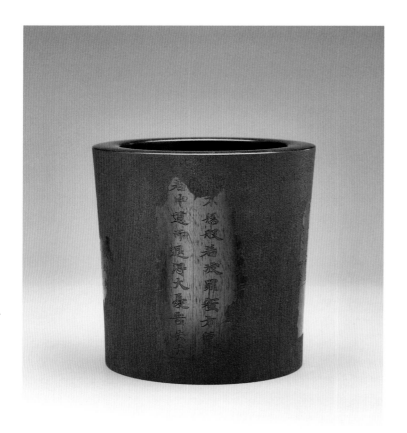

with no complete texts included, but it is a rich and instructive object, nonetheless. An appraisal by Fang Guangchang, an expert on the Dunhuang manuscripts, suggests that its contents date to a wide variety of time periods. Documents from almost every layer of the Dunhuang cache are represented, from the Eastern Jin in the mid-first millennium to the Song dynasty six hundred years later. Each fragment comes from an identifiable Buddhist sutra, and the sheer number of scribes involved in creating the various fragments makes the album a useful source for authenticating other calligraphy from the site. One page that caught my eye when I first read it includes the phrase, "the small intestines, the liver, the lungs, the spleen, and the kidneys", which I immediately thought must be a reference to medicine.

After living in the United States for many years, Kwan S. Wong eventually moved back to Hong Kong, where I first met him over a decade ago. I never expected that our relationship would one day see *Treasures from the Desert Sands* come into my possession, but that is precisely what happened. In May 2016, during a visit to my clinic, he generously gave me the album as a gift. At the back, he had written a colophon:

> *This album was formerly in the collection of Naka-mura Fusetsu of Japan. A lover of Chinese culture and calligraphy, he was the founder of Tokyo's Taito City Calligraphy Museum, which holds many important works, including a certificate of appointment in the hand of Yan Zhenqing, the "Memorial of Thanks" written to the emperor by Cai Xiang, and Song and Yuan stele rubbings. Mr Nakamura, who was born in 1866 and died in 1943, had been a student in Paris, and he would often paint oil paintings in the traditional style on subjects from the Chinese and Japanese classics.*

I commissioned this pot the year after I received Mr

Wong's gift. The carver was Li Zhi, a specialist at the Shanghai art and auction house Duo Yun Xuan, whose work we have encountered a number of times already in this catalogue. His choice of background is especially eye-catching. In keeping with the origins of the album, Li creates a sandy effect using tiny dots made with the point of the knife. The rubbing, taken by Zhang Pinfang of the Shanghai Library, shows just how much effort went into this: truly a labour of love.

Fang Guangcheng—方廣錩 (b. 1948). Researcher in Buddhist and Dunhuang Studies at the Chinese Academy of Social Sciences (CASS).

Treasures from the Desert Sands—the Chinese title is *Liusha yishu ce* (流沙遺書冊).

Kwan S. Wong—see notes to item 62. Wong's time in the United States included spells on the staff of both Sotheby's and Christie's in New York.

Nakamura Fusetsu—中村不折 (1866–1943). Japanese paint-er, calligrapher, and collector. In addition to his oil paintings, Nakamura was also noted for introducing archaic styles of callig-raphy to a Japanese audience.

Yan Zhenqing—顏眞卿 (709–84). Tang official and calligrapher. Yan is widely regarded as one of the greatest calligraphers in the tradition, and his regular script in particular is much-imitated.

Memorial of Thanks...Cai Xiang—the "Poem and Memorial in Thanks for the Bestowal of His Majesty's Calligraphy" (*Xie ci yushu shibiao juan* 謝賜御書詩表卷). The scholar-official Cai Xiang (蔡襄, 1012–67) composed the piece in the 1050s, after the em-peror had gifted him a calligraphic rendering of his courtesy name, Junmo (君謨). The Taito City Calligraphy Museum holds one of four known versions of the piece.

Duo Yun Xuan—朵雲軒 (Cloud-Wisp Gallery). Established in 1900, Duo Yun Xuan is notable for having founded the first art auction house in the People's Republic in the early 1990s.

070

Huanghuali brush pot

2009–10
Decorated with "Poems on the Cold Food Festival"
(text and calligraphy by Su Shi, Song dynasty)
Carving: Fu Jiasheng
Rubbing: Fu Wanli

The most common form of Chinese calligraphy is runn-ing script, the semi-cursive style used for everyday writing. There are many great pieces of running script, but three stand out above the rest. When I commissioned this brush pot, I knew I wanted to use one of them for the deco-ration. The challenge was which one to choose.

At the top of the tree is the best-known piece of calligra-

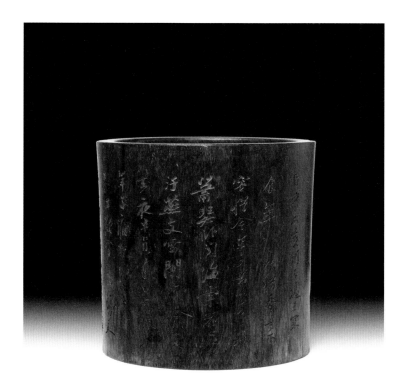

phy of all, Wang Xizhi's "Orchid Pavilion Preface". An extract from it, taken from the Tang copy by Feng Chengsu, decorates item 67 in this volume. It would have made a fitting choice for the brush pot, but its length ruled it out.

The second finest piece of running script, "Draft of a Requiem for My Nephew" by the Tang calligrapher Yan Zhenqing, presented its own difficulties. It commemorates Yan Jiming, the young son of the writer's cousin Yan Gaoqing, who was killed along with his father by the army of the rebel general An Lushan. Yan's emotional tribute to the young boy is justly famous. But, as the title suggests, it is a draft, and Yan's many revisions and alterations to the text would make it a challenge to carve.

In the end, I chose Su Shi's "Poems on the Cold Food Festival", widely acknowledged as the third finest piece of running script (Fig. 70.1), whose dimensions made them a perfect match for the pot. Like many of the works that appear in this book, the "Poems" were part of the "Precious Collection from the Stone Moat", the collection of calligraphy and painting assembled by the Qianlong Emperor in the 18th century.

When Su wrote the two poems that make up the piece in spring 1082, he was in the third year of a period of exile in Huangzhou, Hubei. It was a time of great personal difficulty, but as they say, "hard times make the poet". I have seen the original "Poems" at the National Palace Museum in Taipei, and I can say without hesitation that they are Su Shi's finest works of calligraphy. His friend and fellow calligrapher Huang Tingjian agreed: the scroll closes with a colophon by him, which praises Su's work in glowing terms.

It was not just the size of the "Poems" that made them such a good fit for this pot. The content of the two poems and the style of Su's calligraphy also marry beautifully with the deep, rich grain of the *huanghuali*. Setting the scene, Su describes the heavy spring rains blanketing Huangzhou. It is

a grim vision, full of foreboding, and it is answered by the yellow-brown, almost painterly quality of the wood. Looking at the pot, one sometimes catches glimpses of the rain on its surface. It seems to loom there, reminding me of the splash-ink storms in Fu Baoshi's landscapes from his time at Jingangpo. Su's writing is heavier than most other calligraphers, and the slightly thicker strokes are perfect for *huanghuali*, whose coarse grain is not well suited to normal running or standard script, with its graceful, slender lines.

Wang Xizhi—see notes to the Author's Preface.
 Yan Zhenqing—see notes to item 69. The piece referred to is the "Jizhi wen gao" (祭侄文稿), written in 758, and Yan's relatives are respectively 顏季明 and 顏杲卿 (both d. 755).
 An Lushan—安祿山 (703–757). An, a Central Asian general in the service of the Tang court, rose in rebellion in 755. His revolt, which continued after his death and was only finally suppressed in 763, is generally held to have fatally debilitated the Tang dynasty, which survived in a weakened state for a further 150 years.
 Su Shi—see notes to item 63. Su's exile in Huangzhou (黃州), the first of two periods of banishment during his career, were the result of an intense factional battle at court, in which he had criticised the policies of the reformist group.
 Precious Collection from the Stone Moat—shiqu baoji (石渠寶笈). The name applies to both the collection and its catalogue, compiled in three parts between the 1740s and the 1810s.
 Huang Tingjian—see notes to item 72.
 Fu Baoshi—see notes to items 48–50.

071

Inscribed plaque

2011
Text: "The Studio of Bitter Rains"
Calligraphy: Su Shi (Song dynasty)
Carving: Fu Jiasheng
Rubbing: Fu Wanli

The original Studio of Bitter Rains belonged to the essayist and translator Zhou Zuoren, the brother of the legendary writer Lu Xun. After he chose the name, his friend

Shen Yinmo wrote a calligraphic version for him. This came up for auction in 2011. Tung Chiao fell in love with it, but he was not able to acquire it.

To make up for this disappointment, I decided to make a replacement for Tung. Happily, the perfect solution was on hand in the form of Su Shi's "Poems on the Cold Food Festival", which Fu Jiasheng had carved for me the year before (see item 70). The first two characters of the studio name (*kuyu* 苦雨, "bitter rains") appear in the "Poems", and we were able to enlarge them and use them as the basis for a new version of the Shen Yinmo calligraphy. We borrowed the final character, "studio" (*zhai* 齋), from one of Su's other works, and Fu carved the whole phrase onto a piece of wood left over from a table I had commissioned (see the Heavenly Numbers Tables, items 95 and 96). The result was this small plaque, which bears the studio name in intaglio with slight elevations in the centre of the brush strokes. To accompany it, I asked Fu Wanli to take a rubbing. Su Shi's calligraphy looks very different, but no less compelling, in this medium.

The plaque and rubbing seemed appropriate for a special occasion, so I gave them to Tung for his 70th birthday. Later, I was delighted to find a reference to them in his essay collection *Happy Writing*, which he published in 2012. It seems they were the right gift.

Zhou Zuoren…Lu Xun—respectively 周作人 (1885–1967) and 魯迅 (the pen name of Zhou Shuren 周樹人, 1881–1936).

Shen Yinmo—see notes to item 50.

Happy Writing—*Yizhi pingan* (一紙平安, Oxford University Press). The original title is a pun on *yilu pingan* (一路平安, "bon voyage" or "happy landing"). The essay in question is "Kuyu jishi" (苦雨紀事).

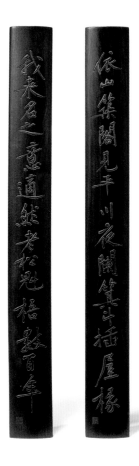

072

Pair of scroll weights

2012
Decorated with the first four lines of "The Pavilion of Wind in the Pines" (text and calligraphy by Huang Tingjian, Song dynasty)
Carving: Fu Jiasheng
Rubbing: Fu Wanli

Inscribed plaque

2020
Decorated with the title of "The Pavilion of Wind in the Pines" (text and calligraphy by Huang Tingjian, Song dynasty)
Carving: Fu Jiasheng
Private collection, China

From two pieces of calligraphy by Su Shi, we now turn to one by his close friend Huang Tingjian. These scroll weights are decorated with the first four lines of Huang's "The Pavilion of Wind in the Pines at Wuchang", written in his own hand. I once saw the original of this piece at the Palace Museum in Taipei, and it is notable for the fine, pastel-coloured decorative paper on which it is executed (Fig. 72.1).

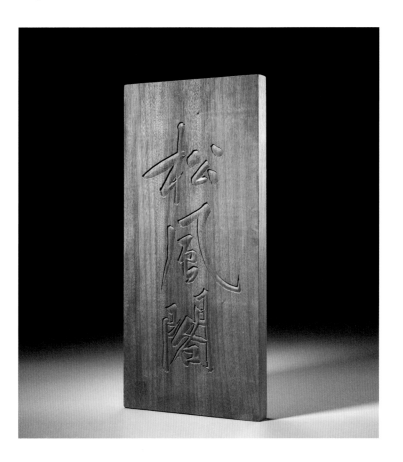

Huang and Su famously enjoyed gently mocking each other's work, and their polar opposite calligraphic styles were a source of much merriment. Huang compared the appearance of Su's thick, full-bodied brushwork to "a toad squished by a rock", while Su likened his friend's thinner, more elongated strokes to "snakes hanging from tree branches". We might not share these withering assessments, but the difference is stark, as these four items show.

Su Shi…Huang Tingjian—see notes to items 63, 70, and 71.
 The Pavilion of Wind in the Pines at Wuchang—the long title is "Wuchang Songfeng ge" (武昌松風閣).

073
Pair of scroll weights

2007
Decorated with the first two lines of "In My Little Case"
(calligraphy by Mi Fu, Song dynasty)
Carving: Fu Jiasheng
Rubbing: Fu Wanli

Bamboo wrist rest

2009
Decoration as above, executed in *liuqing* relief
Carving: Zhu Xiaohua

The piece that decorates these items brings together two of the great masters, the Tang dynasty monk-calligrapher Huaisu and Mi Fu, the Song calligrapher whose work we have encountered several times in these pages. Huaisu was an expert in the free-ranging "wild cursive" style, while Mi made his name with his mastery of the "tipside" method of brushwork, which allows close control over the thickness of each stroke.

As well as his achievements in calligraphy, painting and poetry, Mi was also an important collector, and he amassed a number of works by Huaisu. In the two lines quoted here, he discusses one of them, asking the poet Liu Jisun: "How do you rate the piece of Huaisu that I keep in my little case? It was once in the hands of the Lis of Changan" (Fig. 73.1). The Li family were a branch of one of the great aristocratic clans of the Tang dynasty, so it is no surprise that Mi's tone is so self-satisfied: he is describing not just a work by a great calligrapher, but one with impeccable provenance.

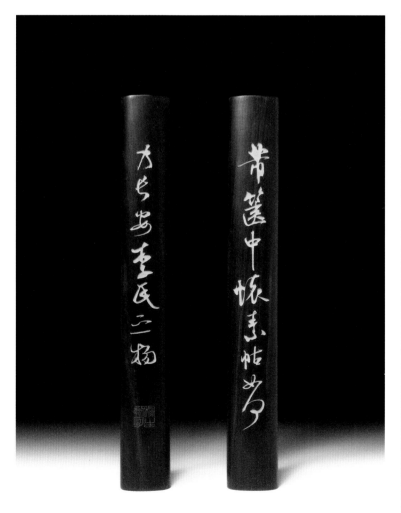

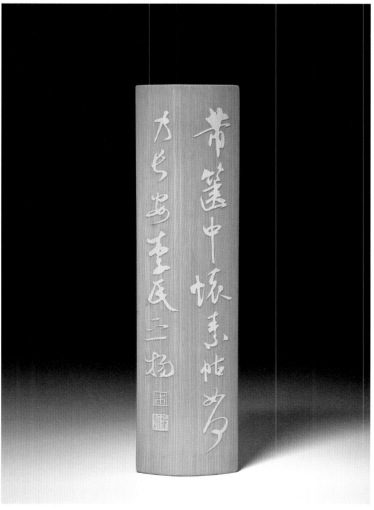

I saw Mi's original calligraphy in 2007 at the Palace Museum in Taipei, and I commissioned the scroll weights from Fu Jiasheng shortly afterwards. The wrist rest followed two years later. It was carved by Zhu Xiaohua in *liuqing* relief: yet another example of "reversing *yin* and *yang*".

Huaisu—懷素 (8th century). "Wild cursive" (*kuangcao* 狂草) calligraphy, of which he was among the most notable exponents, is characterised by exceptionally free, even illegible brushwork.

Mi Fu—see notes to items 63 and 65. In the "tipside" or "oblique attack" (*cefeng* 側鋒) technique, strokes are executed with the brush bent or angled, with different degrees of bend producing variations in the thickness of the line.

Liu Jisun—劉季孫 (1033–1092), sometimes known as Liu Jingwen (劉景文), his courtesy name. The piece takes the form of a letter to Liu, hence its alternative title, "Letter to His Excellency Jingwen of Xizhou" (*Zhi Jingwen Xi gong chidu*, 致景文隰公尺牘). The magistracy of Xizhou (隰州) in Shanxi was Liu's last official post. Below, the Li family of Changan are the *Chang'an Li shi* (長安李氏).

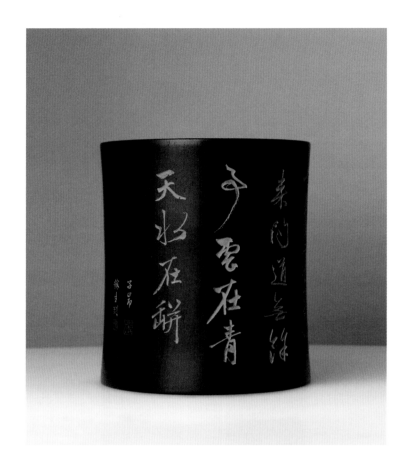

074
Brush pot

2006
Decorated with "Refining my bodily form"
(text by Li Ao, Tang dynasty; large running script calligraphy
by Zhao Mengfu, Yuan dynasty)
Carving: Fu Jiasheng
Rubbing: Fu Wanli
Private collection, Hong Kong

The Zhao Mengfu scroll reproduced on this piece (Fig. 74.1), now held in the Palace Museum in Beijing, takes as its text a poem by the Tang writer and thinker Li Ao. In it, Li describes questioning a master for information about the Way, the true path that guides the actions of the enlightened:

> *Your body so refined in form*
> *its limbs are like a crane's;*
> *With you, under endless pines,*
> *two caskets filled with scriptures.*
> *I asked you how to understand*
> *the Way. You simply said:*
> *"The clouds that deck the azure sky;*
> *the water in this crock".*

Li's poem is most famous for its final line, which has become proverbial for its assertion that the Way or Dao is visible in the everyday world. Alongside this Daoist insight, the text also has strong resonances with early Chinese medical theories. Li's depiction of the master in the first two lines shows us someone both physically robust, his body lithe and trim like a crane, and intellectually sharp, ready to grapple with the mysteries of the scriptures. In insisting that bodily

and mental strength belong together, Li echoes the great physician Sun Simiao's concept of "nurturing life". Sun couples "exterior work" designed to strengthen the physique with "interior work" focused on mindfulness and the individual's internal world. The former is clearly emphasised in the first line of the poem: without physical training and healthy eating, the hallmarks of "exterior work", a body "like a crane's" would be impossible. In the second line, "interior work" comes to the fore – in this case, developing the spirit through engagement with the sacred texts. In the search for the Way, both kinds of work are important, and each feeds and supports the other.

Seen from this perspective, Li's poem is not, as one might first think, a description of being shown the Way. Li does not visit the master and receive a clear answer. Instead, it is about the training that allows one to find the Way oneself. The final line tells us what that training leads to: the ability to see the Way in a few clouds and a pitcher of water. With enough clarity of mind and with barriers to awareness removed by self-cultivation, this is all that is needed. Everything else can be cast aside: a kind of post-materialism *avant la lettre*.

Zhao Mengfu—see notes to items 60–62 and 64.

Li Ao—李翱 (late 8th–mid 9th century). Writer and philosopher.

Sun Simiao—孫思邈 (581[?]–682). Physician and medical theorist sometimes referred to as "the medicine king" (*yaowang* 藥王). Below, "nurturing life" is *yangsheng* (養生); exterior and interior work are respectively *waigong* (外功) and *neigong* (內功).

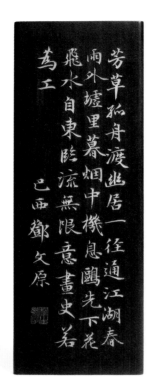

Deng Wenyuan—see notes to item 4. For Zhao Mengfu and Ni Zan, see notes to items 19, 60–62, 64, 76, 77, and 78, respectively. The other calligraphers referred to are 張雨 (1283–1350), 王蒙 (1308–85) and 陸繼善 (Yuan dynasty, dates unknown).

075
Granadilla scroll weight

2007
Decorated with "Fragrant Grass"
(calligraphy by Deng Wenyuan, Yuan dynasty)
Carving: Fu Jiasheng
Rubbing: Fu Wanli

The style of a piece of calligraphy is always to some extent a product of its time. The effect of changing styles is visible not just in art calligraphy done with a brush and ink but in everyday writing with a pen as well. Ask a person born in the 1980s or '90s to write you something in ordinary, simplified script, for instance, and compare it to the same thing written by someone thirty years their senior. The text will be unchanged, but the composition of the characters and the way the writer handles curves and bends in the strokes will tell you instantly which generation they come from.

Small regular script of the kind seen on this item (Fig. 75.1) could only be a product of the Yuan period. The simplicity and elegance of the writing sets it apart even from stylistic cousins, such as the sutra copies of the High Tang, which are noticeably more vigorous and forceful in their brushwork. Deng Wenyuan, the writer here, is clearly working in the same vein as contemporaries like Zhao Mengfu and Ni Zan, whose calligraphy we have already encountered in these pages. There are also clear parallels between his work and that of other Yuan masters like Zhang Yu, Wang Meng, and Lu Jishan.

curves and bends in the strokes—some commentators have ob-

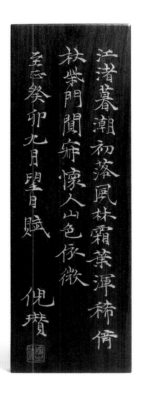

076
Dalbergia louvelii scroll weight

1999
Decorated with "Evening Tide on the Riverbank"
(calligraphy by Ni Zan, Yuan dynasty)
Carving: Fu Jiasheng
Rubbing: Fu Wanli

This scroll weight was the first wooden scholar's object I ever commissioned. It is decorated with a poem by Ni Zan, in which he describes standing by a river, longing for an absent friend.

I discovered Ni's poem during my days as a doctoral student at Oxford, when I stumbled across it while browsing the Metropolitan Museum's catalogue of Chinese calligraphy and painting. It was written as an inscription for one of Ni's paintings, *Wind Among Trees on the Riverbank* (Fig. 76.1), but I thought it would work equally well as a standalone text on a scroll weight. I wrote to my friend Tian Jiaqing to share my idea, saying I was interested in making a *zitan* scroll weight. He offered to provide the wood, which was very generous, given how hard it is to obtain. I asked Fu Jiasheng to carve the text. While this was being done, Tian had his own

version of the weight carved by one of the carpenters at his Aotu Studio. This second version is almost identical to my own, except that it carries the signature of the carver, added at my request after it was finished.

Ni Zan—see notes to item 19.
　　Tian Jiaqing—see notes to items 86–88, 90–92, and 94.

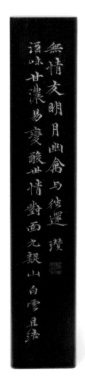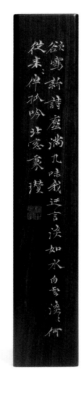

077
Pair of granadilla scroll weights

2007–8
Decorated with "Poem from a Plain Cell"
Text and calligraphy: Ni Zan (Yuan dynasty)
Carving: Fu Jiasheng
Rubbing: Fu Wanli

Some calligraphers change their style from one work to the next, while others have a trademark, a way of writing that they return to time and again. Ni Zan belonged to the latter group. The majority of his calligraphy is written in small characters in regular script (in which the components of each graph are written in full, with no shortcuts or simplifications). In "Poem from a Plain Cell", Ni breaks the mould. The characters here are far larger than usual, and in place of standard forms he switches to "running" script, in which some brush strokes are fused, and the characters begin to flow into one another (Fig. 77.1).

In this item, the two stanzas of Ni's poem are divided be-tween a pair of scroll weights. The pattern that Fu Jiasheng and I chose for the carving, the so-called "dragon's gate", arranges the text into four columns: a pair of long outer columns flanking two shorter ones. Ni begins by describing the moment when, sitting alone in an austere, plain room, he decided to write out a poem he had composed:

I went to write my new lines down,
*　　but dust engulfed my desk.*
I saw my high-flown words for what
*　　they were: insipid, weak.*
The clouds are pale and light. What path
*　　has brought them to my side,*
While I sit beside the northern
*　　window at my work?*
We favour deep, sweet wines, but these
*　　can sour in a trice.*
I face the world, a traveller
*　　before the Nine-Doubt Heights.*
Now the clouds are gathering,
*　　my cold, unfeeling friends,*
To meet the moon and distant birds
*　　that pass them in the skies.*

Ni lived a fascinating life, full of ups and downs. (I have found Huang Miaozi's discussion of him in "Notes from a Reading of Ni Zan's Biography" to be a particularly useful introduction.) He was a highly respected man, able to with-draw from the world and live the life of quiet seclusion that so many have coveted down the centuries. But it was not all smooth sailing: on one occasion, Ni, who had fallen out of favour with the authorities in his hometown, found himself thrown into prison. He seems to have had a clear sense of the fickleness of people and events, a point driven home by his description of fine wine "souring in a trice".

The same sense of precariousness lies behind Ni's ref-erences to the clouds in the poem's third and seventh lines. An old saying, to which Ni's choice of image clearly alludes, compares the highs and lows of life to the ever-changing, un-predictable clouds, which look "now like white robes, now like grey dogs". Ni's personal circumstances meant that he felt this more keenly than most. Born into a wealthy fam-ily, he was known for the many beautiful buildings he had constructed on his estate, a serene, spacious haven, remote from the cares of the world. In the early 1350s, however, Ni changed his life beyond recognition. He parcelled out his possessions and began living on a houseboat, dividing his time between Lake Tai, the great lake on the Jiangsu-Zhejiang border, and the Mao Lakes to its east. Shortly afterwards, the decision was made to look prescient: a rebellion broke out in the region, and the whole estate was destroyed in the fighting.

No doubt many readers will recognise Ni's portrait of a capricious, mercurial world in "Poem from a Plain Cell". For me, the poem recalls the fate of one of the 20th century's great collectors, Zhang Boju, who figured in the history of several of the artworks in this book. By the time he was 50, Zhang had amassed an extraordinary group of treasures running from the Jin dynasty in the third century, to the

Yuan a thousand years later. He owned Lu Ji's "Letter on Recovery" (see item 8), the Sui painter Zhan Ziqian's masterwork *Spring Excursion*, and Du Mu's "Poem for Chanteuse Zhang" (see item 68), along with another priceless Tang piece, Li Bai's "Written on Shangyang Terrace". From the Song period, he had an unrivalled collection of calligraphy, including Cai Xiang's "Poems in My Own Hand", Huang Tingjian's "Elder Monks", Mi Fu's "Coral" and "Returning to Office" and Fan Zhongyan's "Ode to a Monk's Robe"; and from the Yuan, a cursive-script copy of the *Thousand Character Classic* by Zhao Mengfu.

In the 1950s, Zhang gifted his collection to the young People's Republic of China. From there, however, his life took a turn for the worse. Writing about his relationship with Zhang in *A Third Lovely Ash-Heap*, Wang Shixiang describes his fate during the Cultural Revolution: "In 1968, he was sent down to the countryside, to Shulan County in Jilin, but the authorities there turned him away. He had no option but to return to Beijing as an 'unemployed vagrant', and he had to rely on relatives and friends for everything, even grain coupons." It was a cruel fall from grace and an all-too-real example of a maxim from the Diamond Sutra: "there is one law to all things: that they are like a dream, an illusion, a bubble, a shadow. They are like dew and they are like thunder. This is the way to look at things." Confucius famously asserted that, "To me, wealth and rank are like floating clouds." Perhaps it was something like Zhang's story that made him so wary.

dragon's gate—the *longmen* (龍門) pattern. The arrangement of the four columns resembles the character 門 (*men*, "gate").

I went to write…that pass them in the skies—a sense of ambivalence hangs over Ni's poem, which in the Chinese draws much of its force from a series of artful repetitions and variations of key terms. The "plain" room of the title is matched by the "weak" words and "pale" clouds of the second and third lines, all of which are described with the same term, *dan* (淡, "plain, mild, light, calm"). The recurrence of another food word, *wei* (味, "flavour, taste"), elided in the translation, binds together the second and fifth lines. (Ni refers to his re-examination of his new poem as an act of "tasting", leaning on the original sense of *dan* as "unsalted" or "mild-flavoured", while the wines of line five are literally "deep-, sweet-*flavoured*.") In lines six and seven, the polyvalent *qing* (情) links the dizzying "state" or "ways of the world" (*shiqing* 世情) and the "unfeeling" or "insensible" (*wuqing* 無情) clouds, which have themselves devolved from the welcome companions of line three to something more ambiguous.

the Nine-Doubt Heights—the Nine-Doubt or Jiuyi Mountains (*Jiuyi shan* 九嶷山 or 九疑山) in Hunan, so named for their multitude of near-identical peaks, among which unsuspecting travellers can easily lose their way.

Notes from a Reading of Ni Zan's Biography—讀倪雲林傳札記, from Huang's 2011 *A Branch in the Forest of the Arts* (for which, see notes to item 43).

an old saying in Chinese—the original phrase, describing clouds as "white robes, then grey dogs" (*baiyi canggou* 白衣蒼

狗), or a variant, "white clouds and grey dogs" (*baiyun canggou* 白雲蒼狗).

Zhang Boju was a significant 20th-century collector—for Zhang, see notes to item 8. The individual artists and works mentioned (excluding those noted in the body text) are:

Zhan Ziqian: 展子虔 (fl. late 6th–early 7th centuries) – 遊春圖
Li Bai: 李白 (701–62) – 上陽臺帖
Cai Xiang: see notes to item 69 – 自書詩卷
Huang Tingjian: see notes to item 72 – 諸上座帖
Mi Fu: see notes to items 63 and 73 – 珊瑚帖 and 復官帖
Fan Zhongyan: see notes to the Author's Preface – 道服贊
Zhao Mengfu: see notes to item 60–62, 64, and 74 – 千字文

In 1968…grain coupons—the quotation is taken from an essay entitled "A Few Events from My Association with Zhang Boju" (與伯駒先生交往三五事).

Diamond Sutra—Jingang jing (金剛經). The earliest complete, dated, printed book currently known is a copy of this sutra from an 868 printing, discovered at Dunhuang and later removed to the British Library in London.

To me…floating clouds—Analects 7.16.

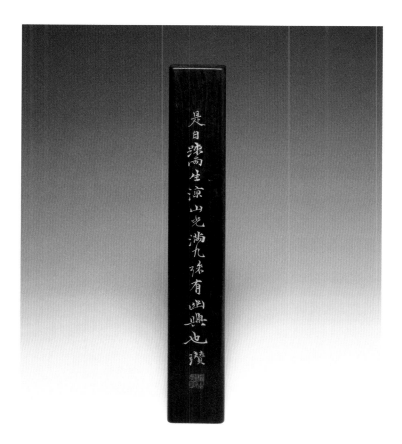

078

Granadilla scroll weight

2007
Decorated with "Postscript to 'Poem from a Plain Cell'"
Text and calligraphy: Ni Zan (Yuan dynasty)
Carving: Fu Jiasheng
Rubbing: Fu Wanli
Collection of Jin Yong

Ni Zan's calligraphy of "Poem from a Plain Cell" was gifted to the nation by Ding Xierou in 1959. On the original scroll, a short postscript follows the poem (Fig. 78.1), and I chose the last three sentences for this scroll weight: "Today a fine rain brought cool weather. The light from the mountains engulfed my desk. All was tranquil." It is a wonderfully refined conclusion.

Drizzle or light rain might seem like an unpromising subject for poetry, but Ni Zan was not alone in elevating it into great art. Three hundred years earlier, Su Shi had set the bar high in his "Wandering Between Temples on the Dragon Boat Festival":

> A little rain
> > falls in fits and starts;
> The narrow window
> > turns from dark to fair.
> Within a bowl of hills,
> > no sun in sight,
> Grass and trees
> > grow green all by themselves.

For Ni to have matched Su, as he does in this postscript, was a remarkable literary achievement.

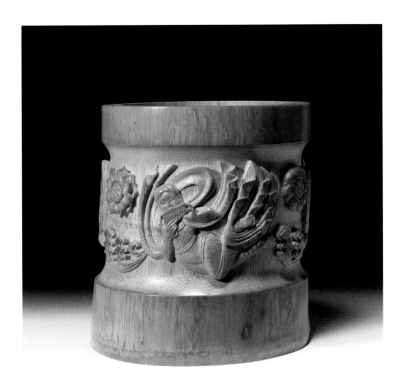

Ding Xierou—丁燮柔 (1903–1986). Ding and her sister Pan Dayu (潘達于, 1906–2007) were major benefactors of the Shanghai Museum. Both were married to members of the influential Pan family, but Ding remains better known by her maiden name.

Su Shi—see notes to items 63, 70, and 71. The poem quoted is "Wandering Between Temples on the Dragon Boat Festival – a poem on the rhyme word 'Zen'" ("Duanwu bianyou zhusi de chanzi" 端午遍遊諸寺得禪字).

Jin Yong—金庸. Pen name of Louis Cha (查良鏞, 1924–2018). Long the most popular living Chinese writer, Jin's martial arts novels, most of which were initially published in serial form, are a cultural touchstone for millions of readers across the Sinophone world.

079
Bamboo brush pot

2011
Decorated with high relief of *apsarās* in the form of musicians
Carving: Zhou Hansheng

Apsarās, Buddhist water and cloud spirits, are a regular subject of Chinese, Indian and Southeast Asian art. Often they are represented as female musicians or dancers. The story of the *apsarā*'s origin and spread to China is a fascinating one. It is unfortunate that perhaps the best work on the subject, *Apsarā Art: From India to China* by Zhao Shengliang of the Dunhuang Research Academy, is not yet accessible in English.

I have seen several fine Chinese examples of *apsarās* over the years, but two in particular stand out: an impressive stone carving from the Northern Wei depicting an *apsarā* playing the *pipa* lute, which I saw during a visit to the Victoria and Albert Museum in the 1990s (Fig. 79.1); and a marvellous set of *apsarās* from the aureole of a Northern Wei Buddha statue, part of an important hoard of statuary excavated at the site of Longxing Temple in Qingzhou, which I discovered somewhat later (Fig. 79.2). In 2016, after this brush pot was finished, I saw a striking modern depiction on the exterior of the massive Xi'an People's Hotel, built in the 1950s (Fig. 79.3).

I first saw the material for this pot, a large bamboo tube, on a visit to the carver Zhou Hansheng's house in Wuhan in 2008. I was not immediately sure how to use it, but two years later I had a flash of inspiration, and I asked him to turn it into a brush pot decorated with *apsarās*. He wrote back to me with his ideas for the piece:

> I plan to place the apsarā designs around the middle of the pot, making a band of carvings inset deep into the surface (a technique borrowed from ancient Egyptian and Chinese cliff carving). Above and below the band I will leave two sections of plain bamboo. Although I will be carving in high relief, I should be able to avoid damaging the material, and this method will allow me to capture the rough-and-ready feel of the original stone carvings.

I agreed, and Zhou set to work drawing up a design. In his next letter a month later, he included initial drafts of three *apsarās*, one playing the pipa, one the konghou harp and one the panpipes. He also described how he planned to arrange them:

> They will follow each other in a circuit around the pot, allowing them to be viewed in any order...with a

lotus flower and a cloud pattern, both common in the Wei and Jin periods, between each figure. I will work to ensure that the principal and subordinate elements of the design complement each other and create a coherent whole.

Zhou proposed using the same lotus design between each of the three *apsarās*, but I felt it would be better to have some variation. In my reply, I sent him two other lotus designs, one from a Tang mirror and another from a recessed caisson ceiling from the same period at Dunhuang.

Now that we had a design, Zhou could start carving. He had not made things easy for himself. The section of bamboo he was working with had two nodes, where segments of the stalk meet. These are notoriously difficult to carve. As he told me:

> *At the nodes, the bamboo fibres abruptly change direction, requiring careful, moment-by-moment adjustments in the direction of the knife while carving. This problem is exactly why previous generations of carvers avoided using segments of bamboo with nodes.*

It may have been difficult work for Zhou, but the completed carving is worth the effort. It is a masterpiece.

the Dunhuang Research Academy—the *Dunhuang yanjiuyuan* (敦煌研究院). Zhao Shengliang (趙聲良, b. 1964) is its director, and the book mentioned is his 2008 *Feitian yishu: cong Yindu dao Zhongguo* (飛天藝術: 從印度到中國).

the site of Longxing Temple—referring to Longxing si (龍興寺) in Qingzhou (青州), Shangdong, a major temple active from the Northern Wei period until its destruction during the Ming dynasty. The large hoard of primarily first-millennium statuary unearthed from the site in the 1990s is among the most important finds of its type.

080
Aloewood brush pot

2013
Decorated with a perching cicada
Carving: Zhou Hansheng

The brush pot used in this item was bought new in 2012. It had been made by hollowing out a large section of wood, and the unworked exterior looked just like the trunk of a tree.

My initial plan was to decorate the pot with a sprig of plum blossom, but this changed when I brought it to Zhou's house in March 2013 to finalise the commission. During the visit, I noticed a bamboo carving of a cicada. Zhou told me that it was meant for mounting on a scroll weight, but when I came back the next day, I found that he had stuck it to the side of the brush pot. He suggested mounting it properly with a small tenon, then planing the other side of the pot flat and inscribing a poem on it. I told him it was a wonderful idea.

Ten days later, Zhou showed me the poem he had composed for the pot, a delightful quatrain about the cicada:

> *Perched on high*
> *to strum its daily tune,*
> *A sole cicada*
> *calls in clear, pure tones.*
> *Settled on*
> *this aloe tree of mine,*
> *For whom does it*
> *intone its wistful song?*

I proposed two minor revisions to the first couplet of Zhou's draft, swapping out a pair of characters that he had used for synonyms that I thought would be more comprehensible to contemporary readers. To decide between the two versions, we sent both to Tung Chiao for his advice. He suggested we use the revised text but, to keep things simple, that we carve only the first two lines. We agreed, and Zhou carved the text in Han dynasty clerical script. The additional carving on the base of the pot – my maker's mark, along with two of my seals – was added by Fu Jiasheng.

Cicadas are a common subject in Chinese carving, appearing in styles ranging from impeccably realistic to more suggestive and schematic. Some of the best examples in private hands belonged to Fu Zhongmo, Fu Xinian's father, as part of his collection at Peide Studio. He owned a trio of Han dynasty jade cicadas, all rendered with just a few simple features (Figs 80.1 and 80.2), as well as another carving from the same period that is closer in style to Zhou's work.

Other cicada carvings adopt different but no less satisfying approaches: a Ming dynasty gold cicada on an agate leaf in the Nanjing Museum (Fig. 80.3); a Qing bamboo brush rinser in the Palace Museum, decorated with a cicada among grapes in winter (Fig. 80.4); a white jade brush rinser from the same period in the Palace Museum in Taipei, decorated with an autumnal cicada on the leaf of a wutong tree (Fig. 80.5); and a small ivory and hawksbill turtle shell cicada from my own collection (Fig. 80.6). All are delightful variations on the cicada theme.

Fu Zhongmo—傅忠謨 (1905–74), an important scholar, the son of Fu Zengxiang and father of Fu Xinian (see notes to item 8 and passim). The studio mentioned is his "Studio of Girding on Virtue" (*Peide zhai* 佩德齋).

081
Inkstone and case

2015
Lid inscribed with the text of a Qing circular ink pellet
Carving: Li Zhi
Rubbing: Zhang Pinfang

The decoration on the lid of this inkstone case comes from a Qing dynasty round ink pellet, given to me by Tung Chiao. About the size of a Hong Kong two-dollar coin, the pellet, whose history Tung describes in his 2006 book *Simply Stories*, carries three inscriptions. The first, on the top face, is copied from a tile-stop, the circular end-tile that decorates the eaves of a traditional Chinese roof. The text, executed in relief in seal script, reads *chang wu xiangwang* (長毋相忘, Fig. 81.1), a common inscription meaning, "May we never forget each other", or sometimes, "Forget me not".

On the reverse, a circular seal-script inscription in gold-inlaid intaglio reads, "Jointly made by Sima Dafu and Cheng Yeyuan" (Fig. 81.2). A final inscription on the edge of the pellet, rendered in standard script in relief, reads, "Made in the Qianlong era of the Great Qing dynasty" (Fig. 81.3), suggesting a date of manufacture in the 18th century. The pellet's box adds another layer of history. A seal on the lid declares that the contents were "appreciated by [Pu] Xuezhai", suggesting it was previously owned by a cousin of the last Qing emperor, Pu Yi.

The inkstone and its wooden case, which was originally undecorated, came to me from Hui Lai Ping of Han Mo Xuan. He had acquired it years before, from a Mr Huang of the Daya Studio on Hong Kong's Hollywood Road. When I first saw it on his desk, I was struck by how imposing it looked, in no small part because of its size: a full foot in diameter, unusually large for an object of its kind. I loved the simple, turned lid, with its gentle, elegant slope. I was delighted when Hui, ever generous, agreed to part with it.

The notion of combining the ink pellet and the inkstone did not come to me until several years later. Even then, the idea took some time to realise. Copying the decoration onto the case was a painstaking task that took Li Zhi, the carver, six months to complete. It was, however, undoubtedly worth the wait. The case is a perfect complement to the pellet, and they work together beautifully.

Simply Stories—Tung's own translation of the title of his 2006 *Gushi* (故事, Oxford University Press). The ink pellet is discussed in an essay entitled "Like a Stone" ("Ru shi" 如石").
 Sima Dafu and Cheng Yeyuan—respectively, the scholar-collector 司馬達甫 (mid-18th to early 19th century) and the calligrapher and ink-maker Cheng Zhenjia (程振甲, 1759–1826), who went by the alternative name Yeyuan (也園).
 Pu Xuezhai—溥雪齋 (1893–1966[?]). Occasionally known by his birth name, Pujin (溥伒), Pu was a skilled painter and player of the *guqin*. He appears to have been an early victim of the Cultural Revolution, although no body was ever found following his disappearance from his home in Beijing in August 1966.
 Daya Studio—*Daya zhai* (大雅齋), "Studio of Great Elegance". The proprietor's name in Cantonese is Wong (黃).

082
Huanghuali brush pot

2016
Decorated with inscription text from a Han dynasty mirror
Calligraphy: Huang Miaozi
Carving: Li Zhi
Rubbing: Zhang Pinfang

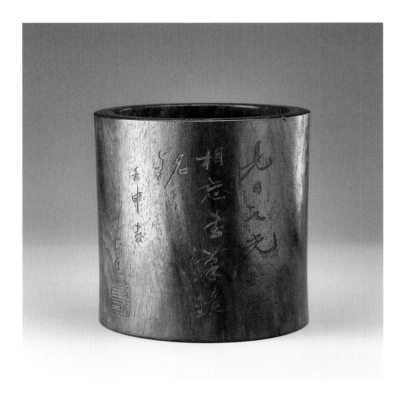

grass-and-leaf pattern—caoyewen (草葉紋). A common form of decoration on early bronze mirrors, in which leaves alternate with stylised ears of grass or wheat.

Huang Dawei—黃大威 (b. 1947). The second of Huang's three sons.

Wang Wei—See notes to the Author's Preface. The poem is his "Xiangsi" (相思). Though not named specifically, the bean "that grows in southern realms" (*sheng nanguo* 生南國) may be the red seed of the Taiwan acacia (*Acacia confusa*), which grows extensively along China's south-east coast.

083

Inscribed plaque

2014
Text: "Grand and profound"
Calligraphy: Pu Ru (1896–1963)
Carving: Fu Jiasheng
Private collection, Hong Kong

The phrase "Forget me not", which decorates the ink pellet in item 81, appears on many early Chinese objects. One, a Western Han "grass-and-leaf pattern" mirror in the collections of the Palace Museum (Fig. 82.1), extends the image of yearning into a couplet:

As long as you behold the sun so bright,
I pray that you will e'er forget me not.

This brush pot uses the longer inscription. The calligraphy is taken not from the mirror itself, but from a version of the couplet on square paper by Huang Miaozi, given to me by his son, Dr Huang Dawei (Fig. 82.3).

In the West, one of the best-known symbols of yearning is the tiny, blue Myosotis flower, commonly called the forget-me-not. An almost identical flower, the *Cynoglossum*, is grown in China, in Tibet, Yunnan, Guizhou, and Gansu. However, it has never had the same significance as that of *Myosotis* in the West. Instead, the emblem of love and fidelity in China is the red bean, which famously appears in one of Wang Wei's most popular poems, "Yearning":

The crimson beans
that grow in southern realms:
When spring arrives,
how many sprays come through?
I wish that you
would gather plenty up:
They show you yearn
for me, and I for you.

It was this image that Wang Shixiang had in mind when he gave Yuan Quanyou a *hongmu* box with a bottle gourd lid, filled with red beans, during their courtship (Fig. A. 7, item 33). I have always thought that that was a wonderfully original idea. In the same vein, I can imagine this brush pot, the ink pellet, and the inkstone and case serving as Valentine's gifts: a promise of fidelity writ large.

"Grand and profound" (*hongyuan* 鴻遠), the phrase that appears on this plaque, is used to describe something of deep moral importance. A great sage's thoughts, the impact of righteous government on the people – both can be said to be *hongyuan*. It is an appropriate topic for a monumental piece of art, and that is just what Pu Ru gives us here. The calligraphy is executed in placard script, a form of large characters commonly seen on the name boards of palace buildings, and the original scroll measures 85cm by 166cm, mammoth proportions for text of only two characters. Sa Benjie's appraisal of the piece captures it perfectly:

Working at scale, Pu has managed to write characters that are at times thin and at times full-bodied, that balance emptiness with substance, which are both majestic and lively, and which are taut without seeming constrained. We could hang the piece on the walls of a great hall in the imperial palace, and it would lose none of its power. Why? Because of the assurance with which Pu writes.

This carved version of Pu's calligraphy was created by Fu Jiasheng using wood left over from the making of the two Heavenly Numbers Tables (see item 96). It seemed fitting that a piece of calligraphy written in the style of a plaque should actually become one.

Sa Benjie's appraisal—in his remarks on Pu Ru's calligraphy in his 2008 monograph *The Last Generation of Royal Customs: Pu Xinyu* (*Modai wangfeng: Pu Xinyu* 末代王風: 溥心畬). For Sa and Pu themselves, see notes to item 30.

emptiness…substance—the balance between these two poles, *xushi* (虛實, "emptiness-substance"), is one of the most important concepts in traditional Chinese art criticism. In the context of calligraphy, it refers primarily to the division between blank space and ink on the page.

084
Set of 12 bamboo wrist rests

2009–10
Decorated with *liuqing* reliefs of
"*Plants from an Autumn Garden*" (Pu Ru, 1896–1963) and
"Postscript and Poems on Fallen Flowers" (Qi Gong, 1912–2005)
Carving: Bo Yuntian
Rubbing: Fu Wanli

085
Set of 12 granadilla scroll weights

2011
Decoration as above, executed in intaglio
Carving: Fu Jiasheng
Rubbing: Fu Wanli

On a visit to his home in 2005, Tung Chiao showed me one of his most prized possessions: *Plants from an Autumn Garden*, an album of ink paintings by Pu Ru (Figs 84.1–84.6). He had collected its contents – six leaves, each depicting a wild plant against a plain background – over a number of years. Eventually, he had decided to have them mounted into a single volume, rounded out with a postscript by the curator and artist Jiang Zhaoshen (Fig. 84.7).

When I saw the album, I was immediately struck by the resemblance of Pu's paintings to the botanical illustrations in Western works of the 18th century. Pu would almost certainly have encountered these during his time in Europe (His student days in Germany, where he took a joint degree in astronomy and biology, are detailed in Sa Benjie's biography.) It also occurred to me that the six leaves would be perfect for carving on bamboo. Their style – flowing, "iron-wire" lines

infilled with colour – made them ideally suited to the medium. When I raised the idea with Tung, he agreed at once and generously offered to provide photo reproductions to help with the project.

To accompany the paintings, I chose a piece of calligraphy by Qi Gong. Tung had shown Qi *Plants from an Autumn Garden* in the 1990s, and it left a strong impression on him. He praised the paintings as "remarkable works" and spoke glowingly of Pu's ability to impart so much force and power to these delicate plants. They are, as he put it, "tender shoots, forged from steel". In response to them, he wrote a substantial work in small regular script: four "Poems on Fallen Flowers" and a long postscript (Figs 84.8–84.10). According to an essay by Qi's former student Zhao Rengui, the poems are a satire against the Gang of Four, the radical political faction who rose to prominence during the Cultural Revolution. Zhao suggests reading the entire work as an example of "metaphorical evocation", a technique with a long pedigree in Chinese arts and letters. Qi, he asserts, gives us "one of the finest examples ever written".

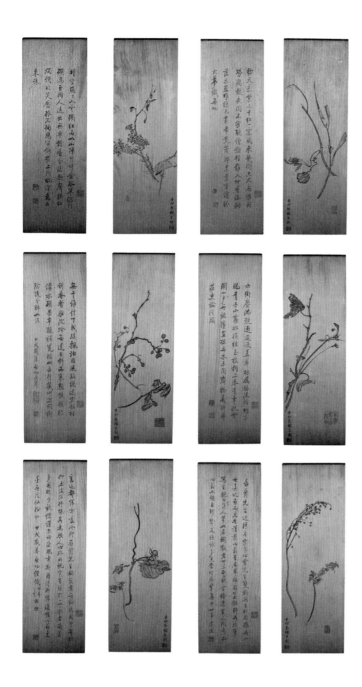

ing almost impossibly fine strokes in the most delicate parts of the composition (Figs 85.1–85.12). Tung generously provided a postscript for these as well (Fig. 84.31).

Both versions of this piece are wonderful in their own way, and both are captured in superb rubbings by Fu Wanli. To accompany them, I wrote four poems of my own describing the original artworks and the carved adaptations. These can be found in the Chinese version of this catalogue.

Jiang Zhaoshen—江兆申 (1925–96). Painter, calligrapher, seal carver and sometime deputy director of Taiwan's Palace Museum.

Sa Benjie's biography—see notes to item 83.

"iron wire" lines—"iron wire outlining" (*tiexian miao* 鐵線描) is characterised by thin, flowing but forceful lines.

Zhao Rengui—趙仁珪 (b. 1942). Professor of Classical Chinese Literature at Beijing Normal University and former student of Qi Gong. Zhao is a member of the September Third Society, in which Qi served for many years (see notes to item 8). The quotation is taken from a magazine essay on Qi Gong's poetry: "Qi Gong xiansheng shici san lun" (啓功先生詩詞三論) in *Forbidden City* (*Zijin cheng* 紫禁城), 2012:07, no. 210, p. 46.

086

Purple Jade Table

1998–9
Workshop of Tian Jiaqing
Inscription: Wang Shixiang
Inscription carving: Fu Jiasheng

087

Yellow Jade Table

1997–8
Workshop of Tian Jiaqing
Carpentry: Cai Huoyan
Inscription: Kössen Ho
Inscription carving: Li Zhi (2015)
Rubbing: Zhang Pinfang

After I spoke to Tung Chiao about adapting the paintings, it was several years before the project progressed any further. Choosing the right carver was a challenge. The work called for someone who was deeply knowledgeable about painting, but who was also still young and sharp-eyed – not an easy combination to find. Eventually, however, I landed on the right person for the job. It still brings a smile to my face to remember the alacrity with which Bo Yuntian took to the task, completing all 12 wrist rests in just a few months (Figs 84.11–84.22). The postscript to the carvings, which Tung was kind enough to supply himself (Fig. 84.30), gives me equal pleasure.

In 2010, the year the wrist rests were finished, Tung decided to put his collection of painting and calligraphy up for auction. I was able to purchase the album from him beforehand, and I decided to have another version of the carving made, this time in intaglio. For the material, I chose high grade granadilla, which has a finer grain than *zitan*, making it more suitable for the delicate detailing of the originals. Fu Jiasheng carved the new version as 12 scroll weights, achiev-

On 1 July 1997, Hong Kong became a Chinese city again. I was living in Oxford at the time, but during the handover I was back in the city visiting my family. Afterwards I flew on to Beijing, where I visited Wang Shixiang and Yuan Quanyou, who had recently moved from Fangjiayuan to a new home in Fangcaodi, east of Chaoyangmen. As soon as I came in, Wang asked me about the situation in Hong Kong: "How are things since the handover?"

"It's too early to say", I told him. "Give it five or ten years, then we'll know." We looked at each other, smiled, and left it at that.

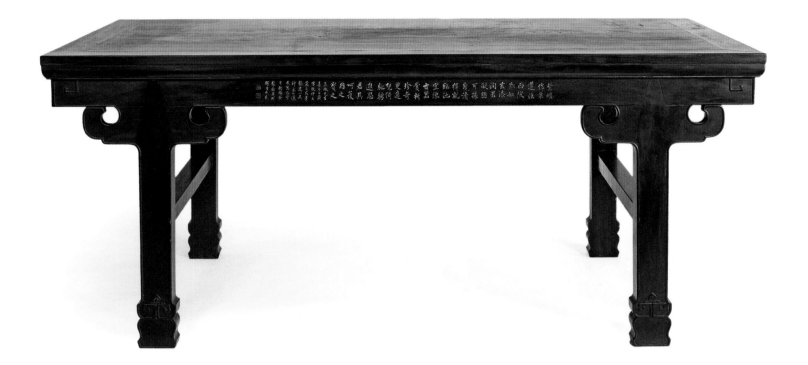

Wang wrote many inscriptions over the course of his life, but only a handful of them were for items of furniture. During my visit, I was able to see one of them: a large table in the reception room, newly made by Chen Cuilu, a carpenter in Tian Jiaqing's studio, to a design by Wang himself. The top was fashioned from a single piece of rosewood, and the inscription had been carved onto the apron by Fu Jiasheng (Fig. 86.1.1–2).

One of Wang's areas of interest was the furniture of the Ming period, and there were clear echoes of Ming tables in his design. But this was not some pale imitation of the past. Instead, Wang had drawn from traditional designs to create something that was entirely his own. I was particularly struck by the decision to leave the apron and legs plain, omitting the decorative beading that characterises many Ming pieces. The change gave the table a feeling of simplicity and weight: a Ming design for the modern world.

Sometimes, it has seemed as though China's traditional art and culture were to fall by the wayside in the headlong rush towards modernity. Wang Shixiang and others like him took a different approach. For them, China's heritage was to be cherished and celebrated. That did not mean that it was to be idolised, with no space for adaptation or creativity. Instead, there was a marriage to be sought between the old and the new. As the writer and politician Liang Qichao put it in his *Poetry Notes from a Room for Drinking Ice*, "It is possible to turn old styles to a new artistic world." Wang's table was a perfect example of that spirit, of the idea of "putting the past to use in the present", as the contemporary phrase goes.

As I looked the table over, Wang drew my attention to the inscription (Fig. 86.1.3) and suggested I read it out. It ran:

> *This mighty bough became a desk*
> *Adapted from a Ming design.*
> *The chisel's strikes, the hatchet's work:*
> *All are here on proud display.*

> *Each piece, each part forms one vast whole,*
> *Whale-backed, with elephantine feet.*
> *These days, folk go for gaudiness;*
> *It's plainness that obsesses me.*
> *The giant section of timber from which this piece is formed was given to me by Mr Guo Yongyao. It took Tian Jiaqing and me almost three weeks of discussion to settle on the design. The carpentry is by Chen Cuilu, and Fu Jiasheng carved the inscription.*

> *Wang Shixiang*
> *Mid-Autumn Festival, 1997*
> *Fangcaodi West Alley, East Beijing*

I remember being so taken with the sixth line ("Whale-backed, with elephantine feet") that I banged the table in approval. Wang nodded and laughed. It was a perfect description for the piece, with its thick, heavy table top and fat, round legs.

That same year, Tian Jiaqing and I began work on a table that would bear another of Wang Shixiang's inscriptions. In April 1997, a few months before my visit to Wang, Tian had written to tell me about a batch of high-grade "rhinoceros horn" zitan. It was recently imported, and the current owners, who evidently had more money than sense, were using it as floorboards – an outrageous waste. Tian knew that I had been thinking of commissioning a table, and he told me that this wood might fit the bill. The key would be to have it properly treated, and for that he suggested that we approach the Forestry University in Beijing for help. An appendix to his recent book, *Qing Furniture*, had included a sample of the university's work on zitan, an electron micrograph showing the structure of the timber, so it seemed that they were the right people to see for a rigorous, scientific approach.

The next thing to decide on was the design. For that, there was an obvious place to look. The centrepiece of

Wang's collection of Ming and Qing furniture was a *zitan* painting table, which had belonged to the 17th-century official Song Luo. Wang's research showed that it had long been admired, having been regarded as the finest example of its type since as far back as the late Qing dynasty (Figs 86.2, 86.4, 86.6). In the mid-1990s, a few years before Tian wrote to me, Wang had sold his collection, including the Song Luo table, to Quincy Chuang, the son of the Shanghai industrialist Tze-Yuen Chuang, for donation to the Shanghai Museum. The sale was still fresh in my mind when I received Tian's letter, and it occurred to me that the Song Luo table would be the ideal inspiration for our own project. If we made a model first to help us refine the concept, there was no reason why a new version of it should not be just as compelling as the original. After all, as the story of General Huan says (see item 11), even precious antiques were new once.

In January 1998, Tian wrote to tell me he had started work on our adaptation, getting hold of the measurements of the Song Luo table and ordering the wood we needed. To make sure his numbers were correct, I checked them against the illustrations in Wang's *The Appreciation of Ming Furniture*. When I scaled up the pictures, I found a few minor discrepancies, which I cleared up with Tian by letter.

In designing our table, we wanted to draw on the past, not to copy it unthinkingly. As a result, the careful observer may notice a few differences between the finished table and the Song Luo original (Figs 86.3, 86.5, 86.7). Some of the components differ in size: the cloud-head spandrels at the top of the legs are wider before curving inward, resulting in a better proportioned piece (Figs 86.6, 86.7). In addition, Tian added a small splay to the base of the legs, angling them slightly towards the corners. On his advice, we did not decide the exact degree of splay in advance, preferring to judge it by

eye at the final phase of assembly, when the tenons connecting the legs to the apron were cut.

The final change to the design concerned the beading at the edges of the aprons, spandrels, and legs. On the Song Luo table, this is executed in intaglio (Fig. 86.8). When Tian brought it up, I suggested swapping to relief to make it stand out better (Fig. 86.9). This meant cutting away a layer of wood along the entire length of the apron to leave the raised decoration behind, an extravagant choice in a material as precious as *zitan*. Histories of Chinese furniture making tell of the Cantonese carpenters who served in the palace workshops under the Qianlong Emperor, whose immoderacy in the use of *zitan* was the stuff of legend. By going down this route, we would be more than matching them, giving our table an imperial pedigree.

The wood was shipped to Beijing in early summer 1998. As planned, I asked Tian to make a full-scale model in rosewood before starting on the final piece, to make sure the proportions were correct. Once the model was finished, he invited me to visit his workshop in Huilongguan on the outskirts of Beijing (Fig. 87.1–87.5). When I arrived, the table was sitting inside. The carpenter who had made it, Cai Huoyan, a young man in his twenties, was there too.

After reviewing the model, I asked for three changes: an increase in the splay of the legs (which gave the piece a stronger visual centre); a thickening of the lateral stretchers (to make them proportional to the thickness of the legs); and a change in the placement of the carpenter's marks on the stretchers and legs (which are used to guide the craftsman during assembly). On the model, these marks were carved on the upper surfaces of the components. For the final piece, I asked Tian and Cai to move them out of sight to the table's undersides.

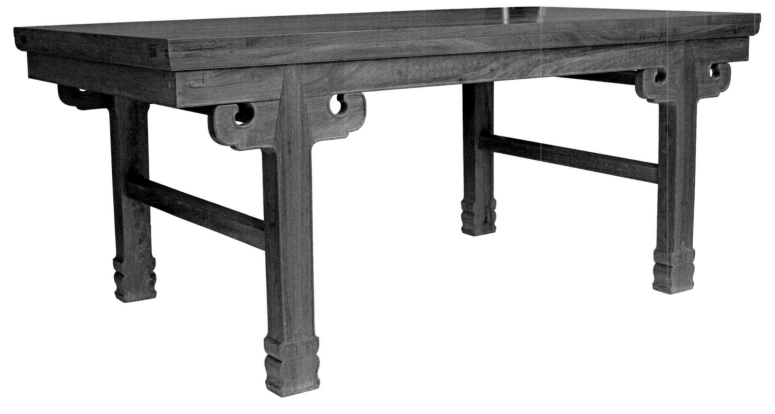

It was another year before the final version of the table, which was carved entirely by hand, was completed, in autumn 1999. Shortly before it was finished, I wrote to Wang Shixiang to ask if he would provide the inscription. Tian then dropped the apron of the table off with Wang, allowing him to see the space in which his text would be carved. After studying it, Wang composed the following:

> A table made from fine zitan,
> After Song Luo's:
> Dark as lacquer, deep and black,
> Smooth and soft its gloss.
> Just the thing for reading at
> Or taking up your brush;
> A stand for ancient vessels, or
> For viewing curios,
> But better still for leaning on,
> Lost in reveries.
> Protect it and preserve it, pray,
> To treasure and to use.
> Mr Kössen Ho was fond of a large table of mine formerly in the collection of Song Luo, and he implored Tian Jiaqing to oversee the creation of another, no less fine than the original.
>
> Mid-Autumn Festival, 1999
> Text and calligraphy by Wang Shixiang
> Carved by Fu Jiasheng

In the third line of the inscription, Wang originally compared the table to "ancient" lacquer, and that description would have made it onto the finished table had it not been for a sharp-eyed paper mounting specialist at Rongbao Studio in Beijing. Tian arranged to have the calligraphic version of Wang's inscription, written to fit the shape of the table's apron, mounted for me there before the carving was done (Figs 86.10, 86.11). The mounter pointed out that the same word, gu (古), also occurred in the seventh line's reference to "ancient vessels". Ever the perfectionist, Wang decided to change it, and the lacquer went from "ancient" to "deep black" (xuan 玄). He wrote the new character on a small square of calligraphy paper, and Rongbao Studio added it to the scroll. Fu Jiasheng, their resident engraver, then added the edited text to the table. I am grateful to him for his wonderful carving, which perfectly captures the spirit of Wang's calligraphy (Figs 86.3, 86.12). My gratitude is also due to Tian Jiaqing for commissioning the scroll and for the small nanmu box, complete with a zitan lid, which he made me to store it (Fig. 86.11).

Once the scroll was mounted, it needed a title. I took it to Baoxiang Studio, Zhu Jiajin's home, and asked him what he thought. He mulled it over for a moment and came up with a suggestion, which he added after Wang's poem: the Purple Jade Table (Fig. 86.10). Now all that was required was the opening inscription, which Huang Miaozi kindly agreed to provide (Fig. 86.10), and, to complete the ensemble, the postscripts, which came from Jao Tsung-i, Fu Xinian and Tung Chiao (Fig. 86.10).

The final section of the scroll is an inscription of my own, which I composed some years later and had added

to the scale model (Figs 87.8, 87.9). It seemed fitting that it should have a name as well, so, following Zhu Jiajin's example, I called it the Yellow Jade Table:

> These mighty boughs were felled in southern lands
> And borne away, shipped off by barge and cart.
> We chose them from a forest's worth of timbers,
> These the fairest of them all by far:
> Wonderful to look on, weighty, grand,
> Their grain a tracery of evening clouds.
> Tian Jiaqing took up his marking line,
> A master still resolved to hone his craft.
> He first devised this piece, our prototype;
> We met and worked the last amendments out.
> Three years went by before the work was done:
> A table that stood tall, majestic, proud;
> Upon it, an inscription gifted by
> Wang Shixiang, which Fu Jiasheng carved.
> Full of life, a dragon coiled in flight,
> It rose; on phoenix wings it soared and towered.
> A precious thing, a jewel rich and rare,
> Its scented wood pours forth its orchid balm.
> Cast your light upon my treasured books
> And aid me as I write: refine my art.
> May your radiance bless my home and halls,
> Where joy and concord compass us around.
> However long the story of your use
> May be, bring fortune, rose- and sandal-boughs.
> A poem written to celebrate the Purple Jade Table. This is the full-scale model, made by Cai Huoyan under the supervision of Tian Jiaqing.
>
> Autumn 2015
> Text and calligraphy by Kössen Ho
> Carved by Li Zhi

After Wang Shixiang wrote his inscription for the Purple Jade Table in 1999, another followed the very next year. In 2000, Tian Jiaqing completed a revised version of my table for Tsui Tsin-tong, the Hong Kong businessman and collector. This new table differed slightly from my own in the design of the apron, which features a relief border but has no scroll pattern at the corners (Fig. 86.13.2). Wang's inscription (Fig. 86.14), a six-line poem with a brief postscript, reads:

> They took these timbers, fair zitan
> grown long and great in size,
> And kept their virtues, thoughtfully
> adapting ancient styles:
> They hewed a mighty table from them,
> made it gleam and shine
> With wondrous lustre, rich as any
> patina of time.
> The craftsman who accomplished this
> was Master Tian Jiaqing,
> And he who uses – treasures – it
> is Mister Tsui Tsin-tong.
> The table on which this was based, once owned by
> Song Luo, was made under the Ming, yet this piece seems

even more resonant of the Ming than was its original. I was delighted to write this inscription for it.

Wang Shixiang
Summer 2000

The trio of tables – the Purple Jade Table, Tsui's table, and Wang's own rosewood table from 1997 – soon began to attract attention. In October 2000, Wang included details of all three in an article in *China Cultural Relics News* (Fig. 87.15), the publication of record for Chinese antiquities. He later reissued it as an essay, "Three Table Inscriptions" in *A Second Lovely Ash-Heap*.

Wang also created a general inscription for pieces in Tian Jiaqing's "Ming Resonances" series and a quatrain for a large desk that Tian made for the lawyer Wang Zhilong (Fig. 86.16, showing the carving of the inscription by Fu Jiasheng). Both are delightful compositions, and I include them here for completeness's sake, beginning with the poem for Tian:

> *With what do they compare,*
> > *These echoes of the Ming?*
> *A perfect-tasting wine:*
> > *Simple, pure, superb.*

For Wang Zhilong's table, Wang included a brief post-script as well:

> *This table and its owner: both were formed*
> > *By following a simple principle –*
> *Prize openness above all in a face;*
> > *And, besides that, look for uprightness.*
> *Written on the Tomb Sweeping Festival, 2004, for a large table belonging to Mr Wang Zhilong. By Wang Shixiang, 90 this year.*

Chen Cuilu—陳萃祿, a member of Tian's workshop.

Liang Qichao—梁啓超 (1873–1929). Late Qing and early Republican reformist. The title of *Poetry Notes from a Room for Drinking Ice* (*Yinbing shi shihua* 飲冰室詩話) derives from Liang's literary soubriquet, The Master of the Room for Drinking Ice (*Yinbing shi zhuren* 飲冰室主人).

Guo Yongyao—郭永堯 (b. 1963). Major Zhejiangese collector and artist.

"rhinoceros horn" zitan—an alternative name for *Dalbergia louvelii*, prized for its exceptionally high density. See also item 76.

painting table—*hua'an* (畫案). A classic form of table characterised by a long, comparatively narrow top.

Song Luo—Song (宋犖, 1634–1714), sometimes known by the courtesy name Song Muzhong (宋牧仲), was a Qing official, poet, and collector. For his table, see Wang's *Classic Chinese Furniture*, pp. 174–5.

Quincy Chuang...Tze-Yuen Chuang—respectively 莊貴崙 and 莊志宸, sometimes given as T. Y. Chuang. The younger Chuang's gift was made in honour of his father and his uncle, Tze-Kong Chuang (莊志剛), after whom the gallery housing Wang's furniture collection is named.

Rongbao Studio—see notes to item 3.

Baoxiang Studio—寶襄齋, Zhu's studio name.

Jao Tsung-i—饒宗頤 (= Rao Zongyi, 1917–2018). Jao, a towering figure in Sinology, produced a dizzyingly varied output, spanning literature, philosophy, philology, and the arts, during the course of his eight-decade scholarly career. By the time of his death in early 2018, he was acknowledged as among the greatest Sinologists of the 20th century. In addition to his academic work, Jao was also an accomplished calligrapher, painter, and player of the *guqin*.

Fu Xinian—see notes to item 9.

Tsui Tsin-tong—徐展堂 (1941–2010). Hong Kong entrepreneur, collector, and philanthropist, sometimes known as T. T. Tsui.

China Cultural Relics News—the weekly *Zhongguo wenwu bao* (中國文物報). First issued in 1985 and now published under the auspices of the State Administration of Cultural Heritage (國家文物局). Below, the essay in *A Second Lovely Ash-Heap* is "Anming san ze" (案銘三則).

Wang Zhilong—王之龍, of the notable Beijing firm Jun He Law Offices (*Junhe lüshi shiwusuo* 君合律師事務所).

Prize openness above all in a face—turning on the multiple meanings of the word *mian* (面), which refers to the face of a person and, by extension, to the top of a table (*anmian* 案面).

088

Pair of footstools

1999
Made to accompany two yoke-back chairs
in the "southern official's hat" style, decorated with peonies
Workshop of Tian Jiaqing

These footstools were inspired by the furniture in two paintings depicting Vimalakîrti, a contemporary of the Buddha. The first, *Vimalakîrti Spreads the Teachings*, housed in the Palace Museum and ascribed to Li Gonglin, depicts him sitting barefoot on a couch, with his sandals placed on a footstool in the foreground (Fig. 88.1). The second, a copy by the Yuan painter Wang Zhenpeng of Ma Yunqing's *The Non-Duality of Vimalakîrti*, now in the Metropolitan Museum in New York, differs in a few details, but the composition is similar (Fig. 88.2). Some years ago, I was able to examine the Palace Museum version, and I noticed that the bodies of both the couch and the footstool were covered with a curling tendril design, executed in razor-thin lines, suggesting a piece of lacquer decorated with gold.

While I was living in Oxford, I sent copies of the two paintings to Tian Jiaqing to ask if he could make a pair of stools based on them, with matching chairs in the yoke-back or "official's hat" style. Tian wrote back: "The footstool designs that you sent are excellent, and in fact I once had the idea of making something like them myself. I think, however, that if you were to pair these with yoke-back chairs as you suggest, the styles would not match." Later, Tian showed the paintings to Wang Shixiang, who suggested pairing our stools with "southern official's hat" chairs, which lack the projecting crest rails and armrests that distinguish the yoke-back design.

Tian completed the footstools in 1999 and showed them to me when I visited Beijing in January 2000. Each stool doubles as massaging roller stool, with three pairs of round spokes at the point where the feet rest. Their usefulness in this role is limited, however, by a shortcoming in the design. The roller spokes are cylindrical, and grouping them together results in an essentially flat rolling surface. This makes it difficult to reach the most important section of the foot, the recessed part at the centre of sole. Traditional Chinese medical thinking associates this zone, a vital point known as "Gushing Spring", with good kidney function, making it crucial to the body's overall health. A better spoke design would have enabled access to this important area. For an example, we might consider a Ming *huanghuali* roller stool from Wang Shixiang's collection (Fig. 88.3), where each foot is placed on a single, spindle-shaped spoke. It would be interesting to see what solution Tian would adopt if he made

another roller stool today.

Like much of the furniture in this book, the stools had an afterlife: Tian went on to enlarge them into a double-waisted, pedestal-style couch, which appears as item 13 in *Ming Resonances: Furniture by Tian Jiaqing* (Fig. 88.4). It is an imposing design, but to my mind it is no match for the original.

Li Gonglin—李公麟 (1049–1106). Painter, official and antiquarian scholar. The painting referenced is "Weimo yanjiao tu" (維摩演敎圖).

Wang Zhenpeng...Ma Yunqing—respectively, 王振鵬 (Yuan, dates unknown) and 馬雲卿 (fl. 12th century). The original painting is the "Weimo buer tu" (維摩不二圖).

"official's hat"..."southern official's hat" chairs—describing two styles of open-framed chair with a vertical splat, respectively *guanmao yi* (官帽椅) and *nan guanmao yi* (南官帽椅). The former design, sometimes referred to in English as "yoke-back", is also known as the "four projections" (*si chutou* 四出頭) style, while the "southern official" style is characterised by clean, plain corners between the armrests and crestrail and the vertical supports (compare this item with item 92, a set of four yoke-back chairs).

Gushing Spring—*yong quan* (湧泉), also known variously as Bubbling Spring, Bubbling Well or, rarely, *fons scatens*.

Ming Resonances: Furniture by Tian Jiaqing—*Mingyun: Jiaqing zhi qi* (明韻: 家靑製器, Joint Publishing, 2006).

089
Footstools with *kunmen*-shaped openings

2012–3
After Tang and Song designs

The footstools in the preceding entry look comparatively late imperial. I designed these in an earlier style. The pointed *kunmen* openings, characteristically associated with

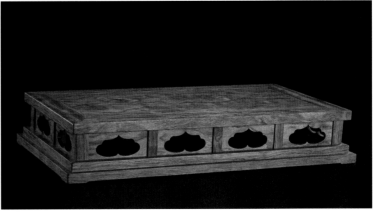

Buddhism, are borrowed from examples from two successive dynasties, the Tang (Fig. 89.1) and the Song (Fig. 89.2). Their different outlines give each stool a distinct appearance.

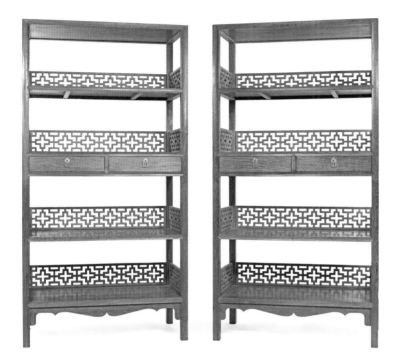

Pair of *huanghuali* shelf units with cruciform latticework railings

2001–2
Workshop of Tian Jiaqing

The original version of these shelves, which I saw in the Palace Museum in the 1990s, was one of Wang Shixiang's favourites (Fig. 90.1). It appears as item D6 in his *Connoisseurship of Chinese Furniture*, where he describes it as one of the finest pieces of Ming furniture ever made.

In the mid-1990s, I decided to commission some furniture from Tian Jiaqing. I spent a long time wrestling with the question of material, and eventually I acquired ten thick planks of *huanghuali*, each two metres long and almost half a metre wide, during a visit to my family in Hong Kong. Later I bought another twelve large, square pieces of the same wood. The purchase was complicated by the fact that I was living in Oxford, where I was reading for my doctorate, so I had to ask my father to handle payment, transport, and storage on my behalf. I remember him telling me at one point that he felt like he had become my personal secretary…

Once I had the wood, I stored it for a few years in Hong Kong, in a shady spot where it would have a chance to dry. When Tian Jiaqing had examined it and passed it fit, I had it shipped to Beijing.

By this time, I had decided that part of the commission should be a set of shelves based on the Palace Museum design. Before we began work, Tian checked the dimensions of the original, and a carpenter at his Aotu Studio made a test section of the latticework railings, an exquisite experiment in rosewood, which he sent to me for approval (Fig. 90.2).

A key point of the design of our shelves was the cross section of the components. On the original, both faces of the railings were concave (Fig. 90.3: 1.2), while the frame itself was made from squared timbers (Fig. 90.3: 1.1). Tian's preliminary design called for the railings to be concave on the outer face and convex on the other side (Fig. 90.3: 2.2), with intaglio borderlines on the concave face (Fig. 90.3: 2.2). Given how fine the latticework was, I felt that this would be too visually complicated and that it would be cleaner to omit the borderlines (Fig. 90.3: 3.2). For the frame, Tian proposed a design that was concave on the front face and convex on the other three sides (Fig. 90.3: 2.1). The extra decoration was intended to add interest to the design, allowing the shelves to be used in the middle of a room as a dividing screen as well as against the wall. I suggested only decorating the two outward-facing sides of each piece of the frame and making them both concave to match the concave outer face of the railings (Fig. 90.3: 3.1).

The last detail we had to decide on was the drawer handles. On the original, these were made to an openwork, "hanging fish" design (Fig. 90.1, 90.2). I initially wanted to base the handles for my version on a pair of dragons from a set of Eastern Zhou jades. I asked Tian to have a test piece made, but the design was too complex to execute, and we were never able to achieve a satisfactory result. As a temporary solution, Tian had a set of rectangular handles made from *paktong*, a decorative alloy of copper and nickel. These fit nicely with the latticework of the railings, so we kept them.

When the shelves were finished, they were shipped to Hong Kong (Figs 90.4). I still remember the wonderful smell of the wood when I opened the packing cases. Tian had left an inscription on the back of one of the drawers, hidden away against the wall (Fig. 90.5):

This pair of shelves, made by hand from the finest huanghuali *timbers, has taken a team of six carpenters two years to complete. No adhesives were used for the frame, which is held together by mortices and tenons. The 24 sections of railing were made from almost a thousand small components, convex on the outside and concave on the inside, all locked together with* chuaichuai *tenons. The railings and the frame are joined together by removable wooden pins. I believe the craftsmanship is equal to the best of traditional Chinese carpentry.*

Tian Jiaqing
2002

Tian's description of the railing as "convex on the outside and concave on the inside" must have been a slip of the brush, since when I checked I found that it was the other way around, echoing the concave outer faces of the frame (Figs 90.3). Thinking about it now, I believe that Tian's mistake could have been made to work. A version of the shelves

with the railing either convex on the outside and concave on the inside or convex on both faces would have been equally convincing, if the outer faces of the frame were made convex to match.

I am grateful to the architect Dr Simon Kwan for photographing many of my pieces of furniture. When Dr Kwan saw the inscription on this piece and Tian's mention of how long the work had taken, he told me that he suspected most of that time must have been spent in the exploratory phase, as the Aotu Studio carpenters got to grips with making the latticework. Apparently, the same technique – building a lattice from interlocking pieces, held together by mortices and tenons – was used to make the wooden window panels in traditional Chinese buildings. In the past, these were essentially mass produced – as Dr Kwan put it to me, "Once you get the knack of it, the work flies along".

While visiting Tian in the winter of 2005, I saw another version of this pair of shelves, this time in *zitan*. The design was identical, but the darker colour gave the piece an altogether different feel.

Connoisseurship of Chinese Furniture—the English version of Wang's *Mingshi jiaju yanjiu* (明式家具研究).

Aotu Studio—Aotu zhai (凹凸齋), Tian's workshop. The name – the Studio of Concave and Convex, or, more liberally, Dovetail Studio – reflects Tian's pride in using traditional, glueless joints in his work.

hanging fish—chuiyu (垂魚), so called for their pronged, fish-tail-like shape.

chuaichuai tenons—chuaichuai sun (揣揣榫) or, as here, *chuaishou sun* (揣手榫). In a *chuaichuai* or "arms-in-sleeves" joint, each piece of wood to be joined is carved with both a mortice and a tenon, both of which lock into the next piece in the framework. The name derives from the resemblance of the resulting joint to a pose commonly struck by wearers of traditional, loose-sleeved robes, with each hand placed into the opposite arm's sleeve.

Dr Simon Kwan—關善明 (= Kwan Sin Ming, b. 1941). Hong Kong architect, collector, and art historian.

Pair of recessed-waist *huanghuali kang* tables with cabriole legs

1999–2000
Workshop of Tian Jiaqing

Tables of this kind, with their unusually short legs, are designed to sit atop a *kang* or bed-stove, a heated brick platform that was once the heart of the home in houses across northern China. One of the more elegant examples of the form is a piece described in Wang Shixiang's catalogue of the now-closed Museum of Classical Chinese Furniture in California (Fig. 91.1). Wang pays particular attention to its distinctive decoration:

The legs terminate in ball feet with upward-turning leaves, a motif that often appears on the feet of high incense stands. At the corners where the aprons and legs meet, two carved leaves curl toward one another. One leaf is part of the apron; the other is part of the leg. One can easily see that a great deal of material would be wasted by carving the leaf and leg from one piece of wood, and thus this technique is quite uncommon. Inspection reveals, however, that the leaf is not a separate piece added to the leg with a planted tenon, but was indeed carved from the same piece of wood as the leg.

In 1999, my younger sister Irene Ho decided she needed a coffee table for her sitting room, and I suggested making one based on the same design. We asked Tian Jiaqing to carve a half-scale model in rosewood, before making the real thing from *huanghuali*. The wood for the body of the table came from the same batch that I had acquired for my other projects with Tian (see items 90 and 92), and he supplied the material for the table top. Just like the original, each leaf is carved from the same piece of wood as the leg from which it sprouts. Tian's studio name appears on the reverse of the apron.

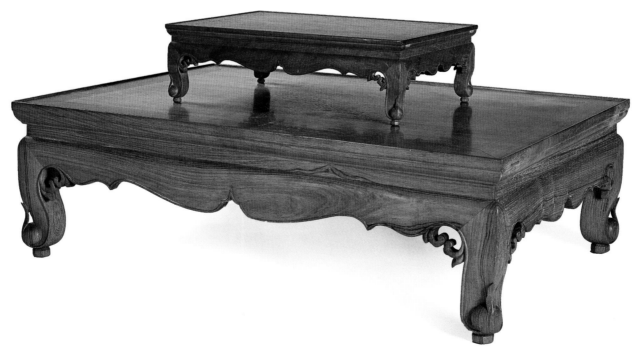

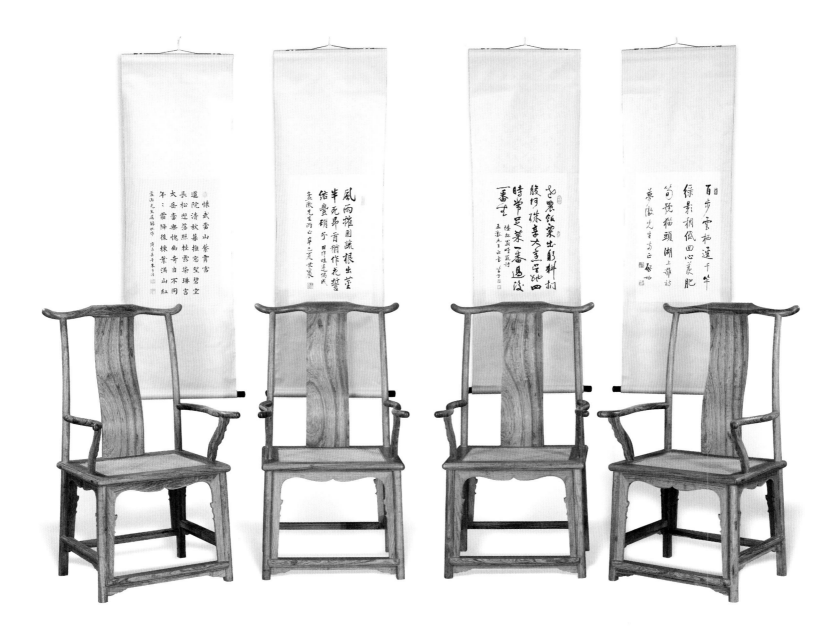

Wang Shixiang's catalogue—Masterpieces from the Museum of Classical Chinese Furniture (Tenth Union International Inc., 1995), co-written by Wang and Curtis Evarts and published in Chinese as *Mingshi jiaju cuizhen* (明式家具萃珍).

092

"Fine Greens from a Rustic Kitchen" Set of four yoke-back *huanghuali* armchairs with projecting crest rail and armrests

1998–2005
Workshop of Tian Jiaqing
Inscriptions: Qi Gong, Wang Shixiang, Zhu Jiajin, Huang Miaozi
Inscription carving: Fu Jiasheng
Rubbings: Fu Wanli
Accompanied by a scale model in rosewood

Great cultural gatherings are a recurring theme in Chinese history. From the fabled Mount Xiang Poetry Assembly in the Tang period to the Elegant Gathering in the Western Garden in the Song, when artists and writers come together,

their work echoes down the ages. It can sometimes feel as if the great moments of the past will never be matched, but in four men whose names have recurred throughout this catalogue – Wang Shixiang, Zhu Jiajin, Qi Gong, and Huang Miaozi – I see a group to equal any such gathering. This is my modest attempt to bring them together.

The Concept

In late 1997, after completing my doctorate at Oxford, I stayed on to continue my clinical training at the Churchill Hospital. I was going through a period of intense fascination with bamboo carving, and I corresponded regularly on the topic with Wang Shixiang and Fan Yaoqing. One of the craftsmen I became interested in at that time was the Ming carver Pu Zhongqian, noted for his wrist rests decorated with landscapes.

One day, out of the blue, I was struck by the idea of adapting Pu's technique to furniture. At the end of January 1998, a few days after Chinese New Year, I wrote to Wang to tell him what I had in mind. It was to be a set of four round- or horseshoe-back chairs, each decorated with a poem and a picture on the back splat, the former carved by Fan Yaoqing in intaglio and the latter by Zhou Hansheng in bas relief. I even had the pairings in mind: Wang's poem "Pines Amid Rocks" would accompany a corresponding scene from the end of Qian Xuan's *Dwelling in the Mountains*; a verse by Qi Gong would appear with the Yuan painter Gu An's *Bamboo Amid*

Rocks; and lines by Zhu Jiajin and Huang Miaozi would be set against details of paintings by Song and Yuan masters.

The idea of including images on the chairs soon fell by the wayside. My choice of design was also scuppered when I learned about the shortcomings of the horseshoe-back chair, which, though much prized, tends to be uncomfortable to actually sit in. I decided to change tack and adopt a different but equally beloved Ming form, the so-called "Four Projections" style. A pair of chairs of this design – with a square seat, projecting armrests and a yoke-shaped crest rail extending out to the sides – had made a particular impression on me when I saw them on a visit to the Museum of Classical Chinese Furniture in the early 1990s (Figs 92.1, 92.2). Wang had written glowingly about them in his catalogue, and I decided that they would be the starting point for the project.

The Poems and Calligraphy Scrolls (Figs 92.3–92.8)
Qi Gong's ode to bamboo and bamboo shoots (Fig. 92.3): As early as the mid-1990s, I had fallen in love with Qi Gong's unique style of calligraphy and decided to try to acquire a piece. As it was still rare to see a Qi Gong at auction at that time, I knew I would have to approach him to request something bespoke, but for that to happen I needed an introduction. Wang Shixiang learned of my predicament. He visited Qi on my behalf and came away with the work that decorates the first of these chairs: a copy of the third of Qi's *Ten Poems on Sojourning at West Lake after a Meeting on the "Orchid Pavilion Preface"* (along with a version of the final poem in the set for my father):

> *III: Ode to a Bamboo Path at the Cloud-Perch Temple*
> *The Cloud-Perch Path: a hundred paces host*
> *A myriad stems with thick green silhouettes.*
> *I roved its length, my whole heart set upon*
> *The sturdy shoots referred to as "cats' heads".*

My copy of the poem contains two errors, perhaps the result of Qi's advanced age at the time of writing. A missing character in the third line makes the piece slightly shorter than the original, and a mistake in the dedication turns my Chinese name from 何孟澈 into the homophonous 何夢澈. This last error turned out to be a happy accident. Wang Shixiang pointed out that Qi's version of my personal name, 夢澈, had a pleasingly philosophical ring to it: it means "dispersing the dream", a metaphor for Buddhist enlightenment. In the end, I adopted the mistake as a pen name. A seal with that text, carved by Fu Jiasheng, appears in this book as item 104.

For some time, I was puzzled by the reference to "cats' heads" in the last line of the poem. Eventually Fu Xinian brought Tian Jiaqing and me to visit Qi, and we asked what he had meant. He revealed that there is a kind of bamboo known as "cat's head bamboo", referenced in poems by the Song dynasty writers Fan Chengda and Huang Tingjian. Its shoots are called, appropriately, "kittens' heads".

Wang Shixiang's ode to the rape flower (Fig. 92.4, 92.7): During a visit to his home in July 1993, Wang Shixiang gave me a copy of his book *Bamboo Carving*, published the previous year by People's Art Press. I was working in a hospital

in the UK at the time, and I read the book after I went back. In one chapter, "Descriptions of Examples", Wang examines a brush pot from his own collection by the Ming carver Zhu Xiaosong, decorated with an image of the famed writer Tao Yuanming renouncing officialdom to become a recluse (Fig. 92.9). Of this item, the third in the chapter, he writes: "It features a pair of swallows swooping and climbing through the sky, an unexpected image which I believe must be the product of a moment of inspiration. Perhaps they suggest that only when we refuse to 'bow and scrape for a bushel of rice' and are able to wander freely through the world can we hope to measure up as poets". After reading that remark, a comment in another chapter, "A Record of the Bamboos I Have Seen", caught my eye. Describing the 23rd item, an anonymous Qing sculpture of a young herdsman and a reclining ox from the collection of the Denver Art Museum in the US, Wang notes: "Many years ago I was banished to Lake Xiangyang, where I worked for three years as a herdsman, spending every waking moment with the cattle."

I knew there must be more to this brief hint, and I remember asking Wang about it in one of my letters. It was some years, however, before I would learn the details of that period in his life.

In October 1996, Wang gave me three essays entitled "Memoirs of My Work Cataloguing Cultural Relics after the Victory over Japan", taken from the serial *World of Cultural Relics* (Fig. 92.10). These gave me a first glimpse of his remarkable scholarly achievements in the 1940s. Then, in the winter of 1999, Zhu Jiajin filled in the gap in my knowledge when he gave me his two-volume *The Palace Museum on My Own Time* (Fig. 92.11). One chapter, "Wang Shixiang and his *Explanation of the 'Record of Lacquer Ornaments'*", included a précis of Wang's experiences from the 1950s to the 1970s. Lake Xiangyang, on the outskirts of Xianning in Hubei, figured prominently: it was home to a "May Seventh Cadre School", set up to re-educate writers and artists during the Cultural Revolution. Zhu takes up the story:

> In 1953, Shixiang left the Palace Museum and went to work at the Chinese Music Research Institute... In 1957 he was erroneously labelled a rightist...
>
> When he came to the Cadre School in 1969, Shixiang was suffering from pulmonary tuberculosis, so his company headquarters assigned him to do light work in the vegetable garden. We were next door to one another in companies seven and nine on Height 452 [Figs 92.12.1, 92.12.2], so we were able to see each other all day. The illness troubled Shixiang for many long, wasted years, but it never succeeded in sapping his spirit.
>
> Passing the vegetable garden one day, I noticed a rape-seed flower. It had toppled over the side of its bed, but it was still bright and golden. I said to Shixiang, "Rape seems to withstand everything life throws at it. Even when it's down, it twists its stalk and blooms anyway!"
>
> "I've written a little poem about it", he said, and he fished a piece of paper out of his pocket and handed it to me to read. This is what he had written:
>
> Wind and rain had raked the garden greens;

Roots exposed, their stalks were good as dead.
You raised your head and flowered nonetheless –
And vowed to bear a panoply of seeds.

I said to him, "You haven't been liberated, you
mustn't show this to anyone. You're playing with fire!"
He just laughed.

It was this poem, a cry of defiance against circumstance, that Wang provided for the chairs. Its four short lines epitomise the Confucian dictum, "You can strip a great army of its commander, but you cannot strip an ordinary man of his will." In the forty years he lived after writing it, Wang was as good as his word. He wrote and wrote and wrote, enough to fill a library – beyond question a panoply of seeds.

When he wrote my copy of the poem, Wang's calligraphy was still remarkably vigorous and emotive. He followed his text with a brief postscript. Initially this read: "During an illness while in exile in Xianning, I happened to see a flower at the edge of its bed. I improvised this short poem to express my convictions." But when Wang came to add the two seals (one of his full name and one of his soubriquet, Chang'an), he applied the second incorrectly, leaving its text at right angles to the poem. At first, he tried to fix the mistake by going over it with a third seal (reading, in intaglio, "the settler of Fangcaodi", after his home in Beijing: Fig. 92.7), but eventually Yuan Quanyou made him redo the entire scroll. This time he wrote a simpler postscript: "An old work, made by chance by the side of a flowerbed." This was this version that we used for the chairs (Fig. 92.4).

Zhu Jiajin's ode to pines, osmanthus, and chinaberry (Fig. 92.5): One of the gods worshipped at the early Ming court was Zhenwu, the True Martial One. In the early 15th century, the Yongle Emperor (r. 1403–24) conscripted over 300,000 craftsmen to work at the Wudang Mountains in Hubei, home to many temples dedicated to Zhenwu. They built or rebuilt 33 Daoist temples, including the so-called "Nine Palaces and Nine Temples" complex. The emperor ordered the erection of 12 steles honouring the entire Wudang Mountain chain as a holy "great peak". Over the following century, a series of his successors, from the Hongxi Emperor (r. 1424–5) to the Jiajing Emperor (r. 1521–1567), erected steles, preserved the site and afforded it the status of "temple of the imperial house".

The Wudang Mountains are close to Xianning, and during his period at the Cadre School, Zhu Jiajin was invited there several times by the local county, Danjiang, to survey the ancient buildings (Fig. 92.13). There he struck up a friendship with a Daoist priest by the name of Mao, who was attached to one of the most important of them all, the Zixiao Temple (Fig. 92.13.3).

The piece that Zhu provided for this project commemorates his time at the temple. I first read it in the 1991 issue of *Poetry – Calligraphy – Painting*, published to celebrate the 40th anniversary of the founding of the Central Research Institute of Culture and History in Beijing. At the time, I was still working in Oxford, so I sent Zhu a brush-written letter asking for a copy, instead of visiting him as would have been customary. The poem runs:

Memories of the Zixiao Temple in the Wudang Mountains
A temple in a fine, clear autumn dusk:
An opened window looks on azure skies.
Aged pine trees greet the sunset's glow,
The season's dews wash halls in lazuline.
No doubt these are the finest peaks of all,
So wondrous that I never saw their like;
And year by year, when first the frosts descend,
The bead-tree's red leaves flood the mountainside.

First constructed in the early 12th century, the Zixiao Temple is among the best preserved temple complexes in the Wudang Mountains. Under the Yuan dynasty it received the name "Zixiao Yuansheng Temple", or "Temple of the Original Sage in the Firmament", and it was later enlarged in 1412 as part of the imperially ordered reconstruction. Today it is a National Major Historical and Cultural Protected Site and a National Major Site of Daoist Activity.

In Zhu's first version of my copy of the poem, both the second and fourth lines ended with the same word (Fig. 92.8). When I checked the published version, it showed the lines ending differently, and I was sure this must be correct: it seemed strange for Zhu to have repeated a rhyme word, and publications by the Central Research Institute are generally edited to the highest standard. After I explained the situation to Tian Jiaqing, Wang Shixiang contacted Zhu on my behalf to ask for a correction. Zhu graciously agreed to produce a new copy, which turned out even better than the first (Fig. 92.5).

Huang Miaozi's ode to vegetables in a planting bed (Fig. 92.6): When I began my correspondence with Huang Miaozi in the 1990s, he was living in Australia, but he and his wife Yu Feng later moved back to Beijing. In 2000, after their move, I wrote to him from the UK to request a piece of calligraphy. He provided a version of Lu You's "Poem on Vegetables in a Planting Bed":

The farmer eats his millet, which
he formed by hand and plough,
And sits back so content you'd think
he'd stuffed a banquet down.
Here in Wu, the whole year long
you cannot move for crops:
The moment one dies back,
another takes its turn to sprout.

The Chairs

When Tian Jiaging discovered my interest in the chair I had seen in the Museum of Classical Chinese Furniture, he showed me a photograph of a new design of his in the same style (Fig. 92.14, 'model A'). This suggestion did not quite measure up, so in December 2001, while I was visiting Beijing, Tian showed me a second design, executed as a full-scale model in rosewood (Fig. 92.15.1, 'model B'), with Huang's calligraphy carved onto the splat by one of his carpenters (Fig. 92.15.2). This was a better starting point, but I felt that there was still room for improvement in the shape and the proportions of the components.

After this visit, I found myself consumed by work. I was

teaching at the Department of Surgery at Hong Kong University at the time, and I was unable to spare a thought for the chairs until fully two years later, during a period studying in Brussels. In December 2003, I finally wrote to Tian with my suggestions (Figs 92.16.1, 92.16.2):

1. *Crest rail*. The crest rail of a "Four Projections" chair, with its upward flick at either end, should imbue the whole piece with vigour. Some readers may know the Palace Museum's wonderful Song painting *The Literary Garden* (Fig. 92.17), which depicts scholar-officials wearing *putou* caps, the wings of which climb in just the same way, full of life and vitality. A plume on a hat achieves the same effect. In some roles in traditional Chinese opera, the actor is expected to wear a crown decorated with a pheasant's tail-feathers: if his movements and gestures are skilful enough, the plume will start to come alive, leaping elastically back and forth. One of the best examples of the effect at work in a chair comes from a large, yoke-back *jichi* wood armchair in the Nanjing Museum. A second pair (Figs 92.1, 92.2), formerly in the collection of the Museum of Classical Chinese Furniture, features a striking crest rail cut from a very large piece of wood, by contrast with which the crest rail in model B (Fig. 92.15.1) appeared a little flat and even monotonous.

2. *Splat and stiles*. The splat and stiles of a chair – that is, the corner posts at the back, leading down into the back legs – make all the difference to how it looks. Together, they determine whether you have an imposing, energetic piece of furniture or a fragile-looking thing that a breath of wind could blow away. In the best examples, the splat is wide, with a pronounced curvature mirrored in the stiles. These curves give the chair a taut, powerful profile, like a drawn bow (Fig. 92.18). Admittedly, one can have too much of a good thing: curve the wood too far and it becomes vulnerable to breakage. Balancing these two extremes, I suggested to Tian that we slightly widen the splat from model B (Fig. 92.15.1) and increase the curvature of the splat and the stiles.

3. *Splay of the legs and feet*. This is one area where the connections between traditional Chinese architecture and furniture making come to the fore. In building design, pillars will often be constructed with a slight splay to give them a feeling of solidity and stability. I remember visiting the Tiantong Temple in Zhejiang, where the Song dynasty pillars have a clear splay; the same is true of the pillars in the main hall of my ancestral hall in Guangdong, built in the mid-16th century. A good way to think about the splay of the legs in furniture is to recall a remark by Qi Gong about calligraphy. Discussing how to construct written characters, he says they should be "like a house built on a soaring cliff": each stroke must work with the others and contribute to a stable whole, or it all falls apart. To give the chairs this same sense of stability, I asked Tian to consider increasing the splay of the chair legs.

4. *Kunmen openings*. Chairs can have *kunmen* either on one side, three sides, or four sides. Model B had *kunmen* on three sides. I suggested changing this to four sides, to give the chairs a more delicate appearance (Fig. 92.18).

5. *Dimensions*. Model B was on the small side. I suggested enlarging it slightly, to make the design more imposing.

6. *Inscription*. The carving of the inscription on model B was good (Fig. 19.15.2), but I felt that Fu Jiasheng would be able to take things one step further. I therefore suggested to Tian that when it came to the final piece, Fu should take charge of the calligraphy. I also sent him a note on the seals to be added to each chair, positioned on the back of the splats: to mark his contribution, an inscription by Wang Shixiang reading, "A work by Tian Jiaqing", along with the Aotu Studio seal; and to recognise the inscription carving, Fu Jiasheng's seal, which I would ask Fu to add himself.

Barely two weeks after I wrote to Tian with my comments, I visited Beijing. He was able to show me a much revised version of the chair, and we exchanged notes before agreeing on the final design.

After that, the work progressed quickly. Tian made the chairs from the same batch of *huanghuali* that we had used for the shelves and the *kang* tables (items 90 and 91) – all except the splats, for which he purchased the material separately. I wrote to Fu Jiasheng to ask him to carve the inscriptions in March 2004; the work took him until mid-autumn 2005. After a short trip to Fu Wanli to take rubbings, the completed splats were installed, and by the end of the year Tian had applied the final polish and the chairs were finished. Seven years after I first conceived the project, it had all come together, thanks to the generosity of Wang, Qi, Zhu and Huang, the dedication of Tian and the diligence of Fu Jiasheng, Fu Wanli, and the craftsmen at Aotu Studio.

From the early days of the Han dynasty, the story has been told of the Four Hoary Heads of the Shang Mountains: a quartet of advisors who cleaved to what was right, even in turbulent times, and who commanded the respect of emperors in their final years. I see an echo of this tale in the four men who inspired these chairs. They were close all their lives: Wang Shixiang and Zhu Jiajin were childhood friends, continuing a long relationship between their families; Qi Gong called Zhu his brother, and Wang said the same of Qi; and in the 1950s, Wang and Huang Miaozi spent a period as neighbours after Wang invited Huang to move to Fangjiayuan. They suffered together too: all four were branded as rightists, enduring a spectacular fall from grace before rising back up. In spite of it all, they kept up the sincerest of friendships down the decades, exchanging poems with each other and producing extraordinary writings to match their outstanding characters.

The plants that Qi, Wang, Zhu, and Huang referenced in their poems for this project are all edible delicacies: bamboo shoots, rape flowers, pine nuts, osmanthus flowers and vegetables growing in beds. I therefore named the chairs "Fine Greens from a Rustic Kitchen". Chairs and calligraphy scrolls are not exactly a traditional pairing, but in this case, I think they make a perfect partnership. Through them, four giants of Chinese culture in the 20th century sit down together in spirit: Four Hoary Heads for the modern age.

Mount Xiang Poetry Assembly—Xiangshan shihui (香山詩會). More commonly known as the Longmen Poetry Assembly (*Longmen shihui* 龍門詩會), referring to a meeting of nine poets at Longmen Temple at Mount Xiang, Luoyang. The late 11th-century *Elegant Gathering in the Western Garden* (*Xiyuan yaji* 西園雅集) purportedly brought together sixteen of the leading literati of the day. Though much celebrated in later painting and literature, recent research suggests it is unlikely that all those supposed to have attended the gathering could in fact have been present.

Pu Zhongqian—濮仲謙 (fl. early 17th century). Ming dynasty bamboo carver.

Qian Xuan's Dwelling in the Mountains—"Shanju tu" (山居圖).

Gu An's Bamboo Amid Rocks—"Zhu shi tu" (竹石圖). For Gu, see notes to item 21.

Fan Chengda—范成大 (1126–1193). For Huang Tingjian, see notes to items 70, 71, and 72.

Bamboo Carving—the 1992 *Zhu ke* (竹刻). Distinct from the earlier and better known *The Art of Bamboo Carving*, for which see notes to item 1. The publisher is 人民美術出版社.

Zhu Xiaosong—朱小松 (fl. late 16th–early 17th centuries). The second of three generations of noted bamboo carvers in his family, collectively known as the Three Zhus of Jiading (*Jiading san Zhu* 嘉定三朱) after their hometown.

Tao Yuanming—陶淵明 (365–427), sometimes known by his earlier name, Tao Qian (陶潛). Poet and official, and also a recluse later regarded as the ideal type of scholarly seclusion. Author of "Peach Blossom Spring" (桃花源記) and other classic works. The phrase "bow and scrape for a bushel of rice" (為五斗米折腰), borrowed from Tao's biography in the *History of Jin* (*Jin shu* 晉書) and referencing the traditional salary for a low-ranking official, has become a byword for debasing oneself for a meagre reward.

World of Cultural Relics—Wenwu tiandi (文物天地), a monthly bulletin published by China's State Administration of Cultural Heritage

The Palace Museum on My Own Time—Zhu's *Gugong tuishi lu* (故宮退食錄).

You haven't been liberated—from outmoded, "feudal" patterns of thought.

You can strip a great army of its commander—quoting *Analects* 9.26.

Chang'an—暢安, meaning "ease and peace".

Zhenwu, the True Martial One—真武, the guardian spirit of the north. Also known as Xuanwu (玄武), the Dark Martial One or the Dark Warrior, and sometimes represented as a tortoise entangled with a snake.

Poetry – Calligraphy – Painting—the Central Research Institute's annual magazine, *Shi-shu-hua* (詩書畫). For the Institute itself, see notes to item 8.

"Poem on Vegetables in a Planting Bed"—"Qishu shi" (畦蔬詩). Lu You (陸游, 1125–1209) was a major late-Song poet.

putou caps—a type of high cloth hat typically worn by officials, with protruding "wings" extending either upwards at the back or outwards from the sides.

The Literary Garden—"Wenyuan tu" (文苑圖). The painting bears an inscription declaring it to be the work of Han Huang (韓滉, 723–787), but this attribution is in doubt on stylistic and technical grounds. The holding institution, the Palace Museum, now ascribes it to the 10th-century painter Zhou Wenju (周文矩).

the Four Hoary Heads of the Shang Mountains—Shangshan si hao (商山四皓). So called for their retreat into retirement in the mountains during the collapse of the Qin dynasty in the late 200s BCE. The four men subsequently rebuffed attempts by the founder of the newly established Han dynasty to secure their services and, when brought to court, refused to endorse changes to the line of succession.

<div style="text-align:center">

093

"Fine Greens from a Rustic Kitchen" Five bamboo brush pots

2013

Inscriptions: Qi Gong, Wang Shixiang, Zhu Jiajin, Huang Miaozi
Carving: Zhou Hansheng, Bo Yuntian

</div>

During the creation of the "Fine Greens" chairs (see previous item), one of my ideas was to carve the plants mentioned in the inscriptions onto the back splat of each chair, with the text below. This layout was inspired by an important work of 17th century design, the *Album of Decorated Letter Paper from the Ten Bamboo Studio*. In the early 2000s, I asked Zhou Hansheng to prepare a set of paintings

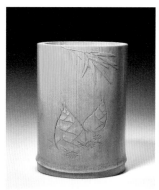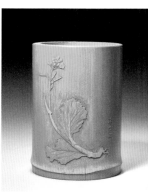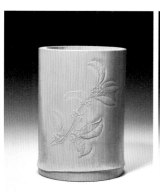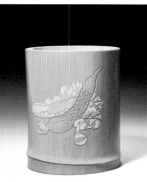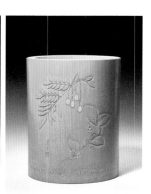

of the plants as the basis for the carvings. In the end, Tian Jiaqing persuaded me that it would be more elegant to carve the text of the poems alone, so they were never used.

Once the chairs were finished, I decided that I wanted to have the paintings carved after all. I had previously acquired four *huanghuali* brush pots, all of similar sizes, which I had not yet had carved, so I asked Zhou whether they would be suitable. He suggested that bamboo would be a more appropriate medium, since it would allow the outlines of the plants to shine through more clearly.

Once we had settled on the material, I turned to Bo Yuntian to complete the preparatory work: choosing the pots and adding the inscriptions on the back. At first, he tried to carve the poems in intaglio, but the pots kept cracking during the carving process. When he finally managed to complete a set, three cracked in transit on their way to Hong Kong. Only the Zhu Jiajin pot was undamaged.

As a result, we had to change plans. I asked Bo to re-carve the poems on new pots, this time in *liuqing* relief. Normally this would mean removing the outer skin of the bamboo all the way round, but I asked him to stop halfway, leaving a blank slate on the front of the pots for Zhou to carve the pictures. Once Bo had finished, I sent the pots on to Zhou, who returned them to me with the images added (Figs 93.1–93.9). From start to finish, the process took about a year.

Later, I decided it would be a shame to waste the Zhu Jiajin pot that had survived from Bo's original set, so I asked Zhou to add a sprig of chinaberry to the corresponding painting and to carve the result onto it (Figs 93.10, 93.11). So, in total, I ended up with five brush pots out of four.

Album of Decorated Letter Paper from the Ten Bamboo Studio— Shizhu zhai jianpu (十竹齋箋譜). A popular and much reprinted manual of luxury letter paper.

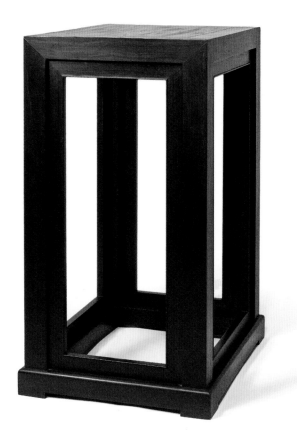

094
Trestle table

2006
Workshop of Tian Jiaqing

While Tian and I were working on the Purple Jade Table (see item 86), we decided to also make a trestle table. I hoped to make the top from a *zitan* frame – the same material as the Purple Jade Table – inlaid with *huanghuali*. When Tian asked our supplier whether we could order the wood for both projects together, he was told that the pedestals would not be a problem and that we could have the material for the table top as well. However, it would be a maximum of two metres in length, a metre shorter than we had hoped for. In the end, we accepted this, and I bought ten pieces of *huanghuali* in Hong Kong for the inlay.

For the trestles, I decided to borrow the design of a small, square table in the Nelson-Atkins Museum of Art in Kansas City (Fig. 94.1). I was still living in Oxford at the time, and I asked Robert Reedman, a retired architect who had a long connection to China[2], and who lived locally, to create a blueprint based on the Nelson-Atkins example (Fig. 94.2). From this, Tian prepared two model pedestals (Fig. 94.3), which he sent to Oxford with a table top for me to examine.

After that, the work progressed, as I thought, steadily. Then, sometime in 2003 (I remember it was during the SARS epidemic), I called Wang Shixiang at Paired Pines House. Yuan Quanyou answered the phone and told me excitedly, "Tian Jiaqing has finished your table!" She passed me over to Wang, who added that he had written an inscription for the piece, which he read to me delightedly, there and then on the phone:

> *Its pedestals are fine zitan;*
> *its top is tieli.*
> *Don't ask me what I paid, as is*
> *the fashion in these times.*
> *Is't generously made, and does*

2. Author's note: During the Chinese War of Resistance Against Japan, Robert Reedman was involved in the work of the Red Cross on the Burma Road, which carried supplies into China from British territory south of the border.

> it show its quality?
> Let that be how you judge, not things
> alone, but people too.

I was puzzled: the mention of *tieli* wood meant this was clearly not the same table I had been discussing with Tian. Then, later that year, Wang published details of the piece in the appendix to "Three Table Inscriptions" in *A Second Lovely Ash-Heap* (Fig. 94.4; see also item 86), and I asked Tian about it. He replied by fax on 22 December 2003. His letter drove home to me how difficult the process of design can be, and I think it is worth recording in full:

Dear Kössen

First, happy Christmas, New Year and Spring Festival. I hope all is well with you.

Your suggestions for improvements to the chairs [item 92] are very helpful, and I will need to think about them carefully.

The trestle table for which Wang Shixiang provided the inscription was the product of a long chain of misunderstandings. Three years ago, I made a 1:3.5 scale model of your table from the drawings [Fig. 94.2] you gave me – Hu Hang brought this to the UK for you to look over [see Fig. 94.3]. Later, when I came to make the real thing, I misremembered the ratio and cut the parts four times bigger than the model, because most of the models we had been making around that time were at 1:4 scale. It was only after finishing the pedestals that I realised they were too large and too tall. When I added the nanmu-*burl top[3], the proportions were seriously mismatched, and the result looked awful.*

I remember bringing up the error during one of our phone calls, but I think you may not have understood me clearly, and I never explained it further. After that, I cut the parts again and made a new pair of pedestals in the 1:3.5 ratio.

The oversize pair of pedestals caused me a good deal of grief. At one point I thought of turning them into incense stands or similar, but nothing really seemed to fit. Later a friend sent me some tieli *wood that he wanted me to make into furniture. One piece was 3.5 metres long, and it gave me an idea: I would use this opportunity to make something of the two pedestals, pairing them with a table top made from a single plank of* tieli *to make an extra-large trestle table. After I had worked up the table top, I mounted it on the pedestals, only to discover that they were too tall for it. So I dismantled and shortened them, which took two attempts. Once I had taken off a little over 10cm, the proportions were finally right, and everyone was happy. The only drawback was that the piece was really much too big: it weighed almost half a tonne. Not even the Palace Museum holds a trestle table*

of that size, and it would look out of place next to ordinary furniture. Eventually I gave a picture of it to Wang, who was impressed enough by the pairing of tieli *and* zitan *to write an inscription for it.*

The creation of this table was what one might call an "accidental success". It looks both refined and imposing, and making it showed me the essence of designing a trestle table: the top must be a single, very thick plank, almost three metres long as a minimum, and the height of the pedestals must match the rest of the design.

Back to your two zitan *pedestals (the ones made in the size specified in your drawings, at 3.5 times the scale model). When I added the* nanmu-*burl table top, the proportions were still out of kilter, the reason being that, while the top was broader than the one it replaced, the length was too short. Obviously, this particular top was not meant for a trestle table. I have therefore asked a friend of mine in the lumber business to look for a single, high quality plank for us, which will be the full three metres long. He should send it to Beijing shortly, and I promise that when that happens I will make you a trestle table that marries the perfect form with the right spirit (and that I will keep it to a shippable size…).*

The promised table was finished in autumn 2006 (Fig. 94.5), and Tian was generous enough to give it to me as a gift, for which I am deeply grateful. The inscription on the end of the table top reads as follows:

A large, single-plank, rosewood trestle table

A table top like this, a jade devoid of blemishes, is a difficult thing to acquire

I gift this to my dear friend Kössen Ho, to treasure and to use

> Tian Jiaqing
> the first day of autumn, 2006

Subsequently, Tian further modified the design of our pedestals into a "waisted" version, which he used to create another large table. Wang Shixiang named it "The Reclining Dragon", and it is described in Tian's *Ming Resonances* (Fig. 94.6). Some years ago, I visited Tian's workshop with several fellow members of the Min Chiu Society and saw this table. It had no inscription, and when I asked Tian why, he told me that, although Wang had given it its name, he had never written the calligraphy.

Hu Hang—胡航, Tian Jiaqing's wife.
 Ming Resonances—see notes to item 77.
 the Min Chiu Society—see notes to item 19.

3. Author's note: Because the huanghuali plank I had bought for the table top was two metres long instead of three, Tian had suggested replacing it with a top made from sandalwood inlaid with *nanmu* burl, which he happened to have on hand in his workshop.

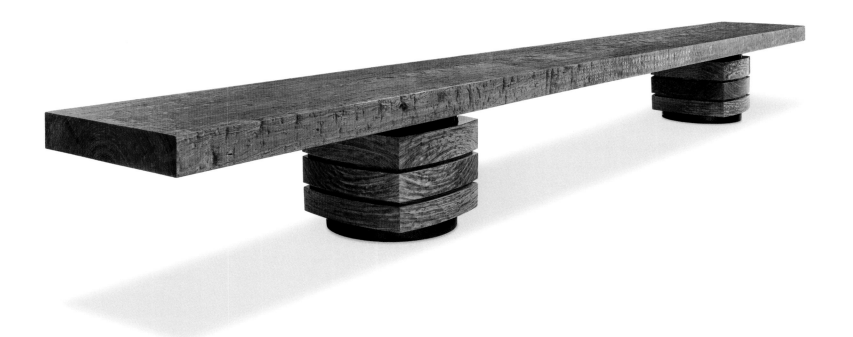

095 & 096
Heavenly Numbers Tables
Numbers One & Two

Inscription calligraphy: Wang Shixiang
Postscript: Fu Xinian
Design & inscription text: Kössen Ho
Woodwork supervision: R. Hampton
Carving: Fu Jiasheng
Collection of the Shanghai Museum (Table two only)

Between summer 2003 and autumn 2004, I travelled to Egypt, Belgium, and Germany, where I studied various types of urological cancer surgery. I had recently begun writing Classical Chinese poetry, and some of my efforts chronicling my experiences in this period are included in the Chinese appendix. When I left Hong Kong, I took with me a copy of a poet's handbook, *Collected Rhyming Dictionaries*, given to me by Wang Shixiang and once used by his mother Jin Zhang (Fig. B2). I also packed an edition of the *Book of Changes*, once owned by Professor Frederick Drake of Hong Kong University.

One day in Brussels, during an especially dull commute, I drew a simplified version of the pedestals from my trestle table (see item 94), minus the top boards, on the back of my train ticket. Each pedestal was made up of 12 components, for a total of 25 components if paired with a single-piece table top. I was reading the *Book of Changes* at the time, and I remembered a line in the accompanying commentary, "Attached Verbalisations", describing the so-called Heavenly Numbers, the odd numbers between one and nine. These add up to 25 – as the text puts it, "The Heavenly Numbers are five-and-twenty." I therefore named my design the Heavenly Numbers Table.

Later, I felt that, instead of following the fashions of the past by making a piece of Ming- or Qing-style furniture, I should strive to break with tradition. I decided to revise the pedestals completely and to create a new design. I would base it on a jade *cong* tube from the Neolithic Liangzhu culture of the Yangzi River Delta (Fig. 95.1), and it would include a reference to the trigram *qian* from the *Changes*. The result would be simple but full of meaning (Fig. 95.2).

Once I had decided on the principles, my thoughts turned to the inscription. It did not seem right to ask Wang Shixiang to provide it, given his advanced age. I thought it over and decided that a classical poem, using a traditional tonal pattern and rhyme scheme, would be the most appropriate format. Eventually, I was able to devise one that fitted the requirements:

> Heaven's Numbers here are timber made.
> > This table's form: a bridge that soars aloft.
> I prized a simple plainness for the stands,
> > And, for the top, solidity and length.
> Upstanding, broad and level, arrow-straight,
> > And fashioned to attune with qian and yang,
> Its browns and deeper shades are intermixed,
> > A dazzling pattern, and a brilliant grain.
> It bides its time, its purposes concealed:
> > A gentleman who grows himself in strength.

When the poem was finished, I showed it to Wang, who gave his approval. I then sent him a brush-written letter, asking if he would provide the calligraphy. It felt unseemly to ask someone so far my senior to write out my work, so, to make up for the embarrassment, I also sent Wang a brush-written copy of the following story, taken from Yuan Mei's *Addendum to Poetry Notes from Accommodation Garden*:

> The scholar Guo Lin sent me his portrait and requested poetry for it. Knowing that I was elderly, he had written two verses for the picture himself, and he told me that I could simply write these out. I happily complied and wrote back politely: "I myself could not have composed better poetry than yours."
>
> Guo also made the same request of Mr Yao Nai. Yao, however, was enraged at his lack of etiquette, and he sent the picture straight back, along with an angry note.

I say that this case is exactly like when Yue Fei returned home after his defeat of Yang Yao. He sent gifts to Han Shizhong and Zhang Jun. One was delighted, but the other was furious, for the hearts of men are not the same.

Liu Xiachang said of the matter: "The two of you are both right. Without Mr Yao, people would not know the respect due to their elders. Without Yuan Mei, people would not know their elders' magnanimity."

Wang completed the inscription and sent it to me the month after the Spring Festival in 2006 (Fig. 95.3). Once I had had it mounted, I asked Huang Miaozi to write the scroll title (Fig. 95.4) and Fu Xinian to add a postscript.

Furniture-making shares many similarities with architecture, one of which is the importance of choosing the right material. I began to look for the wood for the table in 2009, and the following February I finally acquired pieces of the right – very large – size. That April, I flew to Germany to supervise as they were split from the timber (Fig. 95.5). Drying was completed at the end of 2013.

The first step with a table top is to plane the wood flat on both faces, before cutting the two sides of the timber to form a rectangle. To get the proportions right, we first made a 1:10 and then a 1:2 scale model. My friend Dr Simon Kwan gave me additional help with the pedestals. We made full-scale models of these and went through several drafts before we fixed the design.

The first Heavenly Numbers Table has completely flat, straight sides. Its two pedestals are made of wood, and each has 12 components (Figs 95.6–95.8). My inscription is carved on the table in Wang Shixiang's calligraphy (Fig. 95.8), followed by Fu Xinian's postscript (Fig. 95.8):

This table is the result of careful reflection on the part of Kössen Ho. The top is in a single piece, almost nine metres long by one metre wide, below which are set two pedestals. Each of these is formed from twelve components, in an allusion to the phrase from the "Attached Verbalisations" of the Book of Changes: *"The Heavenly Numbers are five-and-twenty." The pedestals are made in imitation of Liangzhu jade cong tubes, with raised triple bands on each face matching the form of* qian, *one of the Eight Trigrams.*

The second Heavenly Numbers Table has slightly rounded sides and four pedestals (Figs 96.1–96.3), made from marble. Fu Xinian's postscript for it reads (Fig. 96.3):

This table is the result of careful reflection on the part of Kössen Ho, who makes use of natural materials on a monumental scale. The top is in a single piece, almost nine metres long by one metre wide, below which are set

four pedestals. Each of these is formed from six components, in an allusion to the phrase from the "Attached Verbalisations" of the Book of Changes: *"Heaven is one, Earth is six." There is a resonance too with the phrase, "The Heavenly Numbers are five-and-twenty." The pedestals are made in imitation of Liangzhu jade cong tubes, with raised triple bands on each face matching the form of* qian, *one of the Eight Trigrams.*

Once the tables were finished, I asked Fu Jiasheng to add another piece of text after the inscriptions, reading, "carved by Fu Jiasheng". The calligraphy of this phrase had been completed by Wang Shixiang many years earlier, and we enlarged it for this piece.

These two tables were extremely expensive to make, and they would not have been possible without support and participation in the project from my younger sister Irene Ho. The work was finally completed in the summer of 2015.

Collected Rhyming Dictionaries—詩韻集成. A standard reference work for writers of traditional poetry. For Wang Shixiang's mother Jin Zhang, see item 7.

the Book of Changes—the *Yijing* (易經, = *I Ching*), an early Chinese cosmological text, organised around a set of eight symbols known as trigrams (*gua* 卦). A trigram consists of three straight lines, each either broken or unbroken, derived originally from depictions of yarrow stalks scattered for divination. Trigrams combine with one another to form hexagrams of six lines each, whose possible meanings the book outlines.

Professor Frederick Drake—1892–1974. Also known by the Chinese name Lin Yangshan (林仰山). Drake was for a time the head of HKU's Chinese Department.

Attached Verbalisations—an early commentary on the *Book of Changes*. In the cosmology of the *Changes*, the Heavenly Numbers (*tianshu* 天數) are the odd numbers one, three, five, seven, and nine, associated with the masculine or *yang* principle.

Liangzhu culture—named for its type site at Liangzhu (良渚) in Zhejiang province and noted for its exceptional jade work. The original function of the two classic Liangzhu objects, the *cong* tube (琮) and *bi* disk (璧), is uncertain, though they are thought to have had a ritual purpose.

the trigram qian—the first trigram, consisting of three unbroken lines and associated, like the Heavenly Numbers, with the masculine principle, *yang*.

Heaven's Numbers here are timber made—the very first word of the poem's Chinese text, "timber", or more broadly "material" (*cai* 材), refers metaphorically to ability and talent – what a person is made of. This opening initiates a series of allusions to

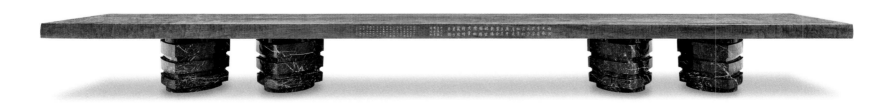

the ideal scholar or gentleman, who should be just as well built as the desk at which he will sit.

stands—the Chinese term *ji* (几) generally refers to a small, low table, but it is also used of the pedestals that support the tops of larger tables, which are roughly *ji*-sized. The Heavenly Numbers Tables both belong to this type of larger table, the *an* (案).

solidity and length—or, in the extended meanings of the Chinese terms, the more scholarly qualities of generosity and expertise.

pattern...grain—the Chinese term *wenzhang* (文章) refers to both decorative and cosmological configurations. By extension it indicates scholarly writings (which ought to capture these wider patterns), a sense preserved in its modern Chinese meaning of "essay".

It bides its time...grows himself in strengthen—the *Book of Changes* is especially prominent in this final pair of versets, which are dominated by two more or less verbatim quotations.

Addendum to Poetry Notes from Accommodation Garden—*Suiyuan shihua buyi* (隨園詩話補遺). Guo Lin and Yao Nai are respectively 郭麐 (1767–1831) and 姚鼐 (1732–1815). For the author, Yuan Mei, see notes to item 40. Liu Xiachang (劉霞裳) was a close friend and follower of Yuan. The other figures mentioned are the great Song commander Yue Fei (岳飛, 1103–41), the rebel Yang Yao (楊么) whom he defeated in 1135, and two other major commanders of the day, Han Shizhong (韓世忠, 1090–1151) and Zhang Jun (張俊, fl. early to mid-11th century).

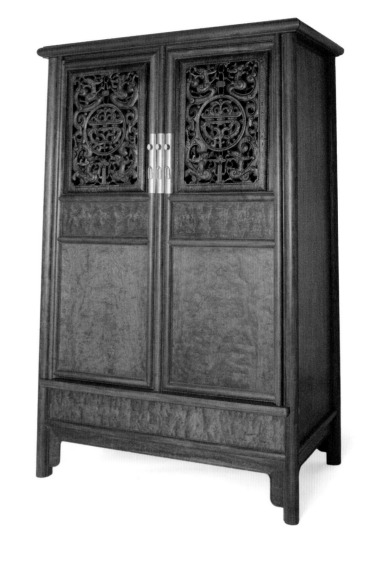

097
Large, round-cornered cabinet with *chilong* dragon motif

2016
Design, inscription and calligraphy: Kössen Ho
Carving: Li Zhi
Rubbing: Zhang Pinfang

In early 2000, I acquired a pair of window grilles decorated with *chilong* dragons supporting the character *shou* (壽, "longevity"). I could not think of a use for them at first, so for some years I set them aside. When the Heavenly Numbers Tables were finished in 2015, I found that there was some wood left over, so I devised the idea of making a cabinet from it, into which the grilles would fit. I drew up a design, deciding on a round-cornered frame and a "three-section" *"quadruple-railed"* structure for the doors, with six shelves. I then chose the wood for the doors and the walls, arranging the pieces so that their grains would match.

After the body of the cabinet had been assembled, I asked Charles Wong of Ever Arts Gallery to build the doors. Ou Guanhua was the carpenter on the project, and Yuan Jianguo completed the polishing. The doors took a month to complete.

My own inscription is engraved on the shelves (Fig. 97.1):
> *A great, round-cornered cabinet,*
> *Replete with dignity and poise:*
> *Three sections to each double door,*
> *With dragons inlaid at their tops.*
> *The wood is fair, its grain sublime,*
> *A view of endless mountain peaks.*
> *Within, a sixfold set of shelves –*
> *Each filled with documents and books –*
> *Remove or add them as you please.*
> *It stands, a flawless, heavenly thing,*
> *And on it this inscription carved:*
> *"With virtue, serve the Constant Mean."*
> *Inscription and calligraphy: Kössen Ho*
> *Carving: Li Zhi*
> *Qingming Festival, 2016*

chilong dragons—*chilong* (螭龍). Sometimes said to be differentiated from the ordinary dragon (*long* 龍) by their lack of horns, though the distinction is perhaps of relatively late date.

"quadruple-railed" structure—that is, the four horizontal stretchers on each door.

Ou Guanhua...Yuan Jianguo—respectively 區冠華 and 袁健國. For Charles Wong, see also item 8.

the Constant Mean—*Zhongyong* (中庸). A classical doctrine predicated on choosing the middle path between extremes.

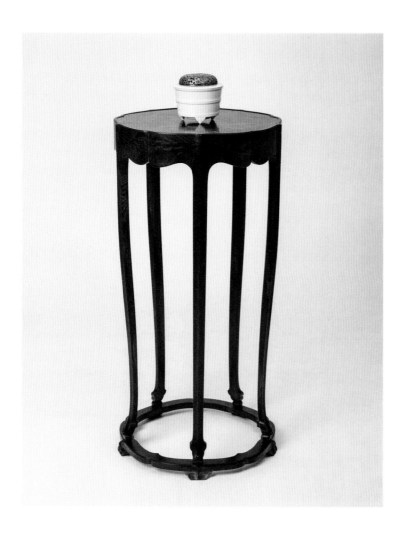

098
Five-legged *zitan* incense stand

2016
Design: Shen Ping
Workshop of Zhou Tong
Inscription and calligraphy: Kössen Ho
Carving: Fu Jiasheng

The origins of this stand can be traced back to summer 2012. My friend Sa Benjie invited me to see *In Company of Spring: A Sense of the Ming*, an exhibition of work by the furniture designer Shen Ping, at Huangcheng Art Museum in Beijing. The following winter, Shen sent me the catalogue, *Collected Works of Furniture Design by Shen Ping*. One of the items was a five-legged incense stand similar to the present piece. I was struck by it, but I felt that the legs were a little on the short side. I decided to ask Shen to create a taller version for me.

Shen has long been associated with the Ziqing Mountain Studio, a Beijing furniture workshop headed by Zhou Tong. This piece was another product of that collaboration. To prepare, Shen created a new, full-scale model, which I was able to see on a visit to the Studio. Once we had agreed on the design, Zhou himself supervised the making of the final piece; the gold-inlaid inscription is by Fu Jiasheng. The Studio's mark, the character *zhuo* (斲, "to carve"), appears on the

two transverse braces on the underside of the stand, once inscribed, once stamped.

The text of the inscription is my own. It reads:

> A five-legged incense stand,
>> Elegant in form:
> Sandal for its wood,
>> Its hue the deepest plum;
> A top of cracked ice, on
>> A nanmu underboard.
> Its legs and edge both curve:
>> Bold lines with gentle ends,
> Perhaps not so unlike
>> A lotus in its bud.
> Set vase and flower upon it,
>> A censer's fair perfume:
> Two masters' work – Shen planned it,
>> And Zhou took up his theme.

Sa Benjie—see notes to items 8, 30, and 83.

Huangcheng Art Museum—Huangcheng yishu bowuguan (皇城藝術博物館). The exhibition was entitled *Yu wu wei chun: Ming wei – Shen Ping jiaju sheji zhan* (與物爲春: 明味 – 沈平家具設計展), and the catalogue *Shen Ping jiaju sheji zuopin ji* (沈平家具設計作品集).

Ziqing Mountain Studio—Ziqing shanfang (梓慶山房).

sandal...deepest plum—indicating *zitan*, whose deep red colour is described as purple in Chinese.

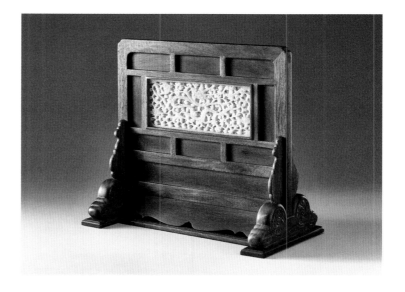

099
Small *zitan* screen

2017
Inset with a jade belt plaque
Design: Kössen Ho, Shen Ping
Workshop of Zhou Tong

In 1994, my father turned 60. I was struggling to find him a gift, so I went to Spink in London, where I purchased a large jade belt plaque with a dragon pattern. On a sheet of squared paper, I sketched out a design for a screen incorporating it, based on a similar piece referenced in Wang Shixiang's *Classic Chinese Furniture* (Fig. 99.1). Finally, I had it made in the UK (Fig. 99.2).

I always felt that my design left something to be desired, with shortcomings in the shape of the screen and the pedestal on which it stood. In 2016, I brought the pedestal and the screen to Shen Ping, who created an improved version. Working with Zhou Tong again, we had the new design made using leftover wood from the five-legged incense stand (see item 98, Fig. 99.3). Fu Jiasheng engraved the inscription on the reverse.

Classic Chinese Furniture—Wang's classic monograph on Ming and early Qing furniture, originally published in Chinese as *The Appreciation of Ming Furniture* (*Mingshi jiaju zhenshang* 明式家具珍賞).

The small jade carving that decorates this screen depicts peony flowers and a paradise flycatcher. It came, like the belt plaque in the previous item, from Spink in London – another 1990s purchase. The screen itself is again made from leftover wood from the five-legged incense stand (item 98). When I met Shen Ping in 2016 to discuss the project, I showed him a picture of the tie beams of the *sanmon* gate at Nanzen Temple in Kyoto (Fig. 100.1) and asked him to base the screen on them. The result, which incorporates the column-and-spandrel design from the gate as the base of the pedestal, was once again made by Zhou Tong's craftsmen. The inscription on the underside was carved by Fu Jiasheng.

Tai Tim—戴添, a former Hong Kong antique dealer.

Nanzen Temple—the Nanzenji (南禪寺) in east Kyoto. Its *sanmon* (山門), a two-storey gate that stands between the main hall and the smaller outer gate, is one of the most important examples of its kind in Japan.

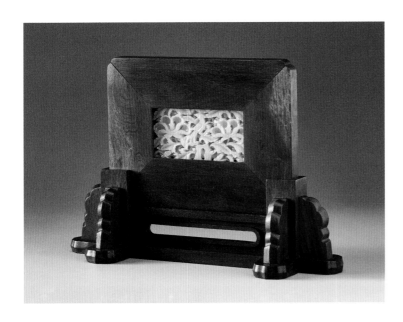

100
Small *zitan* inkstone screen

2017
Inset with a jade carving
Design: Kössen Ho, Shen Ping
Workshop of Zhou Tong

This item is an echo of an object that I saw in the early 1990s: a small, *zitan* inkstone screen inset with marble, which the dealer Tai Tim had in his shop in Sheung Wan. It was a lovely piece with a delightfully smooth, well-rounded appearance. At the time, however, I was going through a *huanghuali* phase, and I missed my chance to acquire it.

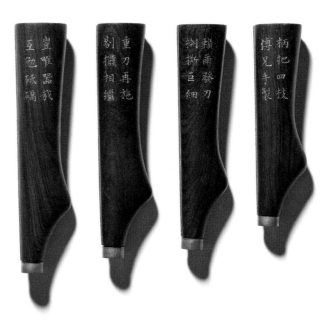

101
Set of four knife handles

2014
Inscription and calligraphy: Kössen Ho
Woodwork and carving: Fu Jiasheng
Rubbings: Fu Wanli

During the making of the Heavenly Numbers Tables (items 95 and 96), I wanted to learn more about the art of inscription carving, so I asked Fu Jiasheng if I could watch him at his work. He agreed, and as a result I spent a substantial amount of time with him throughout 2014, observing the engraving process.

Fu's first step was to measure the edges of the tables,

where the inscriptions were to be carved. He used these measurements to position photocopies of the calligraphy on the table edges, which he affixed with a thin glue applied to the wood (Fig. 101.1), before covering them with a layer of newspaper to protect any areas not being worked on. The photocopies were on two materials: fine gampi paper for smaller characters and ordinary paper for larger ones. Once they were in place, Fu could begin carving. For this he used five tools: chisels, a pear wood mallet, a palm-fibre brush, a sickle-shaped scraper and his engraving knives.

The blade of each engraving knife is made from a hand-ground strip of steel. Its tip is crescent-shaped, with a long point on one side and a second, shorter point closer to the handle. The knife is held with the wooden handle in the four fingers of the right hand. The right thumb sits on the top end of the handle to keep the knife steady, and the left thumb presses against the blade. If the carver requires, a magnifying glass can be held over the carving area by placing it between the left middle and index fingers (Fig. 101.2). Engraving is done from left to right and takes place in five stages:

1. "Initial knife": the carver marks round the outline of the characters using the longer part of the knife tip (Fig. 101.3);

2. "Splitting open": the carver breaks away some of the wood inside the outlines created in stage one, starting with the longer part of the tip (Fig. 101.4) and picking wood fragments out using the shorter part (Fig. 101.5);

3. "Second knife": the carver cuts around the edges of the characters a second time, creating a deeper outline (Fig. 101.6);

4. "Scraping out": the carver cuts out the interior of the characters using the chisel, striking it with the pear wood mallet (Fig. 101.7);

5. "Picking away": the engraved characters are planed down. The chisel is used again in this stage, but now without the mallet (Fig. 101.8).

Finally, after planing, any remaining scraps of wood are swept off with the palm-fibre brush.

This set of engraving knife handles, made by Fu himself, is carved from a single piece of South American rosewood divided into four sections. After Fu had made the handles and ground the blades, I wrote an inscription for them, which he engraved for me:

These handles, four in number, were
Handmade by Mr Fu Jiasheng.
He coolly made the initial cuts;
He split the wood apart along
Each stroke, then made the second cuts
And scraped and picked them clean. Behold,
No mere implements: we spurred
Each other on to greater heights.
Inscription and calligraphy: Kössen Ho
Carving: Fu Jiasheng
Summer 2014

I am grateful to Fu Wanli for the fine rubbings he took of these items.

gampi paper—雁皮紙 (Mandarin: *yanpi zhi*, Japanese: *ganpiji*). A glossy, semi-translucent Japanese paper made from the *gampi* plant.

No mere implements—recalling the Confucian dictum that the virtuous gentleman should not be treated like a mere tool (*qi* 器) in the hands of the ruler he serves.

102
Seal

2008
Text: "The Ho family, residents of Confucius Temple Lane, near the double plank bridge over Fen Creek, Dongguan"
Carving: Xu Yunshu

This seal was a gift from the late Li Pengzhu, the chairman of the *Macao Daily News*. He told me who he had in mind to carve it, and he asked what text I wanted. When I said I wanted my family's place of origin, he readily agreed.

My ancestors originally moved to Nanxiong (in what is now Guangdong province) during the late Song dynasty, when they settled in Zhuji Lane. In 1273 they moved again, first to Lianzhou and then to the nearby county of Nanhai in Guangzhou, where they stayed for three generations. The founder of my branch of the lineage was He Dongqi, who served as an imperial inspector in Shawan, part of Panyu district, under the Yuan. He moved to Dongguan after his term of office ended, and there the family remained until the 1920s, when my grandfather moved to Hong Kong. It was a shock to me to discover how long we had spent in Dongguan: over 500 years.

I still remember visiting our old hometown in the 1980s. It felt like an oasis of calm far from the cares of the world: footpaths crisscrossed each other in the fields, streams flowed under little bridges, simple houses in grey brick and pink stone stood side by side. But time changes things. 30 years on, the whole place is a concrete jungle.

Li Pengzhu—see notes to item 8. Xu Yunshu (徐雲叔, b. 1947) is a noted Shanghainese calligrapher and seal carver.
He Dongqi—何東起 (fl. early Yuan dynasty).

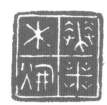

103
Two seals

2000, 2007
Text: "Many fair blossoms make a fine tree"
Carving: Fu Jiasheng

Zhu Jiajin's postscript to the title calligraphy gives the story behind the text of these two seals. The larger, intaglio version (above, bottom) was carved in 2000 by Fu Jiasheng, using an antique script. In 2007, I asked Fu to cut another, smaller version with the text in relief (above, top).

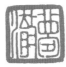

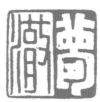

104
Two seals

2005, 2015
Text: "Dispersing the Dream [夢澈]"
Carving: Fu Jiasheng

Some years ago, Wang Shixiang asked Qi Gong to present me with a piece of calligraphy (see item 92, Fig. 92.3). On it, Qi accidentally miswrote my name with a homophone (夢澈 for 孟澈). Wang thought the new name, "Dispersing the Dream", sounded deeply philosophical, and at his suggestion I adopted it as a soubriquet.

In 2005, I asked Fu Jiasheng to carve my new name onto a tile-knob seal (below, left), with one character in relief and the other in intaglio. The resulting seal impression has a delightful, classical elegance. The second item in this pair, an old ivory seal (below, right), was carved by Fu in 2015 and uses relief script throughout.

tile-knob seal—*waniu zhang* (瓦紐章). Describing a seal topped with an arc resembling a rooftile.

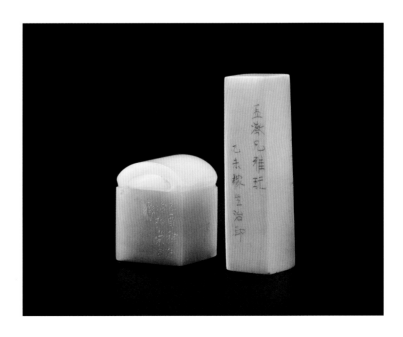

105
Seal

2008
Text: "A work of the brush by Kössen Ho"
Carving: Chen Mingwu

This seal was another gift from Li Pengzhu. When he asked what text I wanted, I decided to suggest something that I could use on my own works. The handle depicts a dragon-eye goldfish.

a work of the brush—translating the Chinese term *hanmo* (翰墨), which encompasses both calligraphy and painting.

Li Pengzhu—see notes to item 8.

a dragon-eye goldfish—*longyan jinyu* (龍眼金魚). A fancy variety with large, protruding eyes. Often referred to in English as the telescope-eye goldfish, after its Japanese name, *demekin* (出目金).

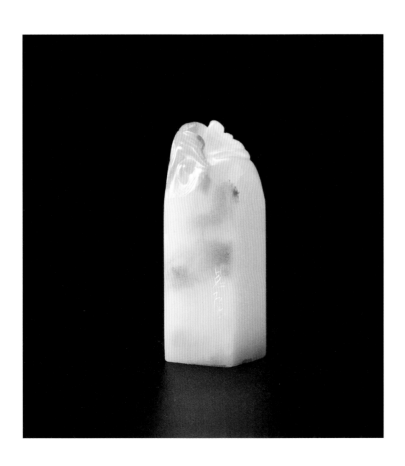

106
Seal

2007
Text: "From the library of Kössen Ho"
Carving: Fu Wanli

I bought this Shoushan-stone seal in the 1990s at Chinese Arts and Crafts in Central, Hong Kong. The *xiezhi* cub that decorates the handle has a plump, gormless appearance that I find absolutely charming. When I bought the seal, I arranged through the shop for it to be inscribed, "From the library of Mr Ho". In 2007, I asked Fu Wanli to grind it flat and reinscribe it with the less formal, "From the library of Kössen Ho".

xiezhi—a mythical creature endowed with supernatural powers of judgment, the *xiezhi* (獬豸) uses its single horn to indicate which of two opposing parties is in the wrong.

I asked Fu Wanli to…reinscribe it—the change in the inscription is more dramatic in the original, which replaces the formal "Mr Ho" (*He shi* 何氏) with the author's personal name (Man Tzit or Mengche 孟澈) alone.

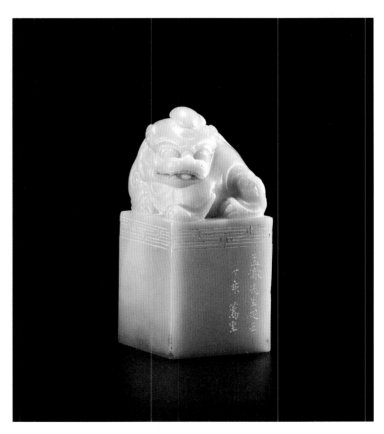

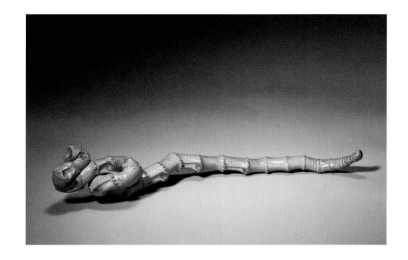

107
Three personal seals

2012
Carving: Fu Wanli

Two of these seals carry my family name, one in relief (below, right) and one in intaglio (below, left); the third (below, middle) carries my personal name in intaglio. All three were carved in small regular script by Fu Wanli. The small size of the seals–only about six millimetres square – taxed his eyesight to the limit.

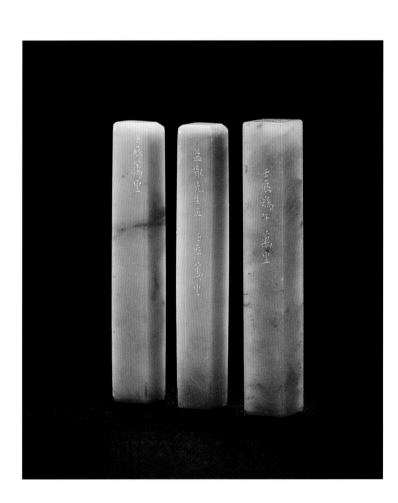

108
Naturally shaped bamboo root
ruyi sceptre

2019
Inscription: Zhou Hansheng
Carving: Li Zhi
Rubbing: Fu Wanli

After Zhou Hansheng acquired this delightfully simple and elegant ruyi sceptre, made from natural bamboo rootstock (Fig. 108.1), he showed me a short text he had written for it. In spring 2019, I asked him to prepare a final version of the calligraphy (Fig. 108.2), which I then asked Li Zhi to carve.

The arrangement of the inscription on the sceptre caused considerable trouble, and we went through three designs before deciding to divide the text between four sections of bamboo, with one line per section (Fig. 108.2). The postscript and the seals were placed on the back (Fig. 108.3).

The sceptre was sent to Shanghai at the beginning of April 2019, and Li completed the carving there in mid-May. Zhou was full of praise for his work, telling me: "I have never seen someone who could carve small characters so deep into bamboo while still achieving such precision. Li's carving has added to the beauty of the material: no jade could be finer or smoother. The shallow bamboo carving one usually sees pales in comparison to this extraordinary work."

Fu Wanli kindly took a rubbing of the entire object (Fig. 108.4), which is in itself a masterpiece of craftsmanship.

The inscription reads:
> *The bamboo rootstock twists and turns*
> *before it comes to life.*
> *I looked at it, and there I saw*
> *a ruyi sceptre's length.*
> *It coils like auspicious clouds*
> *and stretches like a staff,*
> *Filling me with envy of*
> *the Mount She Monk himself[1].*

ruyi sceptre—the S-shaped *ruyi* design, whose name means "according to your wishes", is a symbol of good fortune. A ceremonial sceptre in this shape represents the power and authority of a Buddhist abbot.

auspicious clouds—often combined with the *ruyi* design in a "*ruyi* clouds" pattern.

1. Author's note: for the name "the Mount She Monk", see the "Biography of Ming Sengshao" in the *History of Southern Qi* (*Nanqi shu: Ming Sengshao zhuan* 南齊書 · 明僧紹傳). The text records that Sengshao (d. 483) resided at Mount She (攝山) in Jiangsheng (江乘), where he built and lived in the Qixia Temple. It was at this time that Emperor Gao of Qi bestowed on him his famous bamboo root *ruyi* sceptre and his crown of bamboo shoots. As a result, he became known as the Monk of Mount She.

Index

	Catalogue number
Pu Ru 溥儒 (1896–1963)	030, 083–085
Zhang Daqian 張大千 (1899–1983)	039
Wong Po-Yeh 黃般若 (1901–68)	065, 066
Fu Baoshi 傅抱石 (1904–65)	048–050
Qi Gong 啓功 (1912–2005)	008, 084, 085, 092, 093
Huang Miaozi 黃苗子 (1913–2012)	010, 082, 092, 093
Wang Shixiang 王世襄 (1914–2009)	001, 002, 004–007, 010, 018, 020, 025, 040, 051, 052, 086, 092, 093, 095, 096
Zhu Jiajin 朱家溍 (1914–2003)	092, 093
Fu Xinian 傅熹年 (b. 1932)	004, 009, 095, 096
Tung Chiao 董橋 (b. 1942)	004, 011, 022, 039, 071, 080, 081, 084, 085
Zhou Hansheng 周漢生 (b. 1942)	002, 004, 040, 043, 079, 080, 093, 108
Fan Yaoqing 范遙青 (1943–2022)	001, 004–007, 018
Chen Mingwu 陳茗屋 (b. 1944)	105
Xu Yunshu 徐雲叔 (b. 1947)	102
Tian Jiaqing 田家青 (b. 1953)	086–088, 090–092, 094
Shen Ping 沈平 (b. 1954)	098–100
Fu Wanli 傅萬里 (b. 1957)	001–006, 008–011, 013, 014, 019, 021–027, 029–034, 037, 039–043, 047–052, 054–056, 059–063, 065, 066, 070–078, 084, 085, 092, 101, 106–108
Wan Yongqiang 萬永強 (b. 1957)	020
Fu Jiasheng 傅稼生 (b. 1958)	002–004, 008–012, 017, 019, 022, 024, 026, 029, 030, 037, 040, 043, 056, 063, 070–078, 080, 083, 085, 086, 092, 095, 096, 098–101, 103, 104
Zhu Xiaohua 朱小華 (b. 1958)	004, 023, 035, 036, 040, 042, 044, 045, 047, 048, 051, 053, 061, 073
Kössen Ho 何孟澈 (b. 1963)	001–108
Bo Yuntian 薄雲天 (b. 1967)	004, 025, 027, 031–034, 038, 041, 046, 049, 050, 052, 054, 055, 058–060, 062–066, 084, 093
Zhang Pinfang 張品芳 (b. 1967)	057, 068, 069, 081, 082, 097
Zhou Tong 周統 (b. 1972)	098, 099, 100
Li Zhi 李智 (b. 1973)	004, 015, 016, 046, 057, 063, 068, 069, 081, 082, 087, 097, 108
Jiao Lei 焦磊 (b. 1983)	046
Chen Bin 陳斌 (b. 1987)	021, 028, 039, 067

My Thoughts on
Many Fair Blossoms Make a Fine Tree

By Fu Yang 傅羍 Translated by Ashley Wu

In the nineties, my grandfather (Mr Zhu Jiajin) often received letters and postcards written in Classical Chinese. "Dr Ho sent these from Britain", he told me. Classical Chinese written in traditional characters was uncommon at the time. These correspondences thus intrigued me, and I was eager to give them a read after my grandfather had finished with them. I still remember the line, "Spring is in the air in the British Isles, it must be too in Beijing", from a postcard, which was wrapped up with a nice spring greeting. The elegant, flowery language captivated my imagination.

Dr Ho invited me to share my thoughts with "a critical mind, best with critiques and suggestions for improvement", after reading *Many Fair Blossoms Make a Fine Tree*. His words made me uneasy at first, for I am not as experienced as he is, and lack the acute insight of a scholar. At the same time, I understood that it was a well-intentioned gesture to guide and support the younger generation. I deliberated over the idea repeatedly and then went ahead, giving it a try before I could back out, deciding that it was a challenge I could not take on.

In his introduction, Dr Ho tells us that a pair of wrist rests designed by Wang Shixiang and executed by Fan Yaoqing inspired him to delve into the bamboo carving field (footnote 1, Item 001). The carving collection in this publication covers a range of designs and themes that could be grouped as follows: the Qing dynasty's Imperial Collection of paintings and calligraphy, stone sculptures and figures of ancient sages, pre-modern and contemporary calligraphy, pre-modern and early-modern paintings, and works themed around patterns found on *nasīj* ("cloth of gold") from the Yuan dynasty and manuscripts from Dunhuang (footnote 2).

The theme, raw materials, and techniques involved in an artifact are windows into the traits of its collector. Dr Ho describes himself as a doctor who performs minimally invasive surgery: "a career of the hand" (Item 015). To me, an outsider, the way minimally invasive surgery operates within a tiny space using an instrument is similar to how a craftsman manipulates a limited space in carving. The size of a scholar's object invites its viewers to hold it in their hands in order to observe and study it closely, reinforcing the concept of space in this type of carved object.

In terms of theme, decorating a *zitan* brush pot with a pattern isolated from a Yuan-dynasty *nasīj* was a distinctive choice (Items 056 & 057). With its deep lustre resembling that of a rhino horn, *zitan* pairs well with the colour and brightness of gold decorations. The contrast draws attention to the beautiful wood texture and brings out the pattern at the same time. Meanwhile, the *zitan* brush pot with an incomplete Dunhuang scripture was dotted with knife points to give a rough, sand-like, granular finish. The decoration echoes the condition endured by the scripture inside the caves, and recreates the paper texture that characterized manuscripts in Dunhuang (footnote 3). It contributes to the object's overall restrained, quaint aesthetics.

The brush pots decorated with Su Shi's *Wood and Rock* painting from the Song Dynasty make use of *huanghuali*, *zitan*, and bamboo, respectively, and are carved with a range of techniques (Item 063, footnote 4). The *huanghuali* brush pot, decorated with *yin* carving peppered with hints of *yang* carving, most loyally portrays the brushwork in the original painting. As for the *zitan* brush pot, the gilt gold *yin* carving animates the object as if it is a philosopher's stone from Chinese mythology. In ink rubbings, the image becomes compelling with its realistic rendering of wood and rock, completely altering the work's visual impression.

Rubbing archives the carving on a bamboo object in a unique manner. The medium, in varying shades of ink, carries an air of sophistication. According to Dr Ho, the slightly elevated *yin* carving accounts for the *je ne sais quoi* in the Su Shi plague of "The Studio of Bitter Rains"(Item 071). The strokes-alternating between black, grey, and white-are made dynamic in rubbings which capture the brush movement and the elegant flow from stroke to stroke. The vividness of Fu Wanli's rubbing of the bamboo root *ruyi* sceptre (Item 108) speaks to the artist's mastery of the craft.

The objects shown in this publication are all designed by the collector himself, and they reflect their designer's disposition to a large degree. Dr Ho's profession demands strong scientific, logical reasoning. He applied his analytical skill and discernment as a medical doctor to the design process. Furniture design and production are especially costly in terms of time and effort. The search for a piece of raw material that is just right simply cannot be forced. Fully communicating the design's rationale to drafters presents another challenge. The

eighteen-year commission process of Heavenly Numbers tables Numbers One and Two was almost a spiritual practice. Thanks to the inclusion of Dr Ho's original diagrams and correspondence with Tian Jiaqing in the Chinese volume, we readers are afforded a glimpse of the entire process.

Collecting art is a luxury hobby, more so now than ever. It asks of a collector the ability to read and comprehend Classical Chinese, the capacity to learn and analyse like a scientific researcher, the generosity to share knowledge, the worldview to appreciate different arts and cultures, perseverance, reverence for ancient civilizations, respect for those intellectuals who came before us, and a passion for nature and its being. Moreover, the role of serendipity is just as important in the journey of collecting as in spiritual practice. As a result, the character of a collection is a direct reflection of the collector as a person.

Note on Tian Jiaqing's photograph of Mr Zhu Jiajin in volume one on p. 4:

When I was in kindergarten, between the age of 3 and 4, my grandmother said that my grandfather would often take photos of her with his camera when they were out and about. After she passed away in January 1993, the family kept at home an enlarged photograph of her as a young woman in the Republican Era. It was taken when my grandparents were newlyweds.

Her death prompted us to freshen up the house with a clean-out and new walls. It raked up the past, including a large number of photos and films from the Republican Era. I went over them one by one, like a tourist browsing postcards. They were mesmerizing.

Later in life, I learnt from my mother that her childhood was a peculiar time when money and resources were scarce, but photography remained a passion for my grandfather. To make every sheet of film count, he would observe the way light and shadow met at his subject matter over different times of the day before clicking the shutter. He was also good at improvising when it came to photography props for special effects. Grandfather took most of the photographs we found at home, as his advanced skills made him particular about the photographs taken by others.

One afternoon when I was in middle school, he showed me a photo he had taken near West Lake a few days before, explaining its lighting and composition. Another photo he took at a work conference in a certain province in southern China came up during our conversation. Holding a cigarette in his hand, he said, "For pictures like this you just need to arrange the group. A piece of cake." Then, with smiling eyes, he grinned at me.

Footnote 1—"It is not a common practice to sign a bamboo carving. An artist pours his heart and soul into carving such delicate pieces. It takes months or even years to complete a work. Wang Shixiang was an avid advocate for bamboo carving. He often made room in his seminars in China, Hong Kong, Macau, and Taiwan to promote the craft." Fan Yaoqing, "In memory of Wang Shixiang" in *Ink on Bamboo: Letters on art from Wang Shixiang to Fan Yaoqing*, 1–3. Beijing: Life Bookstore, 2015.

Footnote 2—I propose categorising the scholar's objects in the book according to their attributes for ease of reference for researchers.

Footnote 3—The comparison was informed by a demonstration I attended at the British Library performed by Dr Frances Wood, then curator of the Library's Chinese collections. She made the paper texture of a manuscript visible by placing it on a lightbox. One can still feel the suppleness of the paper used for these Dunhuang scripts a thousand years ago. It is not as thin and fragile as we imagine. The carving on the *zitan* brush pot is an imitation of the gritty paper.

Footnote 4—The diameter of the brush pot decorated with *liuqing* carving is 7.8cm, which makes it 40% smaller than the other two brush pots. It is an elongated cylinder. Perhaps it would look more like the other two if its wall were rounded and thickened into an ellipse. I formed my understanding based on diagrams so the reader will forgive any error I may have made since I have yet to see the work in person.

Biographies

Zhou Hansheng（周漢生）

Zhou Hansheng (b. 1942) is a graduate of the Guangzhou Academy of Arts, where he studied in the Crafts Department. Following his graduation in 1966, he spent the period from 1968 to 1979 as a worker in Hefei. Thereafter he was head of the Hefei Applied Arts Research Institute, manager of the Ten Bamboo Studio and finally Deputy Director of the Hefei Applied Arts Company. From 1985 to 2002, he worked at Wuhan's Jianghan University, where he was Head of the Teaching and Research Division in the Art Department before becoming Department Chair. In his spare time, Mr Zhou is a bamboo carver, specialising in high relief carving and freestanding sculpture. Wang Shixiang has described his freestanding work as "the best that has been produced in China for four centuries, going all the way back to the great carvers of the late Ming".

Praise for Zhou Hansheng:

"In Mr Zhou's brief retrospective essays, knowledge is premised on experience, and true understanding develops out of practice. Gone are the outlandish descriptions offered by generations of Chinese men of letters, who have waxed lyrical about the virtues of the handcrafted scholar's object. Instead, many of Zhou's views reflect the sheer difficulty of sitting down in a studio and actually executing or planning a carving. Reading his work was a relaxing pleasure, but also an eye-opening joy."
– Tung Chiao, "A Sullied Mind" (董橋, "染心")

"After seeing work of this kind, I feel shaken and saddened. Shaken, because it conveys an eternal, sublime beauty. Saddened, because it reminds me of the will and tenacity of artisans, who have striven to better themselves, even as the educated have looked down on their labours."
– Tung Chiao, "In Her Summery Boudoir, She Wore Flowers in Her Hair" (董橋, "夏閨裏那個簪花人")

"I will not call him a bamboo carver: the term does not seem to do him justice. 'Scholar of applied arts' is probably a better fit. In the 30 years since he graduated from the Guangzhou Academy of Arts, he has been constantly researching and gathering information. He has been a creator and designer, a writer and editor, a manager and administrator. Old and new, Chinese and foreign – if applied arts are involved, he has done it. Bamboo carving has been a hobby, done only in his spare time."
– Wang Shixiang, " Transmitting the Old, Creating the New: An Introduction to the Bamboo Carving of Zhou Hansheng" (王世襄, "兼善繼承與創新 ——介紹周漢生竹刻")

Fan Yaoqing（范遙青）

Fan Yaoqing (1943–2022) was a contemporary bamboo carver, born in Diaozhuang district, Changzhou, Jiangsu. Widely regarded as one of the Five Masters of the *liuqing* technique, Mr Fan began weaving birdcages and carving bamboo from an early age. He later specialised in *liuqing* under the guidance of the well-known carver Bai Shifeng (白士風) and studied other carving techniques, including sunken relief, guided by Wang Shixiang (王世襄). Writing in *People's Daily* in 1985, the scholar and diplomat Li Yimeng (李一氓) described Mr Fan's work as "carving of the highest quality, brimming with vigour", adding: "At its best, it compares favourably with the great carvers of the Ming and Qing. In fact, it may even be superior to them… This is a bamboo carver of exceptional accomplishment."

In 1995, Mr Fan was awarded the title of UNESCO Folk Arts and Crafts Artist. In 2009, he was recognised by the government of Jiangsu for his work preserving the province's intangible cultural heritage. Fan's work has been acquired by museums in London, New York, and Hong Kong and has been treated at length in several authoritative monographs on bamboo carving, including Wang Shixiang's *The Appreciation of Bamboo Carving* (竹刻鑒賞), *A Lovely Ash-Heap* (錦灰堆), and the English language edition of *Bamboo Carving of China*, as well as Gong Jinliang's *Compendium of Liuqing Carving* (貢進樑, 留青竹刻集).

Tian Jiaqing（田家青）

Tian Jiaqing (b. 1953, Beijing) graduated from Tianjin University with a mechanical engineering degree. He was for many years an engineer at the Research Institute of Petroleum Processing in Sinopec's headquarter in Beijing, devoting his spare time to the study of Chinese antiquities, especially furniture from the Ming and the Qing Dynasties. He is the author of the pioneering study *Classic Chinese Furniture of the Qing Dynasty*. Giving equal importance to theory and empirical knowledge, Tian has enjoyed considerable success in the design and production of traditional furniture with a modern twist since 1997, blurring the line between art and furniture.

Selected Publications
1. *Classic Chinese Furniture of Qing Dynasty*, Philip Wilson Publisher's, London, 1996.
2. Member of the editorial board of *The Art of Diaoyutai State Guesthouse* and caption writer for furniture from the Ming and the Qing dynasties in the collection, Diaoyudai State Guest House Administration, 1997.
3. *Notable Features of the Main Schools of Ming and Qing Furniture*, Joint Publishing, Hong Kong, July 2001.
4. *Ming Yun: Tian Jiaqing she ji jia ju zuo pin ji* (Enduring Resonance: Furniture designed by Tian Jiaging), Joint Publishing, Hong Kong, 2006
5. *Ming Yun II: Tian Jiaqing she ji jia ju zuo pin ji* (Enduring Resonance II: Furniture designed by Tian Jiaging), Joint Publishing, Hong Kong, 2019.
6. *Ming Qing jia ju jian shang yu yan jiu* (*Connoisseurship and Research of Furniture from the Ming and the Qing Dynasties)*, Wenwu Chubanshe, Beijing, 2003.

Shen Ping（沈平）

Shen Ping (b. 1954, Beijing) was a self-taught fitter, measurer, drafter, and professional in art and props for film and television in his twenties. In the 1990s, he took a dwarf southern official's hat armchair that he had designed and which had been approved by an art and design academy, to visit Wang Shixiang. Wang fostered his passion for Chinese culture and traditions as Shen worked to develop a rigorous practice with an emphasis on precision. He has since devoted himself to the study of Chinese antique furniture and the method of its construction.

Fu Wanli（傅萬里）

Fu Wanli (b. 1957) is a research associate in the Technical Department of the National Museum of China, where he works on the copying of calligraphy and paintings and the preparation of rubbings. Born in Beijing, Mr Fu studied calligraphy, seal carving, and rubbing-making from a young age with his father, Fu Dayou (傅大卣). Beginning in the 1970s, he undertook an apprenticeship with the calligrapher Kang Yong (康雍). He received additional training from Kang's brother Kang Yin (康殷), as well as from Shang Chengzuo (商承祚), Qi Gong (啟功), and other leading lights of China's 20th-century art world. He subsequently received regular instruction from Wang Shixiang (王世襄), covering a wide range of fields. In 40 years as a calligrapher, seal carver and rubbing maker, Mr Fu has taken rubbings of important items for institutions including the National Museum of China, the State Administration of Cultural Heritage, the Palace Museum, the Poly Art Museum, the Shanghai Museum, and Taiwan's Academia Sinica. He would like to take this opportunity to express his gratitude to all his teachers and mentors, whose memory he continues to carry with him.

Wan Yongqiang（萬永強）

Wan Yongqiang (b. 1957, Tianjin) began his career in a gourd art atelier in 1979 and has since fostered a deep interest in the art form. He first devoted himself to the study of the horticulture of the gourd, then in 1980 introduced gypsum to replace earthen ware for a simple and effective moulding process. From the early 1980s onwards, under the mentorship

of Wang Shixiang, Wan has engaged in the horticulture, impression, connoisseurship, and collection of gourd art, with the mission to pass on the knowledge, skills, and customs of this intangible cultural heritage.

Fu Jiasheng （傅稼生）

Fu Jiasheng (b. 1958, Beijing) started his wood-block printing apprenticeship in the printmaking Rong Bao studio at the age of 20. In three years, he began to work solo on paintings by Wu Zuoren and Wu Guanzhong, and was one of the carving artists of Zhang Zeduan's *Along the River During the Qingming Festival*. In 1990, he joined another team at the workshop to focus on preparing outline drafts for carvings. He joined the market management in Rongxing Art Gallery in 1993. Since then, he has spent his free time in the research of masterpieces of Chinese paintings and carving techniques. His work has entered the collections of Wang Shixiang, Zhu Jiajin, Fu Xinian, T.T. Tsui, Tian Jiaqing, Wang Zhilong, Tung Chiao, Hui Lai Ping, and C.P. Lau. He is a three times winner of the highest award in the exhibitions organised by the China Publishing Group between 2009 and 2012. His art has been featured in an educational programme on China Central Television, and he has been an exhibiting artist in an exhibition held by the China National Academy of Painting.

Zhu Xiaohua （朱小華）

Zhu Xiaohua (b. 1958, Zhanggang Township, Xiong County, Hebei) graduated from high school in 1975. In early 1976, he started his agricultural mechanics studies at the May Seventh Cadre School and joined the agricultural machinery management station the same year. In the second half of the 1980s, following the closure of the station, he began trading second-hand goods and developed an interest in bamboo vessels.

In 1991, Zhu began learning bamboo carving from scratch by himself, through books and tools. Starting with high relief, Wang Shixiang's *Zhuke* inspired him to specialise in intaglio and *liuqing* carving. He wrote to Wang in 1997, but an address error meant that Wang did not receive the letter until two years later. With Wang's guidance and support, in addition to practicing the craft and studying calligraphy and painting diligently, Zhu formed his own artistic style. Wang featured Zhu in his essay "Bamboo carving from a farmer: Zhu Xiaohua's shallow sunken relief and *liuqing*", published in *Collectors* in 2001, which was later included in Wang's own *A Lovely Ash-heap* and *Compendium of a Few Old Things*. Zhu is lauded as one of the five most distinguished *liuqing* bamboo carving artists in China. His work has been featured in The Palace Museum's *Zijin cheng (Forbidden City)* and *Collectors*. He was awarded the Certificate of Folk Artists in Hebei province in 2014.

Kössen Ho （何孟澈）

Kössen Ho (b. 1963, Hong Kong) is a specialist in urology. He completed his medical degree at the University of Wales College of Medicine before earning his DPhil from the University of Oxford. He is a fellow of the Royal College of Surgeons of England, the Royal College of Surgeons of England (Urology), the Royal College of Surgeons of Edinburgh, the Royal College of Surgeons of Edinburgh (Urology), the Hong Kong College of Surgeons, and the Hong Kong Academy of Medicine. Wang Shixiang's mentorship sparked Kössen's interest in bamboo carving in the early 1990s, encouraging him to collaborate with artists to commission bamboo and wood carvings. He has contributed to magazines such as The Palace Museum's *Forbidden City* and *Collector*. He is the editor and writer of *Bamboo Carvings of Zhou Hansheng* published by Chung Hwa Book Co. in 2017.

Bo Yuntian （薄雲天）

Bo Yuntian (b. 1967) is a national, first-class carving artist and a member of China Arts and Crafts Association. He began his training in calligraphy and painting in 1986 as a student of Zheng Renhe, and started to specialise in bamboo and wood carving after his engraving caught the attention of Wang Shixiang in January 1996. He is known for bringing the grace and elegance of traditional Chinese works on paper to his carving. Since 2012, Bo has appeared in *Zhongguo minjian wenyijia da cidian* (Encyclopedia of Chinese Folk Artists) co-published by the China Federation of Literary and Art Circles and Chinese Folk Literature and Art Association. Since July 2013, he has been included in the modern edition of *Zhu ren shuo (Masters in Chinese Bamboo Art)*. He received the Gold Award in the "Works of Chinese Arts and Crafts Masters" exhibition in 2013.

Zhang Pinfang （張品芳）

Zhang Pinfang (b. 1967) is a rubbing maker and restorer. Following her graduation from university, Mrs Zhang apprenticed with the noted rubbing maker and antiquarian rubbing and book restorer Zhao Jiafu （趙嘉福）. In 30 years as a book restorer, rubbing maker, and mount restorer for rubbings, calligraphy and painting, she has performed emergency restoration work on a wide range of artefacts, including badly damaged rare books and rubbings and material from the archives of various historical figures. Mrs Zhang's major projects include leading the restoration of the library of the Qing official Weng Tonghe （翁同龢） and the calligraphy of Zhang Zhao （張照）, both in public collections, as well as of archival material from the Hong Kong branch of the Bank of Communications. She has participated in the creation of

stone-inscribed copies of important calligraphy for municipal governments, universities and individuals, most notably Chen Congzhou's "Stele Inscription on the Restoration of Aloewood Pavilion" (陳從周, 重修沈香閣碑記), Ma Gongyu's copy of "Record of Siqun Hall" (馬公愚, 思群堂記) and a rare edition of the letters of the scholar-official Wang Chang (王昶). She has also taken rubbings of the stone statuary of the Museum of the Scholarship of Feng Qiyong (馮其庸) in Wuxi. Mrs Zhang is a specialist tutor at the National Library of China's National Centre for the Preservation of Ancient Books and an occasional tutor at Shanghai's Fudan University. In 2017, she was awarded the coveted title of "Shanghai Artisan" in recognition of her work.

Zhou Tong（周統）

Zhou Tong (b. 1972), the proprietor of the Beijing's Ziqing Mountain Studio (梓慶山房), has spent his entire career researching and creating fine, traditional Chinese furniture. He is familiar with every aspect of traditional furniture making and is especially noted for his subtle approach to form and the visual charm of his work. Mr Zhou was part of the restoration of the interior and furnishings of Beijing's historic Studio of Exhaustion from Diligent Service (倦勤齋, Palace Museum) and Prince Kung's Mansion (恭王府). Sales of his work at Christie's have attracted the attention of collectors in China and beyond. Mr Zhou's furniture has been exhibited at institutions around the world, including Kyoto's Jotenkaku Museum, the Arthur M. Sackler Museum at Peking University and the Shanxi Museum in Taiyuan, garnering praise from observers in the US, the UK, Japan, and China.

Li Zhi（李智）

Li Zhi (b. 1973), a native of Anhui province, is currently senior craftsman at Shanghai's Duoyun Studio (朵雲軒), which he first joined in 1991 as a junior carver. During his early years at the studio, he was apprenticed to the nationally recognised carver Jiang Min (蔣敏). Mr Li's skill in carving line drawings is matched by only a handful of artists currently working in China; he is also trained in embossing. His major works include a woodblock version of the Qing artist Ren Bonian's *Immortals Offering Birthday Congratulations* (任伯年, 群仙祝壽圖, set of 12 hanging scrolls). In the late 1990s, he was involved in the carving of the calligraphy from Gu Kaizhi's handscroll *Rhapsody on the Spirits of the River Luo* (顧愷之, 洛神賦圖). His revised version of the 1626 *Luo Studio Album of Decorated Letter Paper Adapted from Ancient Models* (蘿軒變古箋譜), published in 2012, included new woodblock illustrations, as well as revisions, repairs, and partial recarving of the original blocks. Mr Li is also an accomplished bamboo and seal carver. He is particularly fond of the rich, scholarly atmosphere found in the bamboo carving of Jin Xiya (金西厓), and of the seal carving of Chen Julai (陳巨來). In his own work, he specialises in Han seals and Yuan-style relief seals. Mr Li is also known by the soubriquets Li Baiwan (李白完) and Master of Sheaf-and-Blade House (一刀居主人).

Zhang Midi（張彌迪）

Zhang Midi (b. 1986, Juye County, Shandong) is a graphic designer based in Hangzhou, where he founded Yu Shu Tang (聿書堂). He is a member of the Book Art & Design Committee under the Publishers Association of China, an adjunct lecturer at the School of Design and Innovation of the China Academy of Art, an off-campus lecturer for graduate students at the School of Art and Archaeology of Zhejiang University, a contracted type designer at FounderType and a study group member. Zhang specializes in typography and the research and production of book design art. He is also the editor of *The Illustrations of Yumeji Takehisa* (竹久夢二圖案集) and *Typographic Composition Yoshihisa Shirai: from International Style to Classic Style and to Idea* (排版造型　白井敬尚——從國際風格到古典樣式再到 *idea*). Zhang has been shortlisted for exhibitions and awards including the 9th National Book Design Art Exhibition, the 4th China Design Exhibition, Kan Tai-keung Design Award, and TDC VOL.30 in Tokyo, Japan.

Chen Bin（陳斌）

A native of Yangzhou, Jiangsu, Chen Bin (b. 1987) displayed a love of art and craftsmanship from a young age. In early 2004, he moved to Jiading, the home of Chinese bamboo carving, where a friend's introduction led to an apprenticeship with Zhuang Long (莊龍), a respected carver recognised by local government for his contributions to the tradition. Mr Chen has been immersed in the extraordinary world of bamboo carving for over a decade, and his versatile command of the major carving techniques – openwork, relief, sunken relief, intaglio and *liuqing* – allows him to achieve a perfect marriage between diverse external forms and a harmonious inner spirit. His work has featured in exhibitions including *Contemporary Bamboo Carvings from Jiading* (當代嘉定竹刻作品展) and has garnered praise from a range of experts and collectors. Since 2010, Chen has been an instructor at Sunshine Workshop (陽光工坊), a local charity teaching bamboo carving skills to the disabled. He hopes to continue to explore and innovate, while seeking to preserve the traditional authenticity of Jiading's bamboo carving. Mr Chen is also known by the soubriquet Chen Youjun (陳友君).

Cameron Henderson-Begg（韓凱邁）

Cameron Henderson-Begg (b. 1994) is a London-based writer and translator. Mr Henderson-Begg was educated at Oxford University, where he read Chinese with a concentration in art history. While at Oxford, he was a recipient of the Gibbs Prize for Classical Chinese, the Rex Warner Prize for Literature and the Ko Cheuk Hung Scholarship for the study of traditional China. He has worked as a translator and cataloguer for numerous museums, libraries, and galleries and as an editor for Cambridge University Press and the Fitzwilliam Museum. Mr Henderson-Begg also researches the material culture of late imperial China, focusing on traditions of antiquarianism and Chinese elites' efforts to understand the past through objects. *Many Fair Bblossoms Make a Fine Tree* is his first full-length translation.

Ashley N. Wu（胡雅茜）

Born and raised in Hong Kong, Ashley Wu holds a BA in English from the Chinese University of Hong Kong, and MA degrees in Art History from the University of Bristol and New York University. Formerly employed as Assistant Curator at the Asia Society Hong Kong, she is now an art researcher based in the US with special interest in the influence of East Asian culture over twentieth-century art in Europe and North America.

Chloe Tung（董靜）

Chloe Tung is an undergraduate history student from Hong Kong, currently studying at University College London (UCL). She is the granddaughter of Tung Chiao and is keen to follow in her grandfather's footsteps in the understanding and appreciation of Chinese antiquities and fine art.

Gillian Kew

British national, Gillian Kew (SRN, RMN, MA) (b. 1959), is a Hong Kong-based editor. A former Registered General and Psychiatric Nurse, Ms Kew studied for her BA at the Open University of Hong Kong and her MA in Gender Studies at the Chinese University of Hong Kong. She has worked as an editor for over 35 years, editing scientific papers, art catalogues, books, and dissertations for universities, NGOs, and individual authors.

Acknowledgements

Translated by Ashley Wu

For the genesis and completion of this publication, I am indebted to the teaching and guidance of Wang Shixiang, Zhu Jiajin, Qi Gong, Huang Miaozi, Fu Xinian and Tung Chiao. I am also grateful to the artists whose names are published in the biographies above, as well as to all the artisans who were actively involved.

I must also thank all the institutions and individuals who granted their permission to reproduce images of paintings, calligraphy, and objects in this publication that are instrumental in illustrating the content:

The Palace Museum, Beijing
The Palace Museum, Taipei
The Shanghai Museum
The Nanjing Museum
The Liaoning Museum
The Zhejiang Museum
The Qingzhou Museum
Art Museum, The Chinese University of Hong Kong
The Freer Gallery of Art
The Metropolitan Museum of Art
The Nelson-Atkins Museum of Art
The Osaka City Museum of Fine Arts
The Trustees of the British Museum
The Victoria & Albert Museum
Ashmolean Museum, University of Oxford
China Guardian, Beijing
Sotheby's
Christie's
The Min Chiu Society, Hong Kong
Han Mo Xuan, Hong Kong
Mengdiexuan, Hong Kong
The family of Mr Fu Zhongmo
The family of Mr Huang Bore
Ms Zhu Chuanrong
Dr Huang Dawei
Ms Sally Tsui
Mr Chris Hall
Professor Richard Y. H. Yu

Mak Kin Bong from Feeling Workshop was the photographer for the images of scholar's objects, furniture, and works on paper. He was exceptional in the deployment of light and shade in images of *liuqing* carving. Dr Simon Kwan took care of the photography of Items 086, 088, and 090; Lo Kwan Chi shot some of the brushpots, and all the panoramic views of the brush pots; Yu Chung Hei took the photograph of Item 094. Chu Wing Chun illustrated the furniture with line drawings.

Zhang Midi was very patient in designing the publication, the layout of which was perfected after dozens of iterations. Cameron Henderson-Begg translated Wu Guanrong's foreword, my preface, all the main text and poetry and part of the biographies into fluent English with his superb writing skills, while Ashley Wu translated Hui Lai Ping's foreword, the introductory essay, this acknowledgment, and some of the artist biographies. Chloe Tung translated Tung Chiao's foreword. Gillian Kew edited the English version. Mao Yongbo and Xu Xinyu, from the Commercial Press, the managing editors of the publication, are appreciated for all the feedback they shared. The copyright of the illustrations was secured through Lu Xiaomin's tireless efforts.

Finally, I would like to acknowledge all the contributors with gratitude: Tung Chiao, Hui Lai Ping, and Wu Guangyong for their forewords; Dr Fu Yang for her response to the text; Tung Chiao for his permission to publish nine of his essays under "Writings from my mentors and peers"; and Hui Lai Ping for his permission to quote his essay "On the Lady Scholar Taotao, Jin Zhang" in full under item 007. Their words have added many insights to the book.

MANY FAIR BLOSSOMS MAKE A FINE TREE

Commissions of Scholar's Objects and Furniture by Kössen Ho

Written by
KÖSSEN HO

Translated by
Cameron Henderson-Begg

Edited by
Yongbo Mao Xinyu Xu

Designed by
Midi Zhang Wanting Liu

Published by
The Commercial Press (H.K.) Ltd.
8/F, Eastern Central Plaza, 3 Yiu Hing Road, Shau Kei Wan, Hong Kong
http://www.commercialpress.com.hk

Distributed by
The SUP Publishing Logistics (H.K.) Ltd., 16/F, Tsuen Wan Industrial Centre,
220 –248 Texaco Road, Tsuen Wan, NT, Hong Kong

Printed by
Artron Art (Group) Co., Ltd.
No. 19 Shenyun Road, Nanshan District, Shenzhen

© 2023 The Commercial Press (H.K.) Ltd.
First Edition, First Printing, June, 2023

ISBN 978 962 07 5766 2
Printed in China